Picasso's Variations on the Masters: Confrontations with the Past

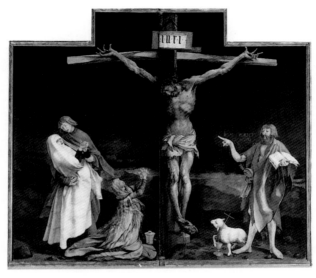

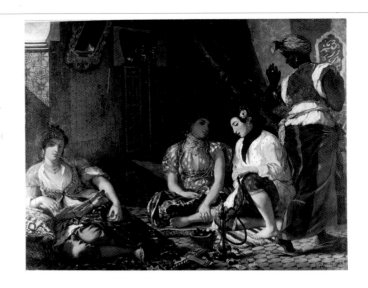

Susan Grace Galassi

Harry N. Abrams, Inc.
Publishers

Picasso's

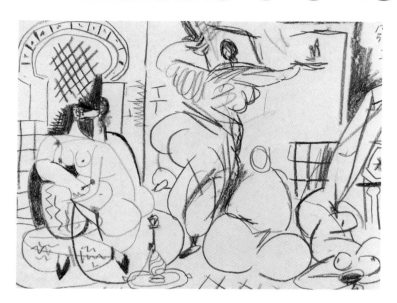

Variations on the Masters

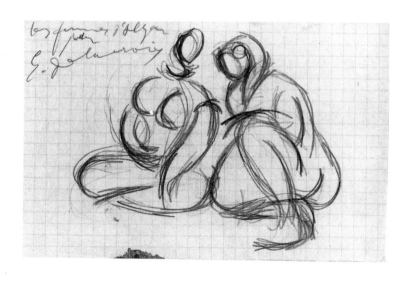

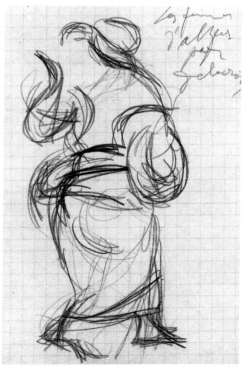

Confrontations with the Past

To Jon

Editor: Elaine M. Stainton
Designer: Judith Michael
Photo Editor: Roxana Marcoci

Page 1:
Above: Mathis Grünewald. *Crucifixion,* from the Isenheim Altarpiece. Musée d'Unterlinden, Colmar
Below: Pablo Picasso. Study for *Crucifixion,* after Grünewald. Musée Picasso, Paris

Page 2:
Above: Eugène Delacroix. *Women of Algiers (Les Femmes d'Alger).* Musée du Louvre, Paris
Below: Pablo Picasso. Drawings from a sketchbook after *Women of Algiers.* Musée Picasso, Paris

Page 3:
Above: Pablo Picasso. Drawing for *Women of Algiers.* Musée Picasso, Paris
Below: Pablo Picasso. Drawings from a sketchbook after *Women of Algiers.* Musée Picasso, Paris

Library of Congress Cataloguing-in-Publication Data

Galassi, Susan Grace.
Picasso's variations on the masters: confrontations with the past
/ Susan Grace Galassi
p. cm.
Includes bibliographical references.
ISBN 0–8109–3741–7 (clothbound)
1. Picasso, Pablo. 1881–1973—Criticism and interpretation.
2. Imitation in Arts. 3. Appropriation (Art) I. Title
ND553.P5G2 1996
759.4—dc20 96–811

Text copyright © 1996 Susan Grace Galassi
Illustrations copyright © 1996 Harry N. Abrams, Inc.

Published in 1996 by Harry N. Abrams, Incorporated, New York
A Times Mirror Company
Printed and bound in Japan

Table of Contents

Acknowledgments

In choosing a dissertation topic at the Institute of Fine Arts, New York University, I returned to Picasso, my first love in the visual arts, whose work, I would soon discover, encompassed a whole history of art. My advisor, the late Professor Gert Schiff, suggested looking into his variations, and throughout the long process remained unstinting in his support and a model in his scholarship. To him, my first Picasso partner, I am enormously grateful. I was fortunate to have also had the guidance of two other Picasso scholars at the Institute who contributed substantively to this endeavor: Professors William Rubin and Robert Rosenblum. In addition, Professor Jonathan Brown made many valuable suggestions on the chapter on *Las Meninas* and invited me to air my thoughts at a symposium on Picasso and the Spanish tradition at the Spanish Institute in New York, while Professor Colin Eisler, with customary generosity, was the catalyst for turning the dissertation into a book. I am also grateful to the Institute of Fine Arts for summer travel grants and a Dean's dissertation fellowship. With Gertje Utley, Dorothy Kosinski, Deborah Rothschild, and especially Professor Robert Lubar—fellow Institute graduates and Picasso scholars—I have benefited from continued discussion of the material as I revised it for publication.

The staff of the Musée Picasso in Paris has been unfailingly helpful in opening its resources. I thank especially Michèle Richet, Hélène Seckel, Marie-Laure Bernadac, Anne Baldassari, Sylvie Fresnault, and Jeanne Sudor for their many kindnesses; I am also indebted to Rosa Subirana at the Museu Picasso in Barcelona. Hélène Parmelin and John Richardson generously shared first-hand accounts of some of the major suites of variations that they had seen shortly after completion. For her comments on the Grünewald chapter, I thank Professor Andrée Hayum of Fordham University; Mme. Sylvie Lecoq-Ramond, Director of the Musée Unterlinden in Colmar, deserves thanks as well for sending me information from its files. I am likewise indebted to the many individuals who permitted their works to be reproduced or photographed, or opened their collections to me, especially to Mrs. Victor Ganz and Mrs. Eleanor Saidenberg in New York.

I have enjoyed two decades of continuous inspiration and friendship with Professor Rudolf Arnheim, with whom I studied as a special student in the Department of Visual and Environmental Studies at Harvard University. With him I discovered the profound pleasure of looking with another; this, in turn, has been shared with the many students I have

encountered during my years as an adjunct professor.

My interest in Picasso was nurtured at The Museum of Modern Art in New York, where I spent several years in the Education Department while a graduate student. At The Frick Collection, my home for the past five years, I have gained a deeper appreciation of the masters through daily contact with their work; I thank the Director, Charles Ryskamp, the Curator, Edgar Munhall, and Research Curator, Bernice Davidson, for their generous support in the form of a leave of absence, travel funds, the opportunity to present my work in a lecture, and encouragement. To them and all my colleagues at the Collection and at the Frick Art Reference Library, and to the former and current Librarians, Helen Sanger and Patricia Barnett, I offer my heartfelt thanks for their support. I am also grateful to the staffs of libraries of the Metropolitan Museum of Art, the Museum of Modern Art, and the Division of Art and Archeology in the New York Public Library. Heather Lind and Emily Gardiner were of invaluable assistance in the final preparation of the manuscript. Richard di Liberto provided photographs, and Brian Nicols gave generously of his computer expertise.

Robin Straus, my literary agent, took on the manuscript, and stood by me throughout the lengthy rewrites. At Harry N. Abrams, Inc., Roxana Marcoci worked with consummate skill and good will to track down pictures from all over the world. My editor, Elaine Stainton, helped shape the manuscript with her sensitive response to the material and scrupulous attention to detail, and was always unfailing in her humor and warmth. To her, I am especially grateful. I also want to thank Judith Michael for her handsome design of the book.

I have had several other Picasso partners of a more personal kind who have contributed to this lengthy effort with their encouragement and advice, among them James Atlas, Julia Berwick, Anna Fels, Joan and Fred Gardiner, Josephine Gonzalez, Mac Griswold, Ned and Sue Hallowell, Christopher and Jamie Hewat, Warren Motley, Sabine Rewald, Cynthia Saltzman, Martha Saxton, Frederick Seidel, Jean Strouse, Alison West, and Diana Wylie. My sister Pamela Model, and brother Bill Grace, my late brother, Tom, my parents, and my family-in-law are all integral to this endeavor, as is my reader. To my daughters, Isabel and Beatrice, I owe the deepest thanks for their loving support, and above all, to my husband, Jonathan Galassi, who will find himself, and many of our years together, reflected in these pages.

1 Variations in Search of a Theme

It is better to copy a drawing or painting than to try to be inspired by it, to make something similar. In that case, one risks painting only the faults of his model. A painter's atelier should be a laboratory. One doesn't do a monkey's job here: one invents. Painting is a jeu d'esprit.
—Picasso, 1945[1]

Pablo Picasso was one of the most iconoclastic artists of the twentieth century, yet he was deeply rooted in the art of the past. As a painter, he was both profoundly instinctual and highly self-conscious, but his truest theme was always art itself. The paradoxical nature of Picasso's art is brought out in strong relief in his variations on works by masters of the past, a critical and creative commentary on his art as a whole and on the work of the artists who obsessed him.

Taking others' work as subjects for one's own—to copy, allude to, or freely transpose into new creations—has long been a staple of art education, and a major avenue of preserving and exorcising tradition. While Picasso made use of all of these methods of appropriating the past, it was through his variations on paintings by old masters that he most openly confronted his most significant forebears. Other modern artists from Vincent van Gogh to Francis Bacon freely transposed works by their predecessors, but no great painter has made such extensive use of this formal operation as Picasso. For other artists, variations were usually an occasional exercise; for Picasso, notably in his later years, they were a continuous part of his creative program, and in his hands the formal operation of variation itself underwent significant transformation. Endowed with an omnivorous visual memory and an insatiable curiosity about all forms of art, Picasso invested variation with a vitality that brought it to the center of his artistic endeavor, where the creative and the critical overlap.

As the full extent of Picasso's oeuvre gradually came to light after his death in 1973, his previously neglected late work, of which the variations make up such a large part, became a new focus of interest.[2] The rise of Structuralist and post-Structuralist interpretation in the seventies also attracted attention to Picasso's variations.[3] With their complex interplay of voices, systems of representation, and historical eras, and the questions they raise about originality, authorship, and the construction of meaning, the variations came to the fore as object lessons in the self-referential nature of modern art.

What has not been undertaken before now is a study of Picasso's variations as a body of work that unfolds over his career, growing in complexity, frequency, and significance. Nor have many of the individual variations or suites of interpretations been examined closely in relation to their sources. Through an analysis of each of the most important vari-

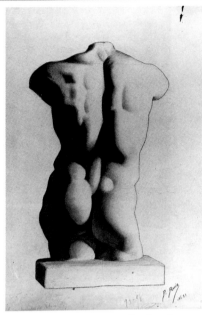

ations, this study traces the process of transformation through which Picasso converted works of the past into, in his words, "something else entirely";[4] it suggests as well the relationship of the variations to each other, and to Picasso's work as a whole.

Variation shares a kinship with a number of other methods of quotation commonly used by artists, including copying.[5] A copy is traditionally regarded as a replica of another work in which the hand and style of the copyist is subordinated to that of the author of the work he imitates. Though a copy calls for considerable skill and can even be a showcase for virtuosity, it is not a work of art in its own right. As the philosopher Arthur Danto notes: "Copies (in general) lack the properties of the originals they denote and resemble. A copy of a cow is not a cow, a copy of an artwork is not an artwork."[6]

A drawing made after a plaster cast (fig. 1–1) shows Picasso's proficiency in copying in his early teens. As a student at the Royal Academy of San Fernando in Madrid in the fall and early winter of 1897–98, Picasso made numerous copies after paintings in the Prado, though even then, in letters to his friends, he expressed his exasperation with such didactic exercises and the limited range of acceptable models.[7] In his copy (fig. 1–2) after Velázquez's *Portrait of Philip IV* of c. 1655 (fig. 1–3) Picasso's rejection of servile imitation is noticeable in his subtle departures from the master's candid portrayal: in the elongating and flattening of the face, the turning of the eyes slightly askew, thus creating a more overtly troubled expression than that of its counterpart, and the loose modeling that exaggerates Velázquez's impressionistic brushstroke.[8] Picasso also exercised his independence in his choice of models, preferring El Greco's expressionism to the naturalism of Velázquez or the Dutch masters held up as the highest example by the Academy. But even with the painters he most admired, Picasso did not hesitate to express irreverence. In drawings after El Greco's *The Burial of Count Orgaz*, executed on a class trip to Toledo, he substituted heads of his teachers and classmates for those of the saints, a prank that earned him expulsion from the Academy.[9]

Picasso's early student copies, in the traditional sense of replicas, occupied him for only a brief period. Later in life, he commented on the type of instruction he received as a student: "Academic beauty is a sham. . . . Art is not the application of a canon of beauty but what the instinct and the brain can conceive beyond any canon."[10] Picasso, however, retained a place for copying in the more traditional sense of imitation after his student years, using it for special purposes throughout his art. His drawings of 1919 after a photograph of Auguste Renoir (fig. 1–4), and in 1954 after a self-portrait of Eugène Delacroix (Ch. 5, fig. 5–6) express his identification with these two predecessors.

Fig. 1–1 *Pablo Picasso.* Study of a Torso after a Plaster Cast. *1893–94. Charcoal and conte crayon on paper, 19¼ × 12⅜″ (49 x 31.5 cm). Musée Picasso, Paris*

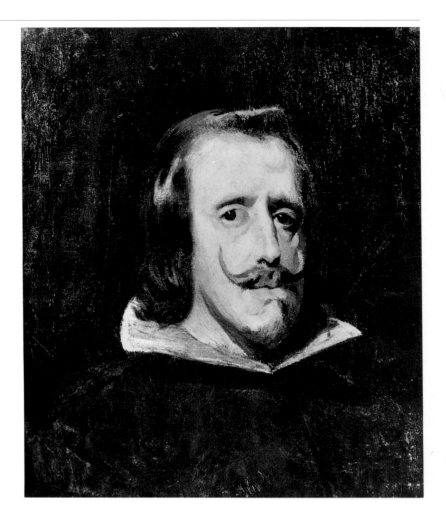

Picasso most commonly tapped the wealth of the Western artistic heritage through allusion to earlier artworks, often drawing from multiple sources in a single work. In this method of borrowing, a salient feature of a well-known painting, such as the pose of a particular figure, a grouping of figures, or a larger compositional pattern, is quoted or excerpted from the original source and used in a new context. With reference or allusion, the subject matter of the linked works is not the same. In Picasso's *Portrait of Gertrude Stein* of 1906 (fig.1–5), for example, the sitter's pose is derived from that of Jean-Auguste-Dominique Ingres's famous portrait of Louis-François Bertin in the Louvre (fig. 1–6), though the borrowing may only be subliminally recognized by the viewer.

Often, the more significant the work, the more numerous and far-ranging are Picasso's allusions to the past. As the art historian Robert Rosenblum notes:

Les Demoiselles d'Avignon, for all its shattering newness, takes its place as perhaps the last of the great 19th century harem and brothel interiors, from Delacroix to Ingres, and from Degas and Toulouse-Lautrec . . . while *Guernica* . . . has now become a public resumé of centuries-old forms and motifs in Western art that include everything from Greek pedimental sculpture and illustrations of the *Rape of the Sabines* and the *Massacre of the Innocents,* to such 19th century records of

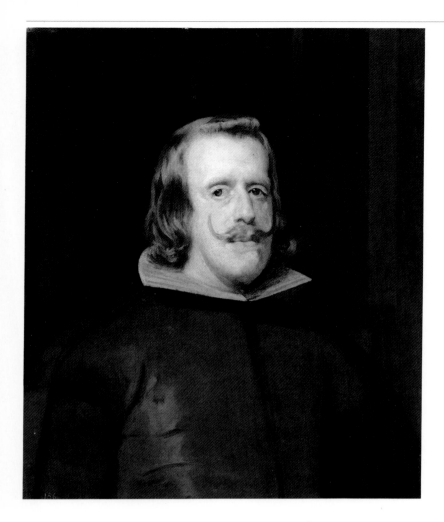

Fig. 1–3 *Diego Velázquez*. Portrait of Philip IV. *c. 1655. Oil on canvas, 27³⁄₁₆ × 22¹⁄₁₆" (69 × 56 cm). Museo del Prado, Madrid*

contemporary bloodshed as Goya's *Executions of May 3, 1808*, Delacroix's *Liberty Leading the People* and Préault's *Massacre*.[11]

Allusions or references to earlier paintings enhance or amplify the meaning of a work, but do not determine it. In a variation, by contrast, the artist takes the formal structure of one specific work as the point of departure for a creation of his own. An example of this is Picasso's painting of 1950 after El Greco's *Portrait of a Painter (Jorge Manuel Theotocopuli)* of two hundred and fifty years earlier (figs. 1–7 and 1–8). The source must be clearly recognizable in the variation; like a copy or a work of criticism, it is not an independent creation but has its primary meaning only in relation to the work on which it is based. Unlike a copy, a variation forms a reciprocal relationship with its source, rooted in contrast, in which the new work and the old modify and define one another in turn.[12]

In a variation the structure (or schema) of the original is preserved, while style, technique and, most significantly, content undergo transformation. The relationship between the two works can vary considerably, from a close approximation to a loose and tenuous connection. The "originality" of the variation depends largely on the ingenuity of the artist in constructing a new disjunctive entity of different and often opposing styl-

Fig. 1–4 *Pablo Picasso*. Portrait of Renoir, after a photograph. *1919–20. Pencil on paper, 24 × 18¹⁄₄" (61 × 49.3 cm). Musée Picasso, Paris*

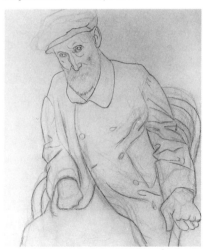

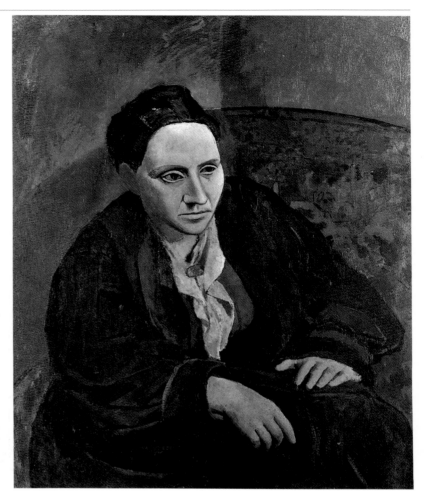

Fig. 1–5 *Pablo Picasso.* Portrait of Gertrude Stein. *1905–06. Oil on canvas, 39¼ × 32" (99 × 81.3 cm). The Metropolitan Museum of Art, New York. Bequest of Gertrude Stein, 1946*

Fig. 1–6 *Jean-Auguste-Dominique Ingres.* Louis-François Bertin. *1832. Oil on canvas, 45¾ × 37⅜" (116 × 95 cm). Musée du Louvre, Paris*

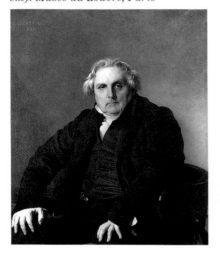

istic elements, while keeping in mind the source from which they are diverging. A variation is always more revealing of the sensibility of its creator than of the material that served as the basis of the transformation. Pictorial variation is similar to allegory, of which the critic Walter Benjamin has written: " . . . such significance as it has, it acquires from the allegorist. He places it within it and stands behind it; not in a psychological but in an ontological sense. In his hands, it becomes something different; through it he speaks of something different . . ."[13]

Variation is both a fundamental musical technique and a common literary device, as can be seen in aspects of James Joyce's *Ulysses*, Ezra Pound's "Homage to Sextius Propertius," or Robert Lowell's *Imitations*, to name only a few modern examples. In painting the practice of making interpretive works also has a long history: among well-known instances are Giovanni Bellini's translations of paintings by his brother-in-law, Andrea Mantegna, Rubens's recreations of works by Titian, and Cézanne's penetrating analyses of Delacroix's canvases. In the visual arts, a new era of copying began, as the art historian Roger Benjamin has noted, when the criterion of duplication was abandoned with the recognition that the artist inevitably interpreted as he copied.[14] By the end of the nineteenth century, he observes, "the real interest of the copy lay precisely in its departure from the model, in the activity of interpretation, in

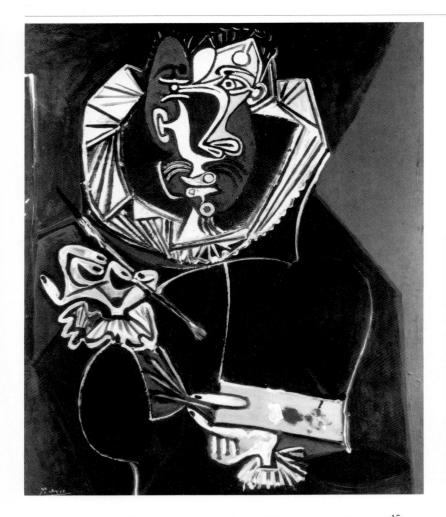

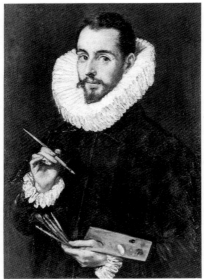

Fig. 1–7 *Pablo Picasso.* Portrait of a Painter, after El Greco. *February 22, 1950. Oil on plywood, 39⅝ × 31⅞" (100.5 × 81 cm). Collection Angela Rosengart, Lucerne*

Fig. 1–8 *El Greco.* Portrait of a Painter (Jorge Manuel Theotocopuli). *c. 1603. Oil on canvas, 31⅞ × 22" (81 × 56 cm). Museo de Bellas Artes, Seville*

the revelation of self through the medium of the borrowed image."[15]

With his highly self-conscious and ironic use of specific images by other artists, Manet opened new paths to conceptual and creative uses of art history, as seen, for example, in *Olympia* and *Le Déjeuner sur l'herbe* (which will be discussed in Chapters 2 and 7).[16] The philosopher Michel Foucault cites these two paintings as the first "museum pieces," which point to "the new and substantial relationship of painting to itself, as a manifestation of the existence of museums and the particular reality and interdependence that paintings acquire in museums."[17] It is van Gogh, however, who has come to be regarded as the legitimizer of the interpretive copy for the new generation of artists.[18] In a letter to his brother Theo, he expressed the spirit of the enterprise and his aims in a discussion of his copies after Millet:

I am going to try to tell you what I am seeking in it and why it seems good to me to copy them. We painters are always asked to compose ourselves and be *nothing but composers.*

So be it—but it isn't like that in music—and if a person or another plays Beethoven, he adds his personal interpretation—in music and more especially in singing the *interpretation* of a composer is something, and it is not a hard and fast rule that only the composer should play his own composition. . . .

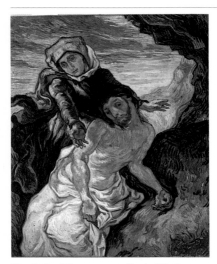

Fig. 1–9 *Vincent van Gogh.* Pietà, after Delacroix. *1889. Oil on canvas, 28¾ × 24" (73 × 60.5 cm). Van Gogh Museum, Amsterdam. Collection Vincent van Gogh Foundation*

I let the black and white of Delacroix or Millet or something made after their work pose for me as a subject.

And then I improvise color on it, not, you understand, altogether myself, but searching for memories of *their* pictures, but the memory, "the vague consonance of colors which are at least right in feeling"—that is my own interpretation.

Many people do not copy, many others do—I started on it accidentally, and I find that it teaches me things, and above all it sometimes gives me consolation. And then my brush goes between my fingers as a bow would on the violin, and absolutely for my own pleasure.[19]

Van Gogh generally worked from black-and-white engravings or photographs—works that were already copies—of paintings and drawings by artists he admired, squaring them off for transfer to his canvas.[20] For him, copying was equivalent to "translating into another tongue"—from black and white into color, and/or from drawing or engraving into painting, a process seen in his variation based on a lithograph after Delacroix's *Pietà* (fig. 1–9).[21] Using works of other artists as starting points for his own also had a practical purpose, for it allowed van Gogh to continue to work from the human figure at times when a model was not available to him.[22] In his comments on his painting after Millet's engraving *The First Steps*, van Gogh mentioned yet another use he had found for his interpretations: he painted canvases that his predecessor had not had time to do.[23] Van Gogh made use of variation not only to "complete" the work of past artists, but also to express his solidarity with his contemporaries; he presented Paul Gauguin with a painting he had executed after a drawing by his friend "as a summary of our months together."[24] In his multivalent approach to variation and the freedom he took in translating a work of another artist into his own idiom, as well as in the wide range of his sources (Rembrandt, Delacroix, Millet, Daumier and Doré), van Gogh is a forerunner of Picasso.[25]

Variation was thus an established, if peripheral, practice in late nineteenth-century art, and many of Picasso's contemporaries took it up in the early years of the twentieth. A notable example of it is Henri Matisse's 1915 Cubist interpretation of a still life by the seventeenth-century master Jan de Heem (fig. 1–10). Picasso, however, extended and transformed the tradition more radically than any other modern painter.

One of the most distinguishing (and disturbing) features of Picasso's art is his stylistic plurality. Looking back over his life, Picasso observed, "Basically I am a perhaps a painter without style. Style is something that locks a painter into the same vision, the same technique, the same formula. One recognizes it immediately, but it is always the same suit, or the same cut of suit. I thrash around too much. I am never fixed and that's why I have no style."[26] Throughout his career, Picasso adopted a succession of styles from other artists—El Greco, before leaving Spain, and Toulouse-Lautrec, Ingres, and Seurat among others during his first two decades in France—and he drew as well from African, Oceanic, Iberian, and Greek and Roman art. From nearly the beginning of his career, Picasso also freely combined different styles in a single work, as in his portrait of Gertrude Stein, where he overlaid a mask-like face inspired by Iberian art on a naturalistically painted figure. It was in the *Demoiselles*, however, that stylistic diversity emerged as a major expressive device.[27] The clash of distorted and fragmented female bodies derived from various Western and non-Western styles with mask-like faces underscores

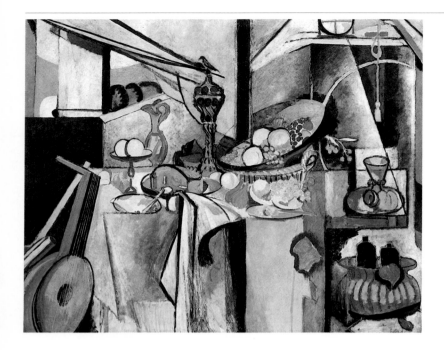

Fig. 1–10 *Henri Matisse*. Variation on a Still Life by de Heem. *Issy-les-Moulineaux, 1915. Oil on canvas, 5'11¼" × 7'3" (180.9 × 220.8 cm). Museum of Modern Art, New York*

the "rule of disruption" manifest throughout the work.[28] This painting initiates Picasso's attack on illusionism, the representational model that had dominated the visual arts since the Renaissance.

Picasso's paintings of the early stages of Cubism, the revolutionary idiom that he pioneered in a creative partnership with Georges Braque, exhibit a withdrawal from the world of appearances in favor of a new paradigm of representation, in which a tension exists between the structure of the pictorial image and the object being depicted. The change is rooted in the idea, as the art historian Yve-Alain Bois put it, "that painting is a language of sorts made of signs, governed by codes which are historically changing, entrusted with the task of interpreting reality, not merely 'copying' it."[29] The implications of this shift have been the focus of much recent discussion by art historians applying the methods of structural linguistics to Cubism.[30]

This sign-like or structural character of painting is first apparent in Picasso's paintings of the Analytic Cubist period, roughly 1909–12, when he and Braque embarked on an intensive examination of illusionism.[31] They broke down mass, line, and light into a system of fluctuating facets and planes submitted to a grid-like structure. Each of these discrete, material elements or marks can be read in more than one way—as referring to surface or depth; their role is determined by their context in the overall structure. The image of the world these paintings conveys is one that is fluctuating rather than static, constructed, not given.

During Picasso's period of closest collaboration with Braque from 1910 to 1912, their unsigned canvases were almost indistinguishable from one another. Looking back on Cubism in later years, Picasso commented to his companion Françoise Gilot: "People didn't understand very well at the time why very often we didn't sign our canvases. . . . It was because we felt the temptation, the hope of an anonymous art, not in its expression but in its point of departure. We were trying to set up a new order, and it had to express itself through different individuals. Nobody needed

to know that this was so-and-so who had done this or that painting."[32] The experiment was a failure, Picasso told Gilot, because individualism was already too strong. Nevertheless, Picasso would continue to explore the tension between the conventionality of the system and individualism in later works.

With his collages, *papiers collés* (pasted paper), and paintings of the Synthetic Cubist phase, from 1912 to 1921, Picasso effected a more radical break from the illusionistic aesthetic. Here, the signs become larger and more defined as independent shapes, and are increasingly arbitrary in their relation to the object they purport to represent. The structure of the work and depicted object work at counterpoint to each other, allowing for a free play of meaning. Picasso's Cubist work makes clear, as Rosalind Krauss notes, that "meaning is always mediated by the system, processed by the system's own structural relations and conventions."[33]

In the postwar period, when Cubism had become the *lingua franca* of the Parisian avant-garde, Picasso further elaborated the concept of art as a structural system akin to language. He now worked in multiple styles simultaneously, ranging from nearly abstract collages to portraits in pencil and in oil in the highly polished manner of Ingres, and from richly-textured neo-pointillist works to paintings in a severe "crystal Cubist" style. Historic traditions are placed on equal footing with his own original contributions. Thus, he challenges the concept of style as the unique mark or handwriting of an individual or of a group of artists of a particular period or school—the externalization of a distinct personality or temperament. Style is instead posited as a set of available conventions or codes to appropriate, transform and recombine. In the postwar period, as Rosenblum notes, he introduces a "relativity of pictorial style" in which no one mode has any greater claim to truth than any other.[34]

Variations are perhaps the purest manifestation of Picasso's concept of visual representation as a language. Here he extends his exploration of the systems of art to the artistic tradition, which is itself treated as a sign system, subject to shifting meaning depending on the context in which it is used. In his art after art, the contrast of styles—so central to his work as a whole—is embedded in the process of variation; meaning is constructed through an interplay among the codes of different historical periods. Picasso constantly pits his powers of invention against the conventions of his predecessors' work. Often laced with humor—and sometimes cruel parody—his variations are a form of free play or *jeux d'esprit*, in which he attempts to work his way out of the paintings that entrap him, and to construct new meaning from the old signs, freighted with historic and personal significance. They express in concise and often witty form his notion of the relativism of artistic expression in which nothing is fixed; any one sign can be made to express something else. As Picasso said, "Raphael's image of a woman is only a sign. A woman by Raphael is not a woman, it's a sign that in his spirit and ours represents a woman. If this woman is decorated with an aureole, and if she has a child on her knee, then she's a virgin. All that's only a sign."[35]

In later years, variation provided a means for Picasso to revisit many of the fundamental representational issues that lie at the heart of his Cubist work, while continuing to explore various historic modes and asserting his anti-abstractionist stance. But there are additional reasons why variation was so compelling and vital an artistic process for Picasso. The

dialectical form of variation draws vitality and significance from a set of concerns that were important throughout his life, but gained momentum in his old age: the interaction of past and present, the dynamic relationship of artist and viewer, the dual nature of the creative process (as a dialogue between the self and other), and the reciprocity of repetition and change. Through variation Picasso dives into many of the productive conflicts that give shape, energy, and direction to his painting. Often elliptical in expression, like his verbal statements on art, they nevertheless guide us from within to the pressure points of his artistic enterprise.

Toward the end of the nineteenth century, the accumulated wealth of the past had become more available than in any previous era—if not unavoidable—through the development of modern methods of photographic reproduction, the mass marketing of journals and books on art, and the growth of museums and of the discipline of art history.[36] The dilemma that this abundant evidence of past achievement has created for the practitioner in every field of endeavor, and the sense of "belatedness" it has engendered, is central to the modern experience.[37] Through his variations, Picasso waged one of his most crucial struggles, that of weighing his own achievement against the legacies of the most significant of his forebears, and of creating a place for himself within the Western European tradition. Picasso's deep anxiety around this issue is revealed in an incident in post–World War II years (discussed in Chapter 4) in which he had the opportunity to hold up some of his own paintings against those of some of the masters he most admired in the Louvre. Having studied them closely in comparison with works by Zurbarán, Courbet, Delacroix, and others, he is reported to have said, as if relieved: "You see, it is the same thing, the very same thing."[38] Yet his variations are not "the same thing" at all, but works against the grain that disrupt the entropic forces of the past. "The painter," Picasso once said to André Malraux, "takes whatever it is and destroys it. At the same time, he gives it another life. For himself. Later on for other people. But he must pierce through what the others see—to the reality of it. He must destroy. He must demolish the framework itself."[39]

Picasso's attitude toward the past was strongly shaped by the anti-historical stance of Friedrich Nietzsche, with whose work he became familiar while still in Barcelona, through his connection with the "Generation of 1898," a group of Catalan intellectuals and writers.[40] Nietzsche was reacting against an "excess of history," claiming that the past is only useful in the "service of life."[41] In "The Use and Abuse of History" (1874), he proposed as an alternative to the ennobling "monumental" and "antiquarian" approaches to the past, a "critical" way, which liberates the present from the burden of the past and opens it to the future:

Man must have the strength to break up the past and apply it, too, in order to live. He must bring the past to the bar of judgment, interrogate it remorselessly, and finally condemn it. Everything past is worth condemning: this is the rule of mortal affairs, which always contain a large measure of human power and human weakness. It is not justice that sits in judgment here, nor mercy that proclaims the verdict; but only life, the dim, driving force that insatiably desires—itself. Its sentence is always unmerciful, always unjust, as it never flows from a pure fountain of knowledge: though it would generally turn out the same, if Justice herself delivered it. "For everything that is born is *worthy* of being destroyed: better it were then that nothing should be born."[42]

From the beginning, as we have seen, Picasso was a voracious consumer of art of all kinds. His various studios were hung with work by artists he admired: along with canvases by his fellow painters (Matisse, Braque, and Joan Miró) were examples by Cézanne, Renoir, Gustave Courbet, Henri Rousseau, and Louis Le Nain, as well as African and Oceanic pieces. Masterpieces and obscure works alike provided sustenance for his visual appetite. "I like all painting," he once confessed. "I always look at the paintings—good or bad—in barbershops, furniture stores, provincial hotels . . . I'm like a drinker who needs wine. As long as it's wine, it doesn't matter which wine."[43] Picasso made use of the conflict between his strong roots in the past and his desire to produce something new as a springboard for pushing the limits of creativity in all aspects of his work. His statements on his own assessment of the place of Cubism in the artistic tradition are revealing. From the perspective of old age, he said: "I saw that everything had been done. One had to break to make one's revolution and start at ground zero. I made myself go toward the new movement."[44] Yet earlier he had remarked: "Cubism is no different from any other school of painting. The same principles and the same elements are common to all."[45] In these declarations, one glimpses Picasso's paradoxical allegiance to both rupture and continuity. Variation provided a focused framework for exploring this tension, and he seized on it in a manner that characteristically embraced contradiction. In the extreme license he often took in transforming the work of his predecessors, subjecting them to ridicule and parody and eviscerating their meaning, Picasso—as he was well aware—still upheld the past, for parody even while mocking, reinforces by preserving the mocked conventions.[46]

In his variations Picasso also gave vent to a strong desire to outflank time and achieve a simultaneous present through his art. In an interview of 1923, he said: "To me there is no past or future in art. If a work cannot always live in the present, it must not be considered at all. The art of the Greeks, of the Egyptians, of the great painters who lived in other times, is not an art of the past; perhaps it is more alive today than it ever was."[47] He applied a similar ahistorical view to the notion of style, as we have seen, and to his own development: "If the subjects I have wanted to express have suggested different ways of expression I have never hesitated to adopt them. Whenever I have had something to say, I have said it in the manner in which I have felt it ought to be said. Different motives inevitably require different methods of expression. This does not imply either evolution or progress, but an adaptation of the idea one wants to express to the means to express that idea."[48] Picasso's powerful drive to reanimate the past and his rejection of a progressive view of the history of art, and of his own development, reflect his concern with keeping his own art alive in the present. As he said, "All I have ever made was for the present, with the hope that it will always remain in the present."[49] Through his recreations of other artists' works, he could not only make art but "make history,"[50] channeling it through his art.

Many of the sources that Picasso selected for his variations, such as Manet's *Déjeuner* and Velázquez's *Las Meninas*, are landmarks in the history of art. In opening these well-known works to dissection, Picasso released the forces of the present on the past, liberating them from their static positions in the canon, while rejecting the notion of history as a linear series of monuments or events. For Picasso, interpretation was creation. Yet, as he clearly recognized, the process does not end with him:

his own recreation is in turn submitted to the viewer, who must link it with its source and who thus "completes" the interpretive act. "A picture is not thought out and settled beforehand," Picasso asserted. "While it is being done it changes as one's thoughts change, and when it is finished it still goes on changing, according to the state of mind of whoever is looking at it."[51] In his work as a whole, as has been often remarked, the viewer is granted a major role, acknowledged through the presence of outward-looking figures who return his gaze, or challenged as a partner who must decode the meaning of his Cubist *jeux d'esprit*.[52] In his variations, however, Picasso himself assumes the viewer's role. He gives free play to the dialogue of artist and viewer in the conflicted area between the "fixed structures of meaning and those that are not determined."[53] The conspicuous place of variation in Picasso's later art reveals an increased preoccupation with the power of the viewer, to whom the painter's creation is submitted, and who activates and transforms or completes it through the act of looking. The "afterlife" of the work of art becomes an increasing concern as he reaches old age.

Yet it was not only the drama of his interactions with history and with the viewer that infused variation with vitality for Picasso. As a double-voiced operation, variation provided a mechanism for exploring the dynamics of his working process at its most intimate. In an uncharacteristically candid statement Picasso told Christian Zervos, his friend and the cataloguer of his work, in 1935: "When I begin a picture, there is somebody who works with me. Toward the end, I get the impression that I have been working alone—without a collaborator."[54] His comments to his friends reveal that this internal dialogue with an "other" was both a source of antagonism and comfort. To his long-time dealer and friend, Daniel-Henry Kahnweiler, he said: "It is uncomfortable always to have a 'connoisseur' standing next to you telling you, 'I don't like this' or 'This is not as it should be.' He hangs on the brush, which becomes heavy, very heavy. Certainly he doesn't understand a thing, but he is always there."[55] On other occasions Picasso claimed in a more positive vein, "When I paint I feel that all the artists of the past are behind me . . ."[56] The variations provided a context for fully exploiting this dualism and capitalizing on the conflict or harmony of the dialogic form of his creativity, though the "other" was not often limited to a single voice.

Picasso's statements about his working process as a form of "collaboration" have a parallel in his life. In her psychological study of Picasso's work, Mary Mathews Gedo recognized the central role of the "creative partnerships" that he forged throughout his life, and which were essential to his functioning as an artist.[57] Picasso's partners ranged from his father (an artist himself and his first teacher), to the poets of his early years in Paris, Max Jacob and Apollinaire, to fellow painters, such as Braque, to the women he loved. The variations of later years, when many of his friends had died, she believes, reflect a nostalgia for lost partnerships.[58] In his recent biography, John Richardson has brought to light the often voracious and destructive nature of Picasso's relationships with his fellow artists, friends and lovers, whom he often depleted and then discarded; the variations, he claims, reflect a similar form of "psychic cannibalism."[59]

For the philosopher Richard Wollheim, the psychological principle of identification is the *raison d'être* of Picasso's art after art. Comparing

Picasso with Manet in his use of earlier art, Wollheim notes, "With Manet, the identification compensates for the borrowing: with Picasso the borrowings are the excuse for the identification. He borrows so as to be able to identify. Indeed when we consider any of the great sets that Picasso did upon his predecessors . . . and we begin to take stock of the way in which Picasso borrowed, what strikes us is how little there is to the borrowing over and above the identification."[60] Perhaps a better psychological model for Picasso's interactions with his predecessors through his paraphrases is a process that the psychoanalyst Heinz Kohut designated "transmuting internalization," as opposed to identification, which involves a complete absorption of another. In transmuting internalization, aspects of the significant other are ingested, undergo creative transformation, and are reassembled in the process.[61]

Close observation of Picasso's most significant variations reveals that while the place of the "collaborator" is held by the other painter on whose work Picasso bases his own, this figure almost always incorporates others—a contemporary with whom he is in competition for the mantle of the master, a loved one of the present, or some figure from his past, or the fraternity of artists, or even the demiurgic power of painting itself against which he endlessly struggles.[62] ("Painting is stronger than I am," he said. "It makes me do what it wants."[63]) Often, one particular "other" shadows the "collaborator" as the dominant shaping partner/antagonist over and above the rest. The variations, carried out mainly during his last three decades, when Picasso himself had attained the status of a living "old master," address overtly the issue of his artistic fame and his place among the giants of the past, including Velázquez, Manet, and Delacroix. They are also sites for resolving issues in the present: those of bonding, competing, celebrating, recovering, or mourning. Though one or another of these processes usually dominates in any one variation or suite of works, they often accommodate several contradictory drives.

Variation, for Picasso, is rooted fundamentally in the dynamic push and pull of repetition and change. His many remarks on copying the works of others give insight into his understanding of this paradoxical relationship and its importance to him. "What does it mean for a painter to paint in the manner of so-and-so or to actually imitate someone else? . . . It's a good idea, but you can't. . . .it turns out to be a botch, and it's at that moment that you're yourself."[64] In a slightly different vein he expressed the same idea: "Try to make a perfect circle. In the discrepancy between the perfect roundness and your closest approximation of it, you will find your personal expression."[65] Picasso acknowledges that in copying or repeating others a process is set in motion in which the work evolves almost ineluctably into "something else." In redoing other artists' works, the copyist searches for his own voice or identity in opposition to that of his predecessors. Picasso's many statements on the subject of copying, and on the creative process in general (such as his famous "I don't seek, I find"), point to the importance he placed on discovery.[66] "It's remarkable," Picasso once said, "how little the 'willing' of the artist intervenes."[67] And on another occasion: "What counts is spontaneous, impulsive. That is the truthful truth. What we impose upon ourselves does not emanate from ourselves."[68]

For Picasso, repetition of past works was not only an assertion of his

creative vitality, and a search for his own identity, but a means of warding off a potential threat—that of repeating himself—which, like finishing a picture, he saw as a form of artistic death. "Where things are concerned there are no class distinctions," Picasso told Zervos. "We must pick out what is good for us where we can find it—except from our own works. I have a horror of copying myself. But when I am shown a portfolio of old drawings, for instance, I have no qualms about taking anything I want from them."[69] "To repeat," he told Zervos on the same occasion, "is to run counter to spiritual laws; essentially escapism."[70] In later years Picasso expressed this sentiment more emphatically: "Repetition is contrary to the laws of the spirit, to its flight forward. . . .Copying others is necessary, but what a pity to copy oneself."[71]

Picasso's comments about copying attest to a deep fear of repetition in the Freudian sense as "a mode of compulsion, reduced to the death instinct by way of inertia, regression and entropy."[72] In his variations, Picasso plays one end of repetition against the other, exploiting its creative aspects against its regressive or deathly pull. Picasso realized intuitively what Harold Bloom later theorized, that "conceptually the central problem for the latecomer is repetition, for repetition dialectically raised to re-creation is the ephebe's road to excess leading away from the horror of finding himself to be only a copy or replica."[73] Variation became more important, even necessary, to Picasso from his seventies through the end of his life because it was not only the vast terrain of the history of art that he needed to hold at bay, but his *own* past, which was beginning to overshadow his present work. Increasingly, he was relegated to art history himself. In his variations of the last decades Picasso confronts his most critical struggle, to keep his art alive, which for him was synonymous with life itself. Given his preoccupation with death, both physical and artistic, it is no wonder that he turned obsessively in his variations of the later years to the theme of art making.

Yet Picasso does not avoid repeating himself in his variations. He returns through the intermediary of his predecessors to the major representational and psychological issues that shape his art and attempts to resolve them through several of the important themes that have run throughout his work: women alone or together displayed for the delectation of the male viewer, the family, the Crucifixion, and, most significantly, the artist and model. Variation itself is repetition, and the form that many of Picasso's interpretations assume, especially toward the end of his life, is a compulsive reiteration; his late series stretch on over months or even years, leading to no one definitive work. Their conspicuous presence in his art and the repetitive form they take alert us to the deep significance and vitality of the issues they address. The fact that most of his variations either anticipate or reflect back on major masterpieces of Picasso's own is also revealing of their connection with central issues in his art; they are like a pulsating afterimage of a lifetime's creative energy.

The following chapters chart the development of Picasso's variations from his early parodistic drawings to the climactic cycles of the fifties and sixties. The centerpiece of this book is the series devoted to *Las Meninas*, which has received the least amount of analysis and represents Picasso's most cohesive dialogue with his forebears. The variations continue through the last decade of Picasso's life, primarily in the graphic media in works after Rembrandt, Ingres, and Degas. By Picasso's last

years, quotation becomes so pervasive in his art that it is difficult to separate his paraphrases from his "original" work. Furthermore, they repeat previous techniques of variation. For these reasons, and because many of these late graphic variations have already received extensive critical attention, they are not included in this study.[74]

Picasso's variations display a wide range of models and of methods of transformation, and cover a broad spectrum of emotional and critical concerns. It is worth considering at the outset, however, the common store from which his variations arise. What links, consciously or unconsciously, such works as Manet's *Olympia* and *Déjeuner sur l'herbe*, Le Nain's *The Happy Family*, Grünewald's *Crucifixion*, Poussin's *Triumph of Pan*, Cranach's *David and Bathsheba*, Courbet's *Young Ladies on the Banks of the Seine*, Delacroix's *Women of Algiers*, and Velázquez's *Las Meninas*? Are they not, perhaps, themselves variations on only a few basic themes that are recurrent in his work as a whole? For Picasso, subjects, like styles, constituted a language in which the images themselves act as signs whose function in the closed system of Picasso's art is contantly being reshuffled. "There are, basically," Picasso said, "very few subjects. Everybody is repeating them. Venus and Love become Virgin and Child—then maternity, but it is always the same subject."[75] Variation, as we have noted, is a dialogic form. It is hardly surprising that one of the most prominent features that unites the paintings that Picasso submits to his creative analysis is that most of them actively solicit the viewer's intervention. They do so through a variety of devices; some incorporate only a few, others several.

All of Picasso's sources contain figures. Many are genre scenes, although he occasionally turns to religious and mythological subjects and, in one instance, a portrait. The majority of the genre scenes make use of the mechanism of the interrupted narrative to solicit the spectator's participation; he or she becomes a protagonist who resolves or completes the action.

The link between figures in the painting and the viewer is often channeled through a device that Wollheim has described as an "internal unrepresented spectator."[76] In Manet's *Olympia*, for example, which Picasso treats in a drawing of 1903, the "internal spectator" is the unrepresented client who stands in front of the depicted scene beyond the frame of the painting, and whose view of the work is identical to that of the actual observer. The viewer thus enters the work through a route already designated by Manet, and becomes a participant in the event on the artist's terms. In his themes that contain an internal spectator (by far the majority) Picasso himself takes up a latent role that is asking to be filled. In so doing he both forges a bond with his predecessor and resists him; in revising the scenario as he always does, he redirects the narrative along lines of his own.

The majority of Picasso's themes are erotic; some depict extreme emotional states. There is an element of drama in most of them; several, such as Manet's *Nana* and *Las Meninas*, are overtly theatrical, and some are ambiguous. The instability of the narrative is often underscored by a similar lack of resolution of spatial relationships. In his variations after Le Nain's *The Happy Family*, or Delacroix's *Women of Algiers*, for example, Picasso takes on an image that appears unresolved in its spatial relationships, and carries it in new directions, both thematically and formally.

Many of the works on which Picasso bases his variations are also con-

nected thematically. As it does throughout his art, the theme of the artist and model runs through many of his variations in both direct and indirect fashion.[77] This longstanding motif rose to the fore in the early fifties with a long series of drawings in pen and ink, *La Comédie Humaine*, executed in response to a major upheaval in his life: the departure of his companion of the previous ten years, Françoise Gilot, with their two small children. In the series, a diminutive, aging artist—a thinly-veiled self-caricature—responds in a variety of tragi-comic ways to his eternally youthful female model, who observes his childish games of representation with supreme indifference.[78] He tries to amuse her, seduce her, and wrest her image from her, but she remains aloof. Returning to this fundamental dyad of artist and model had a restorative effect on Picasso; through it he circumvented creative paralysis and opened the way to the last phase of his art, in which variation played a major role. In his variations the "model" is in fact another artist's painting.[79] In taking on the subject of the painter and his muse in his art after art, the double-voiced form of variation and the implicit theme of creativity as a dialogue with an other mirror and reinforce each other. Behind the artist and model motif, and the practice of art after art, lies an allegory of generativity to which Picasso returns obsessively in old age, perhaps as a talisman to ward off death.

In the *Comédie Humaine* series, the artist vents a wide range of emotion in the face of his model's eternal perfection and indifference to his desire, which is to possess her by incorporating her into his art. Helplessness, rage, humiliation, ironic grandiosity, and tender respect are all in evidence. In the attitudes he displays so openly, we may see a reflection of a similar range of emotion he brings to those other "models" that serve as the basis of his new creations. Implicit in the enterprise of Picasso's art after art is a similar tragic realization, that despite his wooing, his cunning, and even his evisceration of his source, the masterpieces, like the ageless nude, also remain fundamentally beyond his grasp, impervious to his attack, immortal.

A further question arises: what do the various ways that Picasso transforms his themes have in common? I return here to Picasso's statement quoted above that when he begins a work, someone works with him, but toward the end he gets the impression that he has been working alone—"without a collaborator." Starting from an initially intense bond with his collaborator, Picasso, in the process of variation, gradually discards him and tries to regain his independence.

This process of discarding his collaborator begins, in fact, even before he sets pen to paper. In his variations, Picasso sets off at a distance from the original.[80] The interpretations emerge as much from deep memories of the work and associations accrued over time as from whatever *aide-mémoire*—a post-card or reproduction (if any)—he happened to come across. Most of his sources were long familiar to him from the museums of Paris or Spain; usually, though, he did not revisit them before undertaking his analyses.

Picasso's variations run through his entire art, beginning sporadically in his early work, and increasing in power, complexity and significance in his later years. The variations connected with Picasso's first two decades in France reveal his concern with situating himself in his adopted land. Those of the thirties to the early fifties, which draw from the widest array of sources, reflect the active exploration of and interaction with the

world around him characteristic of the middle phase of life.[81] From the mid-fifties to the early sixties, when the process reaches its peak, Picasso focuses on a few deeply familiar works at the heart of the great tradition as an attempt to close the circle, with himself inside it. During this last phase the form of variation itself undergoes transformation: it becomes more open-ended and merges with his independent creations. Like ruminations in pencil and paint, they follow the path of his thought at its most unguarded. This letting down of boundaries between his original and critical work is paralleled in the equally free and painterly style of his late variations. Through his painted critiques, Picasso takes us into his laboratory of art, his self-enclosed world of images that he carries within him. In late life he offered a glimpse into his *musée imaginaire* to his friend, André Malraux:

Museum or no museum, we live with paintings—there is no doubt. What would Goya say if he saw *Guernica*, I wonder. I think he'd be rather pleased, don't you? I live more with him than I do with Stalin. As much with him as I do with Sabartès. I paint against the canvases that are important to me, but I paint in accord with *everything that is still missing from that museum of yours*. Make no mistake! It's just as important. You've got to make what doesn't exist, what has never been made before. That's painting, for a painter it means wrestling with painting, it means . . . practicing painting, right? The paintings that come to you, even those that don't, play just as big a part as your museum without walls. We each have one, but we make changes in it . . . Even if only to paint against it.[82]

Picasso and the French Tradition: Variations from 1903–1919

Picasso created variations only sporadically during his first two decades in France. Four of these represent different approaches to this process that Picasso would develop throughout his career. Each belongs to a different phase of his development and each is linked to a major work of its period. All four are based on paintings by French masters and thus reveal a larger preoccupation that spans this period: Picasso's simultaneous assimilation of the artistic tradition of his adopted country and his assertion of his own roots.

These early variations were left in different stages of completion and convey a sense of having been executed *en passant*, as part of an ongoing conversation with one friend or another rather than as ends in themselves. Picasso kept three of the four in his personal collection throughout his life, rarely exhibiting them.

Parody of Manet's *Olympia,* c. 1903

The scapegoat of the Salon, the victim of Parisian lynch law. Each passerby takes a stone and throws it at her face. *Olympia* is a very crazy piece of Spanish madness. . . . Armed insurrection in the camp of the bourgeois: it is a glass of iced water which each visitor gets full in the face when he sees the BEAUTIFUL *courtisane* in full bloom.

Painting of the school of Baudelaire, freely executed by a pupil of Goya; the vicious strangeness of the little *faubourienne*, a woman of the night from Paul Niquet's, from the mysteries of Paris, and the nightmares of Edgar Poe.
—Jean Ravenel, 1865[1]

What work could serve as a more effective vehicle for a young Spaniard attempting to situate himself in the turn-of-the-century Parisian avant-garde than Manet's *Olympia* (fig. 2–1)? In his parodistic sketch (c. 1903) (fig. 2–2) based on this quintessential modern masterpiece, Picasso moves in and takes a seat at Olympia's bedside, and in a characteristic tongue-in-cheek manner, reveals his grand intentions: to unseat the "father of modernism" by appropriating Manet's own practice of self-conscious appropriation of historic models.

So violent was the reaction of the public to Manet's "female gorilla"

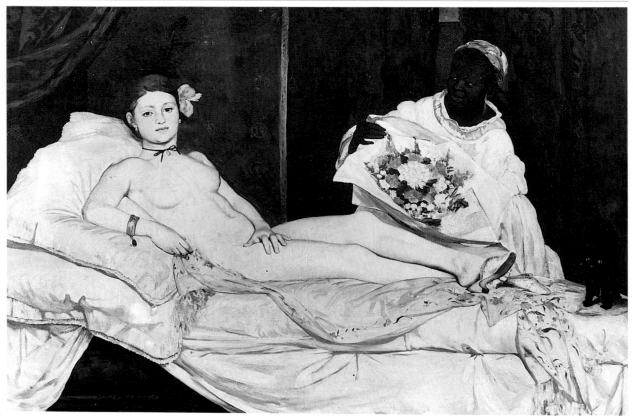

Fig. 2–1 *Edouard Manet.* Olympia. *1863. Oil on canvas, 51⅜ × 74¾" (130.5 × 190 cm). Musée d'Orsay, Paris*

when it was first exhibited at the Salon of 1865 that guards had to protect it from physical assault.[2] It was not only Manet's "appropriation of the conventions of high art to depict a low-life subject that shocked contemporary viewers,"[3] but his wholesale attack on the system of classical representation. In its combustible mix of overt eroticism, bold transgression of tradition, and revolutionary technique, *Olympia* is modernism incarnate. For Cézanne, the work signaled "a new status for painting,"[4] and Gauguin acknowledged its importance in the formation of his Synthetic style.[5] Monet took the initiative of starting a subscription to raise funds to present *Olympia* to the State in 1890, praising Manet in a letter to the Ministry of Public Instruction and Fine Arts, as "the representative of a great and fruitful evolution."[6] By the time Picasso reached Paris for the first time in 1900, *Olympia* was a veritable icon of modernism.

Manet's *Olympia* actively solicits the viewer's participation. In the painting, the "beautiful courtisane" reclines on a bed in a curtained room. A few cheap ornaments—a large pink flower tucked in her auburn hair, a black velvet ribbon tied around her neck, a bracelet, and a pair of satin mules—set off her naked flesh, and clearly designate her profession. A turbaned black servant standing behind the bed presents a lavish bouquet, but Olympia stares out boldly beyond the boundaries of the painting at some undepicted figure in the room with her. Is it the client who brought the bouquet, or the viewer himself? The painting hinges on the tension between the depicted figures and the viewer (Wollheim's internal spectator), who completes the implied action.

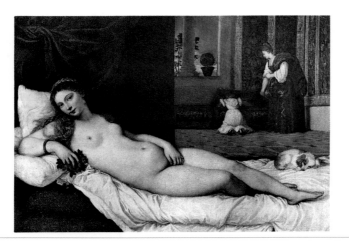

In *Olympia*, Manet draws from and cannibalizes one of the most venerated themes of Western art, the reclining female nude, updating it to the world of contemporary low-life Paris. Courbet's realist nudes, Ingres's odalisques, Goya's *Majas*, and contemporary prints and pornographic photographs of *demi-mondaines* all form part of *Olympia*'s exotic family tree,[7] but a more direct model is Titian's *Venus of Urbino* (c. 1538) (fig. 2–3), which, by the nineteenth century, had come to epitomize the tradition of the reclining nude.[8] Manet himself had made a copy of the painting in the Uffizi ten years before undertaking his own infa-

Fig. 2–2 *Pablo Picasso.* Parody of Manet's *Olympia. 1902–03. Pen and ink and colored crayon on paper, 6 × 9⅛" (15.3 × 23 cm). Collection Leon Bloch, Paris*

Fig. 2–3 *Titian.* Venus of Urbino. *1538. Oil on canvas, 46⅞ × 65" (119 × 165 cm). Galleria degli Uffizi, Florence*

mous figure. His dialogue with Titian takes the form, in one scholar's words, of "a simultaneous assertion and betrayal of stereotypes."[9] The naturalness of the pose of Titian's model is countered by Olympia's stiff and compressed posture, her deferential half-glance replaced by a level gaze, her ideal nudity by tawdry nakedness, and her modest gesture of covering her genitalia with one of provocation, or even masturbation.[10] The supporting characters are also transformed: Venus's domestic servant is replaced by an exotic African maid, often a companion to prostitutes in art of this period,[11] and her homely lap dog, symbol of fidelity, by an alley-cat, icon of promiscuity.

In Picasso's lighthearted drawing in pen and ink and colored pencil on paper, Manet's dyad of mistress and maid are replaced by a triad: himself and a fellow painter, Sebastià Junyer-Vidal, and a black woman, all three nude.[12] Exactly when and where the drawing was executed cannot be determined with certainty, but it has been traditionally assigned to 1901. John Richardson's and Marilyn McCully's recent dating of the work to the period that Picasso spent in Barcelona, from mid–January 1903 to the spring of 1904, seems more likely, however, as the parody fits in with numerous witty erotic sketches executed in Barcelona at that time featuring the artist and his friends with prostitutes, and it was then that his friendship with Junyer-Vidal was at its height.[13] Picasso would leave with Junyer-Vidal on his fourth and final trip to Paris in April of 1904. In a cartoon strip or *aleluya* that commemorates the journey, Picasso makes fun of their grandiose expectations of fame and gain. The Manet parody may have been executed in anticipation of this journey.[14]

Freud defined parody as a "substitution of illustrious persons or their utterances by lowly ones";[15] Picasso capitalizes on the irreverent element in Manet's painting, taking it further in his drawing. While Manet resituated the mythological nude in present-day Paris, Picasso recasts the scene in his own personal (or fantasy) life, and shows "what happened next." On the most obvious level, Picasso's comparison with his model takes the form of a witty series of inversions: the exotic African servant in Manet's painting has stripped and taken the place of her fashionably thin white mistress on the bed, the servant is replaced by a skinny man (Junyer-Vidal), who holds aloft a bowl of fruit in the place of flowers, and the fierce black alley-cat is supplanted by a timid house cat and tame small dog, which perhaps allude to Manet's source in the painting by Titian. Assuming the role of the unseen observer/client, Picasso inserts himself into the scene. The nude Picasso, however, seems only partially present: his profile figure is out-of-scale with the other characters, and he appears self-absorbed. Looking straight ahead over the full length of "Olympia's" body and out into space, he raises his right hand in a gesture that seems to signal caution. In contrast to Picasso's apparent detachment, Junyer-Vidal gazes down lasciviously at "Olympia," while she eyes the bowl of fruit he holds, ignoring both men. The posture of Manet's heroine, with her angular crossing of limbs and "shamelessly flexed hand" on her thighs, could best be described as one of coiled tension. Her substitute, by contrast, is emphatically inert, which lends her a mysterious, hieratic quality.

Picasso also counters Manet in the structure of his drawing: his "Olympia" is reversed from a leftward to a rightward orientation, and is set at a slight diagonal. Furthermore, she faces inward, as do the other figures, and the animals; Picasso has thus ruptured the tension between

Fig. 2–4 *Paul Cézanne.* A Modern Olympia. *c. 1872–73. Oil on canvas, 18½ × 27¾" (57 × 55 cm). Musée du Louvre, Paris*

pictorial and physical space, the most radical and disturbing aspect of the original. With the implied client resituated within the scene in the parody, the displaced focal point of the original composition is wiped out, and the tension between the two spatial realms necessarily broken. The viewer is relegated back to the outside, looking in at a closed situation. In destroying the relationship between viewer and viewed that lies at the very core of the Manet painting, Picasso trivializes the original work and indicates the parodistic intent of his drawing. Through this reductionist approach, he clears ground for content of his own, an operating method that will be developed in many of his later variations. Yet Picasso preserves and augments an essential aspect of the original that accounts to a large extent for the furor it unleashed: its ambiguity. Commenting on the critics' inability to come to terms with the painting, the art historian T. J. Clark writes, "There was something about *Olympia*, which eluded their normal frame of reference, and writers were almost fond of admitting that they had no words for what they saw."[16] In Picasso's hands the scene is converted into something even more ambiguous, a kind of charade or initiation.

On another, less obvious level, Picasso seizes control of his source by resituating *Olympia* in an historical continuum of his own making through references to other works, thus carrying on Manet's dialogue with his predecessors and incorporating him in the process. The art historian Meyer Schapiro has already noted Picasso's likely allusion in the parody to Cézanne's fantasy-like responses to *Olympia* in *An Afternoon in Naples* (1870) and *A Modern Olympia* (c. 1873).[17] The inclusion of his own self-portrait in the right-hand corner of *A Modern Olympia* (fig. 2–4), and the change from flowers to fruit are reflected in Picasso's parody. Indirectly, Schapiro also suggests another likely reference in the parody. In his painting *Woman with a Fan* of 1905,[18] he notes, Picasso appears to have taken the posture of the figure in strict profile with her right arm uplifted from the attentively listening Augustus in Ingres's

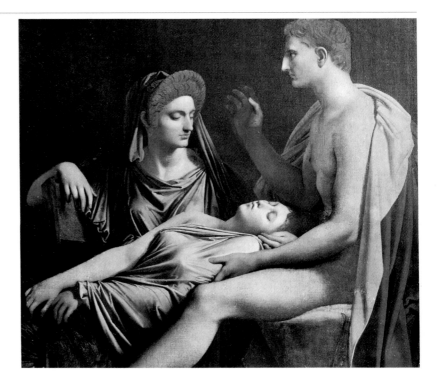

Opposite, above:

Fig. 2–6 *Titian.* Venus with an Organ Player. *c. 1545. Oil on canvas, 53¾ × 87″ (136 × 220 cm). Museo del Prado, Madrid*

Opposite, below:

Fig. 2–7 *Francisco Goya.* The Naked Maja (Maja Desnuda). *c. 1798–1805. Oil on canvas, 37⅜ × 74¾″ (97 × 190 cm). Museo del Prado, Madrid*

Vergil Reciting from the Aeneid (fig. 2–5), adding that there is already a precedent for her in Picasso's *Parody of Manet's* Olympia.[19]

There are other striking parallels between the parody and Ingres's painting as well. The leftward orientation of the woman on the bed with two figures on either side of her—one static, in profile, and remote from the scene, and the other more active and engaged, twisting from the waist as he looks directly down at the woman on the bed—corresponds with the composition of the Ingres. In the parody, Manet's masterpiece is thus situated in a continuum of works by earlier French painters in which the young invader aims to "seat" himself.[20]

Another scholar, Theodore Reff, has perceptively noted that Picasso refers in his drawing to Manet's source in Titian, but not to the *Venus of Urbino*. He chooses instead a closely related Titian in the Prado, *Venus with an Organ Player* (fig. 2–6), which he had known since adolescence. The posture of the organ player, with his back to the viewer, staring over one shoulder at the center of Venus's body, and the position of the nude facing left, he observes, most likely served Picasso as prototypes for Junyer-Vidal and the reclining female.[21] Why did Picasso make this substitution? In veering to the other Titian (if indeed he was aware of Manet's historic source in the Uffizi painting) Picasso not only underlines the voyeuristic and titillating intent of his sketch, but links *Olympia* with a masterpiece on Spanish soil and his own coming of age as an artist. In addition, the Prado Titian is connected with the theme of "looking and longing" that preoccupied Picasso throughout his life.

But Picasso pulls Manet's courtesan into the orbit of his own cultural heritage in a more overt way. Some of the departures from Manet in Picasso's "Olympia"—her total nudity, the viewpoint from slightly above, the leftward orientation of her body, the outline of her hips, and the position of her tapering legs pressed together—link her with Goya's *Naked*

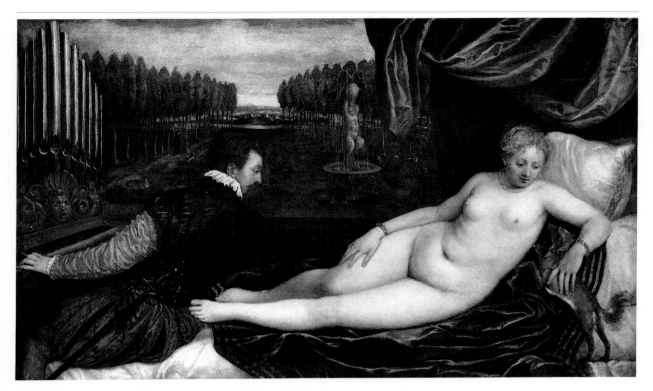

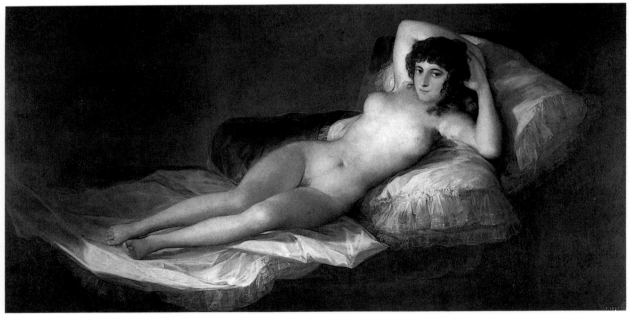

Maja (fig. 2–7), a work so overtly erotic that until the end of the nine-teenth century, it was kept under lock and key in the Madrid Academy. In his Goyesque "Olympia," Picasso may well be referring to the reception of Manet's work as a piece of "Spanish madness," a mixture of Goya, Baudelaire, and Poe.[22] Picasso emphasizes *Olympia*'s Hispanicism and blends it with African elements, perhaps alluding ironically to the French perception of Spanish art as "instinctual" or "primitive." Is

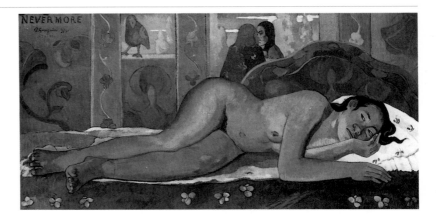

Picasso reclaiming from Manet, who drew so strongly on Spanish sources in the 1860s, what the French painter appropriated from his own native tradition? Or is he, in Baudelairean fashion, simply "praising the black Venus, precisely because the Western one was white?"[23]

With all his allusions to both French and Spanish sources, Picasso evades the choice by introducing another: his "Olympia" recalls as well the dreamy, self-enclosed, and immobile Oceanic nudes of Gauguin, such as the figures in *Anna the Javanese* and *Nevermore* (fig. 2–8).[24] References to Gauguin and Primitivism began to appear in Picasso's art from the time of a visit in 1901 to the studio of Paco Durrio, a fellow Spaniard living in Paris, who owned many of his works.[25] Picasso's friend Jaime Sabartès recalled in a memoir the enthusiasm with which Picasso and his Spanish companions discussed "Gauguin, Tahiti, *Noa-Noa*, and a thousand other things."[26]

Another parody, a drawing of 1902–03, *Reclining Nude with Picasso at Her Feet* (fig. 2–9), related closely to the *Olympia* sketch, is based directly on Gauguin's *The Spirit of the Dead Watching (Manao Tupapau)* of 1892 (fig. 2–10).[27] The painting was exhibited by Vollard in 1901, and Picasso would have also known it from a lithographic variation of the painting published in *Noa-Noa*, Gauguin's long poem of 1901.[28] In this mysterious painting, Gauguin portrays a young Oceanic nude lying on her stomach on a bed with an expression of fear or wonder on her face. Behind her sits the *tupapau*, the spirit of the dead, portrayed by an old woman, represented in an hieratic quasi-Egyptian profile with a frontal eye. In his extensive notes on the work in *Noa-Noa*, Gauguin wrote that it represents (on the poetic level) "the soul of a living person linked with the spirit of the dead. Night and Day."[29]

In his drawing Picasso himself, dressed in an overcoat and scarf, replaces the *tupapau*, who is also muffled, and a svelte nude Parisienne lying prone on the bed takes the place of the young Tahitian girl. Picasso depicts himself from the back with his face in profile like Gauguin's spirit, but while the latter's hand rests on the edge of the bed, Picasso's reaches out to caress the bare buttocks of the nude. The specter of death is replaced by a figure of life, while in the foreground, flowers sprout up in a pot, echoing the exotic flowers printed on Gauguin's *pareo* (or bedspread). Given that the two parodies are so closely connected in content and method, as well as in dimensions, media, style, and date, it is possible that Picasso did them as commentaries on each other. Where he "primitivizes" one work, he westernizes the other. Where he converts

Manet's mundane sexual transaction into something more ambiguous, he transposes Gauguin's symbolic work into a sexual encounter. Linking these two paintings in his sketches, Picasso acknowledges Gauguin's own debt to Manet, and draws attention to "the latent primitivism of *Olympia*."[30] Indeed, Gauguin made a copy of this painting when it was first exhibited at the Musée du Luxembourg in 1890, and took it with him to Tahiti; *The Spirit of the Dead Watching* has, in fact, been seen as Gauguin's response to *Olympia*.[31] Following Gauguin's lead, Picasso substitutes the swelling shapes of his fertility goddess for the simplified and flattened forms of Manet's Parisienne inspired by Japanese prints, and announces his interest in a more remote and exotic tradition, depict-

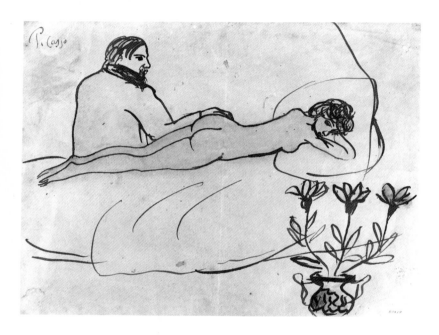

Fig. 2–9 *Pablo Picasso.* Reclining Nude with Picasso at Her Feet. *1902–03. Ink and watercolor on paper, 6⅞ × 9⅛" (17.6 × 23.2 cm). Museu Picasso, Barcelona*

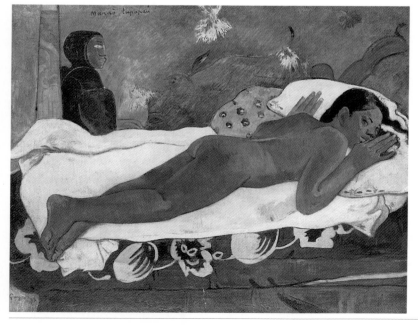

Fig. 2–10 *Paul Gauguin.* The Spirit of the Dead Watching (Manao Tupapau). *1892. Oil on burlap mounted on canvas, 28½ × 36⅜" (72.4 × 92.4 cm). Albright-Knox Art Gallery, Buffalo, New York. A. Conger Goodyear Collection, 1965*

ing himself in an act of ironic homage at the bedside of this black Venus.[32] The full impact of Picasso's encounter with non-Western art, however, would not be realized fully for several years. In his layering of references to Manet's modern heroine and her African maid, Titian's Venus, Goya's *Naked Maja*, Gauguin's Tahitian nudes, and perhaps Baudelaire, in his black Olympia in this small sketch, Picasso seems to point in the direction that he would soon follow. With *Les Demoiselles d'Avignon*, in which he juxtaposes various styles, he stakes his claim as both the inheritor and the driving force of the avant-garde. Yet, seated within Manet's brothel, the very crucible of modernism, Picasso depicts himself as an outsider.

Picasso's small sketch anticipates later developments not only in its compression of references but in its subject matter as well. The outsider theme is sounded on another level, too. Picasso's self-absorption contrasts with Junyer-Vidal's active participation in the scene. As he looks down at the nude woman, Junyer-Vidal's body twists and turns, and his thumb plunges through a hole in the bowl of fruit which he holds aloft in an obvious reference to intercourse. (The "bowl" may also allude to the painter's palette, and Junyer-Vidal's lascivious gaze to the artist's "possession" of his model through his art.) Picasso, however, appears to be more a commentator on than a participant in the scene. Is it caution or alienation that his posture and hand gesture suggest? A similar gesture appears in one of his rare self-portraits in the nude in a drawing of 1902–03 (fig. 2–11). Picasso's self-depiction as remote in a sexual encounter is consistent with other works of his early years, as we can see in a preliminary study for the masterpiece of his Blue Period, *La Vie*, executed in Barcelona in the spring of 1903, probably around the same time as the parody (fig. 2–12). The nude pair is now standing; the woman leans on Picasso's shoulder, but he turns his eyes away from her and gestures downward with one hand to the drawing on the easel behind them, and points upward with the other hand—a more vigorous and exaggerated form of his upward/downward hands in the *Olympia* parody. Richardson has connected the opposing hand gesture of Picasso in this drawing to the first card in the Tarot pack representing the Magician, a reference, he concludes, that was "perfect for an artist who wanted to endow an image with ambivalent or antithetical meanings."[33] In the final version of *La Vie* (1903) (fig. 2–13) Picasso overlaid his own head with a portrait of his friend, Carles Casagemas, whose suicide over a tragic love affair two years earlier continued to haunt him, and added a stern and androgynous mother holding an infant on the other side of the easel looking over at the couple; sexuality, death, and life are linked.

A connection of the Olympia parody to Picasso's culminating work of his early years, *Les Demoiselles d'Avignon* of 1907 (fig. 2–14), through the subject of the brothel and the inclusion of the bowl of fruit, has already been noted, but there are other links.[34] In the early stages of the canvas, which was developed over a period of six months, Picasso returned to the theme he first explored in the *Olympia* sketch, that of two men in a brothel, one involved, one distant. In the well-known Basel study for the painting (fig. 2–15), for example, one man stands by the door, hesitant to enter; the other, surrounded by women and food, participates fully in the scene. Focusing on the contrasting attitudes of the two men, the art historian Leo Steinberg notes that the *Demoiselles*

began "as an allegory of the involved and uninvolved in confrontation with the indestructible claims of sex."[35] Another Picasso scholar, William Rubin, in turn, equated Picasso himself with the hesitant one at the door, who held a book or skull in some of the studies and was described by the artist himself as a "medical student"; he also identified the insider (a "sailor") with Picasso's friend, Max Jacob, and interpreted the painting in light of another opposition, that of life and death.[36] Of the Basel study, Rubin comments: "The image lends itself to many readings, but insofar as the sailor represents the one who gets the pox in a brothel, and the medical student the one who cures it, their pairing reflects a little-reported but very important symptomatic aspect of Picasso's make-up—his exaggerated concern for and fascination with venereal disease as reflected in his 1902 visits to St. Lazare Hospital to

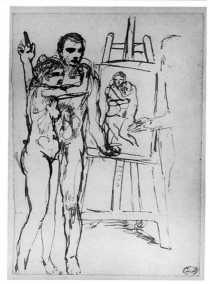

Fig. 2–12 *Pablo Picasso. Study for* La Vie. *1903. Brown ink on paper, 6¼ × 4⁵⁄₁₆" (15.9 × 11 cm). Musée Picasso, Paris*

Fig. 2–13 *Pablo Picasso.* La Vie. *1903. Oil on canvas, 27⅜ × 50⅝" (196.5 × 128.5 cm). The Cleveland Museum of Art, Cleveland*

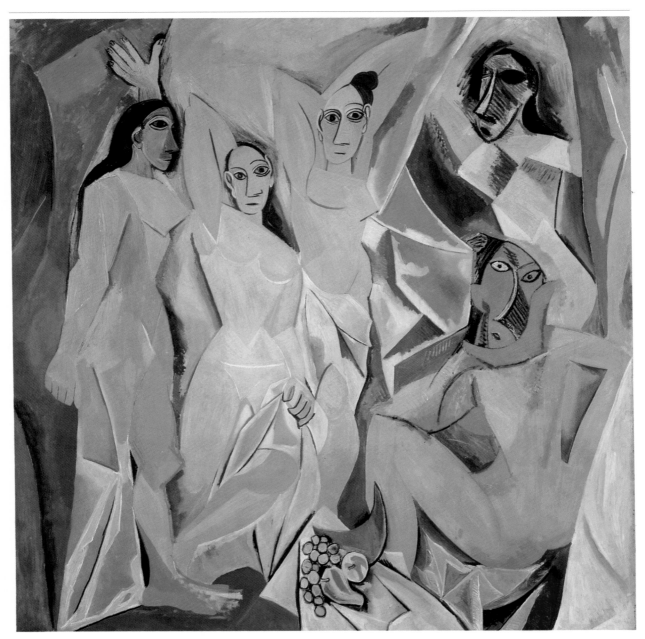

Fig. 2–14 *Pablo Picasso.* Les Demoiselles d'Avignon. *June–July 1907. Oil on canvas, 8' × 7'8" (243.9 × 233.7 cm). The Museum of Modern Art, New York. Acquired through the Lillie P. Bliss Bequest*

study prostitutes being treated for syphilis."[37] Picasso's cautionary—or distancing—gesture may suggest a similar apprehension here.

Over the course of the development of the *Demoiselles*, as is well known, Picasso abandoned the narrative device of the two men in the company of prostitutes in favor of a more direct and powerful outward confrontation: the men are relegated to the viewer's place to become the focus of the women's fearsome stares. Thus, in a masterpiece of his own, Picasso borrowed the essential structure and pictorial strategy of Manet's painting (though, needless to say, the *Demoiselles* draws on countless other sources) that he had negated in his parody.[38]

The *Demoiselles d'Avignon*, like *Olympia*, is a focal point in the history of art, collecting and cannibalizing disparate sources; it is also a

Fig. 2–15 *Pablo Picasso.* Medical Student, Sailor, and Five Whores in a Brothel (Study for *Les Demoiselles d'Avignon*). *1907. Charcoal and pastel on paper, 18⅞ × 25" (47.7 × 63.5 cm). Oeffentliche Kunstsammlung, Kupferstichkabinett, Basel*

form of "armed insurrection in the camp of the bourgeois."[39] Some of the seeds for this major work are found in Picasso's humorous sketch of four years earlier in which he announced in a self-mocking way his intention of claiming a seat in the inner sanctum of the avant-garde. With the *Demoiselles* of 1907, the young outsider realized his ambition to take a place, not in Manet's brothel, but alongside it in that "great and fruitful evolution." Ironically enough, it was only earlier in the same year that *Olympia* was promoted from the Musée du Luxembourg to the Louvre, where it was hung next to the *Grande Odalisque* of Ingres.

Odalisque, after Ingres, *1907–08*

When Picasso turned to variation again in late 1907 or early 1908, it was to one of *Olympia*'s closest antecedents, the *Grande Odalisque* itself (1814) (fig. 2–16).[40] At the time, Picasso was in the early stages of Cubism, the revolutionary idiom he developed over the next seven years in a creative partnership with Georges Braque. Picasso's gouache painting after the *Grande Odalisque* (fig. 2–17) is the first variation in which he converts the style of another artist into his own distinct idiom, a method he would follow in all of his subsequent art after art. It is revealing not only of Picasso's ongoing relationship with the French Neoclassical master, but with his contemporary rival as well.

Picasso's fascination with the work of Ingres (1781–1867) was lifelong.[41] His interest in him in the early years of the century was likely stirred by the reevaluation of classicism taking place in all branches of the arts, but a more immediate stimulus would have been the large retrospective of Ingres's paintings at the Salon d'Automne of 1905. Ingres's *Turkish Bath* (1862–63) found an almost immediate echo in Picasso's *Harem* of 1906, and was a potent source of inspiration in the *Demoiselles*. It has been noted that Picasso's interest in Ingres in 1907 may also have been due to the fact that the *Grande Odalisque* was currently the focus of debate.[42] *Olympia*, which since 1890, as we have seen, had been housed in the Musée du Luxembourg, had now been pro-

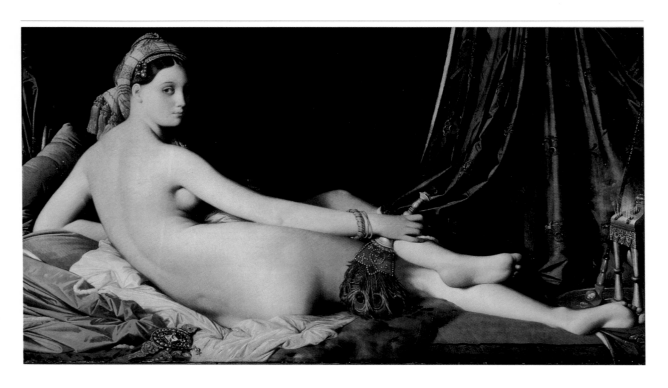

moted to the Louvre, and hung next to the *Odalisque*.[43] For some, the pairing of these two works signaled the triumph of modernism, while for others it brought to light the older master's iconoclasm, *his* modernity.[44] Picasso's response was characteristically inclusive: the erotic charge and formal distortions of the two women, staring brazenly out from their shallow, curtained lairs, found their way among many other sources into Picasso's *Demoiselles*, which he began in March of that year.[45] But when Picasso took on the *Odalisque* in a one-to-one encounter in his 1907–08 gouache—one of numerous postscripts to the *Demoiselles*—he focused more narrowly on the structure of the figure and its integration into a shallow picture space, ignoring her individual characteristics and sexual aura, as well as the setting.[46]

The dynamic tension of the *Odalisque* has been aptly captured in Rosenblum's description: "The head is held erect by the unyielding vertical of the neckline, the weight of the upper torso is borne by the taut triangle of the flexed arm, subtly echoed in the shape of the pillow; the left leg crosses the right in a precarious torsion. The whole figure is tightly compressed in a narrow enclosure not only by the four framing edges that impinge upon elbow, toe, and head, but by the shallow, rectilinear confines of the panelled and cushioned wall plane behind the edge of the bed in front, with the artist's signature seemingly embroidered upon it."[47] Recasting Ingres's illusionistic idiom into his newly developed vocabulary of large, flat, hatched planes derived from Cézanne's *passage* and from his initial exploration of non-Western art, Picasso preserves the overall structure of his prototype without following it in a slavish fashion. He carefully notes the points of maximum tension such as the crossing of the elongated arm across the hip, thigh, and knee, and the fall of the curtain behind the figure, which appears to continue in one long sweep through her hand and the fan that she holds. The Odalisque's extended leg is cropped, however, and the proportions of Picasso's painting differ significantly from that of the original, in which the width is almost twice its height—one of its most distinctive features. Picasso's focus on the long curve of her back and arms, on the crossing of limbs, on the combination of viewpoints through which we see the back, the side, and the side of the breast and buttocks from slightly below makes clear that it is the complex, even irrational arrangement of the body seen from various angles in a shallow space and the relationship of the image to the surface of the painting that engage him here. As if to underline his exclusive interest in the structural and spatial qualities of the figure, Picasso wipes out her face and distinctive stare, a reductive act that will characterize the dehumanizing approach of many of his later variations.

Yet it is not only in limiting the variation to elements related to his developing Cubism that Picasso betrays an aggressive and competitive spirit toward his predecessor, but also in his willingness to take things further. It can be demonstrated that in the variation, Picasso carries Ingres's subtle perspectival distortions of the figure into a new realm of formal invention that both calls attention to the Cubist character of the *Odalisque* and surpasses Ingres's formal audacities by departing entirely from the conventions of naturalism.[48] The lower torso of the figure from the waist down can be read as both resting on the couch, as in the original, and, in reverse, facing downward, with buttocks raised and knee bent under. From this perspective, her arm stretches out behind her and brushes the top of her buttocks, reaching toward her (cut-off)

Opposite, above:
Fig. 2–16 *Jean-Auguste-Dominique Ingres.* Grande Odalisque. *1814. Oil on canvas, 35⅞ × 63¾" (91 × 162 cm). Musée du Louvre, Paris*

Opposite, below:
Fig. 2–17 *Pablo Picasso.* Odalisque, after Ingres. *1907–08. Watercolor, gouache and pencil on paper, 19 × 24⅞" (48 × 63 cm). Musée Picasso, Paris*

feet, the dark shaded triangle representing the pubic area. Thus, the figure can be read as made up of two opposing views: above the waist, her back faces us, and below, her front. The two juxtaposed views are joined in a seamless twist, an extrapolation of the famous "squatter" on the right-hand side of the *Demoiselles*. The elimination of the face also facilitates the momentary joining of these opposing aspects. Picasso's variation on Ingres's nude thus belongs among his earliest explorations of the figure portrayed from multiple perspectives, which would preoccupy him throughout his life.[49]

As in many of his later variations, however, Picasso's competition with Ingres was likely stimulated by a rivalry with an artist closer at hand. When Matisse visited the Louvre in 1907 to see the famous pair of nudes hanging side by side, he made known his preference for the earlier artist because "the sensual and willfully determined line of Ingres seemed to conform more to the needs of painting."[50] His Fauvist masterpiece of 1905–06, *Joy of Life* (fig. 2–18), echoes Ingres's *Golden Age* (1862) through their common Arcadian theme pervaded by a "nostalgia for a lost classical world of erotic freedom,"[51] while the two reclining nudes in the center of the painting pay tribute to the tradition of Ingres's odalisques. Picasso's rivalry with Matisse, who was ten years his senior and the only contemporary whom he would ever acknowledge as a peer, was particularly intense in 1907, as the incipient Cubist movement was extinguishing the fires of Fauvism.[52] The fact that Matisse had also claimed one of the same artistic father figures must have contributed to Picasso's competitive feelings. The *Demoiselles*, in fact, has been seen in part as Picasso's response to *Joy of Life*, his bid to capture the leadership of the avant-garde from his rival.[53]

In redoing Ingres's *Grande Odalisque*, Picasso may have had in mind another of Matisse's most radical works exhibited at the Salon des Indépendants in March 1907: *Blue Nude (Souvenir de Biskra)* (fig. 2–19) a figure developed from (among other sources) the Ingresque reclining nudes in the foreground of *Joy of Life*, and which most likely pays tribute to the *Grande Odalisque* as well.[54] In the alternate reading of Picasso's *Odalisque* with the leg folded down, she conjures up the dis-

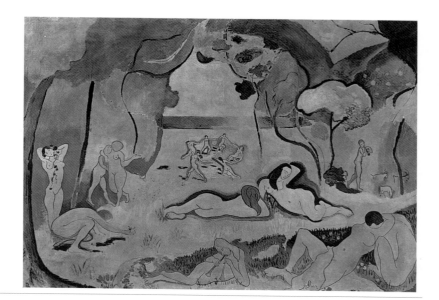

Fig. 2–18 *Henri Matisse.* Joy of Life (Joie de Vivre). *1905–06. Oil on canvas. 68½ × 93¾" (174 × 238 cm). The Barnes Foundation, Merion Station, Pennsylvania*

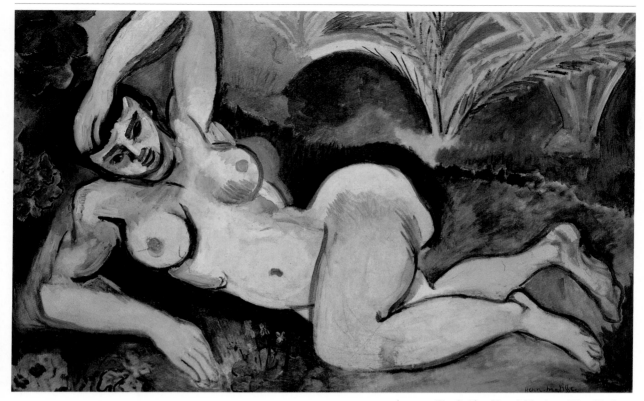

Fig. 2–19 *Henri Matisse.* Blue Nude (Souvenir de Biskra). *1907. Oil on canvas, 36¼ × 55¾" (92.1 × 161.6 cm). The Baltimore Museum of Art, Baltimore. Dr. Claribel Cone and Miss Etta Cone of Baltimore, Maryland*

torted *Blue Nude*, submitted to the regularizing rhythm of Cubist planes, while the intense aquamarine blue and ocher of his palette are closer to Matisse's painting than to Ingres's. If Matisse's *Blue Nude* is homage and challenge—Ingres's odalisques (and the whole tradition of the classical reclining nude from antiquity to Manet) "primitivized" and returned to a more primal setting[55]—Picasso's variation, in turn, appropriates aspects of both the *Grande Odalisque* and Matisse's contorted nude, and converts them into an audacious simultaneous image that speaks a new formal language. With his Cubist interpretation of the *Grande Odalisque*, Picasso executes his first formal variation on a great work of the past, "translating it into another tongue." In the process, he also steals the mantle of the master away from his rival, and initiates his long dialogue with Matisse on their shared subject of the odalisque.

The Happy Family, after Louis Le Nain, *1917–18*

Picasso's next variation, a decade later, is based on an obscure seventeenth-century work by Louis Le Nain, *The Happy Family* (1642) (fig. 2–20).[56] Changes in the cultural milieu of postwar Paris, and Picasso's artistic and personal preoccupations, are directly reflected in his choice of theme. Here, as in his previous two variations, he carries on a dialogue with an artist of his adopted home.

With the outbreak of the Great War in 1914, the camaraderie of the bohemian community in Montmartre and Montparnasse, and the climate of unprecedented freedom and experimentation within the avant-garde came to an end. When the war began, Picasso, as a foreigner, remained in Paris while his close friends, including Braque, Derain, and the poet

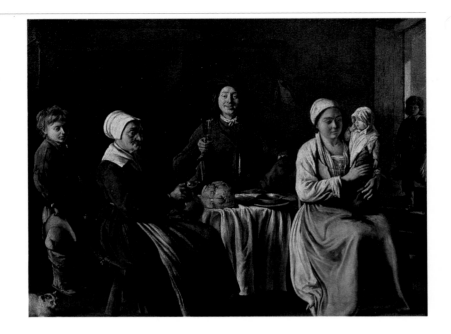

Guillaume Apollinaire, left for the front. In 1915, Eva Gouel, Picasso's mistress since 1912, died of tuberculosis. It was against this background of wartime isolation, deprivation, and loss that Picasso accepted an invitation at the end of 1916 from a young poet, Jean Cocteau, to create sets and costumes for *Parade*, produced for Serge Diaghilev's Ballets Russes, which had attracted many of the leading musicians, choreographers, and dancers of the day. At the time of painting his Le Nain variation in late 1917 or early 1918, Picasso had been occupied for much of the year with his work for the ballet, and his courtship of Olga Koklova, one of the company's ballerinas, was at its height.[57]

The circumstances of Picasso's encounter with *The Happy Family* remain a mystery. The painting could only have been in a private collection or in the hands of a dealer at the time that Picasso executed his variation; prior to its purchase in 1923 by Paul Jamot, a curator at the Louvre and a Le Nain scholar, the work had been unrecorded in the literature, and there were no known reproductions or copies.[58] Picasso's "copy" (fig. 2–21) is, in fact, the only indication that *The Happy Family* must have been in Paris before Jamot's purchase.[59] The variation had to have been executed sometime between November 1917, when Picasso returned to Paris from a five-month stay in Barcelona, and March 1918, when Apollinaire remarked on his "dazzling copy" in a letter.[60] Picasso's interest in the Le Nain brothers was then at its peak. Not only did he paint his own interpretation of a Le Nain painting, but in 1919, he acquired a version of Louis Le Nain's well-known painting *The Rest of the Cavalier* (fig. 2–22) from his dealer Paul Rosenberg and, in 1923, a work attributed to him, *The Procession of the Fatted Calf* (fig. 2–23), from his primary dealer of the prewar years, Daniel-Henry Kahnweiler.[61] Picasso kept both Le Nain paintings in his personal collection throughout his life, along with his variation. Nor was Picasso alone in his admiration for these "little masters" of peasant subjects; they enjoyed renewed popularity in the context of the post–World War I movement known in retrospect as the "return to order." This movement, character-

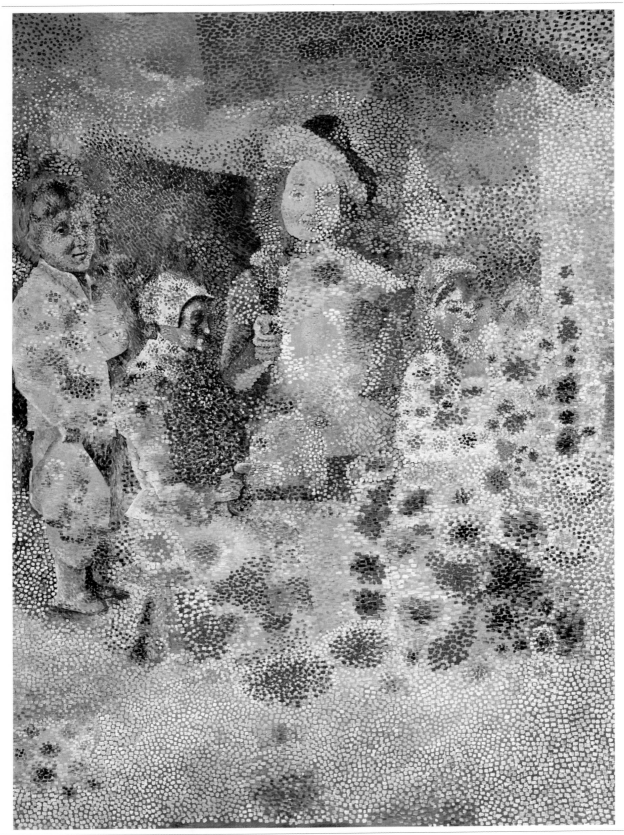

Fig. 2–22 *Louis Le Nain(?).* The Rest of the Cavalier. *c. 1650. Oil on canvas. 22½ × 26⅜″ (57 × 67 cm). Musée Picasso, Paris*

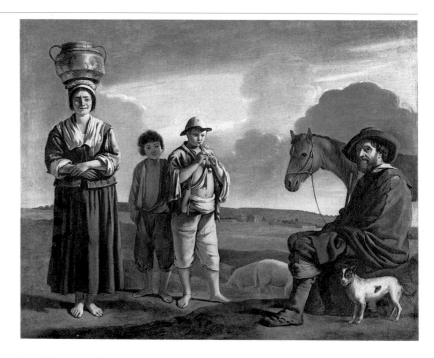

ized by a reaffirmation of the classicizing roots of the French national tradition, took shape in response to the outpouring of patriotism and desire for reparation that followed the war.[62] The spirit of classicism, broadly interpreted as one of construction, clarity, order, and rationality, pervaded the work of avant-garde artists in the postwar years, and brought about renewed appreciation of the French masters of the *grande tradition* such as Poussin, David, and Ingres.[63] The once-forgotten Le Nain brothers also found renewed popularity.

Rehabilitated in the mid-nineteenth century by Champfleury, the influential critic and champion of Realism, the three artist brothers, Antoine, Louis, and Mathieu Le Nain (born somewhere between 1602–10) were appreciated for their humble subject matter and for the "natural and uncomposed qualities of their compositions."[64] Interest in these painters of peasant life continued to grow in the first decades of the twentieth century, but on different grounds. In the wake of World War I, the brothers enjoyed a second revival as exemplars of the indigenous classical spirit and formal purity of French art.[65] In 1919, Louis Le Nain's *The Peasant Family* entered the Louvre with great fanfare, and, in 1923, twelve of his paintings were exhibited at the Galerie Sambon in Paris to critical acclaim.[66] Writing of the Le Nains in this period in *L'Intransigeant*, Picasso's friend, the poet and critic Maurice Raynal, summed up the postwar attitude toward their work: "The subject is chosen without research. Always it is peasant in essence, yet these luminous . . . variations on popular themes were always submitted to a taste for order and economy of means in the interest of compositional balance, a purely pictorial classicism."[67]

In *The Happy Family*, a group of six, spanning three generations, is seated at a table on which are placed a loaf of bread and a pewter bowl and plate on a coarse white cloth. The central group, which includes a smiling young father raising a glass in a toast, flanked by his wife, with a swaddled infant on her lap, and an old woman holding an earthenware

pitcher, is enclosed at either end by two small boys. One of the boys is standing at the left and another in shadow at the doorway about to enter, a stock figure in Le Nain's art who allows the viewer to imagine the scene from the other side.[68] The presence of bread and wine, the simple abode, the allusion to the cycle of life, and the suffusion of happiness that unites the group suggest a symbolic meaning may have been intended, although no specific interpretation of the scene is known.[69]

The outpouring of patriotism and reaffirmation of French national tradition must have contributed strongly to the appeal to Picasso of this idealized depiction of familial love and continuity. It may also have reverberated with the artist's personal situation and aspirations. When he began the variation, Picasso had just returned from a lengthy visit with his future bride to his family in Barcelona, his first trip back to Spain since his father's death in 1913. His reconnection with his mother, and his impending marriage to Olga—whom the young mother in the painting with her pure oval face resembles—must have made him acutely aware of his position at the mid-point in the cycle of generations between his family of origin and family to be, like that of the father in Le Nain's composition. The painting may also have symbolized the "family" of French art at a time when Picasso's foreignness, and the view of Cubism as an alien or "German" virus that had infected the purity of French art,[70] was a particularly sensitive issue. In redoing the work, Picasso, in a sense, paints himself into the family.

Picasso's involvement at the time with the ballet undoubtedly contributed to the appeal of the Le Nain painting as well. The work is inherently theatrical: the two boys look outward, and the father, who faces the viewer directly, seems to include us in the family circle with his convivial smile and raised glass. The shallow space of the room and the rudimentary props contribute to a stagelike impression. The peasant subject matter may also have attracted him, for through his work on *Parade*, Picasso had renewed his interest in popular imagery.[71]

Picasso's approach to *The Happy Family* is one of opposition. The long, horizontal format of the original becomes vertical; volume, weight, and line are converted into a dense screen of large dots, which cover much of the surface of the canvas, uniting figure and ground. The sobriety of the older master's palette is replaced by a riot of color, and the

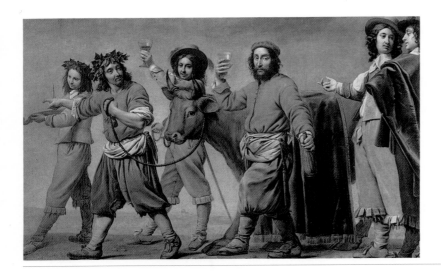

Fig. 2–23 *Maître du Cortège du Bélier (formerly attributed to Louis Le Nain).* The Procession of the Fatted Calf. *c. 1650. Oil on canvas, 42½ × 65⅜" (108 × 166 cm). Musée Picasso, Paris*

gentle gravity of the group gives way to an ironic humor.

The discarded outlines of the forms, sketched lightly in charcoal on a gray-brown ground, are visible beneath the screen of dots. While following fairly closely the features of the faces and details of clothing, Picasso takes liberties with the proportions and placement of the figures. Pulled closer together to fit the narrower format of the canvas, they break from Le Nain's static triangle, jostling and overlapping each other. Thus released from gravitational space, they grow and diminish or disappear altogether. The boy on the left (to whom Picasso returned in an Ingresque portrait drawing of 1921, fig. 2–24) is endowed with flaming red hair and a more mature face. He towers over his grandmother, who has shrunk and become a mere caricature of her former self. The father has also grown in proportion and his position in space has become indeterminate: it is unclear whether he is standing or sitting, behind or in front of the other characters, while his extended hand and glass seem to push forward into the viewer's space. The ambiguity of the father's spatial position, and even his gender, is underlined by his enigmatic, flattened white face, which recalls a Japanese *No* mask. Picasso evidently worked from left to right in this canvas; the mother and infant are only partially visible, and the boy on the top of the stair is absent.

Picasso's oppositional relationship to his theme continues in his treatment of the structure of the work. In the original, the figures are represented with a convincing sense of volume, but the room itself is as flimsy as a theater set. Picasso exaggerates the spatial instabilities of the room, pressing volume into shifting diagonal surfaces. Through these transformations, Picasso lays claim to the work not only by imposing his own idiosyncratic view on the painting, but also by opposing the prevailing view of Le Nain as a classicist—an exemplar of the *grande tradition française*. Picasso capitalizes instead on the sense of mobility in Louis's composition. In the mid-thirties, while looking at his *Procession of the Fatted Calf* (then attributed to Louis), Picasso explained to Kahnweiler that what he admired about the seventeenth-century brothers was "their clumsy simplicity and awkwardness." "The Le Nains," he said, "had plenty of ideas about composition, but they never followed them through to the end, they lost sight of them on their way. In fact it is perhaps this awkwardness that gives them their charm. And then it is very French. Look at all the French painters and you'll see the same thing . . . basically the French painters are all peasants."[72] Picasso's interpretation of *The Happy Family* is closer in spirit to that of the mid-nineteenth-century Realist critics and artists who admired Louis's (and his brothers') "humble subjects" and "natural and uncomposed qualities of composition."[73]

Just as Picasso derationalizes the Le Nain composition, he likewise liberates the pointillist method that he borrowed from Georges Seurat. Like Le Nain, Seurat was enjoying renewed popularity in postwar Paris. Picasso's close friend, the poet and critic André Salmon, hailed Seurat in an article of 1920 as "the first to construct and compose."[74] Seurat's technique of pointillism, which he developed as a means of acquiring precise control over color and form, reveals the classical nature of his art. Drawing from Eugène Chevreul's scientific studies on the laws of simultaneous contrast of color, Seurat applied pure hues in tiny dabs of the brush to his canvas, taking into consideration the effect of each hue and its reflection on the surrounding dots.[75] In his Le Nain variation, as in

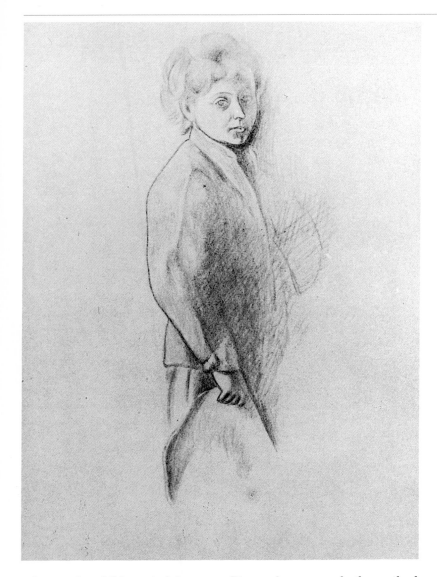

Fig. 2–24 *Pablo Picasso.* Young Man with a Hat, after Louis Le Nain. *1921. Pencil on paper, 12 × 8¼" (31 × 21 cm). Musée Picasso, Paris*

other works of this period, however, Picasso borrows only the method of painting in dots and dashes, ignoring Seurat's scientific principles of color mixing, and making use of pointillism for purely decorative effects and to enrich his work with historical reference.[76] Seurat's calculated method of creating spatial recession becomes in the hands of later artists a technique for asserting the flat, material quality of the painter's medium—oil on canvas. As the art historian Rosalind Krauss has noted, Picasso's use of a pointillist technique in his Le Nain variation alludes not only to the originator of the method, Seurat, but to Matisse and fellow Fauve painters who updated and transformed it in the early twentieth century.[77] Picasso's reference to multiple artists within the same national school—Le Nain, Seurat, and Matisse—echoes the theme of the cycle of generations represented within the painting; both point to the theme of renewal and continuity with the past in keeping with the spirit of postwar reconstruction and national pride. Yet Picasso's interpretation is emphatically against the grain of this notion of continuity: he appropriates an image from a painter of the distant past, and a style from

a later artist that is diametrically opposed to that of the former.[78] As we have seen, this juxtaposition of opposing representational modes had been a major feature of Picasso's art from the *Demoiselles* onward, and after the war, he extended this concept to working in multiple idioms simultaneously.[79] In his work for *Parade*, for example, his most significant project of 1917, Picasso contrasts the poetic realism of the drop curtain with that of the huge Cubist figures on stage. His Le Nain variation, in which a painterly style overlays a linear substructure, is yet another example of this collapse of "influences." Over Le Nain's touching image of regeneration and continuity, Picasso chooses to display his own disruptive and ahistorical view of tradition.

Picasso's pointillist *Happy Family* belongs in spirit to the harlequinade, a theme that dates back to his Rose Period, and which he revived after the war. While in Italy with the Ballets Russes, Picasso had attended performances of the *commedia dell'arte* in Naples, and *commedia* characters appear in his drop curtain for *Parade* (Zervos 2, pt. 2:951). The father's hat in the variation resembles Harlequin's tricorn, and the painting's yellows, reds, and greens are those of his diamond-patterned suit, which have now been dispersed into daubs of color.

Connections between Le Nain's poeticized peasants or cavaliers and the itinerant performers had already been made in Picasso's *Family of Saltimbanques* (1905) (fig. 2–25), to which this variation harks back in spirit. Among the sources for *The Family of Saltimbanques* is Manet's *The Old Musician* of 1862, which in turn depends on the composition of Le Nain's well-known *Rest of the Cavalier*, a version of which Picasso acquired in 1919.[80] The link between Le Nain's nostalgic figures and those of the *commedia* lingers on more subliminally in the paintings of the postwar period.

Although a nineteenth-century Neapolitan drawing (which Picasso knew in postcard form) has been suggested as the origin of Picasso's composition for the drop curtain for *Parade*,[81] the group of performers to the left also recalls similar depictions of figures gathered around a table in the work of the Le Nain brothers.[82] Even the culminating work of his Synthetic Cubist period, in which the maskers appear once again, *The Three Musicians* of 1921 (Ch. 6, fig. 6–28) has affinities with Le Nain's *The Three Young Musicians*.[83] In *The Happy Family* it appears that the Harlequin theme slipped in almost unconsciously, reflecting Picasso's love of popular subject matter that embraces both the peasants and the *commedia* figures, and his current preoccupation with the theater. His new-found sense of camaraderie with fellow artists in his ballet work may have rekindled Picasso's idealized sense of himself as a member of the wandering *commedia* group, a nostalgic evocation of his younger, more carefree self of the Rose Period.[84]

Another figure, I believe, stands between Picasso and Le Nain, and bridges the two: Guillaume Apollinaire. This poet of mysterious Slavic origin was one of Picasso's closest friends of his prewar days, along with Max Jacob, the three forming the *bande à Picasso*. A revolutionary in poetry of comparable significance to Picasso in the visual arts, Apollinaire had been one of the painter's strongest supporters, writing impassioned descriptions of his harlequins and serving later as Cubism's primary advocate. During the war, Apollinaire (although a foreigner) enlisted in the French army; he returned to Paris from the front with a

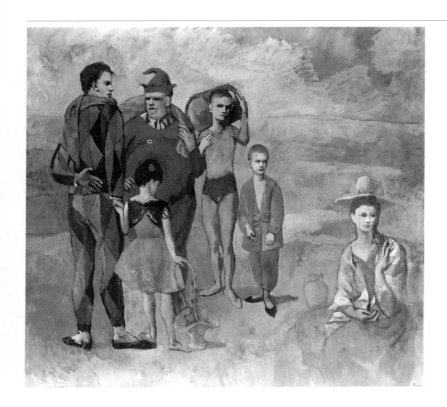

head wound in 1916, and was acknowledged as a war hero.

After the war, Apollinaire resumed his passionate advocacy of Picasso's art, defending his most radical works, such as *Parade*, which caused a riot when first presented in Paris in May 1917,[85] while also expressing his support of the painter's current preoccupation with the work of his predecessors. In a preface to a catalogue of an exhibition of Picasso and Matisse, held in January and February 1918 at the Paul Guillaume Gallery, Apollinaire noted that Picasso "gains strength from his contact with the mysteries of nature and from comparisons with his peers of the past," observing that "the aim of all his experiments is to free art from the shackles of the past."[86]

In a letter of late summer 1918 to Picasso, who was on his honeymoon with Olga in Biarritz, Apollinaire encouraged him to continue his dialogues with French classical masters, writing, "I would like you to paint big pictures, like Poussin, something lyrical like your copy of Le Nain."[87] He informed Picasso of the direction of his poetry in a subsequent letter: "The ones I am writing now will be more in keeping with your present concerns. I am trying to renew the poetic tone, but in a classic rhythm."[88]

Thus, the Le Nain variation may be not only an homage to a past master through which Picasso tests his own stylistic language and posits his ahistorical view of tradition in the "return-to-order period," but a testament to his renewed friendship with Apollinaire. The painting may also mark a rite of passage on which they were embarking: both were married within two months of each other in 1918, each serving as witness for the other. But their shared mission of renewing the classical heritage through the liberating impulse of the present would remain Picasso's alone, for Apollinaire died of influenza that November. The luminous variation remained unfinished, a legacy of a severed partnership.

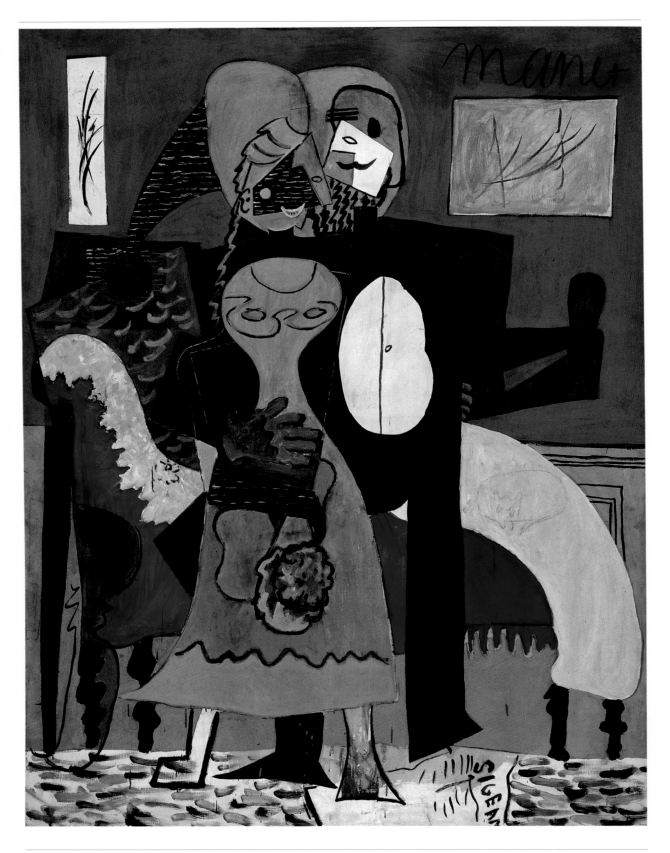

The Lovers, *after Manet, 1919*

In a painting entitled *The Lovers* (fig. 2–26) Picasso turned again to a work by Manet. In 1919, he also made three drawings after an early painting by Renoir, *The Sisley Couple* (figs. 2–27 and 2–28), and a portrait drawing of Renoir himself after a photograph of the artist (Ch. 1, fig. 1–4). Renoir had died in December and these three variations in pencil were undoubtedly a form of homage to an artist he greatly admired. Frequent references to Renoir's late monumental nudes appear in Picasso's paintings of the early Twenties. Both the Renoir drawings and the painting after Manet, as well as the previous variation after Le Nain, are in keeping with Picasso's preoccupation with the French tradition after the war, and with his current work for the theater. Picasso's approach to his theme in this variation, however, differs from his previous examples. In his variations to date, the source on which his work is based has always been obvious, even when he develops the narrative as in his drawings after *Olympia* and Gauguin's *The Spirit of the Dead Watching*. *The Lovers*, however, would not be recognizable as a variation at all had Picasso not scrawled the name "Manet" on the bottom of the canvas, in a parody of the master's signature. Yet even with this obvious cue, the particular painting to which Picasso is referring is not immediately apparent.

The Lovers, like *The Happy Family*, was also left unfinished, and remained hidden in Picasso's personal collection throughout his life. It was exhibited only once and rarely reproduced.[89] Executed in a decorative Synthetic Cubist idiom, *The Lovers* depicts an older man with a bald head and a foppish moustache, elegantly attired in evening dress, and his young mistress, in a scanty light blue dress or slip with a transparent lace bodice, who leans against his knee. On the floor beneath their feet is a newspaper, *L'Intransigeant*, of which only a few letters of the title are visible.[90] With arms around each other's waists, the lovers face the viewer directly, like actors on the stage: the man raises a glass in a toast, while she holds a bouquet of flowers. The woman is clearly the dominant force: her posture is rigid, yet the curvaceous forms of her body convey an irrepressible sense of vitality and power, while her toothed smile and sharply delineated breasts attest to the predatory nature of this Cubist *femme fatale*. Not surprisingly, *The Lovers* was first reproduced in a Dada journal in 1923, the recently launched *Littérature*, edited by André Breton, and reappeared in Breton's book of 1928, *Le surréalisme et la peinture*."[91] Like earlier paintings by Picasso that the Surrealists adopted as ancestors of their aesthetic program, such as the *Demoiselles d'Avignon* (also reproduced for the first time in a Surrealist publication of 1925), and his *Woman in an Armchair* of 1913, *The Lovers* no doubt struck a chord with this group for its irrational spatial qualities, jarring red and orange colors, and blatant sexuality. While continuing the convulsive strain found in some earlier Synthetic Cubist works, such as *Harlequin* (1915) (fig. 2–29), *The Lovers* anticipates the expressionist works of the 1920s. In *The Embrace*, a ferocious painting of 1925 (fig. 2–30), for example, Picasso portrays a fully clothed couple toppled into an armchair. Of this work one scholar notes that Picasso "stresses the grotesque collision of the biological pressures within contemporary men and women rebelling against their civilized trappings."[92] The theme is announced in *The Lovers*, though in a lower key.

Opposite:

Fig. 2–26 *Pablo Picasso. The Lovers. 1919. Oil on canvas, 72⅞ × 55⅜" (185 × 140.5 cm). Musée Picasso, Paris*

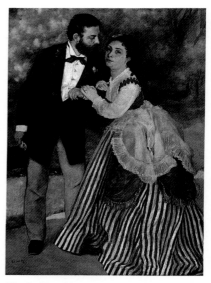

Fig. 2–27 *Pierre-Auguste Renoir. The Sisley Couple (Le Ménage Sisley, ou Les Fiancés). c. 1868. Oil on canvas, 41¾ × 29⅛" (106 × 74 cm). Wallraf-Richartz Museum, Cologne*

Fig. 2–28 *Pablo Picasso. The Sisley Couple, after Renoir. 1919. Pencil on paper, 12¼ × 9⅜" (31.2 × 23.8 cm). Musée Picasso, Paris*

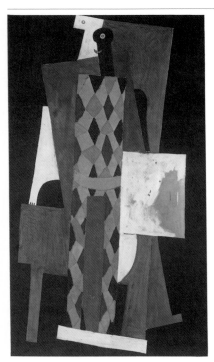

The painting also contains parodistic references to Picasso's earlier Cubist style. The "signature" of Manet and the newspaper thrown down on the floor recall Picasso's use of verbal puns and signs during his Analytic Cubist period. The masthead of *L'Intransigeant* had appeared in numerous Cubist paintings and collages of the prewar period, just as Picasso "depicted" his own signature in various works.[93] Here, Picasso makes use of Manet's signature to refer to an image that his work masks.

The Lovers, in fact, is largely drawn from Manet's *Nana* of 1877 (fig. 2–31).[94] The painting portrays a modern-day prostitute or *cocotte*, based on a character who first appeared in Emile Zola's novel *L'Assommoir*, which was published initially in serial form in 1876 "in the very months when [Manet] planned and executed the picture."[95] Nana epitomizes the predatory women who brazenly plied their trade on the grands boulevards of Second Empire Paris. Manet's painting stems from the episode in *L'Assommoir* in which the elderly Count Muffat visits Nana in her boudoir after her triumphal appearance in a music hall as Venus. The setting for Manet's painting is described by Zola as a room "hung with some light colored fabric and contained a cheval glass framed in inlaid wood, a lounge chair, and some others with arms and blue satin upholsteries. . . ."[96]

Just as Manet's *Olympia* referred to and updated one of the central motifs of Western European art, the reclining female nude, another traditional theme underlies this painting of a contemporary bourgeois prostitute—that of the toilet of Venus, a symbol of vanity and lust. In *Nana*, as in *Olympia*, Manet transforms the traditional theme into a modern-day encounter between a *demi-mondaine* and her client or protector. Dressed in a light blue camisole and stockings and a frilly white slip, Nana stands in front of the mirror on a tall stand at the center of her boudoir with her body in profile and head frontal. She appears to have been interrupted in the act of applying powder to her face by someone beyond the frame of the picture. Manet captures her at the moment of turning her head to look at the intruder, with her hand, holding the puff, suspended in mid-air. To the right, partially cut off by the frame of the painting, is Count Muffat in evening clothes, who looks at her with desire, impatience, and perhaps trepidation. The fact that his body has been cut in half by the edge of the canvas signifies his marginality to Nana, and to the viewer. The Rococo couch and the table behind Nana reflect her sinuous form, while the crane in the decorative screen or hangings behind the figures, an allusion to her status as a kept woman, mimics her stance.[97]

Picasso could not have seen *Nana* in the original at the time of painting *The Lovers*, as it was then in the Behrens collection in Hamburg, but the work was by then widely reproduced, and a postcard or reproduction may have brought it to mind.[98] Picasso's "Nana" is a schematic reflection of her Manet self: her hour-glass figure, bird-like stance, frilly slip, and shoes are preserved in her Cubist incarnation, though her body is now frontal rather than in profile. The vertical division of Manet's gentleman, furthermore, is reflected here in the long line drawn down the shirt front of Picasso's male figure. The pear-shaped right half of the shirt in the Picasso repeats that of the left half of the shirt front in the Manet. Both men sport moustaches, though Picasso's turns up, not down, perhaps to reflect his pleasure in finally encircling Nana with his arm and pulling her to him, while Manet's Count is kept waiting.

Some telling elements of the decor of the room on the earlier painting can also be found in the Picasso, though in simplified form. A common *chaise longue* (probably a piece of Picasso's household furniture, as it appears in other works of this period) recalls the gilded divan in the Manet, while the flat, stippled planes behind the couple reflect Manet's elegant satin pillows. The stool behind, heaped with clothes in the lower left of *Nana*, is distantly recalled in the abstract, curvilinear green shape that overlaps the chair in the corresponding area of the Picasso, and the decorative motifs in the screen behind Manet's couple are also reflected in the later work. The screen itself is transformed into two calligraphic paintings on the wall that parody Japanese art. In the right-hand "painting," the pattern of lines conjures up the crane of the Manet painting, which was essential to the meaning of the work.

The cat curled up on the divan and the bouquet of flowers in *The Lovers* appear to be imported from *Olympia*. It is not surprising that Picasso should draw from both these paintings, as they share the subject of the bourgeois prostitute, and *Nana* can be seen, as George Heard Hamilton has suggested, as a sequel to the earlier painting, "Olympia risen from her couch to dress for the evening amusement."[99] In his variation, Picasso takes us one step further in the implied course of events.

Manet's compositional structure, in which figures and objects are aligned parallel or at right angles to the picture plane, has become rigidified and yet more unstable in Picasso's painting. With his characteristic Cubist distortions, he exaggerates Manet's spatial instabilities while contributing to the sense of irrationality in the work. Whereas Manet's couple is enveloped in a softly receding cool atmosphere that draws the viewer in, Picasso's figures bear down on the observer. The couple is propelled forward into the spectator's realm not only by the shallow space and shifting planes of the picture, but by the hot, vibrant colors behind them.

But Picasso's most striking revision of the painting lies in the fact that by turning the figures to the front and eliminating the motif of the mirror, he has destroyed the complex structure of glances that underlies the meaning of Manet's narrated scene. On a deeper level, *Nana* is about looking; Nana herself is both seer and seen, mediating between the realms of fictional and real space. While she is the object of the viewer's gaze, as well as that of her painted companion on whom she has turned her back (and who may be seen as the viewer's surrogate or rival in the painting), she, in turn, looks back indifferently at us, countering our gaze with her own. Nana's intrusion into our space through her glance is more of a barrier than an invitation to enter her realm. The painting makes us aware of the unbridgeable distance between the observer and the object of scrutiny, both in the depicted scene and in our relation to the fictive characters who inhabit spaces other than our own. Though the object of our vision has the power to arouse desire, we can no more possess the painted woman before our eyes than can the elderly man his young mistress, or Nana her own image in the mirror. In *Nana*, the act of looking suggests ungratified desire and refers by implication to the relation of artist and model. The painting bears witness to the artist's own aroused longing—unsatisfiable through the means of his art—which he shares, or leaves, with the viewer.

In *The Lovers*, as in his earlier variations after *Olympia* and the *Grande Odalisque*, Picasso dives into the heart of his source through

Fig. 2–30 *Pablo Picasso.* The Embrace. *1925. Oil on canvas, 51½ × 38⅛" (130 × 970 cm). Musée Picasso, Paris*

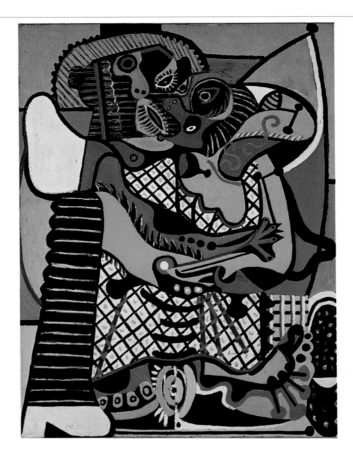

the essential relationship of the depicted figures and the viewer, only to disrupt it and seize control over the material. The intimate and private relation of the viewer to the figures in *Nana*, which accounts largely for its sensual appeal, gives way in *The Lovers* to an impersonal and yet more immediate relationship, like that of an audience to actors on a stage.

Picasso's transformation of the looking theme reflects the changes in the narrative he has imposed on his response to Manet's painting; anticipation is replaced by the attainment of the object of desire. His involvement with the theater at the time was undoubtedly a factor in this transformation as well. Toward the end of 1919, Picasso had begun work on a new Diaghilev ballet, *Pulcinella*, in collaboration with Leonide Massine, choreographer and principal dancer with the Ballets Russes, and the composer Igor Stravinsky.[100] Massine had thought of basing a ballet on the *commedia dell'arte* two years earlier, but working sessions with Stravinsky, whose score was adapted from fragments of works by the eighteenth-century composer Pergolesi, did not begin until December 1919.[101] In a conversation with the critic Douglas Cooper, Picasso said that he had initially wanted to transpose the costumes and setting of *Pulcinella* from the traditional *commedia dell'arte* form into a modern idiom.[102] Cooper reports that Picasso apparently made no sketches at this time because the idea was rejected out of hand by Diaghilev, but the artist's first executed sketches for the decor presented in January 1920 demonstrate that he did not completely abandon the idea of giving

Opposite:
Fig. 2–31 *Edouard Manet.* Nana. *1877. Oil on canvas, 60¾ × 45¼" (154 × 115 cm). Kunsthalle, Hamburg*

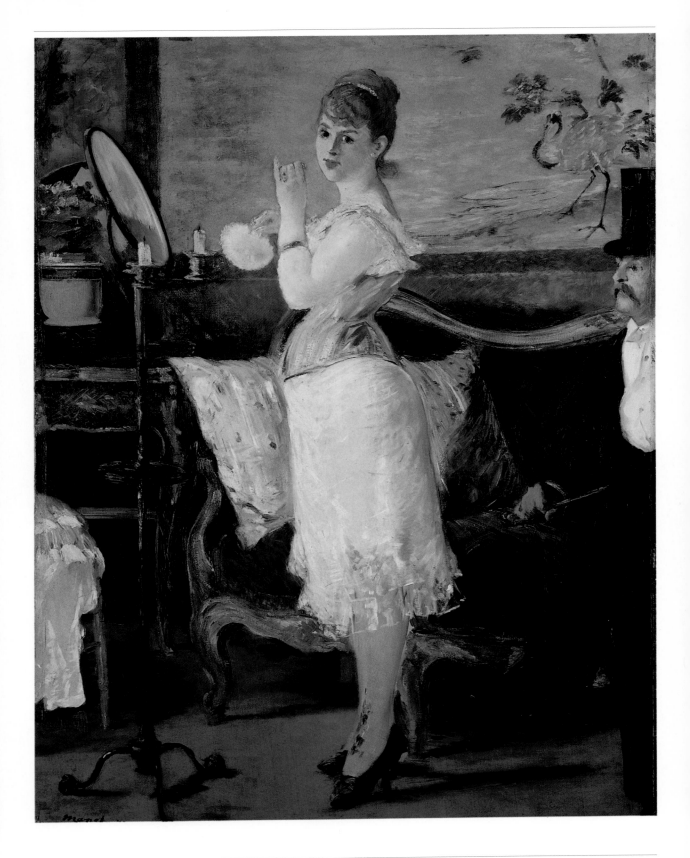

Fig. 2–32 *Pablo Picasso*. Sketch for the Set Design of *Pulcinella, later reworked for* Cuadro Flamenco. *1920–21. Pencil on paper, 7⅞ × 10¼″ (20 × 26 cm). Musée Picasso, Paris*

Pulcinella a modern setting (fig. 2–32).[103] These drawings reveal his plans for a painted backdrop depicting the interior of a theater in a pseudo-Baroque style, complete with a false stage flanked by boxes of painted spectators of the Second Empire who look out at the audience. Cooper writes that Picasso wanted to "underline the artificiality of the action, its puppet show element, for the dancers would have to perform in the middle of a false stage and in front of the inner stage."[104] Diaghilev, however, rejected Picasso's stage within a stage, and the artist later provided him with a greatly simplified decor and more traditional *commedia* costumes.

Fig. 2–33 *Pablo Picasso*. Study for the Set Design of *Pulcinella. 1920. Gouache, india ink, and pencil on paper, 8½ × 10¼″ (21.6 × 26 cm). Musée Picasso, Paris*

Fig. 2–34 *Pierre-Auguste Renoir.* La Loge. *1874. Oil on canvas, 31½ × 25" (80 × 64 cm). Courtauld Institute Galleries, London. Samuel Courtauld Collection*

Fig. 2–35 *Pablo Picasso.* The Box (*Fragment of the Set Design of* Cuadro Flamenco). *1921. Tempera on canvas, 76½ × 58⅜" (194.4 × 148.3 cm). Kunstmuseum, Bern*

The comical Second Empire couples seated in boxes in the *Pulcinella* sketches (fig. 2–33) are reminiscent of the figures in *The Lovers*. In both, the women wear the fashionable décolleté dresses of the period, while the men are portrayed in evening dress in simple black and white shapes. In the *Pulcinella* sketches, however, the sharp Cubist planes of *The Lovers* have given way to a simpler curvilinear style more suitable to the decorative purposes of stage design. But it is in spirit as much as in appearance that the couples are connected. The critic Pierre Cabanne suggests that in the decor "Picasso was trying to get into the spirit of Stravinsky adapting Pergolesi: a mixture of artifice and irony based on pastiche," an observation that seems also to apply to *The Lovers*.[105] Though the *Pulcinella* sketches are dated from January 22 to February 1, 1920, it is possible that by December Picasso was already thinking about setting the backdrop for the ballet in the Second Empire.[106] Parodistic figures adapted from another painting of the Second Empire, Renoir's *La Loge* of 1874 (fig. 2–34), appear in the Pulcinella sketches.[107] *Nana* and *La Loge* have certain elements in common: executed within

three years of each other, both are connected with the theater (Manet's heroine was a music hall performer), portray an aspect of fashionable urban life, and have outward-looking figures. Though Picasso abandoned his idea of a stage within a stage and a Second Empire setting for *Pulcinella*, he was to rework the discarded plans a year later for the set of another Diaghilev production, *Cuadro Flamenco*.[108] In the backdrop of this ballet, the Renoir couple appears as one of the three Belle-Epoque couples seated in boxes that flank the inner stage and face the audience (fig. 2–35).[109] Picasso revised the Renoir couple in a manner similar to the Manet pair: they have been reduced to flat, simplified planes and brought into a more direct and frontal relationship with the

Fig. 2–36 *Pablo Picasso.* Study of Two Persons with an Umbrella and a Cane in front of a Curtain. *1916. Lead pencil on paper, 9 × 11⅜" (23 × 29 cm). Musée Picasso, Paris*

viewer. Furthermore, the women resemble each other in their simplified curvaceous forms, while both couples have similar caricatural expressions. Picasso appears to have made use of the Renoir painting as a witty solution to a problem of stage design, as well as a tongue-in-cheek homage to an artist he admired. Picasso was similarly drawn to Manet's *Nana*, though he developed his painting into an independent work. A sketch of 1916 (fig. 2–36) shows that the idea for the composition may have been in his mind for some time.[110]

The likely connection of *The Lovers* with his ongoing theater projects may explain why Picasso borrowed only some of *Nana*'s scenic qualities. Picasso appears to have used Manet's work as a coloration for his painting, rather than as a specific point of departure. But considering the

strong emotional tone of the picture, and the fact that Picasso had married a ballerina only a year before, it is possible that this "amorous" pair may well be a veiled self-portrait with Olga.

The Lovers has elements in common with Picasso's drawings after Renoir's *The Sisley Couple*, executed around the same time: in both, Picasso caricatures the couple in an unflattering manner. Yet another work may lurk beneath the surface, Rembrandt's famous self-portrait with his wife of c. 1635, *Rembrandt and Saskia* (fig. 2–37).[111] In both paintings the woman sits or leans against the man's knee while he encircles her waist with one arm, and holds aloft a glass in a toast, and in both the couple looks out directly at the viewer. Generally considered a

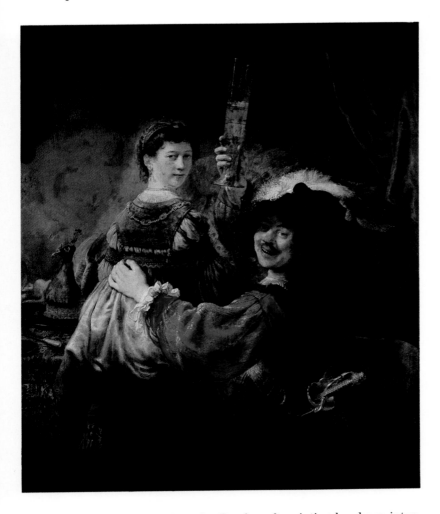

Fig. 2–37 *Rembrandt van Rijn. Rembrandt and Saskia. c. 1635. Oil on canvas, 63⅜ × 51½" (161 × 131 cm). Staatliche Kunstsammlungen, Dresden*

reference to the Prodigal Son, the Rembrandt painting has been interpreted as a "warning against rather than a glorifying of extravagance and frivolity."[112] Picasso may also have intended his depiction of a reveling couple in a lush bourgeois setting in *The Lovers* as a tongue-in-cheek self-criticism. Like all his variations, *The Lovers* is in the end more revealing of Picasso's immediate concerns—his involvement with the theater, and his relationship with Olga in the early years of their marriage—than with the work that served as the basis for the transformation.

3

"The Typhoon of Art": Variations on Grünewald's Crucifixion

There in the old Underlinden convent, he seizes on you the moment you go in and promptly strikes you dead with a fearsome nightmare of a Calvary. It is as if a typhoon of art had been let loose and was sweeping you away and you needed a few minutes to recover from the impact, to surmount the impression of the awful horror made by the huge crucified Christ . . .
—J.-K. Huysmans[1]

In September and October 1932, Picasso, aged fifty-one, executed thirteen drawings in india ink after the *Crucifixion* panel from Mathis Grünewald's Isenheim Altarpiece. This massive polyptych, composed of multiple painted panels, which enclosed an existing sculpted shrine, originally stood on the high altar of the church of the Antonite monastery in Isenheim, Alsace, about twenty miles from Colmar.[2] Commissioned between 1508 and 1516 by Abbot Guido Guersi, preceptor of the monastery, the altarpiece's two hinged sets of wings opened in succession to expose three different faces (figs. 3–1, 3–2, 3–3), each appropriate for a particular liturgical purpose.[3] It is, however, with the nightmarish *Crucifixion* (fig. 3–4), visible in the fully closed state, that the Isenheim Altarpiece is most closely identified.

In the central panels, the battered body of Christ, skin discolored with gangrene and limbs frozen in *rigor mortis*, is suspended on a crude cross. At the left are the collapsing Virgin, cradled in the arm of St. John the Evangelist, and a kneeling Mary Magdalene, convulsed with grief, her arms upraised in frenzied prayer. On the other side of the cross, calm and detached, stands St. John the Baptist. Brought back from death in the role of witness, he points with a greatly elongated forefinger to the crucified figure, and above his hand are written the words "*Illum oportet crescere, me autem minui*" (He must increase but I must decrease [John: 3.30]).[4] Painted in shrill colors and bathed in an eerie light against a night sky, the ensemble thrusts itself upon the viewer with unmitigated power. As the religious historian Gertrude Schiller notes: "In its intensity of utterance, and in the realism raised to the level of a testimony of faith, [*The Crucifixion*] reaches a culmination never attained again."[5]

In his previous variations, as we have seen, Picasso had compressed multiple references and styles in a single work. In his Grünewald drawings, he submits his theme to a process of continuous transformation in a series of works where no single version is definitive. Although such suites of drawings were by then commonplace in Picasso's art, the Grünewald variations mark the first time (with the exception of his three sketches after Renoir's *The Sisley Couple* of 1919, which are closer to copies) that he submitted another artist's work to a series of trans-

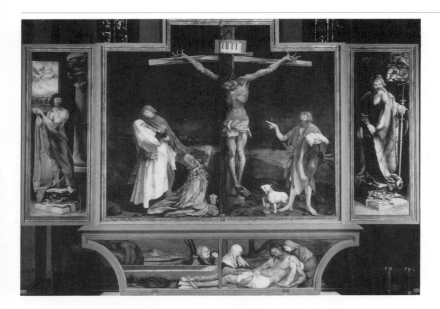

Fig. 3–1 *Mathis Grünewald.* Isenheim Altarpiece, *closed:* St. Sebastian, Crucifixion, St. Anthony; *predella:* The Entombment. *1510–15. Oil on panel, center 9'9½" × 10'9" (2 m 98.6 cm × 3 m 27.9 cm); each wing 8'2½" × 4'11¾" (2 m 49.4 cm × 1 m 51.8 cm); predella 2'5½" × 11'2" (75 cm × 3 m 40.6 cm). Musée d'Unterlinden, Colmar*

Fig. 3–2 *Mathis Grünewald.* Isenheim Altarpiece, *first set of doors open:* The Annunciation, Concert of Angels and The Nativity (The Incarnation), The Resurrection; *predella:* The Entombment. *1510–15. Oil on panel, center 8'10" × 11'2½" (2 m 69.4 cm × 3 m 40.9 cm); each wing 8'10" × 4'8" (2 m 69.4 cm × 1 m 42.3 cm). Musée d'Unterlinden, Colmar*

Fig. 3–3 *Mathis Grünewald.* Isenheim Altarpiece, *fully open: Carved Altarpiece and predella by Nicolaus Hagenauer, flanked by painted panels by Grünewald:* The Visit of St. Anthony to St. Paul the Hermit, The Temptation of St. Anthony. *1510–15. Oil on panel. Musée d'Unterlinden, Colmar*

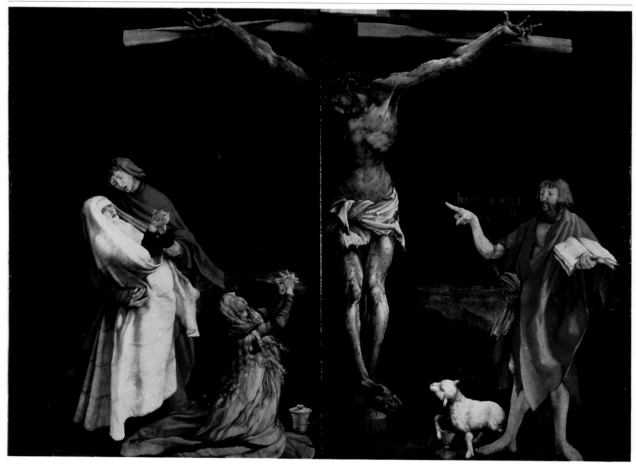

Fig. 3–4 *Mathis Grünewald.* Isenheim Altarpiece, The Crucifixion, *main body of altarpiece, wings closed. 1510–15. Oil on panel, 9′9½″ × 10′9″ (2 m 98.6 cm × 3 m 27.9 cm). Musée d'Unterlinden, Colmar*

formations. Furthermore, his previous variations were, for the most part, private works, exercises, or jokes, made for himself or a small circle of friends, usually left unfinished and kept in his personal collection throughout his life. The Grünewald series, by contrast, was made with greater deliberation, and is addressed to a wider audience. Each drawing is signed and dated, and Picasso published a number of them almost immediately in the first issue of *Minotaure*, a journal associated with the Surrealist circle.[6] The expansion of the form of variation from single to multiple works is reflected in an extension of this artistic practice from private investigation to public statement.

It is noteworthy that Picasso launched this new approach to variation with the Crucifixion, a theme of intense personal significance to him. The Crucifixion provides a rich subject for artistic transformation in general, and in ways that were of particular interest to Picasso. The sign-like character of this symbolic image, with its symmetrical vertical and horizontal axes, and its central place in Christian iconography permit immediate recognition within an almost limitless range of representations. Whether Christ's sacrificial death is shown as a narrative with multiple figures, or in purely iconic form, in two or three dimensions, in a straightforward or highly distorted style, it remains as instantaneously recognizable as the human face or body, and thus open to continual reinvention. Given Picasso's concern with historical continuity and his insa-

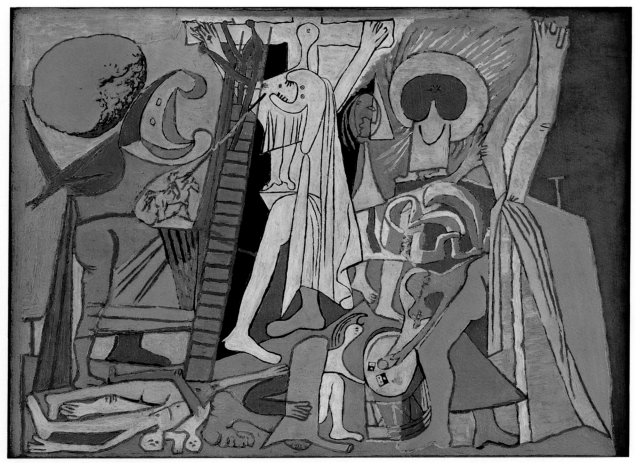

Fig. 3–5 *Pablo Picasso.* Crucifixion. *February 7, 1930. Oil on wood, 19¾ × 25⅞″ (50 × 65.5 cm). Musée Picasso, Paris*

tiable interest in formal invention and transformation, the Crucifixion (which embodies the concept of transformation within itself) offered a challenge of the first order. "There is no greater theme than the Crucifixion exactly because it's been done for more than a thousand years, millions of times," Picasso opined in a conversation with a fellow painter in 1964.[7] Yet his preoccupation with Calvary was not limited to the aesthetic realm; it is intimately connected with his childhood experience and early training, his religious attitude (characterized by one author as a "Spanish faith against the grain . . . an adulterated, depraved faith dominated by the tragic notion of the passion"[8]), his magical conception of art, and the private meaning that the Crucifixion held for him.[9]

Picasso's first ten years were spent in the fervently religious climate of Andalusia in southern Spain, where images of the passion of Christ—emphasizing its brutality—and the suffering of the Virgin, were ubiquitous.[10] Picasso had actually painted devotional images, for as an art student in Barcelona in 1896, he apprenticed briefly in the studio of the religious painter, José Garnelo Alda, and his notebooks of this period reveal a strong grasp of Christian iconography.[11] The subject of the Crucifixion in particular continued to absorb him throughout his life; Picasso depicted it some forty times over the course of six decades in works that range from the straightforward to the blasphemous.[12]

During Picasso's association with the virulently anticlerical milieu of Surrealism, the theme of the Crucifixion took on renewed significance for him and appears most frequently in his work. Picasso had been unofficially allied with the group since 1924, when the poet André Breton launched the movement with a written manifesto, and his involvement with the Surrealists was at its height in the early thirties. In 1930, Picasso painted a small, highly expressive *Crucifixion* emphasizing the brutality of the subject (fig. 3–5), in a combination of styles and jarring colors, one of his most iconographically complex and overtly Surrealist productions. Ruth Kaufmann, in her study of this painting, notes that the Surrealists' interest in the unconscious led them to explore irrational impulses not only within themselves through the Freudian-inspired methods of automatic writing and drawing, but also through the more detached study of primitive religious rites as well as myths and symbols, including Christian art that was heretical and demonic.[13] Grünewald's hyperreal and mesmerizing *Crucifixion* would have fit in with the interests of the Surrealists. It would also have fulfilled Breton's insistence on the marvelous.[14] ("The marvelous is always beautiful, anything that is marvelous is beautiful; indeed, nothing but the marvelous is beautiful," he declared in his 1934 essay, "What Is Surrealism?"[15]) As Kaufmann notes, in his 1930 *Crucifixion*, Picasso shared the Surrealists' impersonal approach to the study of "human irrationality in the form of hysteria, sadism, and brutality."[16] In her study of Picasso's Crucifixion cycle of 1926–36 (in which the painting of 1930 is the key painting), Lydia Gasman links the works with a central concept of Picasso's art as a whole: his "magical primitivism," which is most strongly posited in his Surrealist period, and the antireligious attitudes of the writers of Breton's circle.[17] In his Crucifixions and other "magical" pictures of these years, she argues, Picasso vies with the mysterious hostile forces of the universe, and attempts to control them.[18] Among the sources and attitudes that shaped Picasso's conception of art as a form of magic were his deep-seated superstition and his "discovery" of African art while painting *Les Demoiselles d'Avignon*.[19]

Picasso spoke vividly of the impact of his encounter with African sculpture in the Trocadéro Museum in Paris during the spring of 1907 in a conversation in later life with André Malraux:

The Negro pieces were intercessors, mediators; . . . They were against everything—against unknown threatening spirits. I always looked at fetishes. I understood; I too am against everything. I understood that I too was against everything. I too believe that everything is unknown, that everything is an enemy! Everything! . . . I understood what the Negroes used their sculpture for. . . . They were weapons. To help people avoid coming under the influence of spirits again, to help them become independent. They're tools. If we give spirits a form, we become independent. . . . I understood why I was a painter.[20]

The Crucifixion, which encompasses other recurrent themes, such as ritual sacrifice, that appear in Picasso's art at this time, and which symbolizes the triumph of life over death, is interpreted by Gasman as an expression of Picasso's profound fear of death and "lasting belief that life and death are inseparable."[21]

The Isenheim Altarpiece epitomizes a mystical tendency in Christianity that reached a culmination in the late Middle Ages, characterized by "a growing subjectivism to live up to the sufferings of Christ as a per-

sonal experience."[22] Yet the complex iconographic program of the altarpiece, rooted in the fundamental Christian tenet of salvation and redemption through Christ's death, its graphic realism, and immediacy of impact on the viewer, can only be fully understood in relation to the locale in which it originally stood. In a hospital adjoining the monastery, the Antonite monks treated patients suffering from a disease known as St. Anthony's Fire, which occurred in much of Europe in the Middle Ages.[23] This fatal disease, which caused extreme pain, hallucination, deformation of the body, pustulating sores, and eventual blackening of the skin and shrinkage and loss of limbs, was discovered only at the end of the sixteenth century to be a result of poisoning from ergot, a fungus found in rye flour.[24] The hospital's patients could immediately identify with the Isenheim Christ depicted in their image, and through a combination of faith and medical treatment find hope for their own salvation. While the role of the altarpiece in the program of healing at the monastery, and the extent to which patients were exposed to it lack specific documentary proof, Andrée Hayum has shown through extensive iconographic research and analysis that "themes of dire illness and miraculous cure [are] central to the meaning of the altarpiece at Isenheim."[25] Picasso may have known of the altar's original context in a hospital, for it had been discussed in an essay of 1904 by the Symbolist novelist and critic, Joris-Karl Huysmans,[26] and in Louis Réau's monograph of 1920.[27] In the Isenheim Altarpiece, Picasso confronted not only the drama of death and rebirth raised to an unprecedented pitch of intensity, but a work that like the *Demoiselles* was also a "weapon, an intercessor." Years later Picasso would refer to the *Demoiselles* as his "first exorcism picture, yes absolutely."[28] The Grünewald variations carry on this exorcistic function in a less absolute way.

The immediate factors that gave rise to Picasso's dialogue with Grünewald's *Crucifixion* in 1932 can only be surmised. There is abundant evidence of chaos and turmoil in Picasso's art and life throughout the late twenties and early thirties, when he created some of his most tormented images of the human figure. During this time Picasso initiated an affair with a very young and apparently unstable woman still in her teens, Marie-Thérèse Walter, while still living with his increasingly volatile wife, Olga Koklova. It is in a context of images of aggression and victimization—screaming female heads attacking his profile, bone-like bathers with toothed mouths, and drowning women—that the Grünewald variations arise.[29] Political and cultural factors would undoubtedly have contributed to Picasso's receptivity to Grünewald's image of profound suffering as well. With the emergence of Hitler's National Socialist party in 1930 in Germany and the establishment of the Nazi dictatorship three years later, nationalism was again an issue of pressing concern. In this context, the altarpiece may have acquired renewed poignancy for Picasso as a German implant on French soil in the contested area of Alsace, which belonged at different times to one country or the other, a work forever suspended between two cultures.[30]

The issue of nationalism had been central to the history of the reception of the altarpiece since its reappearance in the mid-nineteenth century. Removed from the monastery in the mid-seventeenth century, and dismantled during the French Revolution, the polyptych returned to public view in 1853, when it was installed in the Musée d'Unterlinden in Colmar, where it remains today.[31] So thoroughly had the massive work

and its creator slipped into oblivion that throughout the eighteenth century the altarpiece was known as a work of Dürer, and, in the early nineteenth, was considered a joint effort of Dürer and Grünewald.[32] Only in the 1840s was the altarpiece reclaimed for Grünewald,[33] although the artist's true name, Mathis Gothart Nithart, did not come to light until the early years of the twentieth century. Even today, little is known of the master's life. The relatively recent rediscovery of the Isenheim Altar (along with the gradual recovery of Grünewald's oeuvre as a whole) invested the monument with the impact of "found art" ripe for conversion to modern, secular needs.

Shortly after the turn of the century, the young German artists of *Die Brücke* and the *Blaue Reiter* schools, concerned primarily with the expression of "inner feeling" and spirituality rather than objective reality and searching for a more immediate and vital form of expression through pure forms and color, discovered in Grünewald a precursor of their aesthetic programs.[34] For them, he embodied the authentic Germanic spirit, associated with the subjective, intuitive, spiritual, and mystical. Appreciation of Grünewald, however, was not limited to Germany. In France, Grünewald's eccentric vision found favor in the context of the late nineteenth-century Symbolist movement in which the exploration of subjective experience and the realm of imagination played a paramount role.[35] Huysmans led the way with his impassioned meditation on Grünewald's *Crucifixion* at Karlsruhe in his 1891 novel, *Là-Bas*, and his vivid and highly personal account of the "typhoon of art" in his essay on the Isenheim Altar in *Trois Primitifs* (1904).[36] No religious image of the past has exerted so powerful an influence on the modern age as the *Crucifixion* panel, though its original Christian meaning was gradually shed for a more generalized image of suffering.[37] Picasso's drawings of 1932 based on the Isenheim *Crucifixion* thus partake of a dialogue not only with the original work itself, but with a tradition of interpretation by painters and writers since the late nineteenth century.

By the 1930s, the altarpiece had been widely reproduced, and there was interest in the work within Picasso's immediate circle.[38] As with most of his variations, the starting point for Picasso's dialogue with Mathis was probably a reproduction.[39] Whatever the factors contributing to Picasso's interest in the panel, however, it is undeniable that in his interpretations of the *Crucifixion*, variation enters the mainstream of his art.

Do you know the *Crucifixion* of Mathias Grünewald, the central panel of the Isenheim Altarpiece? I love that painting, and I tried to interpret it. But as soon as I began to draw, it became something else entirely.
—Picasso to Brassaï, 1932[40]

1 Crucifixion, after Grünewald, *September 17, 1932*

Picasso's initial drawing (fig. 3–6) focuses almost exclusively on Christ, submitting Grünewald's grotesquely contorted figure to even greater deformation and bringing it closer to the picture plane. The other figures are only summarily indicated, if at all. Using a loose graphic style, he renders into line the traces of dynamic processes arrested and frozen in the corpse: the downward gravitational pull of the enormous hulk, the

Fig. 3–6 *Pablo Picasso.* Crucifixion, after Grünewald *(1). September 17, 1932. India ink on paper, 13⅝ × 20″ (34.5 × 51.3 cm). Musée Picasso, Paris*

bursting of ribs under taut skin, the wrenching of swollen joints nearly pulled out of sockets, the unsupported head and neck fallen from the body's vertical axis, and the dark hole of a mouth framing a shrill cry, echoed in the contorted open hands. These features, read as deviations from a norm, are the primary conveyers of the pain that Christ suffered prior to his death; Picasso extracts them from the whole, and converts them into a different system of signs that conveys a new meaning. For Grünewald's dead Christ, whose agonized passage from flesh to spirit is revealed in his wrecked corpse, Picasso substitutes a form of subhuman detritus in which man and beast, organic and inorganic, merge. Christ's divinity, moreover, represented in the original by the upward-moving vectors of the figure, is eliminated. As one historian observed, "Nature sags downward; spirit, force, and energy surge upward."[41] In his variation, Picasso ignores this paradoxical inversion and concentrates almost wholly on downward gravitational pull. While Grünewald's figure was tautly suspended on the cross, Picasso's is propped up against it, the burden of its weight transferred to his grossly enlarged feet. The effect is closer to that of a body grounded or trapped; only a vestige of upward movement is retained.

The interplay of directional forces in Grünewald's Christ is also reflected in the overall shape of the panels on which the scene is painted, reinforcing the central theme of death and rebirth, and symbolizing the intersection of heaven and earth. Although the panels of the altarpiece form a horizontal rectangle, an additional, smaller rectangle projects upward over the head of Christ, creating a separate, implied vertical framework for the slightly off-center crucified figure. While his earthly companions are spread out along the horizontal dimension, Christ alone is propelled heavenward; this, too, Picasso chooses to ignore. He emphasizes instead the more static horizontal axes through the elongation of the outstretched arms of Christ and the horizontal bar of the cross, symbolizing the earthly realm, and the shortening and thickening of the body and the vertical plank of the cross—which "denotes the active principle . . . the transcendent world or spiritual evolution."[42] In these transformations, he wrests the image from its specific

Opposite, above:

Fig. 3–7 *Pablo Picasso*. Crucifixion, after Grünewald *(2)*. September 17, 1932. India ink on paper, 13⅝ × 20¼″ *(34.7 × 51.5 cm)*. Musée Picasso, Paris

Opposite, below:

Fig. 3–8 *Pablo Picasso*. Crucifixion, after Grünewald *(3)*. September 17, 1932. India ink on paper, 13½ × 20¼″ *(34.3 × 51.4 cm)*. Musée Picasso, Paris

Christian context, and converts it into material to manipulate for his own expressive purposes, as a carrier of pain. Picasso's visceral and immediate response to his theme is reflected in his deliberately crude drawing technique as well. His multiple contours, erasures, rips in the paper from the pen tip, blotches, and smudges of ink carry with them the full force of the impact of the image upon him and reveal his struggle to contain it. His first image is as much a violation of the sacred body as a representation of it.[43] In its intensity and spontaneity of expression, this drawing is the baseline of the series as a whole. It is also a repository of traditional and unconventional drawing techniques—thick, heavy outlines and delicate whiplash lines, traditional cross-hatching and random zig-zag, graffiti-like markings, areas of wash, and the raw smudge and splatter of ink—all of which will be brought back into play in different combinations throughout the series.

2 Crucifixion, after Grünewald, *September 17, 1932*

The second drawing (fig. 3–7), executed the same day, both opposes and follows the first. Picasso now "steps back" to become a spectator of the scene, and continues to transform his material. Form is now represented by reserved, white areas of uncovered paper against an ink-black sky; flesh and bone have dissolved into spirit. While in the initial drawing distortion served to suggest pain, here Picasso makes use of dematerialization to call forth another aspect of his theme: the magical, spectral qualities of the painting expressed in its eerie illumination and the writhing, fluid contours of the figures, which now emerge from darkness before our eyes. In this drawing, Picasso fully exploits the unmediated form-giving quality of his medium to underlie the scene's forceful visionary impact. Although the style and expression of the first two drawings are distinctly different, Picasso began this drawing very much as he did in the previous work; the contours of the figures, and even the cross, still visible underneath the black wash, follow it fairly closely.

Christ maintains his dominant place through his exaggerated scale, but he is now reunited with his mourners. To the left we discern a back-bending female form with arms extended and hands frenetically clasped, either the Virgin or Mary Magdalene, or a conflation of both, with the outline of John the Evangelist barely visible underneath the black ink. On the other side of the cross is a composite shape in which we can make out the head of the Baptist at the far right, his pointing hand just below the armpit of Christ, a long white conical shape that suggests his right leg, and a rounded white form divided into two parts that perhaps alludes to his buttocks. A curious detail—imported from the modern world—appears in this work, to which Picasso returns in a later drawing: in the center of the body of Christ, on a flat panel of white (perhaps his loincloth) is an ordinary safety or diaper pin.

In these first two drawings, Picasso explores his theme in contrasting modes, linear and painterly; his dialogue with Grünewald will unfold between these alternating poles.

3 Crucifixion, after Grünewald, *September 17, 1932*

The last and most spare of the three drawings executed on the first day (fig. 3–8) borrows its structure from the previous work, augmenting its

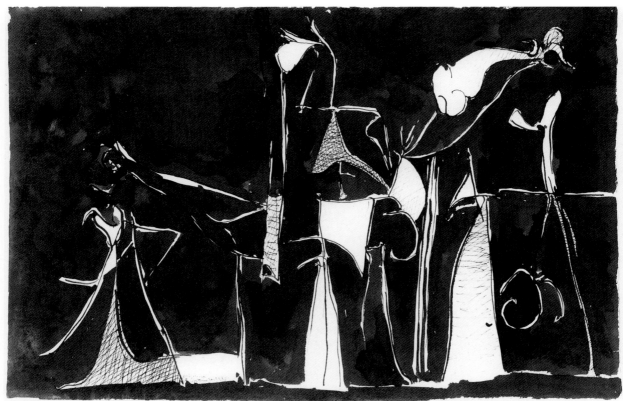

spectral qualities. Once again both contrast and continuity with the previous drawing are evident in the ongoing transformation, but the agitated biomorphic forms of the second have been stylized. Both the swooning Virgin on the left of the cross and St. John the Baptist maintain their places, becoming yet more segmented and abstract. The figure of Christ is reduced to only a few identifying features, and parts begin to drift away from the whole. The increasing sense of order, economy of form, and refinement of drafting technique suggest an emotional distancing from his theme. An organic shaping process asserts itself. "The secret of my many deformations," the artist once commented, "is that there is an interaction, an intereffect between lines in a painting; one line attracts another and at the point of maximum attraction the lines curve toward the attracting point and the form is altered."[44] The relative calm of this drawing shows Picasso now pushing beyond the convulsive content of Grünewald's image to explore its symmetrical composition.

Some of the white planes are now embellished with delicate cross-hatched lines that create a screenlike effect—a conscious allusion to a traditional method of shading—transformed here into a spontaneous scribble. Using the vocabulary of modern art, Picasso asserts his own primacy as a virtuoso master in the six-hundred-year history of drawing in pen and ink. In his hands, cross-hatching becomes a decorative element, paradoxically reinforcing the flatness of his drawing. Is Picasso at this point taking a sidelong glance at Rembrandt? The Dutch master's dramatic use of light and dark, and his combination of freedom and finesse in the handling of pen, brush, and ink appear to impose themselves between Picasso and Grünewald as an unavoidable standard of comparison.

Picasso's first three drawings after the *Crucifixion* are stylistically various, yet closely interrelated. Each in turn draws from the previous work in the series, and elicits a different aspect of the theme. The human suffering of the Savior, the magical and spectral qualities of the scene, and the underlying sense of order of the composition are brought to the fore one after the other. The increasing abstraction and order evident in the first three drawings suggest a progressive distancing from Picasso's initial tumultuous encounter with the tortured figure of Christ—the springboard of the series. Yet, as Picasso continues, the panel's central message of life over death is absorbed, and the theme becomes "something else entirely."

4 Crucifixion, after Grünewald, *September 19, 1932*

Two days later Picasso produced three more drawings. Like the previous set, two are similar in style—one essentially a refinement on the other (like two states of a lithograph)—and one completely new. In the first of the three works (fig. 3–9), Picasso's focus moves outward from a fixation on the central protagonist to the group as a whole. Here, we find a continued expansion of the Grünewald theme: it is now carried into the wider context of Picasso's broader artistic concerns, and those of his Surrealist friends.

Picasso did not indicate the order of the drawings. He probably began with the linear drawing, carrying forward the direction of his last work toward greater abstraction, and then moved on to the more complex and challenging sculptural works, since the sculptural essays constitute

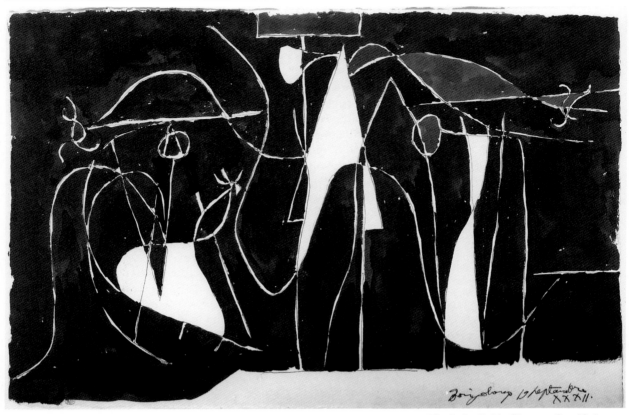

Fig. 3–9 *Pablo Picasso. Crucifixion, after Grünewald (4). September 19, 1932. India ink on paper, 13⅝ × 20⅛″ (34.1 × 51.3 cm). Musée Picasso, Paris*

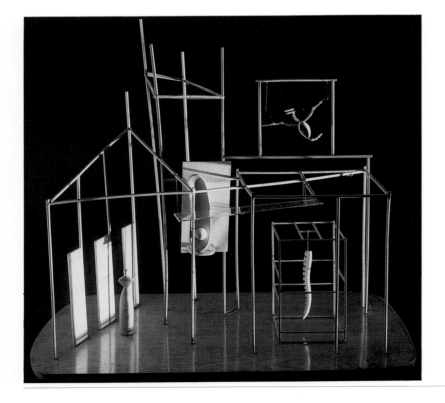

Fig. 3–10 *Alberto Giacometti. The Palace at 4:00 A.M. 1932–33. Construction in wood, wire, glass, and string, 25 × 28¼ × 15¾″ (63.5 × 71.8 × 40 cm). The Museum of Modern Art, New York. Purchase*

something of a climax to the series as a whole, and are a likely stopping point. Indeed, two weeks would pass before he took up his theme again.

In the fourth drawing, the group of five figures in the original is again represented by the three who have dominated so far: Christ, the mourning Magdalene, and St. John the Baptist. Continuing the method of reserving areas of the white paper for figures against a black ground, Picasso has now reduced the bodies to three simplified, abstract signs. An acute triangle, like an arrow pointing heavenward, stands for Christ, his horizontal neck and head falling leftward from its tip, slightly breaking the rising energy of his spirit; a curvilinear teardrop form represents the backbending Mary Magdalene, and an hour-glass shape the calm, detached Baptist on the other side of the cross. These floating shapes are suspended in a web of rhythmic, flowing lines, conveying the pulsating energies of the work as a whole. The gradual conversion of mass into the distilled energy of line in the first four drawings mirrors the theme of death as "the transformation of all things, the progress of evolution, dematerialization."[45]

While the shape of the figures differ, their small, blank, circular heads are similar. Only two types of heads have appeared in the series so far, each of which, as Gasman has shown, carries specific meaning in the context of Picasso's Surrealist work: "the small type, suggesting the irrational and the demonic, and the head-jaw referring to the devouring instinct and to the Mouth of Hell."[46] As he continues, not only do Picasso's familiar motifs and symbols imprint themselves on Grünewald's image, but references to his own works and those of other artists of his circle also enter into the mix. This elegant and spare drawing recalls Picasso's transparent "cage" works of the late twenties, such as the maquette for a monument for Apollinaire,[47] with its similar small disk head and armature of rods that enclose—rather than displace—space, as well as Alberto Giacometti's enigmatic cage sculpture enclosing floating, biomorphic forms, *The Palace at 4:00 A.M.* (1932) (fig. 3–10), some of Miró's paintings of the period, and Alexander Calder's mobiles and stabiles.

5 *and* 6 Crucifixion, after Grünewald, *September 19, 1932*

In a dramatic leap, the dynamic aspect of the model is reconstituted in an entirely new idiom of greater formal power and black humor, marking the expressive climax of the series as a whole. Picasso makes an abrupt transition in the fifth and sixth drawings (figs. 3–11 and 3–12) from an analytic to a synthetic mode of expression, and from a painterly to a sculptural idiom. By restoring volume, which had been pressed out over the last several drawings, he heightens expression and widens his range of references. The Crucifixion, allegorized as pure energy in the previous drawing, is now represented in terms of base materialism. It appears here as a fossilized residue of some ancient ritual frozen in time, for which the original context has been lost, but which remains, nevertheless, dynamic and enduring—a ruin.[48]

Propped up on pointed, tooth-shaped legs, the dominating figure of Christ is composed of a precarious scaffolding of thrusting and rounded forms: finlike or pincerlike arms, a bulbous rib cage, an elongated neck slanted to the left, and a menacing head comprised of a sickle-shaped jaw framing the cavity of the mouth. Attached to the jaw is a comma-

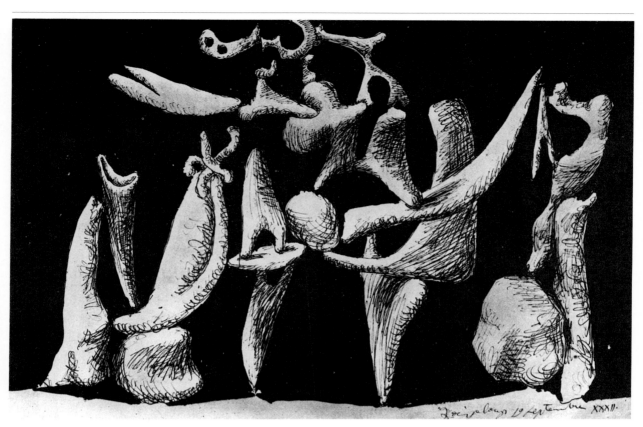

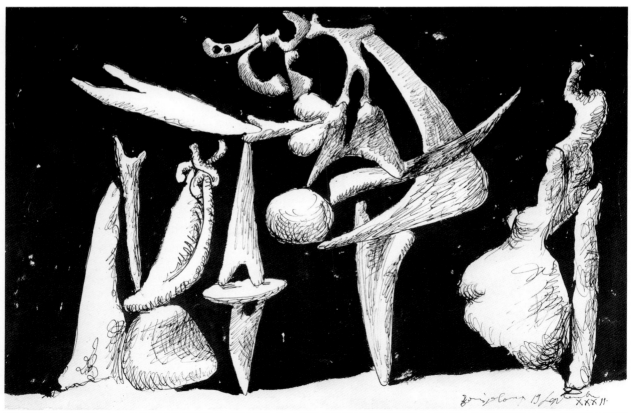

shaped bone pierced with two holes for eyes, reminiscent of the sinister Harlequin masks of the 1920s.[49] His left arm thrusts upward from a ball at the very center of his body. Looming over the two figures below, the bone-Christ's upward movement is checked by the top edge of the paper, and his head is pushed down over his outflung right arm. At the left, a conflated Virgin/Magdalene figure is recognizable by her signature upraised arms and twisted hands, grossly enlarged and now turned into something more snoutlike. A long empty funnel open at the top suggests her thrown-back head—the visual equivalent of a wail. In the first of these drawings, the Baptist is made up of four shapes, while in the second, the shapes merge into a single contour. (The rest of the drawing remains fundamentally unchanged.) His long, pointing finger in the original is reflected in a clothes-pin shape here, which reaches out to join the hand of the Savior, though in the original they are widely separated. The photographer Brassaï, one of the first to see these drawings shortly after they were executed, commented: "It was as if Picasso has amused himself by making a crucifixion from the fins and claws of shellfish."[50]

Several years before, in the summer of 1928 at the seaside resort of Dinard, Picasso had developed an idiom of hollow, biomorphic forms that featured bones, shells, or pieces of driftwood in a series of pen-and-ink drawings for witty monuments based on the human figure, though these were never realized in three dimensions (fig. 3–13). In the so-called Dinard suite, Picasso explored the limits of the human body, and exploited the tension between the impersonality and implied grand scale of these parodies of public sculpture and the modesty of dimensions and hand-crafted refinement of the images drawn on paper. This "bone" style also appears in some of Picasso's Surrealist paintings of the period, such as his threatening *Seated Bather* (fig. 3–14) and in parts of his *Crucifixion* (both of 1930). Picasso revives the style, medium, and concept of the monument from the Dinard suite in these variations, carrying the bone style into the context of the most sacred body of all. Gasman comments: "As Picasso's series of *Crucifixions* unfolds, the equation of bones with Death makes quite clear his awe-inspiring conceit that Christ on the cross is Death on the cross."[51]

While Picasso made use of bones throughout his art for their obvious symbolic significance, he was also fascinated by their metamorphic forms. As he told Brassaï, all bones appeared to have been taken from a mold having been first modeled in clay: "On any one piece of bone at all," he said, "I always find the fingerprints of the god who amused himself with shaping it."[52] In these variations, Picasso exploits the Surrealist principle of metamorphosis, which he described as a process of destruction and recreation of the model: the artist must "pierce through what the others see—to the reality of it. He must destroy. He must demolish the framework itself."[53] Even in this sinister travesty of his theme, in which he "demolishes the framework" of the Christian symbol of eternal life, recreating it as empty shards, Picasso affirms the enduring power of the *Crucifixion* by giving it "another life," albeit a negative one. As in the previous variations, associations with works by other artists enter in. The vocabulary of brittle biomorphic forms and the principle of metamorphosis itself were in common currency among the younger Surrealist painters, such as Tanguy and Dalí.

Given Picasso's preoccupations with sculpture in the early thirties, it is not surprising that his own work in white, molded plaster, which he

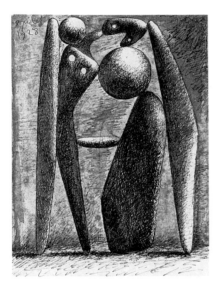

Fig. 3–13 *Pablo Picasso.* Bathers. *Dinard, July 8, 1928. Pen, brush, and india ink on a page from a sketchbook, 11⅞ × 8¾" (32.2 × 22 cm). Musée Picasso, Paris*

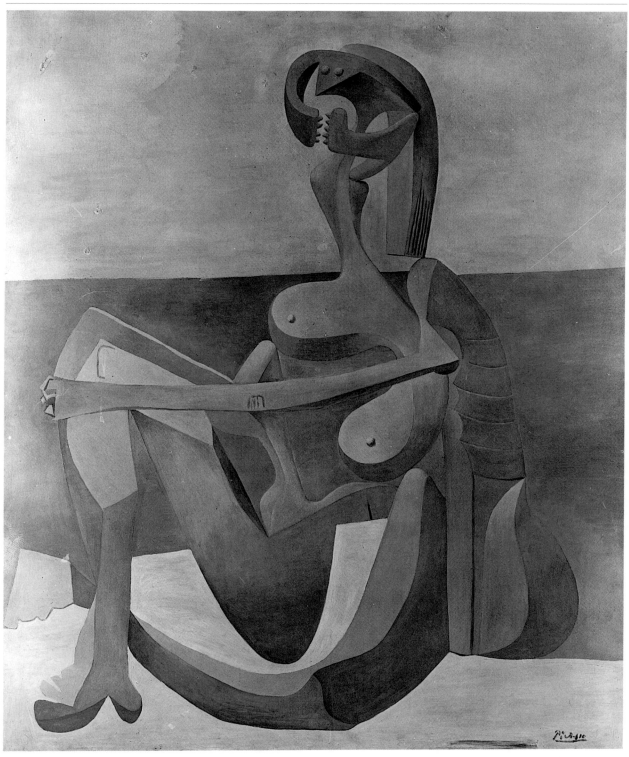

Fig. 3–14 *Pablo Picasso.* Seated Bather. *1930. Oil on canvas. 64¼ × 51" (163.2 × 129.5 cm). The Museum of Modern Art, New York. Mrs. Simon Guggenheim Fund*

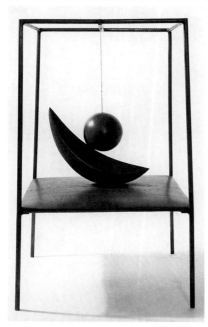

Fig. 3–15 *Alberto Giacometti. Suspended Ball. 1930–31. Plaster and metal, 24 × 14¼ × 13⅛" (61 × 36 × 33.5 cm). The Alberto Giacometti Foundation, Kunsthaus, Zürich*

Opposite:

Fig. 3–16 *Pablo Picasso. The Three Dancers. 1925. Oil on canvas, 84⅝ × 55⅞" (215 × 142 cm). The Tate Gallery, London*

was carrying out simultaneously at Boisgeloup, would be reflected here.[54] Sculpture by other artists may have entered into the mix as well. The combination of the ball and long curvilinear arc that joins the groin to the neck in the body of Picasso's Christ recalls Giacometti's famous *Suspended Ball* of 1930 (fig. 3–15), which first earned him the recognition and admiration of André Breton and his group, and would have fit in with the tenor of these drawings. Picasso himself made two notebook sketches after the *Suspended Ball* earlier in 1932.[55] The sculptural style of these two drawings may also allude to the wooden shrine at the center of the altarpiece behind the painted panels.

Underlying the Crucifixion theme in these two works is that of a ritualistic dance, themes that had come together in Picasso's *The Three Dancers* of 1925 (fig. 3–16). Over the course of the development of the painting, which originated in Picasso's direct experience with the dance through the Ballets Russes, the work evolved, in the words of one critic, into "a paradigm for the relationship of man to woman, a sort of Dance of Life that is also a Dance of Death."[56] In the fifth and sixth variations Picasso may be alluding to the popular medieval belief "that the dead rose from their tombs at midnight and performed a dance on the graveyard before setting off to claim fresh victims from among the living."[57] That associations with *The Three Dancers*—the work that launched Picasso's Surrealist period—should crop up while analyzing Grünewald's *Crucifixion* is not surprising, for the painting was inspired in direct and indirect ways by the monumental altar.[58]

In overlaying the Crucifixion with a dance of death, Picasso taps the primitive roots of the Christian symbol of eternal salvation, and converts it into the threatening, aggressive ritual (as he did in *The Three Dancers* and his *Crucifixion* of 1930). Through his conception of "image magic," Picasso vents his anger and despair and attempts to free himself from it: as he later affirmed in a conversation with Françoise Gilot, his work was "a form of magic designed as a mediator between this strange hostile world and us, a way of seizing the power by giving forms to our terrors, as well as our desires."[59] In these two drawings Picasso converts the element of bewitchment or night magic of his theme into something more macabre.

Some of the bone shapes in drawings 5 and 6 were developed from the negative spaces between lines in the schematic drawing executed earlier that day. The upward-rising energy that both the linear and bone drawings share, setting them apart from the earlier works in the series, is yet another link. The connections between one drawing and another, despite their obvious differences in style and content, reveal that Picasso's working method is one of a continuous chain of transformations rather than an aggregate of separate impulses.

7 *and* 8 Crucifixion, after Grünewald, *October 4, 1932*

After the cathartic works of September 19, it comes initially as a surprise that the Crucifixion panel remained a potent source of inspiration, or irritation, to Picasso. The artist once described the creative process as an oscillation of "states of fullness and evacuation. A painter paints," he said, "to unload himself of feelings and visions."[60] Two weeks later, he delivered himself of two more visions of the haunting scene in different styles (one abstract, the other representational), each recapitulating

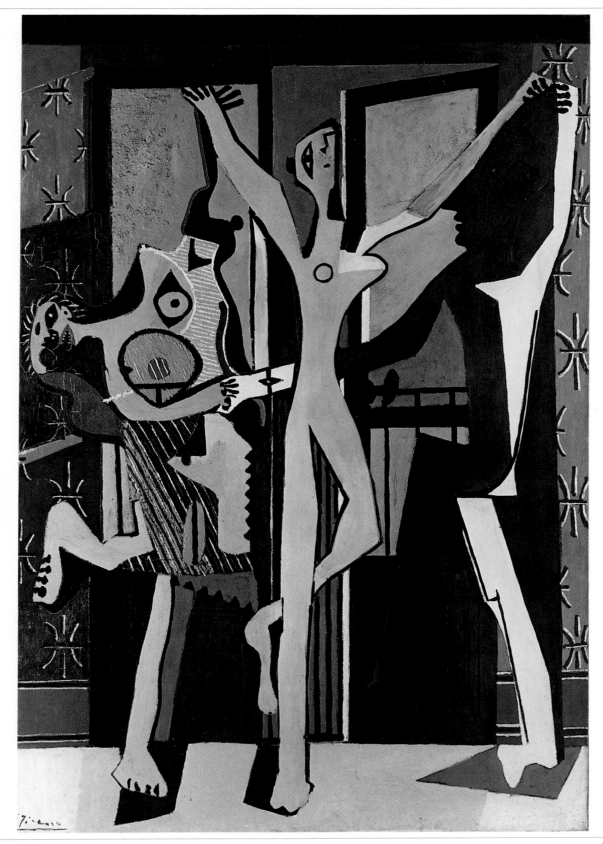

aspects of earlier variations. As in the first work in the series, Picasso again hones in on the central figure, only summarily indicating the witnesses.

The order in which these drawings were executed is not indicated, and both make sense as starting points. The abstract drawing (no. 7, fig. 3–17), with which I will begin, continues the use of the black ground (now invaded by rectangles of white) of the previous five drawings; the other goes back directly to the source in Grünewald and the initial drawing in the series, representing a second beginning. Whereas the dramatic bone drawings of two weeks earlier summed up the achievements of the previous variations in a spirit of irony and self-conscious showmanship, these drawings, in contrast, reveal some degree of empathy with the suffering Christ. Formal invention is replaced by a return to a normative human image and brutal pathos.

In the abstract image, the reference to bones continues, drained of volume and reduced again to outline. A recognizably human skeleton glimmers in white against black, giving way to a play of figure and ground in two dimensions. Positive and negative areas arrange themselves in a cruciform shape. Outlined in delicate, shooting white lines that turn to black where the ground reverses to white, the image of the man on the cross appears to be in the process of disintegration, like an afterimage of a powerful impression. Here Grünewald's suffering Christ appears to have been conflated with an earlier, Romanesque type in which the proportions of the figure are generally shorter and squatter, and the arms opened horizontally in a gesture of blessing.[61]

The phantom skeleton, which hovers between the realms of abstraction and representation (or man and beast) in the previous drawing, takes on the recognizable form of Christ in drawing no. 8 (fig. 3–18)—the only "representational" work of the series as a whole. For the first time since the initial work in the series, Picasso returns to the use of black outline on white ground and adopts a loose, calligraphic style of drawing. Once again, he focuses on the body of Christ, emphasizing the fallen head (now ringed with thorns), the pulled and swollen joints, and the whirl of clawlike fingers at the end of elongated arms.

After the fantastic flights of imagination and bizarre transformations of his subject, the relative simplicity of this drawing seems perplexing at first. Yet as Rudolf Arnheim has observed in another context: "All distortions must be readable to the perceivers as deviations from the norm. . . ."[62] Here Picasso returns to the norm and renews inspiration. His identification with the suffering victim is carried into the process of representation itself: ink is spattered and pooled on the paper, and flows freely down it, like the blood from Christ's wounds; form, process, and meaning merge.

9–12 Studies for the Crucifixion, after Grünewald, *October 7, 1932*

A reaction to the spontaneity of the previous drawing imposes itself in the four works that emerged three days later. Picasso retreats to his "bone" style and a controlled technique, reinvesting his dialogue with irony and distance. Despite his productivity, however, this set—comprising two views of the body of Christ alone and one of the ensemble, and a sheet of miscellaneous details—does not carry Picasso significantly further; instead, he refines ideas already expressed, although the

Opposite, above:
Fig. 3–17 *Pablo Picasso.* Crucifixion, after Grünewald *(7). October 4, 1932. India ink on paper, 13⅜ × 20⅛" (34 × 51 cm). Musée Picasso, Paris*

Opposite, below:
Fig. 3–18 *Pablo Picasso.* Crucifixion, after Grünewald *(8). October 4, 1932. India ink on paper, 13⅜ × 20⅛" (34 × 51 cm). Musée Picasso, Paris*

"bone" style itself undergoes change: he now uses forms that are closer to real animal bones (of which he had a large collection at Boisgeloup). The revelatory mode is replaced with a cooler approach, closer to that of the detached gaze of the scientist.

Consistent with the increased emotional distance from his theme is the introduction of a familiar Surrealist technique of incongruous juxtaposition. In his Dinard notebook of 1928, Picasso amused himself by substituting objects for body parts in imaginary constructions of figures. Speaking of one such drawing (fig. 3–19) with Tériade (who published them along with the Grünewald variations in the first issue of *Minotaure* in 1933) Picasso said: "Look how I have constructed a woman out of a ham hock, a potato, a form, and a cucumber."[63] In drawing no. 9 (fig. 3–20) Christ's left "bone" arm resembles a leg and foot, while the right arm suggests two bone hands gripping each other. The right leg recalls a clenched fist, and the rib cage a giant bone hand with the thumb and fingers outstretched.

The three remaining drawings of the day are closely interrelated. In the full-length single figure study (no. 10, fig. 3–21) Christ and his cross are now combined into a cohesive self-supporting entity, and, as in the previous drawing, his very small head is pushed to the top of the page.

Compared with the previous work, the bone parts are simpler, and the humor of the double-entendre has disappeared. The bulbous bone forms are now brought into a static vertical and horizontal arrangement. Emptied of the affective power and magical qualities of the theme, so strongly manifest in the bone images of September 19, this drawing presents a chilling spectacle, recalling an exhibit in a natural history museum. The sinister figure with its toothed jawbone and empty holes for eyes repels emotive connection on the part of the observer, or any hint of spiritual transcendence.

In the next drawing (no. 11, fig. 3–22), Picasso inflates the parts of his bone-god, and arranges them in a more dynamic composition, complete with the mourners. Is the ball under Mary Magdalene a reference to her ointment jar, and the small cone at the base of the Baptist the *Agnus*

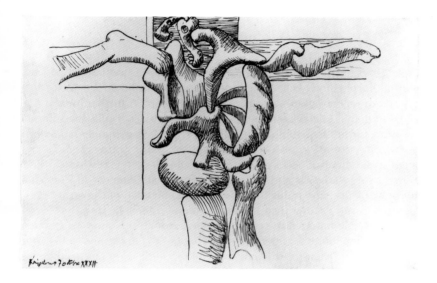

Fig. 3–20 *Pablo Picasso. Study for the Crucifixion, after Grünewald (9). October 7, 1932. India ink on paper, 13⅝ × 19⅞" (34.5 × 50.5 cm). Musée Picasso, Paris*

Dei? Some freely drawn squiggly lines in the background suggest the gathering darkness of Grünewald's panel, while numerous blotches of ink distributed over the surface convey a spontaneity of expression that seems at odds with the quasi scientific tenor of the drawing.

Perhaps most intriguing among Picasso's drawings of October 7 is the sheet of strange details represented in a realistic manner (no. 12, fig. 3–23). Just as he turned back in the previous three works to a style already used in the series, here he returns to the curious object that he inserted in drawing no. 2—the infant's diaper pin. The pin is depicted fastened to a piece of flapping white cloth, which hangs over the branch of a tree or a long bone, attaching the two sides. The same image is repeated to the right in smaller form with the words "épingle de nourrice" (wet nurse's pin) written above it and over a third, larger and more detailed representation of the pin in isolation. Above the pin he draws a screw, depicted both alone and inserted into the end of a fin-shaped bone arm. These "new attributes for the Passion," as Brassaï referred to them,[64] were no doubt intended for incorporation into yet another Calvary, with the flapping fabric representing Christ's loincloth.

Picasso's introduction of these enigmatic "found objects" supports his attempt to keep his theme alive by resorting to greater novelty and sur-

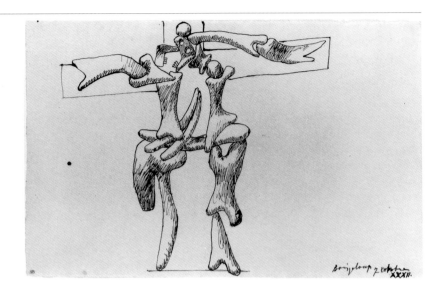

Fig. 3–21 *Pablo Picasso*. Study for the Crucifixion, after Grünewald *(10).* *October 7, 1932. India ink on paper, 13⅝ × 30⅛″ (34.5 × 51.2 cm). Musée Picasso, Paris*

prise. Does his meditation on the central image of Christianity thus end with a blasphemous substitution of a fossilized effigy of Death for the symbol of regeneration—that is to say, in despair? A further look at the sheet of details sheds light on this issue. Though never fully incorporated into a further Crucifixion, the pin, cloth, and screw remain indicators of the direction of Picasso's thought as he withdrew from his engagement with Grünewald. Gasman has connected these details to the more general role that pins and nails play as magical elements in Picasso's Surrealist work. She notes that Picasso's explicit use of the term "épingle de nourrice" rather than the more common "épingle de sureté" suggests that he compared the cloth wrapped around the bones of Christ's loins with the infant's diaper, showing that he "did not abandon his conception that life and death are indissolubly linked."[65] The traditional iconographic connection between the cloth in which the child is wrapped at birth and the loincloth Christ wears at his death is borne out in Meier's and Pevsner's remarks on the Nativity scene in the Isenheim Altarpiece: "the napkin is torn, a deliberate sign of humility, or a deliberate and violent reminder of the loin cloth of the crucifixion."[66]

Yet to conclude that the dialogue ends in either hope or despair would be to negate the evidence of the series so far, which with its alternations of attack and retreat, multiplicity of expressive codes, and range of meaning, bear witness to a vital, if deeply ambivalent, religious faith. The serial form itself, in which Picasso chose to conduct his dialogue on the *Crucifixion* suggests the fluctuating nature of his attitude toward his subject. So significant was the theme that Picasso felt compelled to retrace his steps; after the drawings produced in a burst of energy on September 17 and 19, he executed a second set on October 4 and 7, essentially a repetition of the first in condensed form. In both groups, an initial focus on the suffering of Christ is followed by a progressive distancing through formal manipulation.

13 Study for the Crucifixion, after Grünewald, *October 21, 1932*

Picasso's final drawing of two weeks later (fig. 3–24) retains the bone style of the previous group, and the manner of execution in precisely

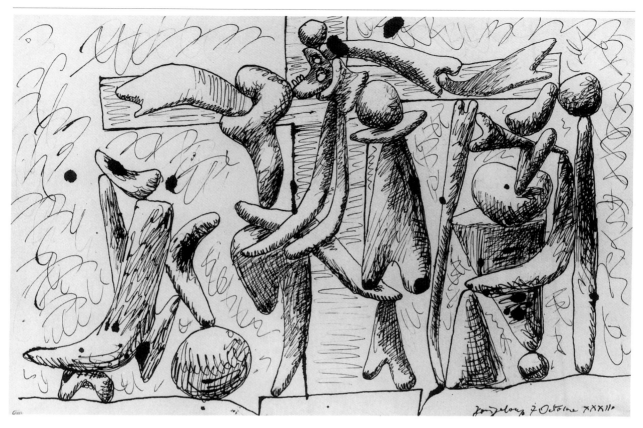

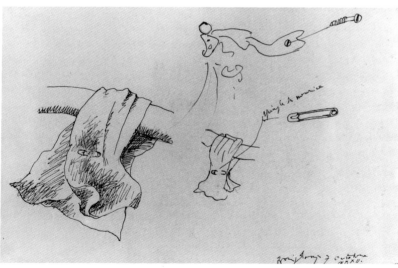

Fig. 3–22 *Pablo Picasso.* Study for the Crucifixion, after Grünewald *(11). October 7, 1932. India ink on paper, 13⅜ × 19⅞" (34.5 × 50.5 cm). Musée Picasso, Paris*

Fig. 3–23 *Pablo Picasso.* Study for the Crucifixion, after Grünewald *(12). October 7, 1932. India ink on paper, 12¾ × 20⅛" (35.2 × 51.2 cm). Musée Picasso, Paris*

drawn contours modeled in a freeform version of cross-hatching. The skeleton is now more recognizably human, though the head is bestial. The cross is drawn in more schematically than in any other drawing in the series. A curved line to the left of Christ is enough to denote the Magdalene, and a few abstract marks in the background refer to the dark atmosphere of Grünewald's scene. The screw that appeared in the previous set of drawings has now found its place here in the hands of the Savior. The spectator's point of view has moved from in front of the

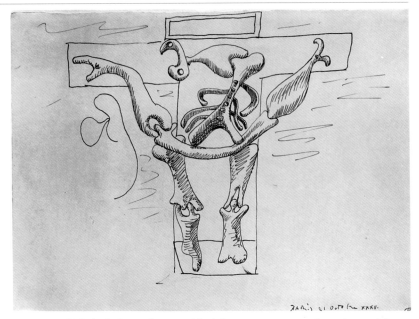

Fig. 3–24 *Pablo Picasso.* Study for the Crucifixion, after Grünewald *(13)*. *October 21, 1932. India ink on paper, 10⅛ × 13⅛″ (25.7 × 33.3 cm). Musée Picasso, Paris*

cross to slightly below: the crucified figure appears to be released from gravity and floating upward on his cross. The introduction of semicircular arms, and the absence of a ground or horizon line, enhance the sense of gentle upward movement. The crucified Christ from the central panel of the Isenheim Altar appears to have taken on aspects of the resurrected Christ from another panel (fig. 3–25). Life and death thus remain "indissolubly linked" with each other, even in so pessimistic a view.[67]

In looking back from the perspective of the final drawing it is clear that a process set violently in motion has reached a state of rest. Picasso ends, as he began, with the central figure of Christ abstracted from the scene. The grotesque image of decomposing flesh has now arrived at a chilling spectacle of a skeleton/Christ transformed and stripped of its Christian meaning, yet still enduring. The destabilization of forces let loose in Picasso's initial foray are brought back into coherence and order. In submitting himself to Grünewald's "typhoon or art," Picasso initiated a formal process through which his model became "something else entirely," all the while exploring the magical, metamorphic nature of artistic language within the context of the most potent Christian symbol of all, and pitting his individual interpretation against dogma.

The serial nature of the variations is in keeping with Picasso's and the Surrealists' belief in art as a form of discovery; it also reflects the altarpiece's "capacity for gradual revelation"[68] through its unfolding panels. But the series also points to Picasso's differences from the group. While the Surrealists manifested a skeptical distrust of the visual medium as a vehicle for "pure psychic automatism," Picasso made use of his dialogue with Grünewald to emphatically affirm the power of the image (choosing as his subject no less than the "visual focus of Christian contemplation") as a vital form of communication in which artist and viewer are united in a creative partnership.[69]

Hayum has noted that Grünewald's great painted polyptych was executed at a time when sculpture was the favored medium for altarpieces, and the authority of painting as the primary vehicle for communication

was beginning to be undermined by the relatively new medium of the printed word.[70] With its "exuberant confidence . . . in the image as a powerful and legitimate agent for spiritual transformation,"[71] she notes, Grünewald's monumental work was "an accomplishment against the grain."[72] Similarly, Picasso asserts his own independent aesthetic position. For the variations, in addition to being a personal and formal exploration of a multileveled theme, may also be seen as a discourse on drawing and affirmation of its central place in his art. Drawing was Picasso's first medium of communication, and he continued to resort to it throughout his life as a preparatory form for work in other media, and as an end in itself. His drawings were among his most intensely personal works, and Picasso rarely let them go. They were for him pages of a diary, liv-

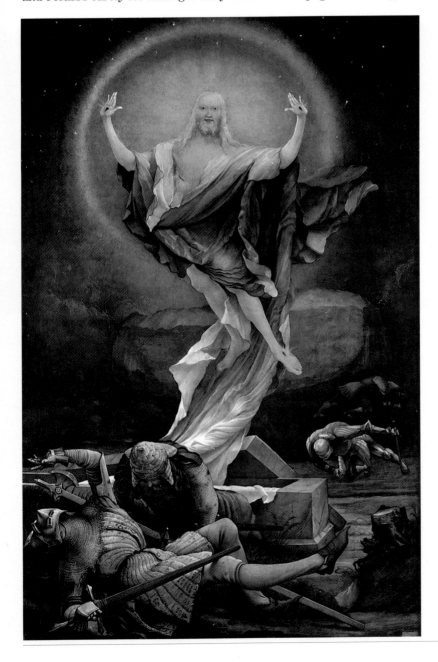

Fig. 3–25 *Mathis Grünewald*, The Resurrection, *right-hand panel of the* Isenheim Altarpiece, *first set of doors open. 1910–15. Oil on panel, 8'10" × 4'8" (2m 69.4 cm × 1 m 42.3 cm). Musée d'Unterlinden, Colmar*

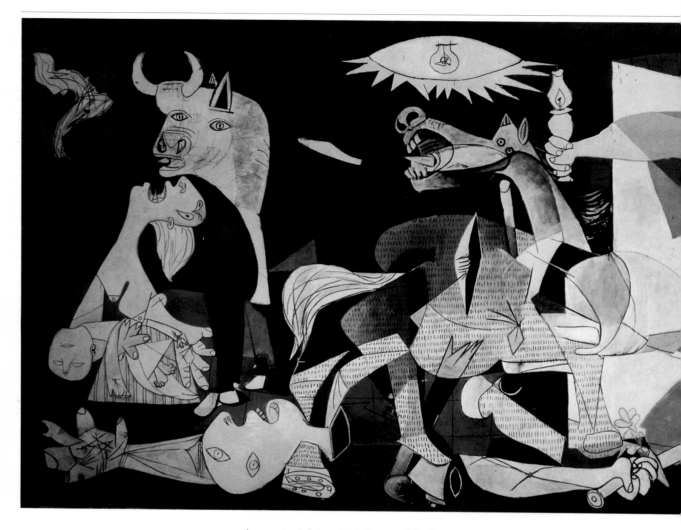

ing material to which he would often return. During Picasso's Surrealist years, from 1927–36, as one scholar has noted, drawing served a primary role in his art, taking an independent course of its own.[73] Picasso's choice of pen and ink for his dialogue with Grünewald's *Crucifixion* is not incidental; it is an intrinsic part of the message, reinforcing the play of historical continuity and discontinuity at the core of the variation process. In his Grünewald suite, Picasso combines updated versions of such old master techniques as cross-hatching and washes with the force and vitality of simple graffiti-like marks and pooling and splattering of ink in his own masterful handling of the medium. The series fits in with Picasso's "reinterpretation of traditional drawing modes" that took place in the thirties.[74]

Picasso also affirms drawing as the root language of all the arts. As he said: "Drawing is no kidding. It's something very grave and very mysterious that a simple line could represent a living being. Not only his image, but moreover, what he really is. What a marvel! Isn't it more surprising than all the prestidigitations and all the coincidences of the world?"[75] Thus the "magical" nature of drawing and of Grünewald's awe-inspiring masterpiece reinforce each other.

Not surprisingly, although these variations form an autonomous group

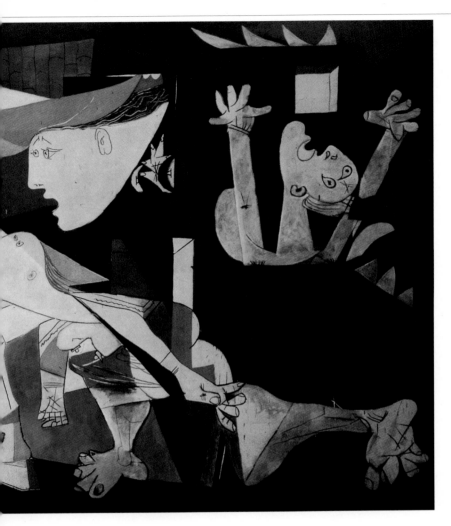

Fig. 3–26 *Pablo Picasso.* Guernica. *1937. Oil on canvas, 11'5½" × 25'5¾" (349.3 × 776.6 cm). Museo Nacional Centro de Arte Reina Sofia, Madrid. On permanent loan from the Museo del Prado*

of works, they are also, needless to say, connected to Picasso's larger projects of this Surrealist period. Just as they reach back to his first major Surrealist work, *The Three Dancers* of 1925, and are loosely connected with his *Crucifixion* of 1930, they are, in a sense, brought to fruition in his monumental work of 1937, *Guernica* (fig. 3–26). Among the many sources of this huge mural—in which the divergent themes of the bullfight and the Crucifixion are reconciled—lies Grünewald's agonizing image.[76] It was only under the impact of the brutality of the Spanish Civil War that Picasso was fully able to exploit the central message of death and rebirth of the *Crucifixion* panel, and to draw on its status as a public monument, an aspect he had largely ignored in his meditation of 1932. Like the polyptych, the mural was executed for a particular locale: it was to be the centerpiece of the pavilion of the Spanish government in exile at the 1937 Universal Exposition in Paris. Merged with multiple sources from the art of the past and contemporary news accounts, Grünewald's masterpiece carries its healing message in the face of suffering and despair. In the grisaille tonality, graphic power, fragmented forms, and immediacy of impact in the blown-up scale of the canvas, we find distant reflections of Picasso's earlier encounter in pen and ink with the "typhoon of art."

4

World War II and Beyond: Variations of 1944–1953

At the end of World War II, Picasso, then in his early sixties, emerged from four years of German occupation not only as the greatest living artist at the peak of his international fame (his only competitor for this being Matisse), but as a Resistance hero who had stayed the course, continuing to work in the nation's capital, while other artists had sought refuge in New York or, in some cases, collaborated with the enemy.[1]

His studio on the rue des Grands Augustins, where he had painted *Guernica*, became a mecca for members of the Resistance, artists, poets and writers, and Allied soldiers on leave. On October 5, 1944, shortly after the Liberation, Picasso's membership in the French Communist Party (PCF) was announced; the next day, a retrospective exhibition of his work opened at the Salon d'Automne.

An extensive study of press clippings from Picasso's personal archives during the war years and after has shown that with the end of combat, in the light of France's humiliating loss of political, economic and cultural power, issues of nationalism and of Picasso's national identity were under intense scrutiny by journalists.[2] For some groups, such as the Communists, Picasso's enormous celebrity as an artist, and his credentials as a Resistance supporter, made him a fitting symbol of the ongoing vitality of the French national tradition. Yet, as one scholar has noted, ". . . Picasso's *extraneousness* to the French tradition, and the perception on the part of some critics that his art represented a danger to the essence of western civilization, was never debated with such virulence."[3]

For Picasso, the tension between the French tradition and that of his native country—then under the Fascist regime of Franco and thus for political reasons out of bounds for him—intensified.[4] France provided him with a living connection with the classical Mediterranean heritage, and had been the intellectual milieu that had nourished his maturation as an artist. Yet Spain remained his spiritual ground and a potent storehouse of memories, which asserted themselves forcefully in his later decades. Although Picasso lived all his adult life in France, he never relinquished his Spanish citizenship.

An incident that took place in 1946 suggests Picasso's sense of himself in the postwar years in relation to the art of the past, and of the standards by which he evaluated his achievement. Having agreed to donate some of his paintings to the newly-formed Musée de l'Art Moderne in Paris, Picasso selected a group of twelve works: they included such diverse paintings as *The Milliner's Workshop* of 1926, one of his most

abstract canvases, and his recent *Pitcher, Candle, and Casserole* (1945) in a realist mode.[5] Before the paintings entered the museum, they were held temporarily at the Louvre. Georges Salles, then director of the French national museums, invited Picasso to participate in an "amusing experiment": to come to the Louvre on a Tuesday, when the museum was closed, and set his paintings beside the masterpieces he most admired. Françoise Gilot, the artist's companion, who accompanied him on the "Louvre test," recalled his anxiety prior to the visit.[6] In the museum, Picasso went first to Zurbarán's *St. Bonaventure on His Bier* (c. 1629), and then to works by Velázquez, Murillo, and Goya, directing the guards to place several of his paintings next to them. After studying his work intensely in the company of the masters of Spain's Golden Age, he is reported to have said, as if pacified: "See, they're the same thing. The very same thing."[7] Only after comparing his works with the Spanish painters did Picasso take his paintings to the French masters, placing them next to Delacroix's *Women of Algiers* and *The Death of Sardanapaulus* and Courbet's *Studio* and *Burial at Ornans*.[8] Yet Picasso, who had achieved the status of a universal artist by the end of World War II, continued to resist being defined as either French or Spanish.

Picasso's postwar work is astonishingly varied; it included not only painting, sculpture, and etching, but lithography and even ceramics. In this period, Picasso moved toward the ideal of the "complete" artist, along the lines of the Renaissance type. His variations of this period reveal a similar broadness of interest in the Western European tradition. He drew from French painting of the seventeenth and nineteenth centuries (as he had in the post-World War I period), from Spain's Golden Age, as well as from the art of the German Renaissance. The themes of his sources—mythological and religious subjects, a portrait, and an erotic genre scene—are also diverse, and he translated them into a variety of media, from drawing to lithography to paint on plywood board. Yet all of his sources for his variations of this period, whether French, Spanish, or German, exhibit a close observation of the phenomenal world.

In a visit to Picasso's studio in October 1944, a young Royal Air Force officer and poet surveying his recent work, comprising landscapes around the Ile Saint-Louis, paintings of the tomato plants on his window sill, and portraits of a young boy, commented on the painter's "return to objective reality." Picasso replied: "A more disciplined art, a less constrained freedom, in a time like this, is the artist's only defence and guard; very likely for the poet it is a time to write sonnets."[9] Picasso's return to a realist mode of expression in the mid-forties is an under-

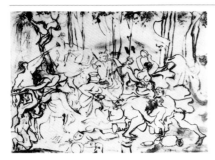

Fig. 4–1 *Pablo Picasso.* Study for the Triumph of Pan, after Poussin. *August 23, 1944. Ink on paper, 12 × 15⅞" (30.5 × 40.5 cm). Location unknown*

standable antidote to years of war and Nazi occupation, and to the extreme distortions of human anatomy that dominated his production of the late thirties and early forties. His use of highly detailed works by past masters whom he admired for their powers of observation, among them Poussin, Cranach, El Greco (in his portraits), and Courbet, may also be understood as a renewal and assertion of his aesthetic position. He remained committed to an art rooted in concrete reality at a time when the two dominant trends were a return to abstraction among younger artists, and social realism, the officially sanctioned style of the Communist party.[10] Neither was compatible with Picasso's aims. The process of transformation through which elements from the world of material things are converted into signs that express symbolic meaning remained central to his artistic program. In the post-war years, Picasso's increased involvement with variation may be seen as a reiteration of his belief in art as a system of notation. It was at this time that Picasso asserted: "Raphael's image of a woman is only a sign. A woman by Raphael is not a woman, it's a sign that in his spirit and ours represents a woman. . . ."[11] Variation served as both an opening onto an expanded territory of artistic expression through historical transformation at a time when his situation in the present was becoming problematic, and as a defensive posture.

Throughout his career Picasso expressed clearly his anti-abstractionist stance. In a statement of 1923, he declared: "And from the point of view of art there are no concrete or abstract forms, but only forms that are more or less convincing lies. That those lies are necessary to our mental selves is beyond any doubt, as it is through them that we form our aesthetic point of view."[12] In his variations, where systems are merged and opposed, Picasso rejects absolutely the possibility of any one "truth," opening up representation to a free play of meaning. As Picasso told Gilot, "What interests me is to make what might be called links, connections over the widest possible distance, the most unexpected link between objects I wish to consider. One must rip and tear reality."[13] In variation, this process operates within the system of representation itself; through his "rips and tears" he generates new meaning.

Study for The Triumph of Pan, *after Poussin, 1944*

Picasso's first interpretation of the postwar period was executed during the very days of the Liberation of France, and commemorates the euphoric event. His fluid drawing in ink of August 23 (fig. 4–1) and painting in watercolor and gouache, executed from the 24th to the 29th of August (fig. 4–2) after Nicolas Poussin's *The Triumph of Pan* (fig. 4–3)[14] signal the onset of a sustained interest in the process of variation, and underline his implicit intentions in his art after art: to liberate the past through the present.

The Liberation of Paris from her Nazi occupiers took place on August 24, 1944. As the Allies approached the Seine, Parisians (provided with arms by the French Forces of the Interior) rose up in street riots against the retreating German troops.[15] Françoise Gilot later wrote of these historic days:

People were already beginning to bring out the cobblestones to build the barricades. Even children were working at the job, especially in the 6th arrondise-

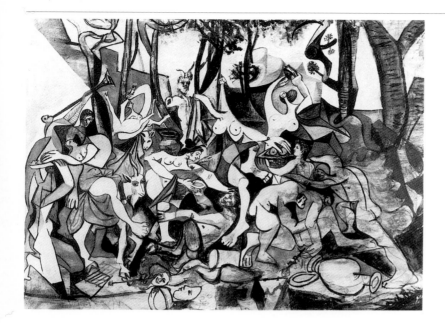

Fig. 4–2 *Pablo Picasso.* The Triumph of Pan, after Poussin. *August 24, 25, 26, 28, 29, 1944. Gouache and watercolor on paper, 12¼ × 16⅛″ (30.5 × 40.5 cm). Location unknown*

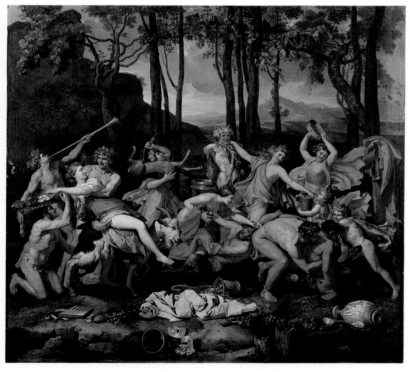

Fig. 4–3 *Nicolas Poussin.* The Triumph of Pan. *1635–36. Oil on canvas, 52¾ × 57⅛″ (136 × 145 cm). Courtesy of the Trustees, The National Gallery, London*

ment where Pablo lived. . . .The last time I talked to Picasso before the Liberation he told me he had been looking out the window that morning and a bullet had passed just a few inches from his head and embedded itself in the wall. He was planning to spend the next few days with his nine-year-old daughter, Maya, and her mother, Marie-Thérèse Walter, who lived in an apartment on Boulevard Henri IV at the eastern end of the Ile Saint-Louis. There was a great deal of fighting in this area and he was concerned for their safety.

Paris was finally liberated a few days later, on the 24th of August. Soon after that, Pablo returned to the Rue des Grands Augustins with two small gouaches

he had painted while he was there from a reproduction of a bacchanalian scene by Poussin. . . .[16]

The Triumph of Pan was one of three bacchanals commissioned in 1635 by Cardinal Richelieu, Prime Minister of France under Louis XIII, to complete the decoration of one of the rooms in the Château de Richelieu.[17] The bacchic revelers, depicted by the quintessential French classical master, served Picasso as the ideal subject on which to project the delirious joy and national pride displayed in the street celebrations in the days following the Liberation. His Poussin variation clearly had significance for Picasso. As Malraux recalled: "[He] would always leave his *Bacchanal* in the studio. . . but never talked about it. Had he meant to test his visitors? Heirless, alone among the controlled still lifes, facing the ironic bicycle seat with handlebars, it seemed like a subtle and secret game."[18]

In the early 1920s, Picasso had drawn from some of Poussin's austere mythological and religious works: the three figures to the left from *Eliezer and Rebecca* (fig. 4–4) have been cited as a possible source for Picasso's *Three Women at the Spring* (fig. 4–5), while Poussin's *Echo and Narcissus* (fig. 4–6) may have inspired Picasso's *Family Scene* (fig. 4–7).[19] In 1944, however, Picasso turned to a more exuberant Baroque phase of his work. Although the bacchanals are considered among Poussin's most carefully constructed works, their decorativeness and lightness of spirit are unusual.[20]

The Triumph of Pan is an almost square canvas, only slightly longer than it is tall. Spread out across the surface in a friezelike composition is a group of high-spirited bacchantes, satyrs, and nymphs dancing, embracing, chasing each other, falling down drunk, riding on animals or carrying them, and blowing long hunting horns. Behind the swirling figures a thin row of dark trees partially shields an Arcadian landscape, which opens out into the distance. At the center of the composition stands a herm, a static focal point around which the group turns. With arms outstretched diagonally, a beautiful bacchante at the right of the herm strews flowers around it. The food, wine, masks, pipes, and musical instruments in the foreground indicate that a bacchanalian rite is in full swing, although scholars have debated whether the herm represents Pan or Priapus.[21] The dynamism of the composition is underscored by the use of strong color: bright blues, reds, and oranges predominate.

In his drawing of August 23, Picasso alters the format of the original by choosing a longer, more horizontal rectangle for his support. He seizes directly on "the mood of nervous sexual energy and erotic freedom"[22] in the original and exaggerates it to the point of parody. Picasso deconstructs Poussin's unifying structure in which the figures are contained "in two triangles subsumed under a larger one,"[23] and sets the figures free in a unified field, bringing the action closer to the viewer, and converting mass to outline. He freely distorts the harmonious proportions of the bodies, increasing the girth of an arm and length of a leg, the size of a breast, while shrinking other parts. This drawing is almost a demonstration of Picasso's remarks on Poussin to Gilot: "I am in complete disagreement with Cézanne's idea about making over Poussin in accordance with nature. In order to work that way I'd have to choose in nature those branches of a tree that would fit into a painting the way Poussin might have conceived it. But I don't choose anything. I take

Fig. 4–4 *Nicolas Poussin.* Eliezer and Rebecca. *1648. Oil on canvas, 46½ × 77⅝" (118 × 197 cm). Musée du Louvre, Paris*

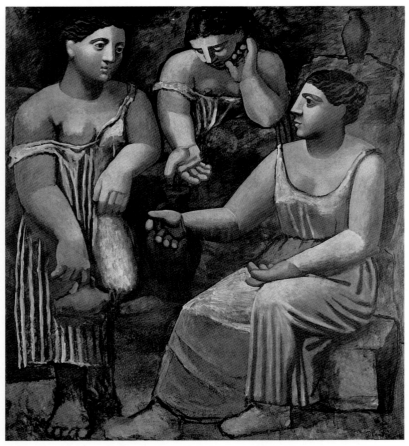

Fig. 4–5 *Pablo Picasso.* Three Women at the Spring. *Fontainebleau, summer 1921. Oil on canvas, 6'8¼" × 5'8½" (203.9 × 174 cm). The Museum of Modern Art, New York. Gift of Mr. and Mrs. Allan D. Emil*

what comes. My trees aren't made up of structures I have chosen but structures chance and my own dynamism impose on me."[24]

While departing freely from his source in both figure style and composition, Picasso is faithful to the details of the work. Comparing Rubens to Poussin, Picasso expressed his admiration for the latter's powers of observation and description: "Nothing is described in Rubens. It's simply journalism or historical films. Look at Poussin, when he

Fig. 4–6 *Nicolas Poussin.* Echo and Narcissus (Echo et Narcisse, ou La Mort de Narcisse) *c. 1660. Oil on canvas, 29⅛ × 39⅜″ (74 × 100 cm). Musée du Louvre, Paris*

Fig. 4–7 *Pablo Picasso.* Family Scene (Famille au bord de la mer). *Dinard, summer 1922. Oil on wood, 7 × 8″ (17.6 × 20.2 cm). Musée Picasso, Paris*

paints Orpheus, well, it's described. Everything, even the tiniest leaf tells the story. Whereas with Rubens. . . . Everything is the same."[25]

The next day, Picasso began a painting in watercolor and gouache after the bacchanal, continuing to work on it for the next several days after returning to his studio on the rue des Grands Augustins. Form is now manipulated into distinctly modern, flattened, biomorphic shapes and submitted to a loose Cubist grid in low, relieflike space. Poussin's stable compositional structure and clear division of figure and landscape setting are subsumed into Picasso's continuum of form and space in which human, beast, and nature are integrated. Yet Picasso's trans-

formation draws on the essential structure of his predecessor's work of this period in which "abstract form and closely integrated surface design are even more self-consciously developed."[26]

Picasso counters Poussin, however, in the distortions of the figures. "It is not at all that I hold to a rational conception of art. I have nothing in common with a man like Poussin," Picasso asserted to Gilot,[27] a statement that is borne out here. Poussin's graceful garlanding woman, for example, becomes a biomorphic-Cubist parody of her former self: a leg, hidden in the original emerges from the fray in elongated form, barely attached to her body, while her bent left leg becomes an enormous foot. Her tiny square head soars above a long phallic neck, rising from inflated breasts.[28] Picasso extends the principle of rupture and fragmentation from form to one of the most fundamental tenets of classical representation, that of the unity of style within a single work of art. He inserts caricatural heads into the composition: the young boy who holds a basket of apples (replacing the flowers of the original) and the hair-pulling woman at the left, which look specific enough to have been based on figures from life. Through this juxtaposition of realistic and abstract biomorphic modes brought together in a shallow Cubist space in a painting based on Poussin, Picasso asserts both his ongoing connection with the classical tradition and his fidelity to his Cubist principles which violate and yet uphold that tradition through inversion. The importance of the work for Picasso is borne out by the fact that it initiated a new direction in his use of classical themes, which he had previously treated in a naturalistic idiom. Here, as Douglas Cooper notes, "for the first time he applied to a classical subject the full resonances of the more expressionist idiom he had been elaborating since *Guernica*, and from this point on Picasso has treated classical subjects in both idioms concurrently."[29]

In Picasso's interpretation, the woman with the tambourine presides over the group, promoted from a secondary position in the Poussin. The greater prominence that Picasso accords her in his bacchanal is understandable from the perspective of his later works: she is a surrogate for his new love, Françoise Gilot. The anatomical formula that Picasso uses for her here—a small head with swinging brown hair, a long neck, large breasts, and a small waist—had already been established in earlier representations.[30] The symbolic persona of a dancing bacchante that Picasso assigns to Françoise here is repeated in later works: the *Bacchanal*, in fact, has been cited as an antecedent of his *Joy of Life* (1946) (fig. 4–8), the major painting of his Antibes period two years later.[31] Is the goat (lust personified) then a symbolic self-portrait? The goat's right eye, hidden in the original, is now on a level with the bared buttocks of the hair-pulling nymph, which was draped in the original. A recurrent subject in Picasso's art as a symbol of sexuality, the goat's head is turned from a profile view in the original to a more frontal one to look out wryly at the viewer.

In redoing *The Triumph of Pan* in a modern style, Picasso both competes and identifies with Poussin, whose mythological scene is itself based on an earlier work by Giulio Romano, which had provided the French master with "an irresistible challenge to emulate the physical exuberance of the art of the antique and also of the Italian High Renaissance."[32] Picasso thus compresses not only multiple styles but layers of history and national schools in his new creation.

Yet Picasso's rivalry with Poussin is surely underscored by another

more pressing one: the bacchanalian theme is strongly associated with Matisse, and before him, Ingres. What is more, Gilot, a painter herself, greatly admired Matisse's art, and, in fact, strongly resembled the female type found frequently in his work. A year after the Liberation, when visiting an exhibition at the Musée de l'Art Moderne with Françoise, Picasso commented on the strong likeness of the model in Matisse's *Girl Reading* (1944) to her, saying, "Can my old friend have such a far-reaching vision that it enables him to paint a face that only exists in my dreams as yet? He already has the answers while I am simply brooding about what should be done with your features."[33] Picasso could not have been unaware of Françoise's "Matissean" beauty before this. By placing his new love in a bacchanal, Picasso competes with Matisse for the position of heir to the French Mediterranean tradition, while flaunting his undiminished sexual prowess and "triumph" in winning Françoise. As an intermediary in his rivalry with Matisse, Poussin was an ingenious choice, for he could serve Picasso in more than one way. As one schol-

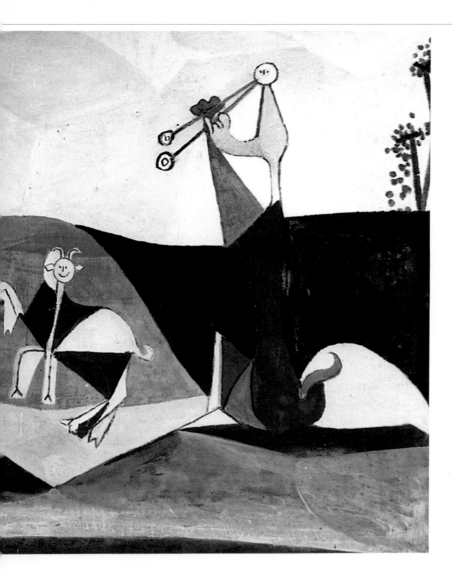

Fig. 4–8 *Pablo Picasso.* Joy of Life (Joie de Vivre, Pastorale). *Antibes, autumn 1946. Oil on board, 47¼ × 98½" (120 × 250 cm). Musée Picasso, Antibes*

ar has noted, the seventeenth-century master's situation in his own time was analogous to Picasso's in the twentieth century: though Poussin set the standards of excellence for his age, his art cannot be considered French, as it was developed in Italy.[34] "The Spaniard Picasso, all his mature life a resident of France, is a modern parallel. Neither artist can be typed by nationality. Each was a leader in the art of his time while remaining independent and autonomous."[35]

Was Picasso, thus, conscripting Poussin into his competition with Matisse in which he asserted his preeminence not only as master in the *grande tradition française*, but also as a universal artist, unclassifiable by national school? This may well be the clue to the "subtle and secret game" of his *Triumph of Pan*. In this multilayered work he brings together generations of artists and pagan rites with public euphoria; he also celebrates his new love, as well as the notion of liberation and renewal that is central to the process of variation, while equating artistic with erotic freedom.

The Cranach Variations, 1942–1949

In the thirties, forties and fifties, Picasso turned occasionally in his variations to the German masters of the Renaissance. As we have seen, Grünewald's *Crucifixion* was the inspiration for a suite of drawings in 1932, and in 1951 and 1953 respectively, he did drawings (essentially free copies) after paintings of religious subject matter by Meister Francke and Altdorfer.[36] It was to the work of Lucas Cranach the Elder (1472–1553), however, and, on one occasion, his son, Lucas Cranach the Younger (1515–1586), that Picasso turned most frequently, and over the longest period of time. In Picasso's return to a more disciplined art in the postwar years, Cranach's elaborately detailed images provided a challenge to his powers of observation and invention.

Lucas Cranach the Elder enjoyed great popularity as court painter to three different electors of Saxony in the town of Wittenberg.[37] Though his subjects included mythological and Biblical scenes, as well as contemporary court portraits, he is chiefly remembered for his coquettish female nudes of oddly elongated proportions, smooth "boneless" bodies, and small heads, whose heavy chain necklaces and bracelets, large hats and gauze veils set off their nakedness.

In order to keep up with the large demand on his workshop for paintings, engravings, and woodcuts, Cranach provided models and original designs for his assistants to carry out in different variations.[38] As demand increased in later years, there is a notable shift to a more linear and mannered idiom adaptable to the purposes of reproduction and variation. It was mainly to these later works that Picasso resorted in his interpretations, presumably attracted, like other twentieth-century artists, not only to the anatomical departures and cold eroticism of the elder Cranach's work, but also to its naive qualities. As Friedlander and Rosenberg note, Cranach was ". . . never really to absorb the Renaissance goal of monumentality and his human figures often lapse into a certain uncouthness, as though unable to shake off his humble origins. . . ."[39] For Picasso this naiveté or awkwardness, which he also appreciated in the work of the Le Nain brothers, was a sign of authenticity of expression, and would have contributed greatly to Cranach's appeal. A photograph of Picasso's studio at the villa La Galloise in Vallauris (where he moved with Françoise in the summer of 1948) shows a reproduction of a portrait of a woman by Cranach tacked on the wall between two paintings by Le Douanier Rousseau, suggesting, as Klaus Gallwitz notes, that Picasso saw the elegant court painter of Wittenberg essentially as a naif.[40]

Picasso was not the first twentieth-century artist to come under the spell of Cranach.[41] The German Expressionists, early champions of Grünewald as well, admired Cranach's antinaturalism and his "primitivism," as expressed in the blatant and bizarre sexuality of his work; the old master served as an exemplar of the Ur-German tradition that they sought to revitalize.[42] Cranach had also found favor among the Surrealists. In an article of 1936 in *Minotaure*, the critic Maurice Raynal described the Cranachs (father and son) as deeply instinctual artists who retained the spirit of antiquity and mythology without its academic aspects. Cranach, Raynal wrote, "gave reign to his profound desire to experiment with a reality that was ferociously personal. . . ." Raynal also called attention to the metamorphic nature of Cranach's imagery,

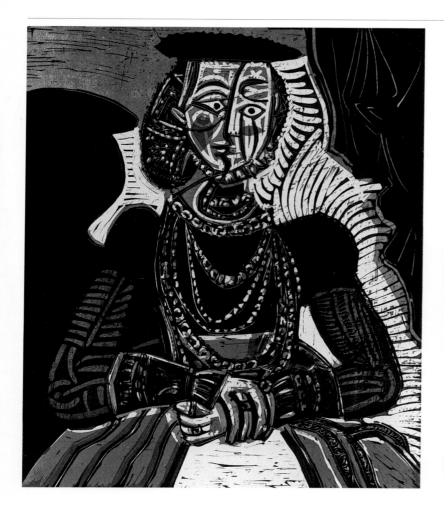

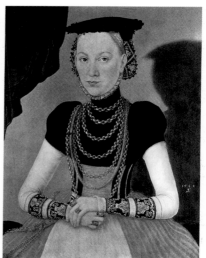

Fig. 4–9 *Pablo Picasso*. Portrait of a Noblewoman. *July 1958. Linoleum cut, 29⅝ × 21" (65 × 53.5 cm). Galerie Louise Leiris, Paris*

Fig. 4–10 *Lucas Cranach the Younger.* Portrait of a Noblewoman. *1564. Oil on linden wood. 32⅝ × 25¼" (83 × 64 cm). Kunsthistorisches Museum, Vienna*

observing that "the branches of trees and the folds of material proceed in a manner of plants . . . a sense of growth that resembles spontaneous generation . . . energy, instinct, lyricism and audacity."[43] Among Picasso's contemporaries, Duchamp, Braque, Klee, and Giacometti also expressed interest in the elder Cranach.[44]

Picasso's involvement with Cranach the Elder was shared with members of his immediate circle as well. In 1950, Christian Zervos published a book on Cranach's nudes, which would have been in preparation while Picasso was executing his lithographs of the late forties after the German master.[45]

Yet, in the highly politicized and acrimonious cultural debate concerning national identity and passionate anti-German sentiment in the years following the war in France, Picasso's dialogue with Cranach raises more questions than it answers. Was he asserting his independence from issues of nationalism by demonstrating the universality of his art, which could encompass even the "other" or "barbarian" tradition? Or was he coming to terms with his recent experience of living under enemy occupation by appropriating a work by a German artist, one, in fact, prized by Nazi leaders? As was revealed after the war, Hermann Goering had "made a specialty of collecting Cranachs."[46] Or, does another figure shadow his collaboration with Cranach? A likely possibility is

Daniel-Henry Kahnweiler, his dealer during his Cubist period and life-long friend, with whom he had a close but adversarial relationship. After a stormy period in the mid-forties, during which the artist tormented his old dealer by playing him against several others competing for his paintings, Kahnweiler triumphed over his rivals, and, in 1947, obtained exclusive rights to all of Picasso's art.[47] It was Kahnweiler who had given Picasso the reproductions of Cranach's work on which his interpretations were based, and even when he was excluded from the market for Picasso's paintings, he continued to sell the artist's lithographic work in the postwar years. Perhaps the Cranach variations mark, on one level, a renewal of Picasso's partnership with his German dealer. As with all of his variations, however, these, too, undoubtedly accommodate multiple and even contradictory drives.

In 1942, while under Nazi occupation, Picasso executed his first work after Lucas Cranach the Elder, a drawing after a work of an unusual mythological subject, *Venus and Cupid as a Honey Thief*.[48] He returned to the theme in an oil painting of 1957, in which he subjected his source to ferocious distortion.[49] In 1958, he produced his well-known lino-cut after another Cranach—this time the younger's—*Portrait of a Noblewoman* of 1564 (fig. 4–9 and 4–10).[50] His most intensive period of interest in Cranach, however, was from 1947–49, while he was engaged primarily in lithography. During those two years Picasso carried three paintings by the elder Cranach through multiple lithographic states, his first variations in the graphic medium. In 1949, he executed lithographs after Cranach's *Venus and Cupid* of c. 1530 (figs. 4–11 and 4–12) (as well as aquatints), and a color lithograph after *Princess Sibylle of Cleves as a Bride* of 1526. Picasso's most significant variations after Cranach, however, are the large black-and-white lithographs of 1947–49 after *David and Bathsheba* (1526) (fig. 4–13).[51]

Lithographs after David and Bathsheba *by Cranach the Elder, 1947–1949*

Although Picasso had used lithography occasionally before World War II, his graphic work up to this point had been chiefly etchings, acquatints, and drypoints. In 1945, however, Picasso returned to lithography with an all-consuming passion; over the next seven years he worked steadily in the atelier of the master printer, Fernand Mourlot.[52] The collaborative nature of printmaking would have appealed deeply to Picasso, since it allowed him to extend the dialogue with a past artist into a yet more complex three-way conversation that included his new partner, Mourlot. Picasso quickly mastered the many established techniques of lithography and introduced unorthodox methods of his own.[53] Together, artist and printer brought the art of lithography to new levels of achievement. The highly flexible medium of lithography, furthermore, provided Picasso with a window onto his working process: it offered the opportunity to "completely rework an image on the same printing surface . . . and thus prints . . . which exist in several states and combinations exhibit the complete evolution of a composition."[54] Printmaking offered a new way to extend the variation process.

Picasso's variations after *David and Bathsheba* were executed after a black-and-white reproduction in the catalogue of the 1937 Cranach exhibition in Berlin, which Kahnweiler had given him.[55] The original, housed in the Gemäldegalerie, Berlin-Dahlem, is a small oil painting on wood,

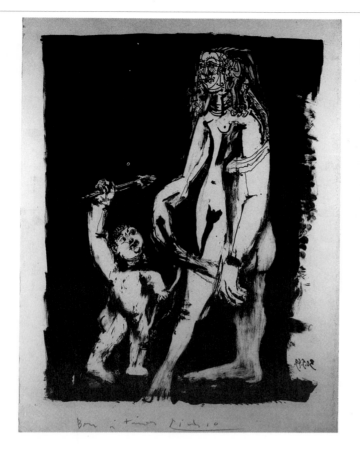

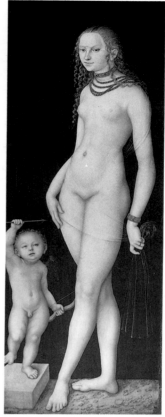

measuring only 14½ by 9½ inches. Picasso chose an upright format similar in proportion to the Cranach, but his variations are nearly twice the size of their source.[56]

Cranach depicts David's first sight of Bathsheba as described in 2 Samuel 11: "It happened, late one afternoon when David arose from his couch and was walking upon the roof of the King's house that he saw a woman bathing; and that woman was very beautiful." Seated in a grove outside the palace, Bathsheba is attired in the fashionable court dress of sixteenth-century Germany. Attended by three ladies-in-waiting, she extends a bare foot to be washed in a stream by a maidservant, while David and three male attendants look down on her from a parapet. This fateful moment set off a chain of tragic events—David's taking Bathsheba as his mistress, impregnating her, and arranging for her husband to be killed in battle—which ultimately brought about the end of his reign.[57]

In the small format of the panel, the lower group fits into an upright rectangle: Bathsheba is bounded on either side by columnar ladies-in-waiting and above by the upper edge of the wall molding. The rectangle is bisected by a strong diagonal line that begins in the head of the lady-in-waiting to the right and descends along the hat of Bathsheba through her extended leg to the stooping servant. Although only the upper parts of the men's bodies can be seen, their active and varied postures counteract the static arrangement of the women below.

The linear character of the work, its profuse detail, and the sense of

arrested forces moving toward a final state made the painting ideally suited to translation into a graphic medium, in which its sense of evolution could be carried on in new directions. In addition, the work's erotic tension and the subject of voyeurism, so central to Picasso's work as a whole and intrinsic to all his variations, would have drawn him to this painting.[58]

State 1 David and Bathsheba, after Cranach, *March 30, 1947*

Not bothering to reverse the image so that it would appear in the print as it is in the painting, Picasso laid out the composition on his zinc plate in a loose, cursive manner (fig. 4–14).[59] As in his first drawing after Grünewald, and sketch after Poussin's *Triumph of Pan*, here too he converts the solidity of the figures into line, which he freely distorts, and carries further the naive perspective of Cranach's jutting wall. The most significant changes, however, are in the composition. With the image reversed, Picasso must redistribute the weight of the original so that it makes both formal and dramatic sense. His solution is to bring the male and female protagonists into a more direct relationship; thus Bathsheba is more centralized and confined by her ladies-in-waiting, while David is larger and closer, bearing down on her more oppressively.[60] Rudolf Arn-

Fig. 4–13 *Lucas Cranach the Elder. David and Bathsheba. 1526. Oil on copper beech wood, 14⅛ × 9½″ (36 × 24 cm). Staatliche Museen zu Berlin—Preussischer Kulturbesitz: Kupferstich-Kabinett*

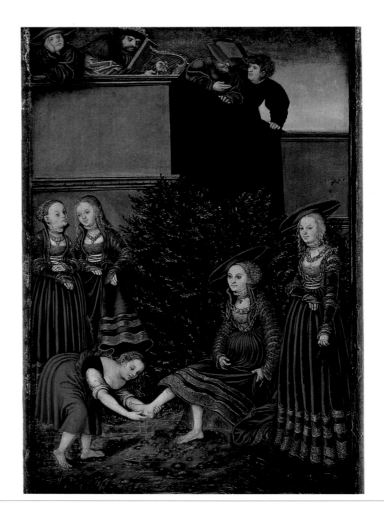

heim has noted of Cranach's composition that "In keeping with the vertical format of this picture, the action is not an interplay between equals, but an imposition of power from above upon the victim below."[61] Picasso seizes on this element and develops it throughout the states; like David's illicit glance from his parapet, his critical intervention into Cranach's work is likewise an "imposition of power."

State 2 David and Bathsheba, *March 30, 1947*

Having laid out the main lines of the composition in the first state, Picasso now fills in and articulates forms, focusing on the richness of the surface design (fig. 4–15). Using pen and scraper, he searches for equivalents in fine linear patterns for the varied textures of leaves and grasses, velvet, embroidery, metal chains, and coils of hair, both to differentiate them and to enliven the surface of the image.

State 3 David and Bathsheba, *March 30, 1947*

While the second state is essentially a refinement of the first, the third (fig. 4–16), executed the same day, moves in a new direction. Picasso reverses figure and ground, and subjects the headgear of Bathsheba and

Fig. 4–14 *Pablo Picasso.* David and Bathsheba, after Cranach. *March 30, 1947. Lithograph, State 1, 25⅝ × 19¼" (65.1 × 49 cm). The Museum of Modern Art, New York. Mrs. Bertram Smith Fund*

the handmaiden to the left to playful metamorphosis: their hats expand into large ellipses and merge with the foliage of the trees or shrubs behind the women. Leaves sprout as well from the sides of the dresses of two framing female figures. The heads of the female figures shrink into small disks, making the disparity between the size of their heads and those of the men above more marked.

State 4 David and Bathsheba, *March 30, 1947*

The reversal of figure and ground begun in the previous state is fully realized here, a change that required a complete re-inking and redrawing with the scraper (fig. 4–17).[62] The ground is now a continuous velvety black, while the figures are represented in a delicate web of white outlines, set off against the finely striated planes of the wall. Cranach's columnar, plastic figures now seem completely dematerialized. Yet Picasso's bodiless forms also draw on and exaggerate an aspect of the source. Of Cranach's late work, one scholar notes: "The picture space is more or less conspicuously divided up usually by curved outlines, into

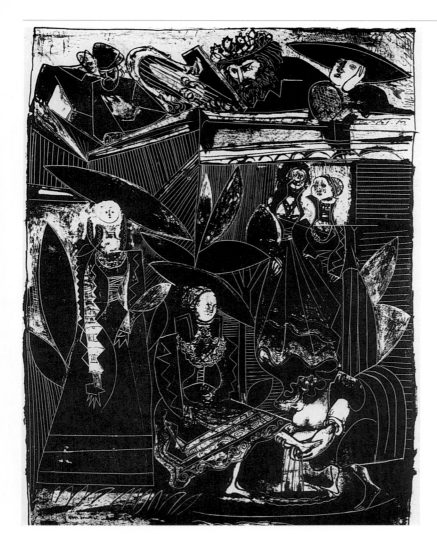

Fig. 4–16 *Pablo Picasso.* David and Bathsheba, after Cranach. *March 30, 1947. Lithograph, State 3, 25⅞ × 19¼" (65.7 × 49 cm). Musée Picasso, Paris*

distinct groupings of planes."[63] Picasso thus retains Cranach's structural system, transposed into a pure linear idiom.

Bathsheba's vegetal headdress, which stands out more prominently here, equates her with the *"Femme-Fleur,"* or "Woman-Flower" (fig. 4–18), the metamorphic persona Picasso had invented a year earlier for Gilot, who becomes the object of David's (and Picasso's) lustful gaze.[64] ("You're like a growing plant. I'd been wondering how I'd get across the idea that you belong to the vegetable kingdom rather than the animal . . ." Picasso told Gilot at the time of painting the *Femme-Fleur.*[65]) While the attending women have taken on an automatonlike similarity in this version, the men become more individualized and emotionally expressive. The attendant to the far right, wearing an elliptical hat similar to that of the women below, is wrapped in his (or her) thoughts, oblivious to the drama unfolding below. This feminized male (if such he is) provides a foil to the virile, gazing king with his classical features, who recalls Picasso's meditative, bearded sculptors from his well-known suite of etchings, the *Suite Vollard*, while his lyre is now more like a palette.[66] Thus, the Biblical story is absorbed into the more gener-

alized theme of artist and model through the common element of voyeurism. Here Picasso achieves a balance of forces between the active heads and torsos of the men in the upper register, and the elongated bodies of the women below, which occupy most of the picture space.

State 5 David and Bathsheba, *March 30, 1947*

Working with the scraper Picasso highlights the faces of certain key figures—the king, Bathsheba and her ladies-in-waiting on either side (fig. 4–19).[67] The momentary balance of the previous state is disrupted here. He redraws the features of the pensive, refined king of the previous state, transforming him into a leering voyeur, the halo of white light behind him propelling him forward from his parapet across the balustrade. Following his glance, we discover the target of his lecherous interest is not the demure Bathsheba, but her stooping servant with bared bosom.[68] This diverted glance recalls Picasso's comments to a friend several years later about Rembrandt's *Bathsheba* in the Louvre (fig. 4–20): "Look at Rembrandt, he intends to paint Bathsheba, but it is

the posing servant that interests him much more—and it is her portrait he paints."[69] As we have seen in many of his previous variations, Picasso most commonly enters into the narrative of the original work through the relation of the observer and observed, converting it into material of his own. King David's fateful glance, which carries with it a sense of prescience, is reduced to a momentary opportunity seized, transforming the Biblical story to a lighthearted farce about the foibles of an old man, who is undoubtedly Picasso himself.[70] With this state, Picasso concluded the day's work.

State 6 David and Bathsheba, *March 30, 1948*

A year later to the day, Picasso took up the plate again, executing one more state (fig. 4–21).[71] The changes are slight. According to Mourlot, the plate had hardened, and could not be properly re-inked without obliterating the fine lines; consequently, Picasso transferred the image from zinc to lithographic stone.[72]

Fig. 4–19 *Pablo Picasso*. David and Bathsheba, after Cranach. *March 30, 1947. Lithograph, State 5, 25½ × 19¼" (64.8 × 49 cm). Musée Picasso, Paris*

Fig. 4–20 *Rembrandt van Rijn*. Bathsheba. *1654. Oil on canvas, 56 × 56" (142 × 142 cm). Musée du Louvre, Paris*

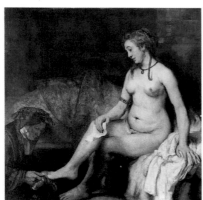

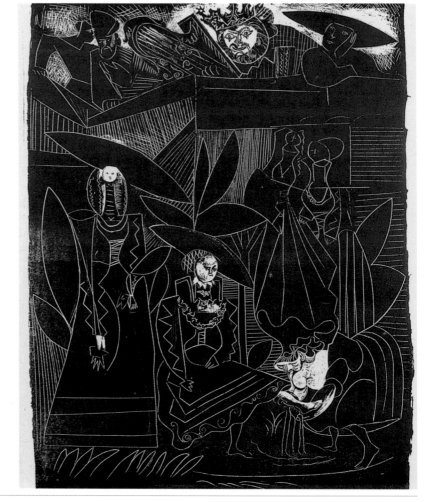

States 7 *and* 8 David and Bathsheba, *March 6 and April 10, 1949*

It was in March again, two years after his first variations on this theme, that Picasso returned to the lithographs (figs. 4–22 and 4–23).[73]

The changes are minor in these states. Picasso experiments with the composition, scraping away the face of one of the pair of women in the background, giving her a comical, bug-eyed look. These states appear to be something of a holding pattern in which Picasso reacquaints himself with the work.

State 9 David and Bathsheba, *April 12, 1949*

Two days later a complete change occurs (fig. 4–24).[74] According to Mourlot: "Picasso . . . removed everything, probably with petrol, but the engraving has left the drawing visible, in grooves, and he has redrawn with pen on the zinc."[75] Picasso sets off afresh in black outlines on a white ground. The heroine's hat becomes even more vegetal (as does the

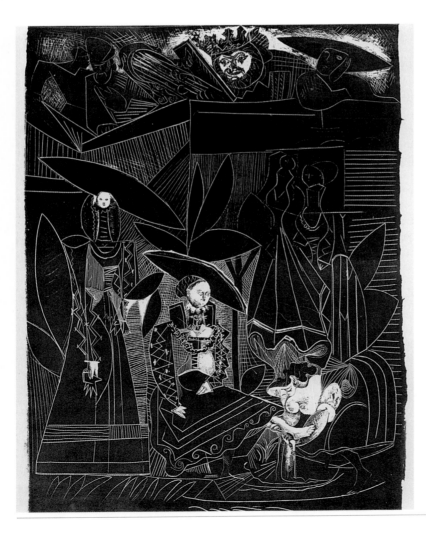

Fig. 4–21 *Pablo Picasso.* David and Bathsheba, after Cranach. *March 30, 1948. Lithograph, State 6, 25½ × 19¼" (64.8 × 49 cm). Musée Picasso, Paris*

Above, left:

Fig. 4–22 *Pablo Picasso.* David and Bathsheba, after Cranach. *March 6, 1949. Lithograph, State 7, 25½ × 19¼" (64.8 × 49 cm). Musée Picasso, Paris*

Above, right:

Fig. 4–23 *Pablo Picasso.* David and Bathsheba, after Cranach. *April 10, 1949. Lithograph, State 8, 25½ × 19¼" (64.8 × 49 cm). Musée Picasso, Paris*

king's) with the leaves sprouting little balls around the edges, a pattern used to decorate the foliage in other areas as well. David undergoes yet another transformation; he is now a fat old man with a wrinkled face, but with the same leering expression. This third incarnation of David recalls another figure from the *Suite Vollard*, the lecherous old Rembrandt peering in at a nude model through the window, or standing in the room with her, holding her hand (fig. 4–25).[76] But whether the figure on the parapet is King David, Rembrandt, or Picasso, or a combination of them all, these variations anticipate the theme of an old man hankering after a beautiful young woman (usually an artist and model), which appears frequently in the artist's last decades.[77] Picasso seems to be poking fun at himself in his relationship with the youthful Françoise, as if acknowledging that "he knew that in the Spanish tradition his old friends were mocking him as a *vejançon*—a ludicrous old graybeard."[78] In this state Picasso draws out another character, the courtier to David's right with the wistful expression. In the earlier states the courtier had metamorphosed into a more androgynous being; here, however, he becomes yet more feminine with a profile inscribed on a frontal face. If the King David/Rembrandt figure can be seen as a surrogate for Picasso, and Bathsheba for Françoise, his "femme-fleur," perhaps the "dreamer" can be interpreted as Dora Maar, whom he left for Françoise. The pure oval face and melancholic expression recall her.[79] Here, as in all his variations, formal metamorphoses are intertwined with thematic play, as material from Picasso's art and life imprints itself on the other artist's work, carrying it in new directions.

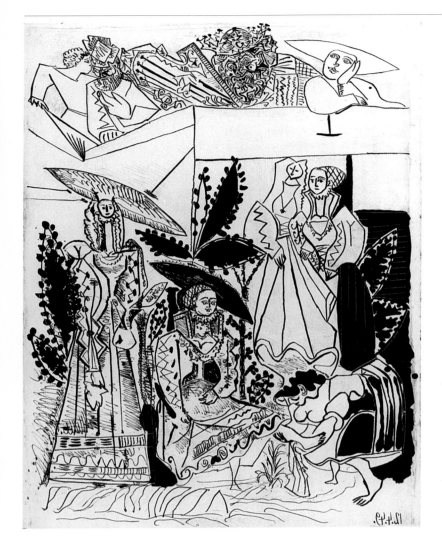

Fig. 4–24 *Pablo Picasso.* David and Bathsheba, after Cranach. *April 12, 1949. Lithograph, State 9, 25½ × 19¼" (64.8 × 49 cm). Musée Picasso, Paris*

Fig. 4–25 *Pablo Picasso.* Two Nudes and Portrait of Rembrandt *(part of the* Vollard *suite). January 31, 1934. Etching, 10⅞ × 7¾" (28 × 20 cm). Musée Picasso, Paris*

State 10 David and Bathsheba, *April 17, 1949*

The only significant change here is a slight enlargement of the composition to the edges of the zinc (fig. 4–26).[80] Picasso has filled in the empty contour lines of his female figures once again with black ink, leaving the upper register untouched.

State 1 David and Bathsheba, *May 29, 1949*

It was perhaps because of the unresolved nature of the tenth state that Picasso turned back to the lithographic stone on which he had transferred the image in the sixth state on March 30, 1948, to carry out one more version (fig. 4–27).[81] Slightly more volume is admitted and the surface has become more ornamental and lush. The king, going back to the first type, is less caricatural. Here Picasso achieves a resolution of the various impulses that guided him through his first six states—the vitality of the first two states, the order and abstraction of the fourth and fifth, and the rich surface ornamentation of the sixth, which he now develops further into an animated field of forces. One recalls here Raynal's obser-

vations on Cranach's style in his article of 1936: "The branches of trees and the folds of material proceed in the manner of plants . . . a sense of growth that resembles spontaneous generation . . . energy, instinct, lyricism and audacity."[82]

Throughout the states of Picasso's variation on *David and Bathsheba*, various levels of meaning are brought together in the theme of voy-

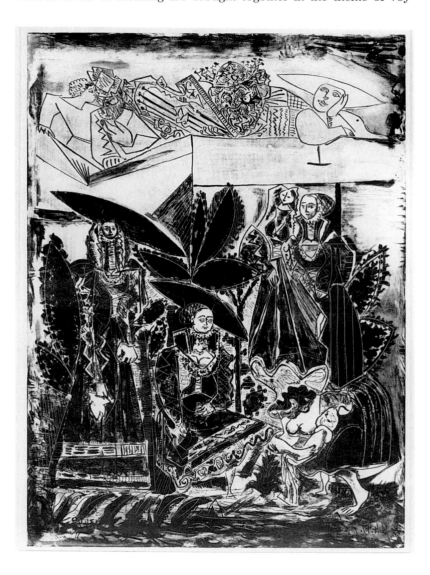

Fig. 4–26 *Pablo Picasso.* David and Bathsheba, after Cranach. *April 17, 1949. Lithograph, State 10, 27½ × 19¾" (70 × 50 cm). Musée Picasso, Paris*

eurism. The looking theme in the Biblical story metamorphoses into a more general meditation on the artist and model, and his relationship to his "femme-fleur." To Gilot's eternal youth, he plays the aged king or the old Rembrandt—or simply an old graybeard—while taking a sidelong glance at her serving girl (perhaps a reference to their beautiful Spanish maid, Inès).

The medium of lithography itself underscores the notion of illicit looking implicit in the Biblical theme. Picasso once described printmaking as a form of voyeurism, because the image does not immediately reveal itself, as in painting, but has to be peeled back and lifted off the press to

be seen; painting, on the other hand, was for him "really making love."[83] Thus, the medium in which Picasso chose to interpret Cranach's painting is integral, not incidental, to the meaning of the variation. It might also be remembered that lithography was a German invention of the not very distant past.[84] The strong cohesion between the subject and style of the Cranach painting and the medium in which he interpreted it, carried

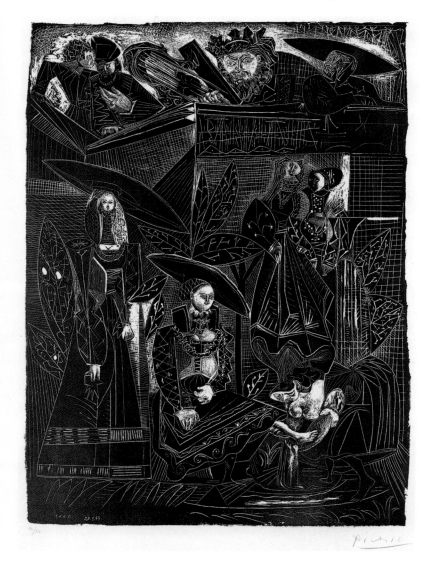

Fig. 4–27 *Pablo Picasso.* David and Bathsheba, after Cranach. *May 29, 1949. Lithograph, State 1, 25¹¹⁄₁₆ × 18⅞" (65.3 × 48.1 cm). The Museum of Modern Art, New York. Curt Valentin Bequest*

Picasso though multiple states and absorbed him on and off for over two years, deepening his forays into making art after art.

Young Ladies on the Banks of the Seine, after Courbet, *1950*

Picasso had not produced a variation in oil since his 1917 painting after Louis Le Nain. With two paintings executed within weeks of each other after works by Courbet and El Greco in oil on plywood—a medium with which he was experimenting at the time—Picasso launches the major

period of his art after art.[85] Both of these variations are connected with artists who played a significant role in Picasso's development and thus inaugurate a return to his beginnings. They are preludes to his large painted cycles of the fifties.

Apollinaire had written in *Les peintres cubistes* (1913) that "Courbet is the father of the new painters." Similarly, Gleizes and Metzinger stated in *Du cubisme* (1912) that "to estimate the significance of Cubism, we must go back to Gustave Courbet . . . he inaugurated a realistic impulse, which runs through all our modern efforts."[86] In his "Realist Doctrine," Gustave Courbet (1819–1877) called for the expansion of the realm of acceptable subject matter in art to include everyday life and ordinary persons, while emphasizing the concrete and material nature of painting.[87] The Realist master insisted that art "only consist of the representation of real and existing things," and that "an object that is abstract is not within the realm of painting."[88] Central to the beliefs of both Courbet and Picasso and fellow Cubists is that art is founded in concrete experience.

Picasso's anti-abstraction stance and the postwar polemics of nationalism were undoubtedly strong factors in reviving his interest in the nineteenth-century Realist master at this time. In his Louvre visit of 1946, Picasso asked to have his paintings placed next to Courbet's *Studio* and *Burial at Ornans*, after comparing them with those of the Spanish masters and Delacroix.[89] Some of his depictions of Françoise with their two children of the early fifties (fig. 4–28) recall Courbet's magnificent *Portrait of Pierre-Joseph Proud'hon and His Children* (fig. 4–29). But a more immediate reason for Picasso's renewed interest in Courbet was undoubtedly Picasso's involvement with politics.[90] Courbet was hailed by the *Partie Communiste Française* at the time as a "champion of revolutionary realism."[91] Picasso's participation in Party activities, and his preoccupation with political subjects in the postwar period, would undoubtedly have revived his interest in Courbet, who had been active in the Commune of 1851. The Realist master thus provided a formidable example of the rare combination of a politically engaged artist and an innovator. Yet, as one critic notes, while both artists were founders of the revolutionary movements of their times and became involved with political affairs, the real struggle for both was in painting. [92]

It was not to one of the master's overtly political works that Picasso turned in his variation, but one that was revolutionary in its provocative and ambiguous subject matter, audacious formal means, and exuberant celebration of the materiality of paint on canvas. Picasso would have been long familiar with *Young Ladies on the Banks of the Seine* (fig. 4–30), housed, since 1906, in the Musée du Petit Palais in Paris. His selection of this icon of modern art in the politicized climate of the postwar years may well have been to reaffirm the forward-looking aspects of Courbet. As one scholar notes, "Courbet was being drawn toward his past, and not toward the future announced by compositions which contravened anecdote."[93] Courbet's provocative portrayal of two women lounging *en déshabillé* on a riverbank in broad daylight aroused the ire of the public and critics when the painting was exhibited at the Salon of 1857. In his *Déjeuner sur l'herbe* of 1863, Manet, while drawing overtly from other sources, paid homage to this early modern masterpiece, developing the theme in a yet more scandalous direction by undressing the women and adding two male companions.

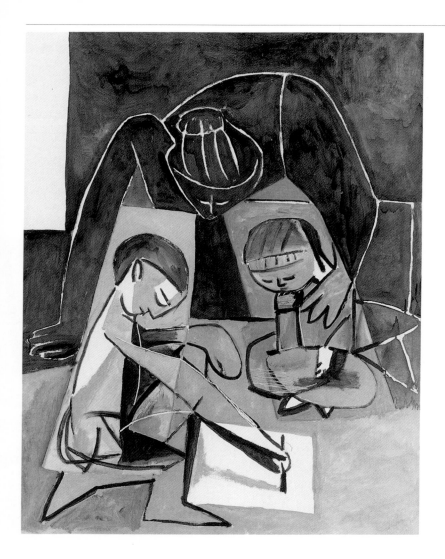

Fig. 4–30 *Gustave Courbet.* Young Ladies on the Banks of the Seine (Les Demoiselles des bords de la Seine). *Salon of 1857. Oil on canvas, 68⅛ × 81⅛" (173.5 × 206 cm). Musée du Petit Palais, Paris*

Fig. 4–31 *Pablo Picasso.* Young Ladies on the Banks of the Seine, after Courbet. *1950. Oil on plywood. 39⅝ × 79⅛" (100.5 × 201 cm). Öffentliche Kunstsammlung, Kunstmuseum, Basel*

The subject of two women, of course, has deep roots in Picasso's art.[94] It appears in the lesbian love scenes of his youth, such as *The Two Friends*, 1904,[95] and in more ambiguous scenes such as *Sleeping Nudes*, 1933,[96] or his many depictions of women in an interior, as in *The Serenade* of 1942,[97] in which one watches over the other or, as in this case, sings her to sleep.

Courbet's painting depicts two indolent young *Parisiennes* lying in the grass under overhanging trees in a secluded spot on the banks of the Seine. The brunette in the foreground has removed her dress and lies on top of it in her flouncy white undergarments, her torso pressed to the ground, arms and legs extended. Halfway between sleep and wakefulness, she looks out at us through heavy-lidded eyes, exuding a sense of sensual torpor. Lying beside her wearing a red dress, a straw hat and black lace fingerless gloves, her blond companion props herself up on her elbow, and stares out absently into space. What were these two "odalisques du boutique," as a critic of the period referred to them, doing in all their finery on a hot afternoon in this secluded spot?[98] "Are they sleeping, thinking of some 'Antinous du Magasin' or drying their laundry on themselves for lack of a change of clothes?"[99]

Picasso deviated substantially in his variation (fig. 4–31) from the dimensions and format of Courbet's painting. While maintaining almost the same length as the French painter's work, he lops off the upper third of the canvas, leaving his figures confined in a long narrow rectangle. Courbet's sensual, curvilinear forms and painterly style have been converted into an opposing linear idiom, which nevertheless retains the spirit of the original submitted to new rules: the figures are compressed into two dimensions and broken down into small, brightly-colored, swelling shapes outlined in black and white and filled in with color (as in stained glass), and stacked one above the other. This new decorative mode of "lines and curves converging and diverging from nodal points" was first used by Picasso to ornament Pierre Reverdy's *Chants des Morts* (1945–48), and carried further in two experimental paintings of 1948 entitled *The Kitchen*, and in his variation after El Greco.[100] Françoise Gilot, Picasso's companion and a painter herself, recalls: "It was awesome to see how fast and with what ease he was able to recapture the sensibility of the original artist. Once he was satisfied with the outcome, it was even more fascinating to follow the evolution of this thinking as he began to systematize *Les Demoiselles des Bords de la Seine* using the method of linear patterns . . ."[101]

While opposing Courbet in most respects, Picasso also draws on and exaggerates some of the more "modern" or controversial aspects of his model, which countered traditional academic practice. Courbet's critics had reviled him in this very work (as in many others) for the lack of the semblance of a solid body in his foreground figure and for his faulty handling of perspective; the women appeared to be superimposed "as in the cabin of a steamboat."[102] Furthermore, in the thickness of his paint surface, Picasso calls attention in exaggerated form to Courbet's emphasis on paint as physical matter.[103]

Picasso opposes Courbet on another level, however: he draws the painting into his familiar language of symbolic imagery. In the upper portion of the brunette we see a fairly lifelike *profil perdu* of a young woman, reminiscent of Françoise, looking down. The bottom part of the head, by contrast, is a gray crescent with a single oval eye, tipped

upright. This "lunar" profile surrounded by bone-like arms, suggests death. The fact that this profile looks upward from the ground, as if from a grave, further contributes to this reading. Indeed, the polarities of life and death, of the conscious and unconscious mind, or of reality and dream, run through much of Picasso's art. This revision, however, draws on an aspect of Courbet's painting, noted satirically by a critic of the period: "They are two. One brunette, the other blond. One dressed in white, the other in pink. One lying on her chest, the other on her back. One dead and the other living."[104] The variation also echoes an earlier work by Picasso: his *Girl before the Mirror* of 1932 (fig. 4–32), "which likewise fuses a double image in an organic version of a stained glass effect."[105] In both we also find a juxtaposition of a lifelike profile with a symbolic one. What Picasso does with the figure and her mirror image in the 1932 painting he brings together in the head of the brunette in the Courbet variation.

Picasso gives special weight to certain details from Courbet's composition, thus assigning them a different value in his system of signs. The increased size of the blond's hand on her companion's body underlines or "points to" the erotic nature of the source. The use of the hand as a bridge between two figures recalls another reclining couple of several decades earlier, *Sleeping Peasants* of 1919 (fig. 4–33), a work that may also have been based in part on the *Young Ladies on the Banks of the Seine*.[106]

Picasso focuses on the shoes as well, exaggerating their size, updating the style, and representing them in a realistic manner. The position of the middle foot has also been altered so that the shoe can serve either pair, and act as a pivot between the two figures. The two women, in fact, can be seen both as separate figures and as the same one in two different positions, the brunette on her stomach having rolled to her side, supporting her head on her elbow and looking out at us. The head of the blond is also treated in a more realistic manner, though there is a suggestion of a double face, with a profile in white facing left, inscribed on a frontal view. These combined views of the head allow us to see the woman as looking out into the distance toward the left as she does in the original, while also looking out at us, a role she takes over from her friend.

The Courbet variation anticipates in several respects two of Picasso's major series of variations of the mid-fifties and early sixties. The subject of women together, the torpor of the figures, and their odalisque-like poses (although they are outside and clothed in fashionable contemporary dress) link Courbet's painting with Delacroix's *Women of Algiers*. What is more, Picasso's fascination with the relationship of prone and supine figures, and with decorative surface patterning, in his Courbet variation becomes a major focus of his Delacroix suite. In his variations after Manet's *Déjeuner sur l'herbe*, Picasso returns to the problem of the figure in landscape. All three paintings by the earlier masters are landmarks in the development of modernism.

Portrait of a Painter, after El Greco, *1950*

Picasso was a year short of seventy when he painted a variation after El Greco's *Portrait of a Painter* of 1603 (fig. 4–36), his first significant transposition of a work by a Spanish artist. Over the next decade, the

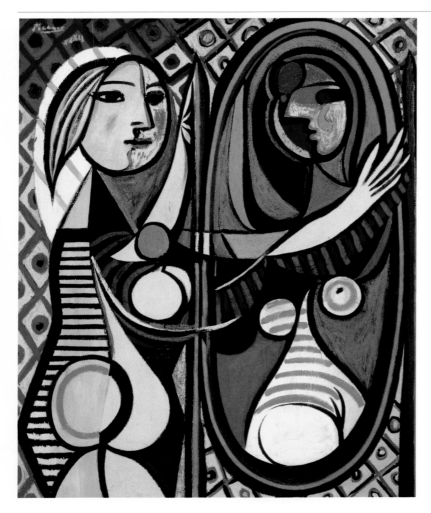

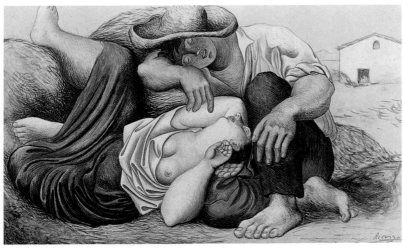

Fig. 4–32 *Pablo Picasso.* Girl before the Mirror. *March 14, 1932. Oil on canvas, 64 × 51¼″ (162.3 × 130.2 cm). The Museum of Modern Art, New York. Gift of Mrs. Simon Guggenheim*

Fig. 4–33 *Pablo Picasso.* Sleeping Peasants. *1919. Tempera, watercolor, and pencil, 12¼ × 19¼″ (31.1 × 48.9 cm). The Museum of Modern Art, New York. Abby Aldrich Rockefeller Fund*

painter would revisit his homeland—physically beyond his reach because he had vowed never to return to Spain while it was under the fascist regime of Generalisimo Franco—through works based on Goya,[107] Velázquez[108] and Murillo.[109] He would also execute numerous

works based on Spanish motifs, including the bullfight, and themes from Spanish literature. It seems appropriate that his return to his origins should be launched in a work after El Greco, one of his first artistic father figures.

Consigned to the periphery of history as a "madman" in the seventeenth and eighteenth centuries, El Greco gained appreciation again with the French Romantics in the mid-nineteenth century.[110] But it was in the milieu of the Catalan *Modernisme* movement, which took root in Barcelona at the turn of the century, that he achieved virtual apotheosis as a forefather of modern art. For these young artists and writers, El Greco provided a vital alternative within their own native tradition to the outworn conventions of naturalism. El Greco's rehabilitation coincided with Picasso's coming of age as an artist in Barcelona in the second half of the 1890s.[111] As a young painter attempting to throw off the shackles of academic art, and to separate himself from his father and first teacher, Don José Blasco Ruiz, Picasso found a powerful ally in El Greco. While studying at the Academy of San Fernando in Madrid in the winter of 1897–98 at age sixteen, Picasso wrote admiringly to a fellow painter about El Greco's "magnificent heads," which he had seen at the Prado.[112] But when he sent copies home to Barcelona after paintings by El Greco, Don José replied severely: "You are following the wrong way."[113] El Greco thus served to some extent as the measure of the young painter's distance from the academic naturalism of the Academy, where Velázquez was revered above all others, and from his father. Yet Picasso also appeared to identify the tall, lean, and bearded aristocratic-looking Don José with figures from El Greco's art. A portrait head of Picasso's father appears on the same sheet with El Greco-like heads in a drawing of 1899 (fig. 4–34), and the connection occurs again in Picasso's late work in some of his prints from the *Suite 347* of 1968.[114] In the same year, when the artist's identification with El Greco seems to have been particularly intense, he made caricatural, elongated faces inspired by El Greco in the fashionable decadent idiom of the period, as seen for example in his *Head in the Style of El Greco* of 1899 (fig. 4–35), and inscribed a notebook sketch numerous times with the words: "Yo, El Greco."[115] El Greco's influence was to remain strong throughout the artist's early years in Paris. The impact of his elongated forms on Picasso's depictions of society's outcasts during his Blue Period has long been acknowledged; more recently the master's continued and vital presence throughout the development of Cubism has been noted as well.[116]

If El Greco's mysticism and formal audacities fueled Picasso's search for a more direct and expressive form of representation in his early years, in later life he most admired the master's realism. In a conversation about El Greco with Kahnweiler in 1955 Picasso said, "What I really like about him are his portraits, these gentlemen with their pointed beards. The pictures of saints, the trinity, the Virgin, its decoration . . . whereas the portraits! And that's the reason I prefer the Germans to the Italians. They, at least, were realists."[117] Picasso's need in later life to repudiate his earlier interest in the mystical side of El Greco's work is illustrated in an incident that occurred in 1944.[118] Asked by a dealer to give an opinion as to the authenticity of a work of religious subject matter attributed to El Greco, Picasso demanded that the large canvas be transported to him in his studio on the rue des Grands Augustins despite the considerable difficulty and danger to the work involved. The paint-

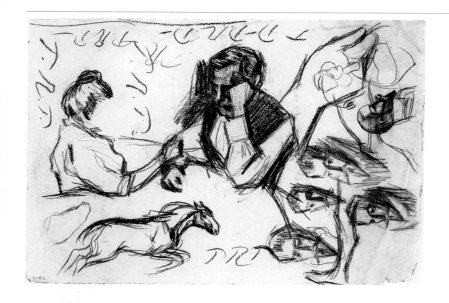

Fig. 4–34 *Pablo Picasso*. The Artist's Parents, El Greco Heads and Others. *1899–1900. Conte crayon on paper, 9¹/₁₆ × 13¼" (23 × 33.7 cm). Museu Picasso, Barcelona*

ing arrived by wheelbarrow. Picasso had conveniently chosen to examine it at a moment when he had an audience: the entire cast of his play, *Desire Caught by the Tail*, was assembled in his studio for a rehearsal, among them Jean-Paul Sartre, Simone de Beauvoir, and Jacques Lacan. When the painting was stripped of its wrappings, Picasso pronounced it authentic—but of no interest to him. As a final touch of showmanship, he had his chauffeur hold up Matisse's *Still Life with Oranges* next to it, declaring his preference for his French contemporary—and greatest rival. Once taken away, Picasso commented to the group, "Poor Greco! He's going on just as he began. No one wants him."[119]

Picasso's performance seems to reflect something of his own situation in post-occupation Paris. One of the factors that may have drawn him to the El Greco portrait in 1950 may have been contemporary discussion in the press about his "Spanishness" and his place in the *grande tradition française*.[120] Seen in this context, El Greco would not only have provided Picasso with a link to his homeland and his youth, but the Greek painter's relationship with Spain also paralleled his own to his adopted home of France. In the early years of the twentieth century, when Picasso's interest in El Greco was at its height, Manuel Cossío published the first *catalogue raisonné* of the sixteenth-century master's work, in which a new interpretation was advanced of his painting as the embodiment of the authentic Spanish spirit.[121] The "Spanishness" of this resurrected genius, according to Cossío, is accounted for by the fact that El Greco only became great after coming to Spain.[122] El Greco, thus, like Poussin—or Picasso himself—provided a significant example of a great artist whose national identity could not be determined by his place of origin, nor his genius limited by it. It is surely no coincidence that El Greco's portrait is a portrait of a painter, and that it was once thought to have been a self-portrait.

In *The Portrait of a Painter* (fig. 4–34) El Greco's figure looks at us attentively. Depicted half-length in a black robe and wearing a large white *gola* (or ruff) and white lace at his cuffs, he holds a palette covered with daubs of color and additional long brushes in one hand, while,

Fig. 4–35 *Pablo Picasso*. Head in the Style of El Greco. *1899. Oil on canvas, 13⅜ × 12¼" (34.7 × 31.2 cm). Museu Picasso, Barcelona*

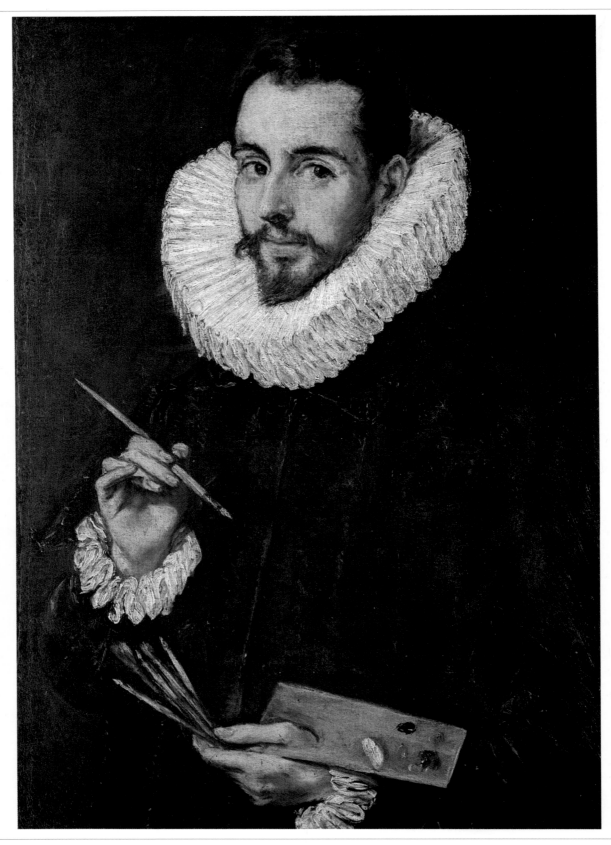

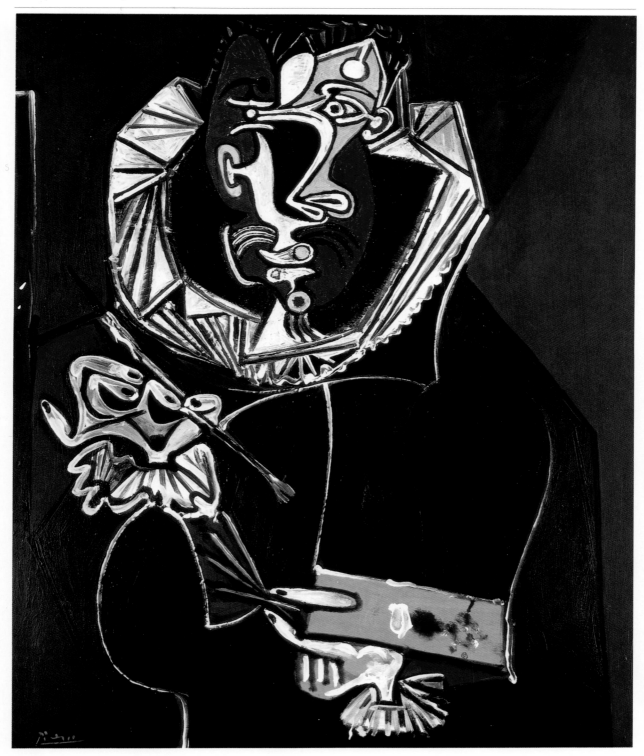

Fig. 4–36 *El Greco.* Portrait of a Painter (Jorge Manuel Theotocopuli). *c. 1603. Oil on canvas, 31⅞ × 22" (81 × 56 cm). Museo de Bellas Artes, Seville*

Fig. 4–37 *Pablo Picasso.* Portrait of a Painter, after El Greco. *1950. Oil on plywood, 39⅝ × 31⅞" (100.5 × 81 cm). Collection Angela Rosengart, Lucerne*

with the other, he carries his brush up to his canvas, the edge of which is visible from the back at the far left of the picture. His hands and head form a triangle set off against a dark green ground by white lace. The lively arrangement of the half-length figure captured at a moment of suspended activity underlines the keenness of the artist's gaze—the true subject of the work.

The outward glance of El Greco's painter, which connects him with the viewer in a reciprocal relationship of seeing and being seen, links this painting with many others that served Picasso as sources for his variations. (Manet's *Olympia* and *Nana* and Ingres's *Odalisque* are examples from his early years, while Velázquez's *Las Meninas* and Manet's *Déjeuner sur l'herbe* would serve as models for long series of variations in the fifties and early sixties.) Here, however, a provocative twist is interjected into the relationship of seer and seen. Standing "before" the work as its viewer, Picasso occupies the place of both viewer and model, as well as artist, while he in turn paints his own version of the same theme: a painter painting a picture—the subject of which is hidden from the viewer.

Picasso's variation (fig. 4–37) is executed in oil on plywood in a decorative Cubist idiom, a medium and style he used frequently at this time. Like his lithographs after Cranach's *David and Bathsheba* of 1947–49, the El Greco variation is also larger than the original.[123] Picasso's colors—browns, tan, and white—which recall his Cubist palette of the 1910–12 period, are different from El Greco's, but preserve the monochromatic effect and strong contrasts of the original. According to one of Picasso's biographers, the painter wanted "to render the lunar light" characteristic of his predecessor.[124] Picasso follows his model in the placement of the figure and in many of the details, while exaggerating such traits as his receding hairline, thin moustache, and elongated hands, transforming him into a mincing Cubist parody of his former self. Whereas in the original both head and torso turned at a slight diagonal to the picture plane, here the body is flattened in a three-quarter view, while the head is frontal, and the various parts of the composition have been drawn more closely together.

In the original work, the painter's eyes pull to the left to look out at something or someone in front of the work, while his head turns to the right. These subtle discontinuities suggest a sequence of movements in space. Picasso superimposes a profile view on the frontal head, thus bringing together two distinct spatial positions and moments in time into one disjunctive image that encompasses multiple points of view. On the right side of the face, the nose and eye belong to the profile, while the mouth is composed of two lips in profile, each facing a different direction. The left eye, chin, and whiskers are frontal, while a left ear, hidden in the original, is brought forward into the same plane. The *gola*, flattened and faceted into triangles, orbits around these conflicting views, bringing them together. Here, as in previous variations, Picasso's primary intervention is through the relation of viewer to viewed. In El Greco's depiction of a painter, where making art is equated with looking, Picasso seizes control of the image by countering the figure's direct and attentive gaze with his own multivalent vision. Two distinct modes of seeing are thus brought into juxtaposition with each other; one overlays the other, like a mask.[125]

Who was this painter? Referring to the variation, a friend and biogra-

pher of the artist commented on Picasso's "interest in the fact that it is a self-portrait."[126] The work was exhibited at the historic Galerie Espagnol in Paris in 1838 as a self-portrait, and it was accepted as such (with slight reservation) by Stirling-Maxwell in his *Annals of Spanish Art* of the mid-19th century.[127] Since the beginning of the twentieth century, however, scholars have considered this work to be a portrait of El Greco's only son, Jorge Manuel Theotocopuli (1578–1631), an unsuccessful painter who worked in and later ran his father's workshop, and whose tragic life ended in financial ruin after three marriages.[128] The identification of the subject is based on the very convincing resemblance of the painter to a known portrait of Jorge Manuel as a page in *The Burial of Count Orgaz*, a painting that Picasso knew well.[129] In a monograph on El Greco published in 1950, the portrait was reproduced as a "Retrato de Jorge Manuel."[130] It may well have been on the full-page black-and-white illustration of the painting in this book that Picasso based his own work, as the original was in a provincial museum in Seville. The painting had also appeared in a book published in 1939 by the publisher and critic Christian Zervos, in which the painter is identified as the son of El Greco, complete with a lengthy discussion on the matter.[131] Given his close relationship with Zervos, Picasso was undoubtedly aware of the question concerning the subject's identity. It is, in fact, the question itself that would have made the painting a provocative source for a variation, and a conduit to deeper levels of meaning. At the very heart of this artistic process is the issue of the relation of self and other. The fact that the problem of the subject's identity is imbedded in a father/son dualism would have made the El Greco portrait all the more intriguing to Picasso.

Jorge Manuel, like Picasso himself, was trained by his father, and the relationship between them was as imbalanced as his own to Don José, though in reverse, as John Richardson has pointed out.[132] In both of these father-son relationships the genius and success of one led to the destruction of the other, a situation sadly repeated in Picasso's relationship with his son, Paulo, then almost thirty.[133] El Greco's painter, in fact, appears as something of a weakling. Considering Picasso's earlier and later identification of his father with figures from El Greco's art, he may well have seen a reflection of Don José—whose fair complexion and hair color earned him the nickname of "the Englishman"—in the painter. The author of the 1950 monograph, in fact, referred to Jorge Manuel's "almost English" looks, "the delicate spiritual quality of his eyes . . . and sense of timidity."[134] Furthermore, the prominently displayed tools of the painter's craft in the El Greco may have stirred associations with Picasso's father. The artist recounted to Jaime Sabartès in later life that when he first entered school he begged his father to leave him his brushes as a guarantee that he would return for him.[135]

In his variation, Picasso grapples with both his father and El Greco—the artist through whom he displaced his father, while at the same time subliminally identifying Don José with the old master. The process of displacement continues: Picasso may now be "killing off" El Greco in favor of the painter who had been (and remained) his rival as the premier artist of Spain, namely Velázquez. In his appreciation of El Greco's portraits, Picasso allies himself with that master, the realist par excellence. The same relationship between the artist depicted in the picture and the viewer/model—and the implicit question regarding the relation-

ship of representation and reality—in *Portrait of a Painter* is found in Velázquez's self-portrait in *Las Meninas*. Indeed, the El Greco portrait, according to one critic, may have suggested the idea to Velázquez.[136] "In his portraits," Velázquez's biographer Palomino wrote, "he imitated Domenico Greco, for in his opinion, that painter's heads could never be sufficiently extolled."[137] The two antithetical giants of his native tradition, El Greco and Velázquez, are thus brought back together through Picasso's portrait, the star of one rising, as the other sets. In seven years, Picasso would undertake his most sustained dialogue in oil on the greatest Spanish masterpiece of all, *Las Meninas*. But according to Sabartès, he was already thinking of the project in the early fifties; the variation after the *Portrait of a Painter* is a prelude. In the series of displacements, replacements, and identifications in his variation after El Greco's portrait of his son, Picasso confronts head on the oedipal conflict at the heart of the artistic tradition, in which each generation of artists is in turn cannibalized, internalized, and immortalized by those who succeed them.

On the most immediate level, this variation—like many of them—serves Picasso as yet another way to explore one of his most constant themes: the artist at work. Within this category of his art after art are examples of a more specific sub-category: painter's portraits or self-portraits. Among them are drawings by Picasso after Renoir's *The Sisley Couple*, after a photograph of Renoir himself from 1919, and a pen and ink sketch after Delacroix's *Self-Portrait* in 1954 (Ch. 5, fig. 5–5). Images of Rembrandt, Raphael, Michelangelo, and Degas appear throughout the variations of Picasso's last decade. Through these interpretations (some of which are close to copies) Picasso expresses a passing identification with his predecessors. The El Greco variation is both a portrait of an individual artist and a painting of any artist—French, Spanish, or Greek—at work; it is also a self-portrait of Picasso. In its fluid play of identities, and in the multiplicity of issues it addresses, Picasso's Cubist re-creation of *Portrait of a Painter* is emblematic of the very process of variation, and perhaps is the most elegant and concise variation of all. In it one can almost hear ironic echoes of the aging Picasso's reiterating the incantation of his youth as he inscribes himself into the great chain of artists: "Yo, El Greco, Yo, El Greco. . . .

"We are all in Delacroix": Variations on the *Femmes d'Alger*

Ah, how I would like to come back in a hundred years and find out what they think of me.
—Delacroix[1]

I wonder what Delacroix would say if he saw these pictures?
—Picasso

I replied that I thought he would understand.
—Kahnweiler

Yes, I think so. I would say to him, "You had Rubens in mind and painted Delacroix. I paint with you in mind and make something different again."
—Picasso, 1954[2]

From 1954 to 1962, Picasso executed three major cycles of variations after masterpieces he had known over a lifetime: Delacroix's *Femmes d'Alger*, Velázquez's *Las Meninas*, and Manet's *Le Déjeuner sur l'herbe*. Variation now shifts from the margins to the center of Picasso's art. If his early interpretations based on French masters reflect his concern with placing himself in the culture of his adopted home, and those of the thirties and forties explore diverse schools of art, this final phase of variation may be seen as a form of closing the circle, of recapitulating some of his major concerns. Variation served as an ideal means of channeling the retrospective forces of Picasso's late years; the serial form into which it evolved reflects the open-ended and sometimes obsessive nature of his search.

Although a return in old age to one's beginnings is a natural aspect of the life cycle, shifts in the cultural and political milieu, and in Picasso's personal life, contributed to this process. By the early fifties, New York had displaced Paris as the art center of the world and Picasso, then in his seventies, had little sympathy with the new movement of Abstract Expressionism, which was thriving across the ocean, nor with the revival of abstraction in the School of Paris. At the same time, he was becoming a burden for the younger generation. One young French critic described Picasso in a review of 1951 as a "cumbersome genius of whom it has been said that he, in himself, constitutes a repertory of the history of art," noting that "The public must be taught to *un*learn Picasso."[3] Celebrated in the postwar period as the figurehead of modernism, Picasso was now no longer at the forefront of the avant-garde.[4] Increasingly, he was a living "old master."

Picasso experienced a sense of displacement in the fifties in the political realm as well; his involvement with the Communist Party, a strong focus of his life since becoming a member in 1944, had become more problematic. While the Communists rejected the formalism of Picasso's

art as incompatible with their policy of social realism, his overtly political paintings—such as the *Massacre at Korea* (based on Goya's *The Third of May*), exhibited at the 1951 *Salon de Mai*—were poorly received by critics and Party alike. Picasso's relations with the Party were severely strained over the drawing of Stalin which he submitted to *Les Lettres Françaises* (a weekly newspaper) on the Soviet leader's death on March 5, 1953. The drawing, based on a photograph of Stalin as a young man, was considered an affront to the dignity of the aged statesman, and was denounced by the Party.[5]

Picasso experienced the greatest upheaval in his personal life. The death in November of 1952 of the poet Paul Eluard was an unexpected loss. Picasso had carried on an aesthetic and political dialogue with Eluard, his primary link with the succeeding generation, since the mid-thirties, and it was largely through the poet's influence that he had joined the Communist Party. Then, in the fall of 1953, Françoise Gilot, his companion of nearly a decade, left him, letting it be known that "she did not want to spend the rest of her life with an historical monument,"[6] and taking with her their two young children, Claude and Paloma.

Following Gilot's departure, Picasso immersed himself in one of his most personal, fertile, and recurrent themes: the artist at work. From November 18, 1953 to February 3, 1954, he produced a cycle of one hundred and eighty drawings in which he depicted with self-mocking humor the tenderness, cruelty, and absurdity of the "Comédie Humaine."[7] These spontaneously executed drawings, which focus obsessively on the creative process through the relationship of the artist and model, and recall other earlier themes as well, are a preamble to the major cycles of variations of the fifties and early sixties.[8] Not only did Picasso withdraw increasingly in later life to the world of the studio, taking art itself as the subject of his art, but the three masterpieces that served as the basis for these suites of variations are themselves directly or indirectly connected with the theme of the artist and model, as the novelist and critic Michel Leiris was the first to note: ". . . *Les Femmes d'Alger* (which, after all can be considered as a group of models posing for an Orientalist painter), *Le Déjeuner sur l'herbe* (an artist's spree away from his studio), and *Las Meninas* (Velázquez in the midst of the royal models."[9]

Gilot, forty years Picasso's junior, was of the generation of artists then in the ascendancy; the deaths during the early fifties of a number of Picasso's contemporaries, among them André Derain, Fernand Léger, Henri Laurens, and the critic Maurice Raynal, signaled the passing of his own era. Matisse's death on November 3, 1954, left an irreparable void, for after World War II, Picasso had formed a close friendship with his old rival, the only artist he accepted as a peer. Not only were Matisse and Picasso recognized as the primary painters of the twentieth century, but, even more important, they shared a common heritage in many of the same masters of the past. Gilot, who was present during many of the conversations between the two painters from 1946 to 1954, notes that they often discussed their legacy: "Both wanted to verify that the very foundation of their artistic friendship was on solid ground: *a mutual understanding of the same artists and the same principles*. Their exchanges had a soothing and affirming effect on both of them."[10] Furthermore, they concurred on the importance of an artist's remaining "alive in the mind of another artist and to a certain extent in that artist's oeuvre."[11] "Who will carry us on in their hearts, as we did Manet and

Fig. 5–1 *Eugène Delacroix.* Women of Algiers (Les Femmes d'Alger). *Salon of 1834. Oil on canvas, 70⅞ × 90⅛″ (1.80 × 2.29 m). Musée du Louvre, Paris*

Cézanne?" Matisse asked Picasso.[12] The question of artistic continuity, central to all of Picasso's variations, took on greater urgency in his later years, as is directly reflected in the increased importance he placed on this process. With Matisse's death, as one scholar notes, Picasso would have to keep alive the heritage of the masters on his own.[13]

From December 13, 1954 to February 14, 1955, Picasso produced fifteen canvases based on Delacroix's *Women of Algiers*, as well as lithographs, etchings, aquatints, and a large number of drawings.[14] This suite marks the first time that Picasso submitted a work of the past to continuous transformation in oil on canvas. Delacroix's painting, executed in 1834 (fig. 5–1), depicts the three wives of a Muslim engineer seated or reclining on the floor of an intricately decorated room, attended by a black servant.[15] At the center and set slightly back in space, two of the wives sit or crouch barefoot on the carpeted floor. In front of them is a *narghile* (or water pipe), the tube of which rests in the hand of the woman to the right, a coal-burning brazier, and a pair of discarded slippers. Lost in quiet conversation or reverie, the pair at the center seem unaware of being observed, while their companion, reclining on pillows at the far left, looks out demurely at a point beyond the confines of the picture, as if subtly acknowledging the viewer's presence. The scene is closed off at the right by a pulled-back curtain, in front of which the ser-

Fig. 5–2 *Eugène Delacroix.* Women of Algiers (Les Femmes d'Alger). *1849. Oil on canvas, 33 × 43¾" (84 × 111 cm). Musée Fabre, Montpelier*

vant looks back over her shoulder at her mistresses before exiting the scene; her active, vertical stance and twisting form contrasts with their languid poses.

Delacroix's painting was executed from sketches made from life during a five-month visit to North Africa, beginning in January 1832 with the mission of the French government led by the Comte Mornay to the Sultan of Morocco.[16] The painter succeeded—with great difficulty—in gaining access to a seraglio only at the very end of his African sojourn during the few days he spent in Algiers, as Muslim custom prohibited the entry of a Christian into an Arab household when women were present.[17]

As Delacroix developed the painting from his sketches (supplemented with studies of accessories and costumes brought back from Africa), he monumentalized the wives, depicting them with scrupulous attention to the details of their exotic garb and the decor of the room.[18] The art historian Lee Johnson has aptly characterized the *Women of Algiers* as a synthesis of several artistic currents: "Romantic in subject and feeling, documentary in origin, it yet exhibits the classic qualities that Delacroix once defined as characteristic of antique art: 'skillful breadth of form combined with the feeling of life.'"[19]

In 1849, Delacroix executed a second version of the *Women of Algiers*, about half the size of the first, which is housed in the Musée Fabre in Montpelier (fig. 5–2).[20] Here, the three wives are set farther

back from the viewer and illuminated by light that seems to emanate from within the picture space. The foreground plane and most of the back wall are now in shadow, and the servant, relegated to the darkened foreground, holds up the curtain, as if revealing the illuminated group to us. As one critic has noted: "The whole scene appears distanced, withdrawn into a different and precarious world, one that may at any moment retire into itself and escape us, extinguished by the closing of a shutter or the falling back of the curtain."[21] Whereas in the first version Delacroix responds to the figures in all their immediacy and fullness, in the second, he recalls the vision from afar, filtered through memory. The subject continued to haunt him: variations on the theme appear throughout his later work in painting and graphic art.[22]

The art historian Leo Steinberg was the first to analyze Picasso's variations on the *Women of Algiers* in his classic essay of 1972.[23] At the outset, Steinberg dismisses the harem subject as Picasso's primary motive for launching the series, proposing instead that it was the "peculiar maneuverability which he found built into the task" that attracted him, and demonstrating that he drew from aspects of both versions of the original work at once.[24] Steinberg establishes as the leitmotif of the series Picasso's ". . . struggle to reconcile distance with presence, possessing with watching . . ."[25]

In his analysis of the paintings, Steinberg traces the artist's engagement with the formal problem of simultaneity of point of view through the evolution of an individual figure, the "sleeper," as Picasso struggles to present her as both "prone and supine" in one compact, contoured form, and to reunite her with a "responsive space."[26] This quest for a simultaneous vision ". . . embodied above all in the Sleeper is for the form that satisfies both the impulse of erotic possession, and at the same time, the most systematic investigation of the plane surface as a receptacle of information."[27] Picasso's obsession with this formal issue, which was central to his work as a whole but more compelling in the second half of his career, is the motivating force, in Steinberg's view, that carries him through the fifteen canvases.

Yet, as we have seen in his previous variations, Picasso's encounters with the masters almost always represent a resolution of multiple concerns. The importance of the *Women of Algiers* paintings as the first of his serial variations in oil, and as works of exceptional quality, would suggest no less. One wonders what other issues Picasso may have addressed in his dialogue with Delacroix, and whether Steinberg's "will to consolidation" in the formal realm could be applied to other aspects of the dialogue as well.

Women grouped together, or depicted singly, in an interior and exposed for the delectation of the (presumably) male viewer—or voyeur—is a constant theme in Picasso's oeuvre as a whole, as well as in his variations. Delacroix's exotic image of an enclosed world of languid sensuality and reverie would undoubtedly have appealed to Picasso as a refuge from his turbulent life in 1954. What is more, the painting had acquired the resonance of long familiarity: known by Picasso over five decades, it was a repository of memories and associations. The spatial ambiguities of the Louvre painting would also have attracted Picasso and incited him to carry on the process of formation, which Delacroix

seems to have left in flux. Brightly lit by sunlight from an unseen window at the left, the women stand out from the darkened recess of the room, which has the unreality of a painted backdrop. A wall to the left, decorated with iridescent tiles, supporting a tilted mirror and punctured by the half-opened red doors of a wardrobe, recedes at an angle behind the women, while the floor tips up. This slight disjunction between the solid figures and the surrounding space of the room imparts a sense of awkwardness, a quality that, as we have seen, appealed to Picasso as the true mark of French art. (". . . basically the French painters are all peasants," Picasso once told Kahnweiler[28]). The circuit of glances among the represented and the implied figures would have been another factor in Picasso's attraction to the work, as it was in many of his previous variations. As the viewer gazes into the interior of the painting at the pair of figures in the center, the reclining woman at left returns his glance, while the three wives are, in turn, looked at by the departing servant, who turns her back to the viewer.

Could Picasso have known about the circumstances surrounding the creation of Delacroix's canvas? The story of the artist's surmounting the difficulties of gaining access to a harem, recounted in Elie Lambert's monograph on the *Femmes d'Alger* published in Paris in 1937, would certainly have interested him.[29] Picasso's remarks to one of his biographers, Pierre Daix, which reveal an appreciation—and lightly veiled envy—of Delacroix's accomplishment, suggest that he was aware of them: "And then, he was one of the first tourists after the conquest. That would have changed things in the harems. In any case, before that, Delacroix would have remained at the door . . . and we would never have had the *Femmes d'Algers*."[30] Delacroix's transgression of a cultural barrier in entering a harem (the word means "forbidden") and the strong implication of the artist's presence before the scene in the close-up view of the women and reciprocated glance of the figure to the left, would undoubtedly have fueled Picasso's competitive drive to usurp his predecessor's place before the women, and upstage him. Daix notes that "Picasso would recount to me in his inimitable fashion what he imagined of Delacroix as a timid voyeur of the harem."[31]

With his variations after Delacroix's painting, Picasso confronted a pivotal figure who encapsulated a whole history of art, linking the Venetian, Spanish, and Flemish masters with the Impressionists, Neo-Impressionists, and Fauve painters through the coloristic tradition. It is as much in a shared sense of the burden of the past, and his ambition to absorb it into his own art, as through the subject of the painting that Picasso connects with Delacroix and attempts to surpass him.[32]

As a witness to Delacroix's celebrated visit to the harem recounted, the artist stood transfixed before the scene, "as if intoxicated," crying out from time to time: "C'est beau! C'est comme au temps d'Homère." (It's beautiful! It's as it was in Homer's time[33]). Of Delacroix's North African trip of 1832, one scholar notes: "Amidst exotic surroundings he discovered a kind of living antiquity."[34] Delacroix, as one scholar notes, sought to go "behind Tradition to its source."[35] Picasso, however, took a more confrontational approach to the past in hand to hand combat with works that were focal points in the history of art. (Interestingly, as Daix has noted, while Delacroix's historic visit followed on the heels of the French conquest of Algeria in 1830, Picasso launched his series shortly after the bloody revolt on November 1, 1954 by the *Front de Libération*

Nationale, which began the long and bitter struggle for Algerian independence from France, finally attained in 1963.[36]) This series, like all his variations, constitutes an act of liberation as well.

Considered a "painter's painting," the *Women of Algiers* occupied a special position in the early phases of modernism and in Picasso's intense and rivalrous relationship with Matisse. Cézanne acknowledged its impact on him and his generation: "We are all in Delacroix. Those pale pinks, those stuffed cushions, that slipper, all that limpidity, what can I say. They penetrate your eye as a glass of wine your throat, and one is drunk immediately."[37] Renoir paid tribute in paintings of his own.[38] The Neo-Impressionists claimed Delacroix as the father of modern color theory. Thus, like Courbet's *Demoiselles des bords de la Seine*, the source of a variation of 1950, and Manet's *Déjeuner sur l'herbe*, on which he would base his final series of variations from 1959–62, the *Women of Algiers* served Picasso in his exploration of the origins of modernism at a time when he perceived the movement—and his own generation—to be coming to an end.[39]

Paul Signac's *D'Eugène Delacroix à Néo-Impressionisme*, first published in 1899, is revealing of Delacroix's stature, and the place of the painting, during the formative periods of both Picasso and Matisse. Written by a painter and the leading theorist of the later phase of Neo-Impressionism, Signac's propagandistic tract served, as one art historian put it, as "the interface between the nineteenth and twentieth centuries."[40] Signac invokes "the authority of the lofty and lucid genius of Eugène Delacroix" to defend the much-maligned method of divisionism and the rational methods of color analysis central to Neo-Impressionist theory and practice.[41] The *Women of Algiers* is the one painting to which Signac devotes an extensive analysis, using it as a virtual textbook of modern scientific methods of color organization through the law of simultaneous contrast, which emerged in the 1820s through the studies of Michel-Eugène Chevreul and others (although the validity of these claims has since been questioned[42]). Delacroix is the key figure in what Signac sees as a progression toward greater brilliance and luminosity from the old masters to Neo-Impressionism. The book ends with the following provocation: "And if their number does not yet include an artist who, because of his genius, can bring about the acceptance of this technique, they have at least found the way to simplify the task. This triumphant colorist has only to come forward: his palette has already been made ready for him."[43]

As the leader of the Fauves, Matisse, who had been indoctrinated into Neo-Impressionist methods by Signac himself during the summer of 1904, was clearly the "triumphant colorist" who came forward to claim the mantle of Delacroix.[44] Yet it was not only as a colorist that Matisse could claim to be Delacroix's heir, but in subject matter as well. In 1906 Matisse made his first trip to North Africa, spending a few weeks in Algeria; in 1911 and 1913 he made extended trips to Tangiers, following in Delacroix's footsteps in search of "the pure, the natural, and uncorrupted."[45] In his youth in Andalusia, Picasso had direct contact with the Moorish tradition. Yet in the area of "Orientalism," Matisse had staked his claim as the modern counterpart of Delacroix, who had imbued this specialty of minor academic painters with the monumentality of classical art.[46] Matisse would develop it further into a grand tradition.

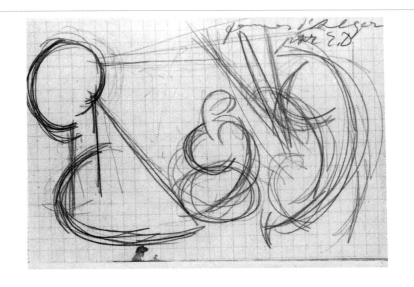

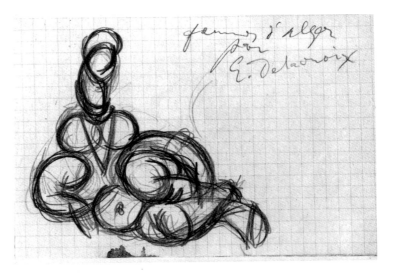

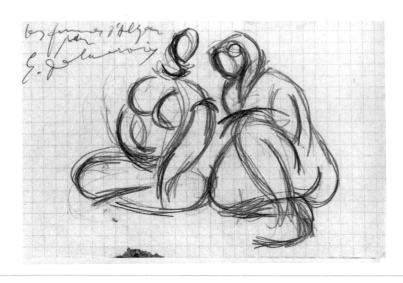

Picasso first met Matisse through Gertrude Stein soon after Matisse had returned from Algeria in the spring of 1906. The two artists "seemed to have understood from the first," Flam notes, "that they were in competition with each other, first for the patronage of the Steins, and eventually for primacy among twentieth century painters."[47] With his primitivistic *Blue Nude (Souvenir de Biskra)* of 1907 (Ch. 2, fig. 2–19), Matisse combined Cézanne's monumental bathers with Delacroix's odalisques. This radical figure "is seen neither from a single viewpoint nor fixed in a single place; she reverberates with a dynamism and fluidity unknown in Matisse's previous work."[48] Picasso's response was immediate: both the *Blue Nude* and the *Women of Algiers* figure among the sources of his *Demoiselles d'Avignon*, in which he surpassed Matisse's innovations with his new formal idiom and captured the lead of the avant-garde.[49] In a postscript to the *Demoiselles d'Avignon*, Picasso challenged Matisse's nude more directly in one of his first variations, weaving her into Ingres's *Grande Odalisque* (Ch. 2, fig. 2–16). Matisse, however, continued to reign supreme in the realm of color, in the exotic subject matter of the Orient, and in the revival of the grand decorative tradition.

For more than a decade before Picasso undertook his variations on the *Women of Algiers* he was actively interested in the work. Four notebook sketches executed in January 1940 in Royan (where Picasso had taken refuge at the outbreak of the war) suggest that he was then in the preliminary stages of creating a variation on the painting (fig. 5–3).[50] On a sheet of squared-off paper, he explored the structure of the work in

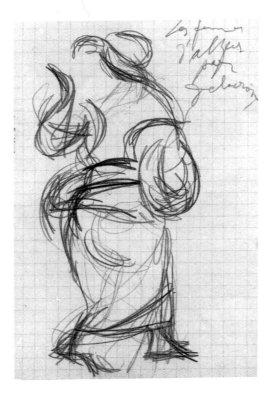

Opposite and left:
Fig. 5–3 *Pablo Picasso. Four drawings from a sketchbook after* Women of Algiers. *Royan, 1940. 4 × 6⅛" (10.5 × 15.5 cm). Musée Picasso, Paris*

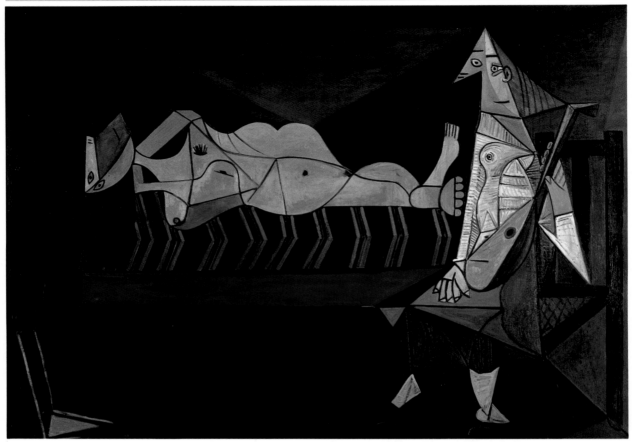

Fig. 5–4 *Pablo Picasso.* The Serenade
(L'Aubade). *May 4, 1942. Oil on
canvas, 76¾ × 104⅜" (195 × 265.4
cm). Musée National d'Art Moderne,
Centre National d'Art et de Culture
Georges Pompidou, Paris*

long sweeping lines and rhythmical curves and circles. In three subsequent drawings, Picasso studied the reclining woman, the servant, and the pair of women sharing an opium pipe at the back in a similar (though less abstract) biomorphic vocabulary of circles and curves, and made notes for color on a fifth sheet. Matisse is strongly evoked in both the odalisque theme and the decorative curvilinear style; it is noteworthy that in the late thirties, his old rival had returned to the odalisque motif in a series of large decorative works. Picasso, however, went no further in 1940 in his interpretations of the *Women of Algiers* than these preliminary drawings.

In the famous "Louvre test" of 1946 (see pages 88–89) Picasso asked to see his works beside Delacroix's harem, as well as other works by the master; he chose for comparison his *Serenade (L'Aubade)* of 1942 (fig. 5–4), a painting in an austere late Cubist style based loosely on Ingres's *Odalisque with Slave*.[51] Recalling the Louvre visit, at which she was present, Gilot notes in her 1964 memoir of Picasso: "He had often spoken to me of making his own version of the *Women of Algiers* and had taken me to the Louvre on an average of once a month to study it."[52]

On the 26th and 29th of June of 1954, Picasso produced four drawings after Manet's *Déjeuner sur l'herbe* representing the group as a whole, a pair of figures, and portraits of individuals, yet the inevitable encounter with the *Déjeuner* would be postponed until the end of the decade.[53] The reason for his abandonment of Manet in this early stage of exploration

is made clear in the fifth drawing in the series (fig. 5–5), executed on the 29th: Delacroix had usurped Manet's place. Based on Delacroix's *Self-Portrait* (fig. 5–6) of 1837 in the Louvre, this drawing reveals a strong connection with the Romantic master: Picasso copied the Louvre painting in a charcoal sketch with relatively little change, a practice rare in his art. In Delacroix's exotic looks ("his Peruvian or Malayan skin, his large black eyes narrowed by intense concentration as if drinking in the light, his thick shiny hair, his stubborn forehead . . ." as Baudelaire described him[54]) and passionate temperament, Picasso perhaps saw himself as a young man. Indeed, some of his own early self-portraits, such as his *Yo, Picasso*, 1901,[55] seem to recall this quintessentially Romantic image of the creative individual, suggesting a passing identification with Delacroix at the outset of his career. Did he perhaps fancy himself a Delacroix in old age? His return to certain Romantic notions of art—his obsessive focus on the creative process, constant striving to break down barriers and boundaries between fixed categories, and the universal scope of his art and desire to absorb the past into the present—would seem to suggest so.[56] What was keeping him, then, "at the door" of the harem?

As we have seen, in two significant areas, that of color and the subject of the odalisque, Matisse was the guardian of the Delacroix legacy. With the death of his old friend, the path was cleared, yet Matisse was still there, transmuted and absorbed into the painting's mysterious depths to be recovered by Picasso, and kept alive in his art. The Delacroix painting served as potent material for resolving the rupture that death had imposed on their dialogue. When his paintings after Delacroix were in progress, Picasso commented to Kahnweiler: "I sometimes tell myself that perhaps this is an inheritance from Matisse. Why shouldn't we inherit from our friends, after all?"[57] And to Roland Penrose, who commented on the presence of Matisse's odalisques on viewing the variations with Picasso, the artist quipped: "When Matisse died, he left me his odalisques as a legacy, and this is my idea of the Orient, though I have never been there."[58]

Matisse's death may also have renewed the pain of Gilot's departure a year earlier, as she had figured prominently in their relationship. At the time of undertaking the Delacroix series, Picasso was in the early stages of a new relationship with a young woman in her twenties, Jacqueline Roque, whom he would eventually marry. The close resemblance of Jacqueline to the third *Algérienne* to the right has also been cited as a likely spur for undertaking the series.[59] Not only does the painting serve him as a means of announcing Jacqueline's primacy in his "harem," but also, perhaps, as a means of leaving Gilot behind.

For some days past, Picasso had been telling me that he always thought about the following day's picture in the *Femmes d'Alger* series and wondered what it would be like. He repeated "You see, it's not "time regained, but time recovered."
—Kahnweiler[60]

The series of fifteen paintings, designated alphabetically A–O, is made up of two parts. The first six paintings are small and were completed within the span of a month and a few days (December 13, 1954–January 17, 1955). These share a common vitality, spontaneity of expression, and a biomorphic figural style, while the backgrounds are densely patterned.

The remaining seven large three- or four-figure paintings, and two

Fig. 5–5 *Pablo Picasso.* Drawing after Delacroix's Self-Portrait. *June 29, 1954. Conte crayon on a sheet from a sketchbook. 10⅝ × 88¼" (27 × 21 cm). Musée Picasso, Paris*

Fig. 5–6 *Eugène Delacroix.* Self-Portrait (Autoportrait au gilet vert). *1837. Oil on canvas, 25⅝ × 21⅝" (65 × 55 cm). Musée du Louvre, Paris*

single-figure works, were carried out over a three-week stretch (from January 24 to February 14). These are generally more abstract and formal. The series culminates in a synthesis of the various impulses that guided Picasso's exploration of Delacroix's composition. Within the two parts of the series, the canvases fall into pairs, or sets of three, executed within a few days of each other.

A *and* B *December 13, 1954*

Picasso painted two small canvases on December 13th, taking the three figures at the right (the two seated wives and their servant) and freely rearranging them. Drawing on both the 1834 and 1849 versions of the painting at once (the hexagonal table comes from the latter), the paintings play off one another.

Canvas A[61] is dominated by the bare-breasted odalisque to the right who has fallen asleep, her head resting on her raised knee. She is based on the "Jacqueline" figure in the original, and embodies the mood of reverie that pervades the original work as a whole. The odalisque next to her, who has taken over the water pipe, sits in a dream-like state, while the servant—squeezed into a jumble of furnishings in the background—scurries by, holding aloft a coffeepot.

In Canvas B (fig. 5–7), Picasso disrupts the sensual torpor of the first canvas, although the sleeper has not yet awakened. A clarification of forms and spatial relations takes place. He imparts a rhythmic quality to the figures through their bold curved outlines, and gives each one her own space. The servant now takes the lead role, cutting a swath between her seated, dreaming mistresses with her dynamic, thrusting form. The phallic shape of the ogive niche to the left, derived from the 1849 version of the Delacroix, seems to wittily evoke the absent master, the viewer, or Picasso himself. Painted in grisaille, the image hovers between painting and drawing, and the states of dream and reality.

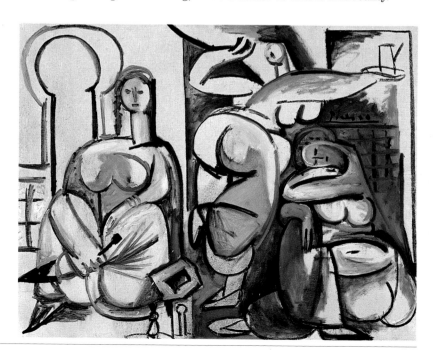

Fig. 5–7 *Pablo Picasso.* Women of Algiers, after Delacroix. *B. December 13, 1954. Oil on canvas, 23⅝ × 28¾" (60 × 73 cm). The May Family Collection, Beverly Hills, California*

As Robert Rosenblum has noted, Picasso's compression of voluptuous female forms in an interior brings to mind Ingres's *Turkish Bath* of 1862–63; in his bridging of these two antithetical nineteenth-century masters, he seems to allude to his own competitive relationship with Matisse, who is also evoked in the curvilinear outlines.[62] Echoes of his own *Demoiselles d'Avignon*, which drew on both nineteenth-century sources, are sounded as well.

C *and* D *December 28 and January 1*

In the next two paintings, which span the turn of the year,[63] Picasso adopts a more aggressive and experimental approach and dives into the problem of the full four-figure composition, freely rearranging the figures, and reconfiguring their forms in a more abstract language. The missing odalisque of the previous two paintings has now rejoined the trio, but identities are somewhat fluid. The squatting posture (with one knee up and the other bent under her) of the Jacqueline look-alike holding the pipe to the far right in the Delacroix painting is assigned to the figure to the far left in the Picasso, while "Jacqueline" breaks loose completely from her passive nineteenth-century counterpart, and assumes a head-standing pose, exposing breasts, back, vulva, and buttocks at once.

At least fifteen drawings preceded this canvas, most of which focus on the upended nude, as seen for example in fig. 5–8, one of the finest of the suite.[64] The sensuality of her Delacroix counterpart is now discarded for a more blatant eroticism, recorded in a graffiti-like manner, but Picasso seems to have been thinking more of Matisse: the headstander suggests affinity with some of his most radical and sensual representations of the nude female body, such as his *Upside-down Nude with Stove* (fig. 5–9), a well-known lithograph of 1928–29.[65]

While in C, Picasso distributes the figure somewhat evenly within the picture space, in the following one (D), two figures—the headstander, who has now slid down on her back, while her legs remain hoisted in the air, and the smoker to the far left—segregate from the group and push

Below, left:

Fig. 5–8 *Pablo Picasso.* Drawing for the Women of Algiers. *December 25, 1954. Blue pencil, 82¾ × 106¼" (210 × 270 cm). Musée Picasso, Paris*

Below, right:

Fig. 5–9 *Henri Matisse.* Upside-down Nude with Stove. *1929. Lithograph, 22 × 18⅛" (55.9 × 46 cm). The Museum of Modern Art, New York. Gift of Abby Aldrich Rockefeller (by exchange)*

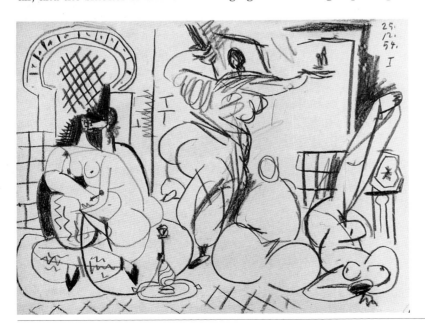

forward to the frontal plane, leaving the other two framed by a darkened doorway.

E *January 16, 1955*

In Canvas E (fig. 5–10), executed two weeks later, Picasso returns to the three-figure composition with which he launched the series. Here, figures are no longer compressed in space but instead create it, their bodies measuring out the vertical, horizontal, and depth dimensions.

The sleeper, now dramatically enlarged, and painted a bold Matissean blue—in direct challenge and homage to his rival's famous *Blue Nude* (Ch. 2, fig. 2–19)—stretches out across the frontal plane, pushing up

Fig. 5–10 *Pablo Picasso.* Women of Algiers, after Delacroix (Femmes d'Alger). *E. January 16, 1955. Oil on canvas, 18⅛ × 21⅝″ (46 × 55 cm). San Francisco Museum of Modern Art, San Francisco. Gift of Wilbur D. May*

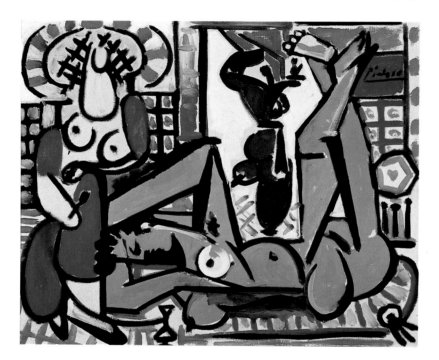

against the red-garbed smoker at the left-hand margin.[66] The nude's extended legs fill the vertical dimension, her feet almost brushing the painting's upper edge. Her head turns downward in opposition to her legs, while her torso twists, revealing aspects of a front and back view.

It is not only Matisse who participates in Picasso's dialogue with Delacroix, but also Velázquez, as Steinberg has noted. The servant, now dressed in green and poised in the opening of a curtained space, recalls the chamberlain in *Las Meninas*, who also glances over his shoulder from a doorway at the back of the room (see Ch. 6, fig. 6–1).[67] What could have prompted this connection? There are certain structural similarities between them: both pictures show a room in which figures confront us in a frieze-like formation with one towering over the rest, the space is somewhat indeterminate, and the viewer is drawn into the scene. But the link lies at a deeper level: both are in a sense "harems" or spaces dominated by women, just as they are also "studios" or theater stages where daughters, wives, mistresses, servants, muses, and models seem to be interchangeable. As Picasso traveled into the Delacroix

painting, the harem and studio themes meet and overlap: in this idealized space beyond time he and his fellow painters—Delacroix, Matisse, and Velázquez—engage in a fraternal conversation, or game of mirrors, each reflecting the other's work. Ingres is there, too, for Picasso's three-figure composition recalls his *Odalisque with Slave* of 1839 (fig. 5–11). The work was quite likely a commentary on the *Women of Algiers*, which Ingres had seen in the Salon of 1834,[68] and Picasso undoubtedly saw the connection. It was his *Serenade* (*L'Aubade*) of 1942 (fig. 5–4), based loosely on the *Odalisque with Slave*, that he held up for comparison with the *Women of Algiers* in his Louvre visit of 1946. Thus the dialogue with Delacroix evolves quickly from the particular source to what Picasso and Matisse referred to as "the great chain of artists," a topic

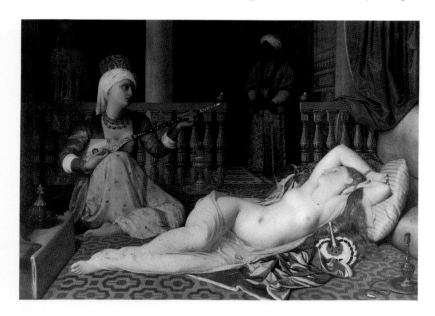

Fig. 5–11 *Jean-Auguste-Dominique Ingres.* Odalisque with Slave. *1839–40. Oil on canvas mounted on panel, 29½ × 40½″ (74.9 × 102.9 cm). Courtesy of the Fogg Museum. Harvard University Art Museums, Cambridge. Bequest of Grenville L. Winthrop*

addressed in many of their conversations.[69] Picasso's references to other artists, however, are underscored by references to his own art as well: in the juxtaposition of the alert and sleeping figures in the foreground, his familiar motif of the watched sleeper also imposes itself and shapes the material at hand.[70] In Canvas F,[71] another version of the composition as a whole, the smoker is elaborated into a "femme-fleur"—Picasso's persona for Gilot, here pushed to the margin by the sprawling nude.

H, I, J *January 24, 25, 26, 1955*

The first of the seven large paintings, Canvas H (fig. 5–12) is the last of the three-figure compositions. While the servant remains unchanged, Picasso continues to experiment with the other two figures. They develop along two different stylistic lines, just as they push apart physically. The smoker, with her cohesive form and smooth contours has become more Matissean. She is set further back in space, and the niche has been all but eliminated, though wittily referred to through the shape of the tiny hat (or fez) that rests on her head.[72] The fragmented form of the sleeper, contracted in length and now more muscular, monumental, and masculine, is characteristically Picassoesque, merged with aspects of

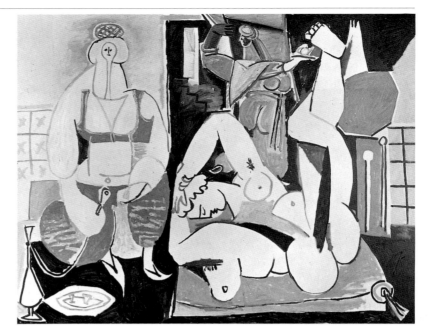

the powerful *Blue Nude*, and perhaps one of Matisse's sources for his 1907 painting, Michelangelo's powerful reclining figures from the Medici tombs.[73] Picasso splits apart the two halves of her powerful torso from the waist up, perhaps rivaling the torsion of the Matisse nude, and carrying it further. With this divided figure, Picasso sets out to resolve the central problem that, in Steinberg's view, will preoccupy him throughout the rest of the series: to depict her from both the front and back at the same time.[74]

The decor of the room has been greatly simplified; patterning is reduced and relegated to discrete areas. The walls are now painted in single colors, and the area beyond the curtain is developed into a dark passageway enclosing a short flight of stairs that lead to an open door. The quotation from *Las Meninas* now appears to be overlaid with reminiscences of the mysterious doors and windows and small bathing huts that appear in Picasso's art of the late twenties and early thirties.

In color, Picasso breaks more definitively from the original, establishing his own course. Set against a pale blue ground, the smoker is represented in a bright red vest embellished with thick striations of yellow, and a white blouse decorated with strokes of creamy white. The servant is garbed in tones of an acidic green, while the sleeper has no color at all; her naked body is represented by the smooth white primer of the canvas. Thus, the sleeper is depicted at a different level of abstraction than the other two figures; the absence of color underlines her otherness.

On the two following days, Picasso produced two more canvases of the full composition (I, J).[75]

K *February 6, 1955*

When he returned to the task eleven days later, he produced three more large canvases over a five-day period. In version K (fig. 5–13) he switches back to grisaille and adopts a linear Cubist idiom that evokes a blend

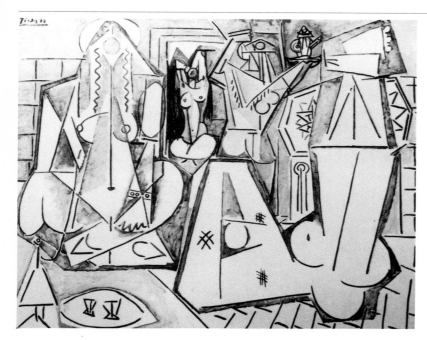

Fig. 5–13 *Pablo Picasso.* Women of Algiers, after Delacroix. *K. February 6, 1955. Oil on canvas, 51⅛ × 63¾" (130 × 162 cm). Collection Mrs. Victor Ganz, New York*

of his classic Analytic and later Synthetic phases. This evacuation of color and volume raises questions. Was Matisse becoming too overbearing in the triangular relationship with Delacroix, or was Picasso giving vent to "nihilistic despair over his friend's demise"?[76] Or was the change of idiom necessary for the resolution of a formal problem? Picasso offered no clues. A friend and biographer of the artist recalled seeing the works shortly after they were completed: "As he continued to bring out more canvases, I remarked upon the variations between the representational and cubist styles. I could discover no direct sequence leading in either direction. With an enigmatic smile, he told me that he himself never knew what was coming next, nor did he try to interpret what he had done. 'That is for others to do if they wish,' he said . . ."[77]

In keeping with the strong reductive impulse on a formal level that Picasso brings to this work, facial features disappear, and, except for the servant's fringed scarf, all figures are nude. The sleeper, however, retains her independence from the other three figures and the surrounding space of the room through her lack of interior modeling. Her flat shape, reserved from the white ground of the primed canvas, and her powerful arms enclosing her small head contrast strongly with the soft, swelling forms of the smoker. The two halves of the sleeper are now elegantly conjoined in a single contour, while the absence of breasts and facial features facilitate a dual reading of the figure as prone and supine; a resolution of the quest for simultaneous vision, central to Steinberg's interpretation of the series, is thus achieved. The open-ended experimentation with form, seen in the earlier canvases, is replaced here by an assertion of the artist's virtuosity as both draughtsman and painter. In a formal tour-de-force, he recreates his predecessor's work in an opposing structural system, in which line and chiaroscuro replace volume and color, and abstract form is substituted for representational. At the same time Picasso revisits his own classic Cubist idiom, by this time as "historic" as his Delacroix source. He "writes" the Algériennes into his art in his own language of signs.

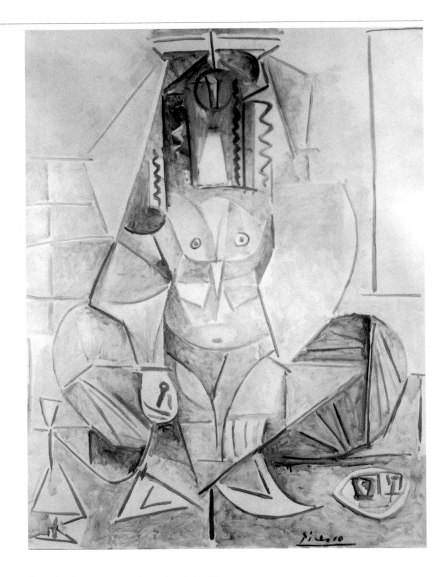

L *and* M *February 9 and 11, 1955*

Picasso retains the abstract vocabulary and grisaille palette of K in L (fig. 5–14)—a detail of the smoker alone—and sharpens the contrast between the smoker and sleeper in Canvas M (fig. 5–15). The palette changes from the warm brown tones of K to a cooler range of gray, black and white, and the format of the canvas from an almost square to a long rectangle. Making use of a vocabulary of predominately circular and angular forms, this work has even greater formal cohesion and austerity than Canvas K. The tension between the two systems of representation is pulled to an extreme in this diagrammatic work. The later work is but a distant echo of its theme, yet the sensuality of the original is retained in its exquisitely crafted, painterly surface. The effect of transparency achieved here recalls aspects of the 1849 version of the harem, with its subtly nuanced, broken colors and atmospheric effects.[78] The grisaille palette and painterly style of variation M also recall aspects of *Las Meninas*. This canvas was painted on the day that Picasso's estranged wife, Olga Koklova, died, and thus passed out of his "harem."

Opposite, above:
Fig. 5–15 *Pablo Picasso.* Women of Algiers, after Delacroix. *M. February 11, 1955. Oil on canvas, 50¼ × 76¾″ (130 × 195 cm). Collection Mrs. Victor Ganz, New York*

Opposite, below:
Fig. 5–16 *Pablo Picasso.* Women of Algiers, after Delacroix. *N. February 13, 1955. Oil on canvas, 44½ × 57⅜″ (114 × 146 cm). Washington University Gallery of Art, St. Louis. University purchase, Steinberg Fund, 1960*

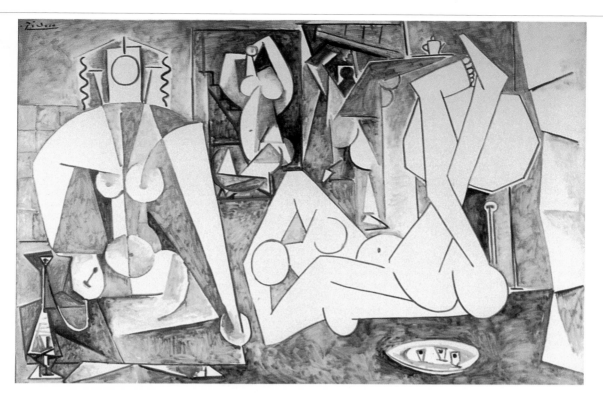

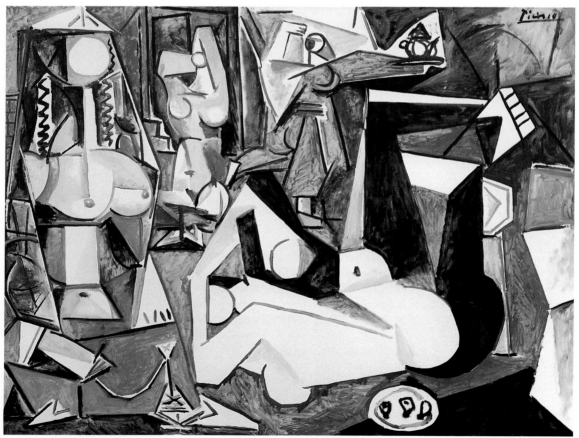

In the penultimate variation (fig. 5–16), Picasso maintains the thinly painted, tactile surface of the previous canvas. His vigorous brushstrokes articulate the surfaces of the geometric planes, and bright, primary colors and volume are readmitted to the dialogue: red, yellow-green, and blue radiate outwards. More striking is the reinfusion of sensuality.

The smoker at the far left is the focus of the composition. As one scholar notes, with her bared breasts, long black curls, red dress, and pointed shoes, she emphatically reasserts the sexuality of the harem women, while conjuring up Jacqueline.[79] Her face, however, remains blank. "She is quiet, solemn and totemic, her inflated breasts making clear that she is an object of desire."[80] The opposition between smoker and sleeper, established in earlier versions, is intensified here. The latter is represented in curved planes of white with gray and black shading, in a style that seems to anticipate Picasso's bent-sheet metal sculpture of 1959–63.

Picasso once told John Richardson that it was often the first or the penultimate version in a series of paintings that he considered the best; the final was often too finished, an observation that applies to this suite.[81] In the directness of means and frank eroticism, Picasso here creates a fitting counterpart to Delacroix's great work, renewed for twentieth-century eyes.

O *February 14, 1955*

This final canvas (fig. 5–17) is slightly smaller and more vibrant than the previous one. Every faceted plane is now embellished with patterns and color. The dialogue between representational systems played out on various levels throughout the series, comes to rest in the dramatic juxtaposition of the volumetric smoker and the Cubist sleeper. Contrasts between colors, between surface and depth, and color and texture are also intensified. Moreover, the composition in this final work reverses that of the original. Here, the frontal, seated smoker at the left fills the space in the vertical dimension and towers over the other figures. In Delacroix's painting, the servant played a similar role at the opposite side. The evocative transparency of the previous works, opening on to layers of depth, is replaced by an emphatic assertion of the material quality of paint on canvas.

"Everything comes together in Canvas O," Steinberg notes, ". . . it reunites the exercise of simultaneity with its erotic impulse, and the multi-aspect figure with a responsive space."[82] Steinberg's "will to consolidation" finds its realization here. In addition, the two halves of the pictorial universe—that of line and color, the domains of Picasso and Matisse—are brought together. Picasso evokes his old rival not only in color, but in his use of patterning: the stripes on the right recall his interiors of his Nice period, and refer back ultimately to Matisse's inspiration in Delacroix's embellished surfaces. In taking his place alongside Matisse as a "triumphant colorist," Picasso retraces the journey of modern art back to Delacroix through the phases of Cubism, Fauvism, and Neo-Impressionism. The juxtaposition of highly saturated primary colors and textured surfaces recalls Signac's positioning of the *Women of Algiers* as the well-spring of future developments in the coloristic tradi-

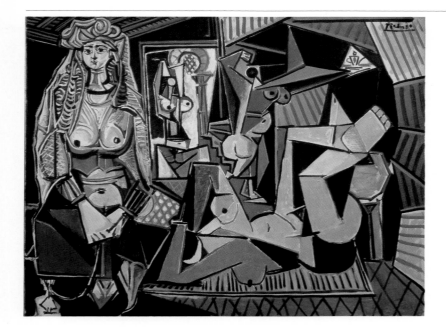

Fig. 5–17 *Pablo Picasso.* Women of Algiers, after Delacroix. *O. February 14, 1955. Oil on canvas, 44⅞ × 57½" (114 × 146 cm). Collection Mrs. Victor Ganz, New York*

tion. This final version also brings to mind Picasso's own reworking of pointillism for decorative effects during the post-World War I years.

Inasmuch as this canvas is the summation of the Delacroix suite, it also serves as a prelude to Picasso's next encounter, with a masterpiece that carried even greater weight in his artistic universe—Velázquez's *Las Meninas*, a painting hinted at earlier in the series. The towering figure of the smoker at the left, which now extends to the full height of the canvas, recalls the dominating figure of the painter in the Velázquez canvas. As in the Spanish masterpiece, the notion of any fixed relation between representation and reality (or sign and symbolic content) is held up to question: the smoker is both model and artist, while the doorway behind her now doubles as the artist's canvas or the mirror (or both), and the "Blue Nude" in the foreground may be seen as her model.

In the *Women of Algiers*, as noted earlier, various artistic currents are synthesized. Likewise, Picasso's series encompasses multiple modern idioms, while Delacroix is "altered" to accommodate Velázquez, Ingres, and Matisse. Picasso's own seminal, early masterpiece, *Les Demoiselles d'Avignon* (Ch. 2, fig. 2–14), for which Delacroix's painting served as a source, hovers as a reference throughout the series. Indeed, "We are all in Delacroix." The subject of the harem itself is fused with the studio and the brothel to become an allegory of creation. Thus, the Romantic impulse toward the continual expansion of boundaries is absorbed and carried out in Picasso's response, in which every element is transformed into something else.

With this body of work, Picasso launched a new form of serial variation, perhaps in emulation of the grand decorative cycles of both Delacroix and Matisse. More than the sum of its parts, this suite bears tribute not only to the artist's force of invention, but also to the enduring power of Delacroix's creation as a point of origin, both in Picasso's individual artistic journey, and in modern art as a whole, which finds here its "latest and most abundant flowering."[83]

In the Studio of Velázquez

In the mind of the artist a sort of chemical reaction is set going by the clash of the individual sensibility and already existing art. He does not find himself alone in the world; in his relation to the world there always intervenes, like an interpreter, the artistic tradition.
—José Ortega y Gasset, 1948[1]

No painting in the history of art was more imbued with personal and historical meaning for Picasso than Velázquez's masterpiece, *Las Meninas*, which first imprinted itself on him in adolescence, before his own notion of tradition was formed and began to intervene. As we have seen, Picasso's 1950 variation after El Greco's *Portrait of a Painter* (Ch. 4, fig. 4–37), his first after an artist of his native land, heralded his so-called Spanish decade. The characters that returned to his art in the 1950s—the swaggering bullfighters, procuresses, and courtesans with their duennas—are freighted with nostalgia for his country of origin, and seem to cover over in a sometimes self-mocking way a loss of a significant part of himself. This longing is expressed most poignantly in Picasso's four-month dialogue with Velázquez's *Las Meninas* (1656), which he carried out from August to December 1957 at his villa La Californie in Cannes. The encounter resulted in forty-five paintings based directly on Velázquez's painting and an additional thirteen related works.[2]

It was perhaps inevitable that at some point in his life, Picasso would be lured into the labyrinthine depths of the greatest of all Spanish paintings. Which other work could present so significant a challenge to Picasso as his forebear's masterpiece, which once bore the inscription "*obra culminante de la pintura universal*" (the culminating work of world art) in brass letters on a placard before it in the Prado?[3] In *Las Meninas* (fig. 6–1) nine life-size, identifiable figures from the court of Philip IV are captured in the act of responding to something or someone beyond the frame of the picture. The scene is depicted with such startling realism that, at first glance, the figures appear to be preserved in an extension of our own space. At the center stands the five-year-old Infanta of Spain, María Margarita, daughter of King Philip IV and Queen Mariana. She is flanked by her *meninas* (or handmaidens), María Agustina Sarmiento on the left, who offers her water in a clay vessel, and Isabel de Velasco on the right. Further to the right are two dwarfs, Maribárbola and Nicolás Pertusato, and a gentle, large dog lying down in the foreground. Behind this group are two chaperons, and standing at the top of a short flight of stairs in an open doorway is the queen's cham-

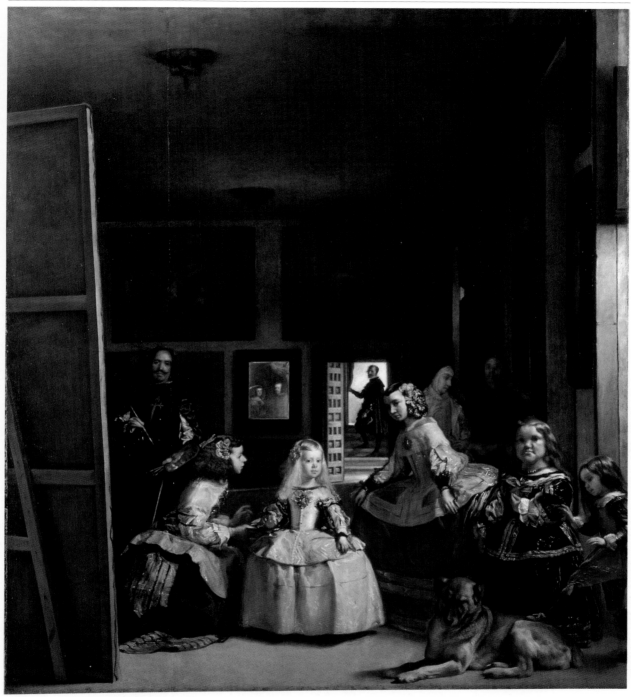

Fig. 6–1 *Diego Velázquez*. The Maids of Honor (Las Meninas). *1656. Oil on canvas, 125 × 118½" (321 × 181 cm). Museo del Prado, Madrid*

berlain, José Nieto, who glances back at the assembled group. At the left, stepping out from behind a large canvas that has its back to us, is Velázquez himself, brush in mid-air. He looks out at a point beyond the space of the room directly in front of the painting, presumably at his model. In his biography of Velázquez of 1724, Antonio Palomino de Castro (to whom we are indebted for the names of the cast of characters) also offers the first published opinion of what the painter is painting on the hidden face of the canvas—a riddle that has obsessed generations of viewers: "Velázquez proved his great genius because of the clever way in which he reveals the subject of what his is painting. He makes use of the mirror at the back of the gallery to show us the reflection of our Catholic kings, Philip and Mariana."[4] Palomino concludes his description of the master's "most illustrious work" with the assertion, "It is impossible to overrate this painting because it is truth, not painting."[5]

The apparent realism of the scene, however, is only a cover for Velázquez's ingenious perspectival sleights-of-hand, which, as the art historian Jonathan Brown has noted, rupture the picture's narrative coherence and leave "gaps in the story. . . .wide enough to invite every imaginable interpretation."[6] Velázquez's subtle departures from the conventions of classical representation epitomize the indigenous counter-classical tendency of Spanish art, which sets itself apart from the "grand manner" that originated in the Italian Renaissance.[7] At the end of the nineteenth century, however, when Picasso first became acquainted with *Las Meninas*, the work was appreciated for its naturalism or "truth"—a view summed up in Théophile Gauthier's witticism, "Où est, donc, le tableau?" (Where, then, is the painting?)[8] In keeping with the self-reflexive spirit of twentieth-century art, however, the painting's paradoxical nature came to the fore, giving rise to myriad iconographic interpretations.[9] By the second half of the century, the picture that had stood for "truth and not painting" came to represent "painting and not truth" (or painting as truth), reflecting modernism's reductive focus on the nature of representation itself and the reciprocal relationship of the objective world with the subjective experience of the viewer. The "tableau vivant" of the late nineteenth century became by the later twentieth a "system of feints." In his essay of 1966, the philosopher Michel Foucault described the work as:

A mere confrontation, eyes catching one another's glance, direct looks superimposing themselves upon one another as they cross. And yet this slender line of reciprocal visibility embraces a whole complex network of uncertainties, exchanges, and feints. The painter is turning his eyes towards us only in so far as we happen to occupy the same position as his subject. We, the spectators, are the additional factor. Though greeted by that gaze, we are also dismissed by it, replaced by that which was always there before we were, the model itself. But, inversely, the painter's gaze, addressed to the void confronting him outside the picture, accepts as many models as there are spectators; in this precise and neutral place the observer and the observed take part in a ceaseless exchange.[10]

Foucault's interpretation has spawned numerous other articles by both philosophers and art historians, which take up the issue of whether the mirror reflects the implied figures of the king and queen in front of the canvas, or their painted images from the front of the painting within the picture, or both.[11] "Truth" came to be intimately connected with the spectator's point of view. A recent spatial analysis by Martin

Kemp of the actual room in the Alcazar palace in which the scene depicted in *Las Meninas* takes place (and where Velázquez in fact executed the painting) demonstrates that, as Palomino first stated, it is the painted image of the king and queen from the front of the large canvas on which the artist is working that is reflected in the mirror.[12] Yet no empirical evidence can override the elusive interchange of illusion and reality that lies at the core of *Las Meninas*, through which Velázquez questions the complex nature of the relationship of representations and real things.

While the preeminent position of *Las Meninas* in the history of art, as well as its theme of the artist at work and the questions it raises concerning representation, were more than sufficient to make it an obvious target of Picasso's emulation, there are also specific formal qualities of the work—e.g., the compelling outward thrust of the composition toward the spectator—that would have seized his imagination. As Kemp notes, "No painting was ever more concerned with 'looking'—on the part of the painter, the figures in the painting, and the spectator."[13] In *Las Meninas*, however, the viewer does not merely complete the narrative as the displaced focal point of the composition. The viewer tries to situate himself by taking up the point of view before the painting that is both explicitly assigned him by the composition of the work and its implicit demand for narrative completion. At the same time, his desire for resolution is denied through the interplay of perspectival viewpoints, and the fact that he must compete for his place with unrepresented members of the cast of characters—the king and queen, and Velázquez himself, who occupied the same general area when painting the picture. Furthermore, the play of real and illusory in the painting's narrative structure is reinforced on another level. The variety of images depicted in the scene, including paintings within the painting, figures reflected in the mirror, windows, a door, and characters from real life, represent, in one scholar's words, "different pictorial realities," with the painter as "the physical and spiritual pivot from which the synthesis of different visual realms originate . . . and around which they turn."[14] These various representational modes vie with each other for dominance and contribute to the painting's questioning of the problematic connection between appearance and reality, and of the possibility of any absolute truth.

To the co-founder of Cubism, these exchanges between real and pictorial space, the represented and the implied, and the interplay of structural systems, were undoubtedly among the primary attractions of the work.[15] Through the quintessential Spanish masterpiece, he continues to investigate an issue at the center of his own art: the irresolvable gap between the painted sign and symbolic meaning.[16] It is in this fissure that Picasso finds connection with his predecessor and discovers meaning of his own, thus renewing one of the most familiar works in the history of art and reconnecting with his artistic roots. The ground on which Picasso sets himself in front of *Las Meninas* is dynamic and shifting; his challenge is to establish his position within the ongoing history of interpretations of the painting and make it his own by absorbing all three roles—that of viewer in the present, implied participant in the historical scenario, and author.

Yet another powerful attraction to *Las Meninas* for Picasso would have been the layers of association and involuntary memory embedded in a work he had known over his entire life. Picasso first encountered

Fig. 6–2 *Pablo Picasso.* Figures from Las Meninas: María Agustina and María Margarita. *1897–98. Pencil on paper, 6³/₁₆ × 8⁹/₁₆″ (15.7 × 21.8 cm). Museu Picasso, Barcelona*

Las Meninas in the spring of 1895 in the company of his father and first teacher, Don José Ruiz. En route from La Corunna to Málaga, the family stopped for a day in Madrid so that Don José could take his son, then fourteen, to the Prado.[17] The year was a watershed for Picasso and his family: in January the youngest of the three Ruiz children, the blond María de la Concepción (Conchita), had died of diphtheria at age seven. As John Richardson has shown, Picasso mourned her throughout his life, and his father never fully recovered from the loss.[18] In the fall the family moved to Barcelona, where Don José took on a new teaching post at the local academy, La Llotja. There Picasso would soon establish his own path in more or less direct opposition to that of his father, and to the naturalism that Velázquez's art then epitomized. The visit to the Prado thus took place just before the young Picasso emancipated himself fully from his father's influence.

Looking back on *Las Meninas* from a perspective of sixty or more years, Picasso's first view of the "*obra culminante*" at his father's side could not but have been deeply imprinted on his memory, and become fused with the work itself. Picasso's first direct reference to the work occurs two years later in the form of a sketch of two of the figures from *Las Meninas* (fig. 6–2), executed during a period of study in Madrid. Over the course of his career, Picasso turned from time to time to *Las Meninas* for inspiration, often in indirect form. In one of his own first masterpieces, the *Demoiselles d'Avignon* (Ch. 2, fig. 2–14), it has been suggested that the intensity of address with which the eyes of the figures in the painting are directed on a spot in front of the picture plane, in the viewer's space, may well derive from *Las Meninas*.[19] Furthermore, in a study for his *Self-Portrait with a Palette* of a year earlier, Picasso had represented himself in the pose of Velázquez in *Las Meninas*, a revealing moment of identification, suppressed in the final version (fig. 6–3).[20] In the late 1920s, some of Picasso's Synthetic Cubist studies reflect *Las Meninas* at a distance.[21] Picasso may also have turned to the painting as something of an interior model in another major work, *Guernica* (Ch. 3, fig. 3–26), painted in 1937.[22] In his struggle to give expression to the spir-

it of the Spanish people in *Guernica*, Picasso appears to have absorbed aspects of the composition as well as the provocative combination of drama and detachment of that most enduring of national monuments.

The critical fortunes of Velázquez represent yet another dynamic process that enters into and shapes Picasso's dialogue with the master. As a youth in Spain, Picasso had witnessed Velázquez's artistic apotheosis. In the last two decades of the nineteenth century, the only extended period of his life that Picasso spent in Spain, Velázquez was the focus of intensive scholarly study in the Peninsula. British, German, and French scholars had been among the first to lay the foundations for a critical assessment of Velázquez's oeuvre, establishing him as "universal master" on a par with Rembrandt and Raphael.[23] In the 1880s and 1890s, Spanish historians rushed to reclaim Velázquez from the outsiders, and to establish his position as Spain's premier artist. "We have the main thing," one writer complained, "the paintings, but lack the interpretation . . . Outside Spain, our art counts for little, and if they discover an artist like Velázquez, they do not realize that he is Spanish."[24] The first Spanish monographs on Velázquez appeared in the last two decades of the nineteenth century, and in 1899, marking the tricentennial of his death, a large retrospective of Velázquez's work was held at the Prado.[25] *Las Meninas* was set up in a special room, a sort of simulacrum of the work itself, "with the light admitted from the left, in the same way as was the case when the picture was painted."[26] During the celebration, the bronze statue of Velázquez was set in front of the Prado, where it remains today. Could there be any further doubt as to his status as the standard-bearer of the national tradition?

During his years in Barcelona Picasso allied himself with the burgeoning Catalan movement of *Modernisme*, the members of which participated in the rediscovery of El Greco, whom they anointed as the prophet and patron of their anti-naturalistic art. The "realism" of Velázquez had considerably less appeal to the Catalan group; in fact, as Palau y Fabre notes, "the modernists' irreverence for such sacrosanct national monuments as *Las Meninas* played a role in bringing about Picasso's integration into the group."[27] For the young Picasso, Velázquez

Fig. 6–3 *Pablo Picasso.* Studies for Self-Portrait with a Palette. *Autumn 1906. Pencil on paper, 12⅜ × 19″ (31.5 × 48.3 cm). Musée Picasso, Paris*

was clearly a presence, though not a powerful influence, as was El Greco. His interest in Velázquez appears to be laced with ambivalence, as revealed in the subtle changes he introduces in his copy of the portrait of Philip IV in the Prado, made in the fall of 1897 (Ch. 1, figs. 1–2 and 1–3) while a student in Madrid. Yet once he was established in France, as discussed in Chapter 4, Picasso's appreciation for Velázquez's naturalism grew, while his early enthusiasm for El Greco's mysticism diminished. "We cannot conceive of a Philip IV in any other way than Velázquez painted him . . . He convinces us by his right of might," he remarked in 1923.[28]

It is no coincidence that Picasso turned to Velázquez's masterpiece at a time when he was becoming increasingly isolated behind the wall of his fame, and his influence on younger artists was waning. By his mid-seventies, the towering figure of twentieth-century art had arrived at a problematic relationship with the present, not uncommon in long-lived artists. As one art historian has noted, "the late works of great masters, which come about at the period style of a subsequent generation, tower over the flow of history as solitudes, inaccessible to the context of time."[29] Although Picasso had discussed redoing *Las Meninas* with his lifelong friend Jaime Sabartès in the early fifties (as he entered his seventies), he only undertook the project at seventy-five, the age at which his own father had died. Reaching this significant marker would undoubtedly have triggered Picasso's morbid fear of death and concern with securing a place among the immortals. The "father" of Spanish art would have been an unavoidable measure of his own stature, while the continuous recognition bestowed on that totem of creativity endowed *Las Meninas* with almost death-defying powers.

When Picasso executed his variations in 1957, *Las Meninas* had just passed by some months its three-hundredth anniversary. Was it once again time to claim it for the Spanish and to reassert his own identity?

The Meninas Variations

Suppose one were to make a copy of *The Maids of Honor;* if it were I, the moment would come when I would say to myself: suppose I moved this figure a little to the right or a little to the left? At that point I would try it without giving a thought to Velázquez. Almost certainly, I would be tempted to modify the light or to arrange it differently in view of the changed position of the figure. Gradually I would create a painting of *The Maids of Honor* sure to horrify the specialist in the copying of old masters. It would not be *The Maids of Honor* he saw when he looked at Velázquez's picture; it would be *my Maids of Honor.*
—Picasso to Sabartès, 1950[30]

Overture

1 *August 17, 1957*

In the first variation (fig. 6–4), Picasso's largest canvas since *Guernica,* and the largest by far of the entire series, the artist boldly propels the image three centuries forward. The first variation, which was left unfinished, announces the themes he will develop, and immediately fulfills his intention of making his predecessor's work "my *Maids of Honor.*" He will paint another thirty-two paintings before he returns again to the ensemble.

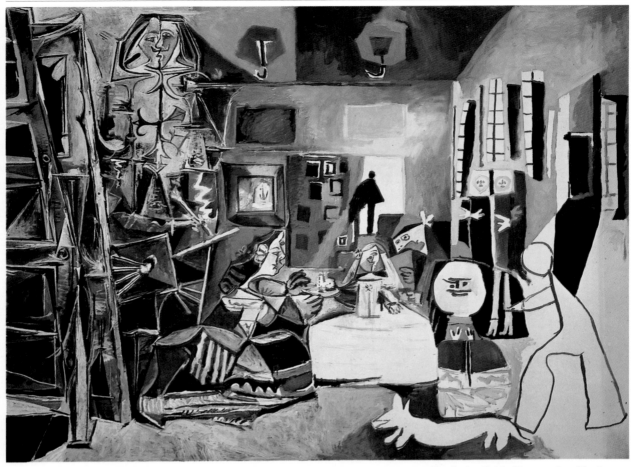

Fig. 6–4 *Pablo Picasso.* Las Meninas, after Velázquez *1. August 17, 1957. Oil on canvas, 76⅜ × 102¼" (194 × 260 cm). Museu Picasso, Barcelona*

If *Las Meninas* had, in fact, entered into Picasso's pool of associations while painting *Guernica*, the connection appears to be reflected here in the horizontal orientation of the canvas (unlike that of Velázquez), in the grisaille palette, and in the overall composition, in which a centralized triangle and two upright flanking panels are used. Picasso attempts to displace Velázquez's authority at the outset by taking a place beside him, merging his reconstruction of his predecessor's culminating work with reminiscences of a masterpiece of his own, which may, in turn, echo *Las Meninas.*

The receding space of the palace room has been compressed in the Picasso into a Cubist layering of planes that retains a strong echo of the depth of the original. Picasso seizes on the perspectival ambiguities of his theme, and develops them in a new direction in a modern, reductive vocabulary, while demonstrating both his appreciation of and his distance from Velázquez's own iconoclasm. Within Picasso's Cubist box—the sides of which have been pushed back—figures, released from perspective, shift places (as he predicted) or shoot up and out of scale with the rest. The painter's head, with its double-profiled face, overlapped by a single nose, brushes the top of the ceiling, and he holds not one, but two palettes.[31] Yet the towering giant of Spanish art is curiously insubstantial: his profiles face inward, isolating him from the rest of the group, and his faceted body melds into the space around him. He is in the

process of dissolution, about to be expelled from the company of the *meninas*. In the next forty-three paintings, the figure of Velázquez will reappear only three times, and then only as an insignificant player. Picasso has already taken his place.

The rest of the figures, with the exception of the chaperons, are drawn into a triangle as in the original, although in a more compact and central one; it is on them—the Infanta and her retinue—that Picasso will focus his attention in the next months. Velázquez's major figure, the Infanta María Margarita, remains Picasso's focus as well. Picasso places increased significance on José Nieto, the *aposentador*, or Queen's chamberlain, who is framed in the doorway on the steps at the back of the picture, presumably holding open the door for the royal couple's passage through the room. Though Nieto is the smallest and most distant figure in the original, his importance is underlined by his position at the perspectival center of the work, located in his bent arm. Poised on the stair and looking back on the assembled group in the room from a point beyond it, he alone shares with the painter within the picture a view of both the royal couple standing beyond the limits of the work, and their painted image on the canvas, both of which are denied to the viewer's sight. An extra or surrogate for the artist, he rounds out the view of the scene from behind.[32]

Picasso shifts Nieto to the apex of the triangle, directly over the Infanta. Given the strong emphasis he placed on the act of looking throughout his art, as seen in his many depictions of lovers watching over their sleeping mates, artists studying their models, and scenes of bawdy voyeurism, it is not surprising that the *aposentador* takes on special significance. Furthermore, Nieto's role as "door opener" undoubtedly reverberated with Picasso's long fascination with doors, windows, and mirrors, frequently presided over by a shadow figure, often a symbolic representation of Picasso himself, as seen, for example, in *The Shadow (L'Ombre)* of 1953 (fig. 6–5).[33] As one scholar has shown, these rectangular architectural elements (with their superimposed shadow figures) are often surrogates for the painting and play a key role in Picasso's concept of art as a form of magic.[34] In shifting the position of Nieto to the left, Picasso imposes a new structure over the original work: two of the main focal points of *Las Meninas*—the physical center of the canvas, located in the eyes of the Infanta, and the vanishing point of the painting in the bent arm of Nieto, which compete with each other for dominance and create tension in the original work[35]—are locked together in a more rigid composition in the variation. In representing himself as large and central to the scene, towering over the phantom figures of the king and queen in the mirror, Velázquez had already taken considerable license with the social order.[36] Picasso develops this element further by placing the courtier directly over the Infanta, asserting his dominance. Nieto stands out from the rest of the cast not only by his position at the apex of the triangle of figures, but also by his small scale and flat, disk-like, featureless head and blank body, which set him apart from the rest of the cast. He appears to be stamped on the canvas like the stenciled letters or numbers in Picasso's Cubist paintings. Neither coming nor going, he is suspended at the threshold, guarding Velázquez's light-filled door.

The most significant change, however, is in the level of abstraction at which Picasso represents reality. By carrying Velázquez's play with the

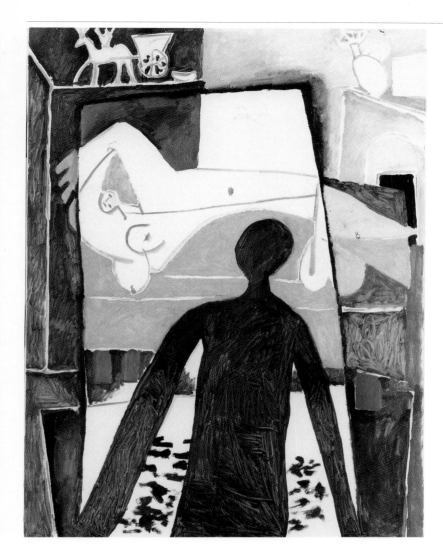

Fig. 6–5 *Pablo Picasso.* The Shadow (L'Ombre). *1953. Oil and gouache on canvas, 51 × 40″ (129.5 × 96.5 cm). Musée Picasso, Paris*

laws of perspective well beyond realistic representation, and introducing a style made up of angular facets and geometric lines, Picasso severs the vital connection between the space within the painting and that of the spectator, and the reciprocity of "direct looks superimposing themselves upon one another as they cross."[37] It is in this relationship of viewer to viewed that much of the meaning of the original work lies. In the variation, the onlooker does not enter into the pictorial space of the painting as a seamless extension of his own, but into an historical continuum—a dialogue between two painters separated by three hundred years on both a formal and thematic level. Picasso's compressed space and flattened forms, which absorb and recast his predecessor's illusionistic idiom, is but a code that overlays another, neither of which has any greater claim to representation as a "valid intentional act."[38] Picasso's painting begins and ends with the surface; the illusion of the external world is replaced with a "truth" of Picasso's own—his own subjective response to Velázquez's depiction of the real world sifted through memory and translated through his fragmented contemporary idiom.

As if to underline his infiltration of the sacred precinct of Velázquez's

studio, he replaces Velázquez's noble mastiff with his own dachshund, Lump, and throws open the windows on the right to let the light flood through modern mullions into the darkened recesses of the room.[39] The first of a long series, this large grisaille is also its masterpiece. From this overall view, a dissection of parts of the composition ensues.

Part I

2 *August 20*

Selecting a moderately-sized upright rectangular canvas, Picasso rivets his attention on the Infanta (fig. 6–6), the central figure of the canvas (fig. 6–7); in the next two weeks he devotes all but one of the next fifteen paintings to her. With her pale golden hair, radiant clothing, and direct outward glance, the Infanta is the most visually compelling figure in the composition, and its linchpin. Picasso launches his series in an analytic spirit, exploring the connections and differences between Velázquez's formal language and his own through careful observation, though he does not refrain from often ruthless parody.

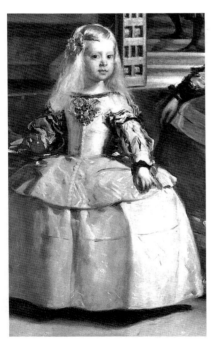

Fig. 6–6 *Diego Velázquez.* Infanta María Margarita, *detail from* The Maids of Honor (Las Meninas)

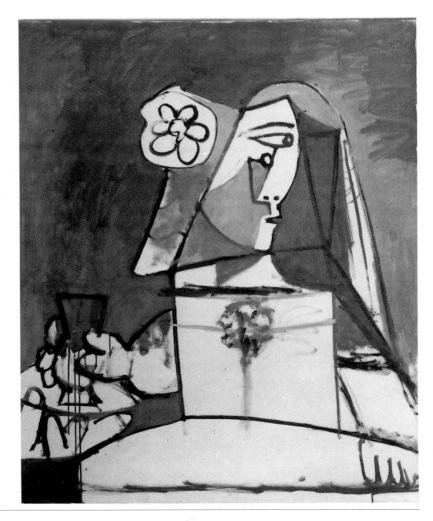

Fig. 6–7 *Pablo Picasso.* Las Meninas, after Velázquez 2 *(Infanta María Margarita). August 20, 1957. Oil on canvas, 39⅜ × 31⅞″ (100 × 81 cm). Museu Picasso, Barcelona*

One of the salient features of Velázquez's painting as a whole, its sense of arrested motion, is made explicit in the "peculiar dislocations between the Infanta's glance and the position of her head."[40] Picasso seizes immediately on the child's quizzical regard and dynamic expression, transposing her soft flesh into a modern vocabulary of flat, angular, and curved shapes set into a triangular framework of rods. Velázquez's subtle dislocations are transposed into a vocabulary of ruptured Cubist planes. Where the Infanta's head pulls gently right and her eyes abruptly left in the original, Picasso responds with a fusion of two interlocking opposing profiles: the top eye, mouth, and chin face right (following the direction of her head), while the bent back profile nose (with frontal nostrils) points to the left, in the direction of her gaze. As if to heighten the points of contrast and continuity between his representational system and Velázquez's, Picasso appropriates certain elements, such as the triangles of light and dark on the princess's neck, directly into his canvas. In the variation, however, these shapes reinforce the child's two-dimensionality and dynamic aspect, and serve as a transition from her complex geometric head to her flat, sandwich-board body. The ragged black line along the neckline of the Infanta's dress in the Velázquez is likewise appropriated almost unchanged. Picasso, however, mimics the "loaded brush" of Velázquez's painterly style through exaggeration, and continues the black border off the edge of her bodice, so that it overruns its representational function to become an abstract element in the design. Picasso's Cubist Infanta is opened up to inspection from multiple points of view, marking Picasso's symbolic entry through this key figure into the painting as a whole. The transformation from flesh to lines and planes, furthermore, reveals Picasso's irreverent and witty approach to appropriation, in which he fits one of the most famous figures in the history of art, frozen in time, to his Cubist template. Yet it is not only form but subject matter that is blatantly altered in translation. To the left of the Infanta, who has been placed slightly off-center, Picasso includes the disembodied hand of the adjacent figure—María Agustina—holding a small clay vessel, known as a *bucaro*, on a tray. The exaggerated size of the *bucaro* and the proffering, cut-off hand create a secondary focus within the work. Not only does this intrusive fragment remind the viewer of the Infanta's relation to the context from which she has been momentarily excised, but it reverberates with the long life of the *bucaro* in Picasso's art, a quintessentially Spanish object which he often overlaid with sexual connotations. The maid's thrusting, phallic fingers and the vessel's swelling form suggest similar meanings here.

3 *August 20*

The attendant, María Agustina, appears in a bust-length portrait in the next canvas (fig. 6–8). Not only was she predicted in the previous work by her arm and hand, but the Infanta's rightward facing profile with parted lips, and receding chin, suggest that Picasso was taking a sidelong glance at the serving girl while painting her mistress, incorporating aspects of the former into the latter. The overlay of one figure upon another, a process that will continue throughout the series, reveals the concision of Picasso's analytic powers.

Changing models, Picasso changes approaches as well: here he rapidly sketches out the adolescent maid in an expressionistic style rem-

Fig. 6–8 *Pablo Picasso.* Las Meninas, after Velázquez 3 *(María Agustina Sarmiento). August 20, 1957. Oil on canvas, 18⅛ × 14¾″ (46 × 37.5 cm). Museu Picasso, Barcelona*

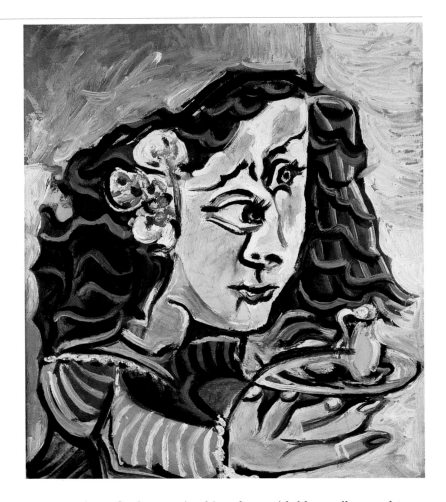

iniscent of van Gogh, warming his palette with blue, yellow, and terra cotta. The disembodied figure of the Infanta is exchanged for one of flesh and blood. Picasso appears to be indulging for a moment in the tantalizing beauty of this dark-haired Spanish girl, but almost immediately he returns to the nucleus of the composition. The Infanta poses a greater challenge: more than any other character, she embodies the whole, her dynamic figure tying the two sides of the large tableau together.[41]

4–7 *August 21–27*

Picasso returns to the grisaille palette and Cubist idiom and continues to analyze the Infanta in alternating standing and bust-length portraits. In the first of these (fig. 6–9), the flattened forms of the full-length figure are projected into low relief and set off by simplified geometrical shapes based on careful scrutiny of the setting as depicted by Velázquez. The presence of Isabel de Velasco, the *menina* to the right of the painting, is suggested by a few stripes from her skirt that overlap the Infanta's. Here, as in the previous depiction of the Infanta, Picasso takes off from, exaggerates, and objectifies Velázquez's shadows, particularly around the left side and hem of her dress, and in the dark areas between her arms and body. The master's brush technique, in which "irregular deposits of pigment float on the surface of rich colors"[42] is taken note of and parodied

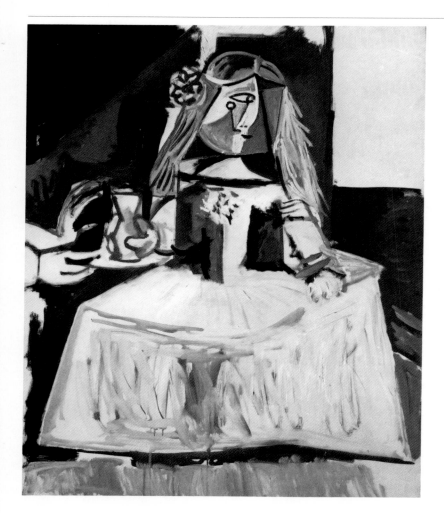

Fig. 6–9 *Pablo Picasso.* Las Meninas, after Velázquez 4 *(Infanta María Margarita). August 21, 1957. Oil on canvas, 39⅜ × 31⅞" (100 × 81 cm). Museu Picasso, Barcelona*

in Picasso's exaggerated free-hand strokes, mere abstractions that lie on the surface. They may also be an irreverent reference to the "empty" gesture painting of the fifties, with which Picasso had no sympathy. As the series progresses he focuses on different elements of Velázquez's illusionistic code—his use of perspective, chiaroscuro, brushstroke, and later, color, and the space of the room itself—holding each up for inspection and testing it against his language of three hundred years later.

8 *August 27*

The eighth canvas (fig. 6–10) represents a moment of synthesis. Picasso throws off the grisaille palette and breaks into color, zooming in on the Infanta's face and shoulders in a highly economical and harmonious work. Reduced to the fundamental elements of visual representation—primary and secondary colors, line and plane, darkness and light—this diagrammatic figure, with its interlocking profiles, challenges the naturalism of his predecessor, with its economy of means and distance from reality, yet with a completeness and complexity of its own. Velázquez portrays an individual captured in a moment in time. Picasso's ideogram spans (and compresses) a broad range of historical styles, yet the figure retains the recognizable features of her counterpart.

Fig. 6–10 *Pablo Picasso.* Las Meninas, after Velázquez *8 (Infanta María Margarita). August 27, 1957. Oil on canvas, 13 × 19¾″ (33 × 24 cm). Museu Picasso, Barcelona*

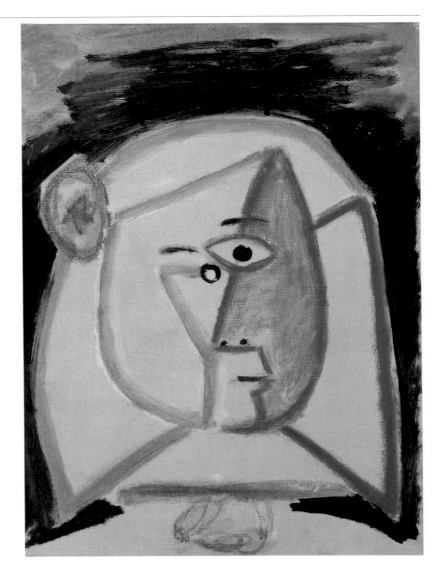

Fig. 6–11 *Pablo Picasso.* Las Meninas, after Velázquez *9 (Infanta María Margarita). August 27, 1957. Oil on canvas, 13 × 19¾″ (33 × 24 cm). Museu Picasso, Barcelona*

9–11 *August 27–28*

The powerful gestalt of the previous work is violently disrupted in the next (fig. 6–11). Here Picasso drives a black wedge down the center of the child's face, and brings her eyes close together, giving her a look that is more simian than human. The picture's cohesion is shattered, and parts drift away. In the next two canvases, no larger than the span of a hand, the child's face fades, like an afterimage.

12–17 *September 4–6*

Picasso picks up where he left off after a week's absence with a bust-length portrait of the Infanta (fig. 6–12), and launches a new approach. Lines and planes dissolve into luminous, painterly fields of yellow and white. The Infanta radiates outward into bordering areas of intense red and blue, as pure energy. The emphasis on parts in her previous incarnations gives way to a greater sense of wholeness, yet the two opposing

profiles remain visible and in discord with each other. A change takes place here from an analytic to an expressionist approach.

In #13 (fig. 6–13), the princess is transformed into a fiery virago set off by the red steps behind her. Picasso has swerved from the ongoing redefinition of a single figure to a quick take of the group as a whole, without the artist. As if to capture the immediacy of his powerful response, Picasso shifts to a crude, almost sub-representational mode, where empty circles stand for heads, and a few, heavy, black lines suffice to define bodies, which do not entirely correspond to forms underneath. The figures reflected in the mirror are reduced to something threatening, resembling crossbones, while above it an empty black frame enclosing an area of white tilts toward us—perhaps a repetition of the mirror. There is a strong feeling of compression and claustrophobia in this small work: the Infanta is hemmed in by her courtiers on both sides, while the prominent doorman pauses at the top of the step, his arm uplifted, as if he is about to descend. The charged, raw energy of this confining and primarily female domain is reminiscent of the *Demoiselles d'Avignon*, while the entering male at the top of the step recalls the medical student stepping into the brothel in an early study for the 1907 painting (Ch. 2, fig. 2–15).[43] The brothel/studio equation is famil-

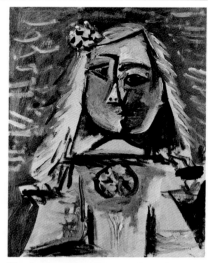

Fig. 6–12 *Pablo Picasso*. Las Meninas, after Velázquez 12 (Infanta María Margarita). September 4, 1957. Oil on canvas, 13¾ × 10⅝″ (35 × 27 cm). Museu Picasso, Barcelona

Left:
Fig. 6–13 *Pablo Picasso*. Las Meninas, after Velázquez 13 (central group). September 4, 1957. Oil on canvas, 13¾ × 10⅝″ (35 × 27 cm). Museu Picasso, Barcelona

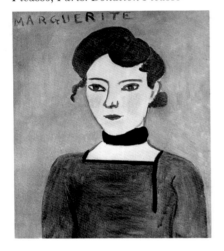

Fig. 6–14 *Pablo Picasso.* Las Meninas, after Velázquez *16 (Infanta María Margarita combined with Isabel de Velasco). September 6, 1957. Oil on canvas, 16⅛ × 12¾″ (41 × 32.5 cm). Museu Picasso, Barcelona*

Fig. 6–15 *Henri Matisse.* Portrait of Marguerite. *1907. Oil on canvas, 25⅝ × 21¼″ (65 × 54 cm). Musée Picasso, Paris. Donation Picasso*

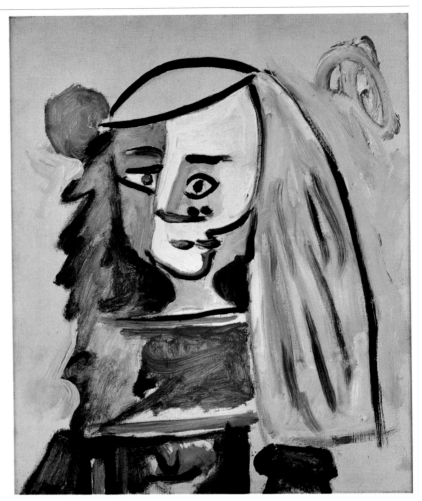

iar in Picasso's oeuvre. The crudeness of the work signals a new level of engagement with the theme. Is it perhaps Picasso himself standing at the doorway, his arm raised as if painting the picture, about to descend into the scene below to take possession of it? As his encounter with Velázquez continues, the analytic process that propelled Picasso through the first twelve paintings toward increasing abstraction gives way to a more associative one. Links with his own paintings, and those of other artists, as well as autobiographical material embedded in layers of memory now emerge with greater force.

The first part of the series comes to a close with three more portraits of the Infanta, each one distinctly different from the previous one. This group of three portraits marks a movement by Picasso toward greater subjectivity and competition with his counterpart. Identities become increasingly fluid and open to manipulation. In #16 (fig. 6–14), for example, the fall and color of the hair, the juxtaposed flowers, and the bemused expression belong to the Infanta, while the three-quarter view of the face looking left and its strong division at the nose into areas of light and dark, as well as the green of the dress are taken from Isabel de Velasco; the lips and chin facing left may belong to her counterpart, María Agustina. A painting from Picasso's collection that he greatly

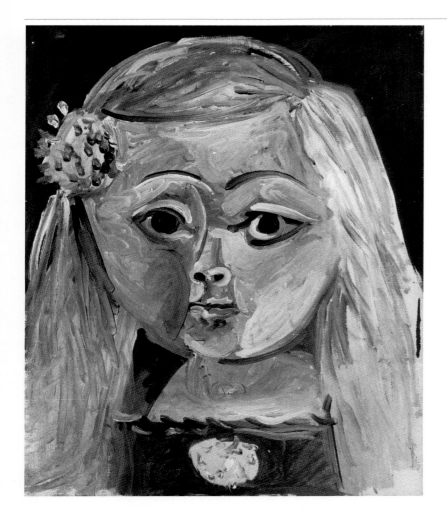

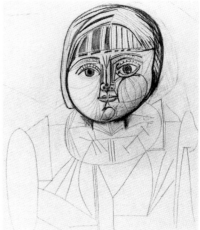

esteemed, Matisse's 1907 portrait of his daughter, may be remembered here as well. The oval face, almond eyes, tiny mouth, square neckline of her dress, and simple manner of drawing recall Matisse's bust-length portrait of Marguerite, who had the same name as the Infanta (fig. 6–15).

The last of the Infanta portraits, #17 (fig. 6–16), is the most naturalistic. Its apparent realism, however, conceals another ingenious weaving together of different figures from the painting and from Picasso's life. The familiar schema established for the Infanta—the sweep of her hair over her forehead, the juxtaposed flowers on her head and bodice, the straight neckline of her dress—remain her identifying markers. But her quizzical expression, delicate features, and cocked head of the Infanta are replaced by the veiled, blunted visage of the dwarf Maribárbola who confronts the viewer head-on with open, staring eyes, which seem to look inward as well as out. In *Las Meninas*, the Infanta and her dwarf, approximately the same height, set each other off as opposite poles of beauty and ugliness, perfection and aberration, youth and age, and high and low social order. Picasso reconciles these antitheses, and introduces a third likeness into the blend, that of his daughter Paloma as she had looked a few years earlier when she would have been the same age as the Infanta (fig. 6–17). Her full, round cheeks and deep, dark eyes—

as much his own as his daughter's—bear her stamp. Or could this hybrid figure from art and life also conjure up his blond-haired sister, María de la Concepción? When he had stood with his father in front of Velázquez's canvas sixty years before, just months after her death, the small blond-haired princess could not fail to have reminded them of their very recent loss. This is a summarizing work in which Picasso fuses observation with memory and invention.

Interlude: The Pigeons

18–26 The Pigeons, *September 6–12*

On the same day on which he painted his last two Infantas, Picasso turned abruptly to another subject, the view framed by his window of a pigeon roost and cage that stood on the balcony overlooking the Mediterranean in the brilliant late summer light; over the next six days he painted nine canvases of the scene (#19, fig. 6–18). The need for diversion after the intensity of his involvement with Velázquez is understandable; what is less clear at first is why Picasso saw the pigeon paintings as integral to the series as a whole. When he donated the *Meninas* suite to the Museu Picasso in Barcelona in 1971, Picasso included the pigeons with them, and they remain on display together.

In this sub-set of pictures within the *Meninas* series, however, Picasso keeps his major theme in evidence: he continues to explore the problematic relationship of the painted image and its counterpart in the physical world in a more contracted focus—through the familiar painting/window analogy. Furthermore, the pigeon scenes, like the *Meninas* paintings, are also variations on a theme, though in these paintings the "frame" remains fixed on the scene as a whole, while Picasso responds creatively to the natural changes imposed on his living tableau by different weather conditions and times of day.

Yet Picasso's preoccupation with the Velázquez is such that even in these scenes from life, aspects of *Las Meninas* are overlaid in a light-hearted way. There is an echo of the squared-off back of Velázquez's huge canvas here in the large upright pigeon-cote at the far left. The pigeons align themselves along the floor of the balcony in something of a parody of the Infanta and her group, while in several of them a solitary black pigeon (in a flock of white) perches on the top of the swung-open gate of the pigeon-cote in a witty reference to the *aposentador* (#19–22).

There are deeper connections as well. As one scholar had pointed out, a link exists between Picasso's father and the pigeon paintings.[44] Don José specialized in "fur-and-feather" paintings, with pigeons being his favorite subject. As a child, Picasso helped him paint in the legs of the birds, and doves were one of his own earliest subjects (fig. 6–19). Thus the series as a whole can be seen as a means by which Picasso reunited with his father.[45] It is notable that Picasso moved directly to the pigeon paintings on the day that he painted the last Infanta with its possible evocation of his dead sister. The pigeons point to another lost relationship as well, though one much closer at hand. Pigeons and doves are also a subject associated with Matisse; he not only painted doves but raised them and even gave some to Picasso. Furthermore, the window scene is a classic Matisse subject dating back to the early years of the century (fig. 6–20),[46] and Picasso's first window scenes of the late teens

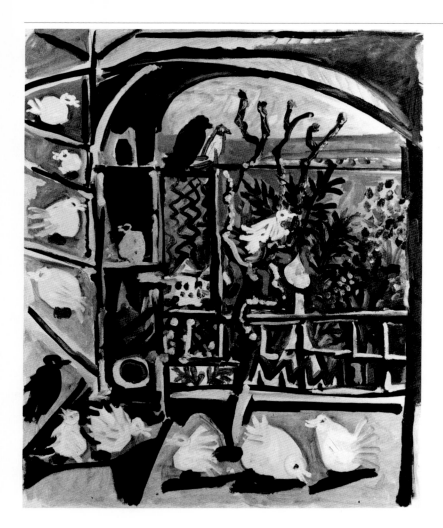

Fig. 6–18 *Pablo Picasso. The Pigeons 19. September 6, 1957. Oil on canvas, 39⅜ × 31½" (100 × 80 cm). Museu Picasso, Barcelona*

Fig. 6–19 *Pablo Picasso. Doves. Málaga, 1890. Pencil on paper, 8⅝ × 4⅛" (22 × 10.5 cm). Museu Picasso, Barcelona*

Fig. 6–20 *Henri Matisse.* The Open Window. *1905. Oil on canvas, 21⅝ × 18⅛" (55 × 46 cm). Collection Mrs. John Hay Whitney, New York*

Fig. 6–21 *Pablo Picasso.* The Pigeons 24. *September 12–14, 1957. Oil on canvas, 39⅜ × 31½" (100 × 80 cm). Museu Picasso, Barcelona*

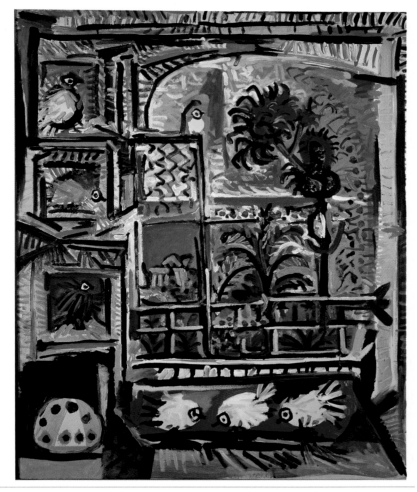

and twenties pay homage to those of his rival. Some of the pigeon paintings evoke works by Matisse: #24, for example, is reminiscent of Matisse's *Egyptian Curtain* of 1948 (figs. 6–21 and 6–22). Matisse, furthermore, admired Velázquez profoundly, and his studio paintings undoubtedly acknowledge the quintessential work on this theme. Having taken up residence in Velázquez's studio for the preceding three weeks, Picasso discovered his old rival's presence there, as well as his father's.

Fig. 6–22 *Henri Matisse.* The Egyptian Curtain. *1948. Oil on canvas, 45¾ × 35" (116 × 89 cm). The Phillips Collection, Washington, D.C.*

27 *September 14*

Like communicating vessels, one series pours back into the other. On the same day that he completed the most ornate of the pigeon paintings, Picasso picked up where he left off in the *Meninas* suite—with a portrait of the Infanta. She is shown full length (fig. 6–23), and the vivid Mediterranean colors from his window scenes flood over her as she once again reaches for her *bucaro* from the disembodied hands of María

Agustina. The figure's head is large in relation to the body: the dwarf/Infanta combination lingers on. With this painting, a synthesis of aspects of several previous versions of her, Picasso retires her from the series.

Part II

28–30 *September 15–16*

A view of the canvas as a whole initiates the second part of the series with a change of direction (#28, fig. 6–24). Over the following two weeks, Picasso would paint six large canvases, measuring 50¾ x 63⅜ inches (some vertical and some horizontal), on the ensemble, though not all the characters are present in each one. Picasso's interest in the central character, the Infanta—so potent that she pulls others into herself—gives way to a new interest: the nature of Velázquez's mysterious, atmospheric space, which he now systematizes in a new language.

Picasso's new attack begins with a change of format: he turns his sizable canvas in the horizontal direction for the first time since the initial painting, allowing the atmosphere of the painting to freely circulate. Regathering the full cast of characters, with the conspicuous absence of

Fig. 6–24 *Pablo Picasso.* Las Meninas, after Velázquez 28. September 17, 1957. Oil on canvas, 50¾ × 63⅛″ (129 × 161 cm). Museu Picasso, Barcelona

Velázquez himself, Picasso carries his predecessor's painterliness to the extreme in his most schematic work to date. Figures and architectural elements are reduced to outlines that float weightlessly in a silvery-green space. Matisse's entry through the pigeon pictures now seems prophetic. The nearly monochromatic color scheme, sense of compressed interior space, and the schematic treatment of solid forms recall Matisse's revolutionary studios of the teens. The rivalry appears to have shifted for the moment from his predecessor to his contemporary, or perhaps Picasso has called on his friend for reinforcements in his battle. With this painting, Picasso widens his dialogue with Velázquez from the issue of the representation of form to that of the artist's studio as the locus of creation, a theme that runs through many of his variations.

It is not only the reverberations of Matisse's studios that are evoked, but of earlier, highly abstract works by Picasso himself on the theme, such as *Painter and Model* of 1928 in the Museum of Modern Art (fig. 6–25) perhaps based loosely on *Las Meninas*, of which this variation may be seen as a late pastiche. Though painted in a Synthetic Cubist style in flat, opaque planes, it shares with this variation a spare linearity and ambiguity of signifiers. Indeed, *Painter and Model* has been described as central to Picasso's conception of painting as a magical object in which he creates an "almost-confusion" between art and life

Fig. 6–25 *Pablo Picasso.* Painter and Model. *1928. Oil on canvas, 51⅛ × 64¼″ (129.8 × 163 cm). The Museum of Modern Art, New York. The Sidney and Harriet Janis Collection*

through numerous formal analogies.[47] The artist, for example can be read as both a figure in front of his canvas in the act of painting it, or as the image on the canvas, and the canvas can also be seen as a radiant door. A similar play of levels of reality takes place here that draws on Velázquez's own ingenious weaving together of truth and artifice, responding with his own flexible sign system. The vacant mirror floats forward, like an abstract painting or—in 1950s terms—a television set; it is linked with the red door, which can also be seen as a canvas on which Nieto is painting; Nieto is framed by the open door, but can also be seen as an enlarged keyhole in a closed white door; and the windows to the right both puncture the wall, and can be read as geometric paintings hung on it.

A new geometric, cartoon-like figural style appears in this painting. Heads expand into an enormous triangle (María Agustina's), or shrink to a small empty disk on a large body (the Infanta's), or wave like a flag on a pole (Isabel de Velasco's). As willfully bizarre and gratuitously cruel as Picasso's figures appear, they have, in fact, been created through careful observation of the models, by extending lines from the figures to enclose the space between them. Writing of the *Meninas* variations just after they were painted, a friend and biographer of the artist recalled Baudelaire's characterization of Spanish humor as "well-endowed with the comic . . . They are quick to arrive at the cruel stage and their grotesque features usually contain a somber element."[48] As Picasso continues, the element of humor, irreverence or shock increases, as he continues to reinvent his theme, and attempts to keep it alive.

31–32 *September 15–16*

In #31, the full cast is now submerged into a colorful web of lines and planes in a decorative Cubist style that resembles stained glass (fig. 6–26). Picasso returns here for the first time since his initial painting to

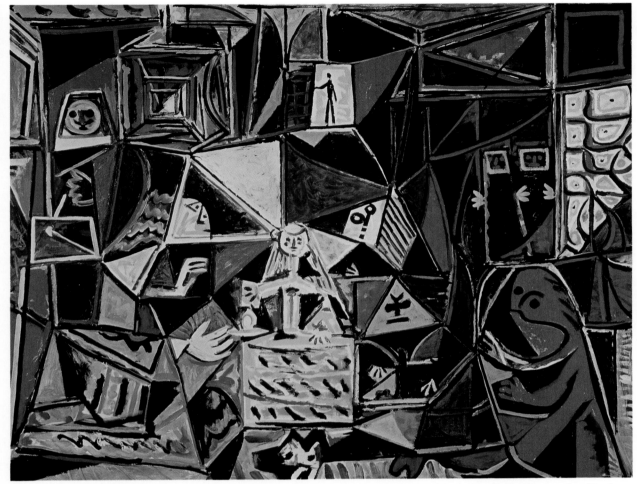

Fig. 6–26 *Pablo Picasso.* Las Meninas, *after Velázquez 31. September 18, 1957. Oil on canvas, 50¾ × 63⅜" (129 × 161 cm). Museu Picasso, Barcelona*

Velázquez's canvas as a whole. In this painting and the following three, Picasso mirrors—in his refracted Cubist idiom—Velázquez's own act of mirroring his world, and reaches the peak of intensity of his dialogue with his countryman. Here space is primary and the figures conform to it, in opposition to the first work in the series, in which the characters dominated their environment. From the multi-aspect figures that absorbed his attention throughout the first part of the series, Picasso now turns to translating Velázquez's chamber, criss-crossed by lines of sight, into a "simultaneous space," as he did in Canvas O in his previous series of variations after Delacroix's *Women of Algiers* (Ch. 5, fig. 5–17).[49] Velázquez's painterly illusionism and Picasso's abstract geometric vocabulary are successfully integrated as overlay and underlay. A temporary harmony between artistic idioms and eras has been reached.

In the following work (#32, fig. 6–27), executed the next day, Picasso recasts the group in a flat Synthetic Cubist style. With its figures painted in bright, primary colors and set against a black ground, the painting recalls his masterpiece of 1921, *Three Musicians* (fig. 6–28) and, more generally, his work as a set designer for the Ballets Russes during that period. (The stage-like space of *Three Musicians*, its dark background, the frontal arrangement of figures, and the large shepherd dog suggest a somewhat remote connection to *Las Meninas* in this work as well.)

Fig. 6–27 *Pablo Picasso.* Las Meninas, *after Velázquez 32. September 19, 1957. Oil on canvas, 63⅜ × 50¾" (161 × 129 cm). Museu Picasso, Barcelona*

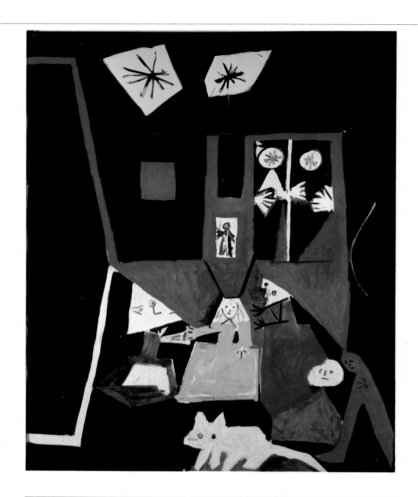

Fig. 6–28 *Pablo Picasso.* Three Musicians. *Fontainebleau, summer, 1921. Oil on canvas, 6'7" × 7'3¾" (200.7 × 222.9 cm). The Museum of Modern Art, New York. Mrs. Simon Guggenheim Fund*

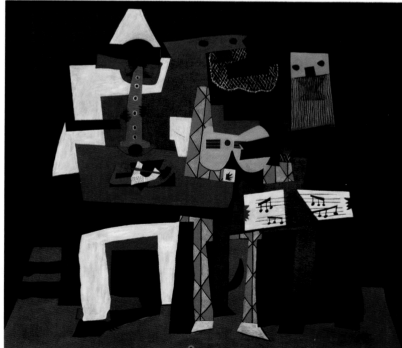

Opposite:
Fig. 6–29 *Pablo Picasso.* Las Meninas, *after Velázquez 33. October 2, 1957. Oil on canvas, 63⅜ × 50¾" (161 × 129 cm). Museu Picasso, Barcelona*

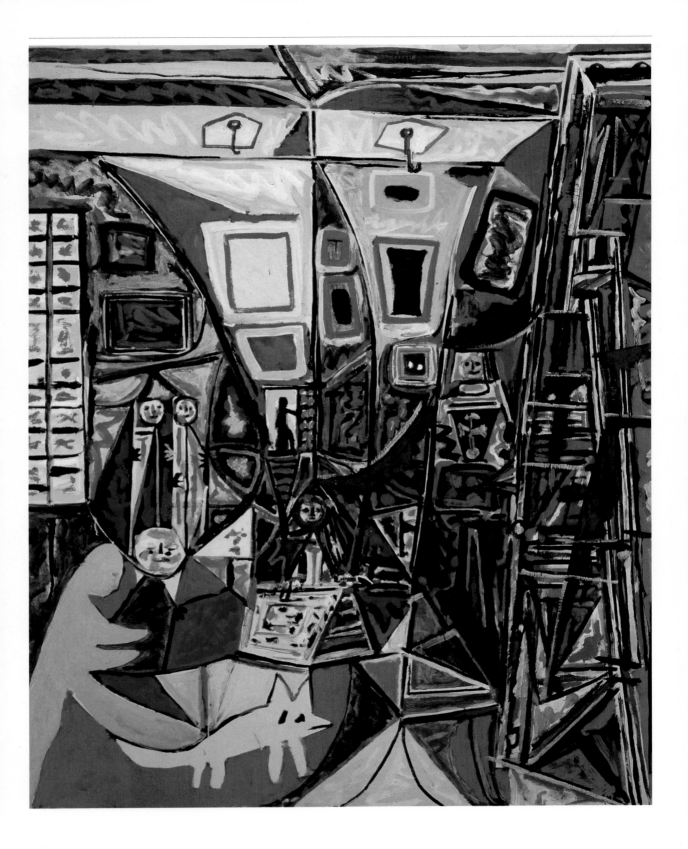

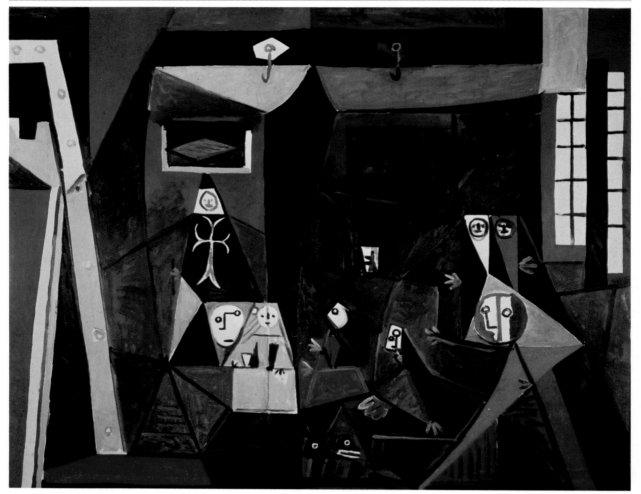

Fig. 6–30 *Pablo Picasso. Las Meninas, after Velázquez 34. October 3, 1957. Oil on canvas, 50¾ × 63⅜" (129 × 161 cm). Museu Picasso, Barcelona*

33 *October 2*

In the third of a series of paintings based on the image as a whole (fig. 6–29), harmony is again disrupted. A lively biomorphic Cubist idiom replaces the geometric order of #31 and #32. The welter of small, swelling shapes and bending lines are pulled into depth as if by magnetic force, while the palette of shrill, primary colors and overall surface patterning contribute further to an almost unbearable sense of claustrophobia. Picasso seems to give expression to his sense of entrapment in Velázquez's irrational space; yet at the center of the canvas, the doorman/painter enclosed in a rectangle of radiant yellow (a conflation perhaps of the door and mirror) remains undisturbed in his duties—a symbol of endurance.

34 *October 9*

In the next painting (fig. 6–30), Picasso returns to a more stable horizontal format, and banishes his vibrating colors and converging lines and shapes. In a reprise of #32, he turns back to somber tones of brown and black for the background, which set off the figures of the Infanta

and her retinue in bright, primary colors. A relative sense of stability and depth returns, which parodies the old master's own spatial play. The figure of Velázquez reemerges for the first time since the initial work in the series, now shrouded in a black costume resembling a monk's habit or a domino. The spare geometric style and coloration of the painting again evoke *Three Musicians*, though here Picasso may also draw on some of its darker meaning. As in his 1921 masterpiece, intimations of death can be felt in this painting too.[50] With the reinstatement of Velázquez in the studio, the door at the back guarded by the shadowy figure of the *aposentador* opens up into a vortex-like tunnel, and the diminutive guard/painter disappears through the passageway.

This painting marks the end of the most intensive part of Picasso's dialogue with Velázquez. Although Picasso would continue the series, the fervor of his endeavor would diminish.

Part III Postscripts

36–58 *October 9–December 30*

In the subsequent twenty-four works, many of which are small in scale, Picasso returns to studies of individual figures and small groups, concentrating now on the handmaidens and dwarfs. Executed in series of three or four paintings, with increasingly long intervals between them, these sets of paintings become more schematic toward the end, until they merely fade away.

Some of these later works can be seen as reprises of earlier canvases in the series. In variation #36 (fig. 6–31), and the next three paintings, for example, Picasso returns to María Agustina, the Infanta's rival for his attention at the outset of the suite. The offering of the *bucaro*, which was touched on in several of the earlier studies, is more fully developed in later paintings. In #37, the scene evolves into a kind of bizarre annunciation.

The element of the bizarre erupts into the surreal in #40, *The Piano* (fig. 6–32). In the series as a whole *The Piano* stands out for its degree

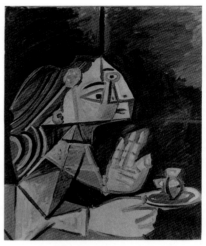

Fig. 6–31 *Pablo Picasso*. Las Meninas, after Velázquez *36 (María Augustina Sarmiento). October 9, 1957. Oil on canvas, 25⅝ × 21¼" (65 × 54 cm). Museu Picasso, Barcelona*

Fig. 6–32 *Pablo Picasso. The Piano 40. October 17, 1957. Oil on canvas, 51⅛ × 37¾" (130 × 96 cm). Museu Picasso, Barcelona*

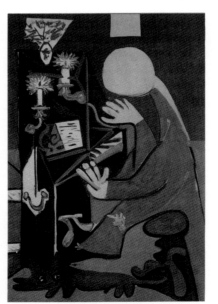

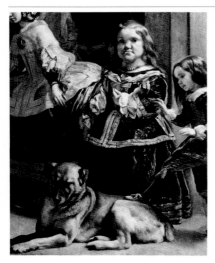

Fig. 6–33 *Diego Velàzquez.* Maribárbola, Nicolás Pertusato and the Dog, *detail from* The Maids of Honor (Las Meninas)

Fig. 6–34 *Pablo Picasso.* Las Meninas, after Velázquez 44 (Isabel de Velasco, Maribárbola, Nicolás Pertusato and the Dog). October 24, 1957. Oil on canvas. 51⅛ × 37¾" (130 × 96 cm). Museu Picasso, Barcelona

of departure from the theme, becoming an almost independent painting; it exemplifies in more exaggerated form, however, Picasso's working method throughout the suite, as his comments about it reveal:

I saw the little boy with a piano. The piano came into my head and I had to put it somewhere. For me he was hanged, so I made him hang. Such images come to me and I put them in. They are a part of the reality of the subject. The Surrealists in a way were right. Reality is more than the thing itself. Reality lies in how you see things. A parrot is also a green salad and a parrot. He who makes it only a parrot diminishes its reality. A painter who copies a tree blinds himself to the real tree. I see things otherwise. Don Quixote can come into *Las Meninas*.[51]

The Piano is followed by a bust-length portrait of the dwarf Nicolás Pertusato (#41) and six large paintings in a vertical format, all of the same dimensions, executed over a three week period (#42–47). In these paintings, Picasso focuses on the *meninas* to the right of Velázquez's painting: Isabel de Velasco, Maribárbola, and Nicolás, as well as the dog (fig. 6–33) executed in bright primary colors in a style of child-like simplicity (#44, fig. 6–34). *Three Musicians* lingers as a reference. Picasso's repetitions of groupings of children recall the fact that the earliest title for Velázquez's painting was *The Family Picture*. They may also be wishful recreations of his own fractured family with his children by Françoise Gilot—Claude and Paloma, then aged ten and eight—and Jacqueline's adolescent daughter Cathy, in the role of the *meninos*. In

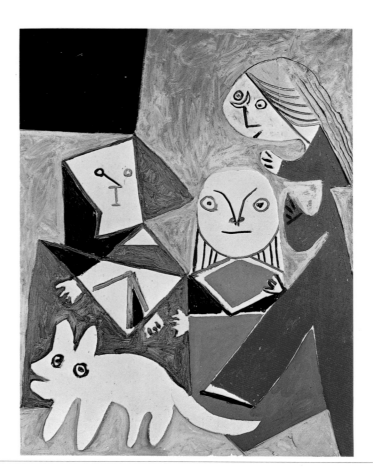

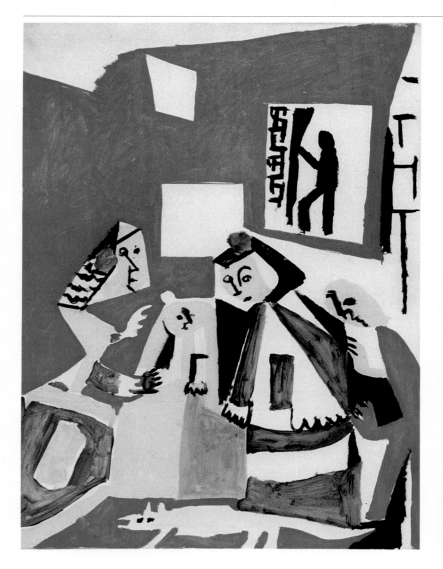

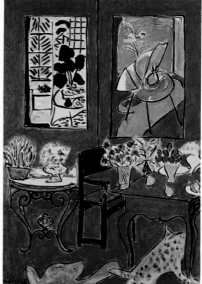

Fig. 6–35 *Pablo Picasso.* Las Meninas, after Velázquez 47. *November 15, 1957. Oil on canvas, 51⅛ × 37¾" (130 × 96 cm). Museu Picasso, Barcelona*

Fig. 6–36 *Henri Matisse.* Large Red Interior. *1948. Oil on canvas, 57½ × 38¼" (146 × 97 cm). Musée National d'Art Moderne, Centre Georges Pompidou, Paris. Succession Henri Matisse*

#47 (fig. 6–35), the last large canvas of the series painted on a flat red ground, the two *meninas*, the Infanta, Nicolás, and the dog are joined by an enlarged Nieto in his rectangular doorway, his arm uplifted like that of Velázquez in his self-portrait. The "painter" goes on working with his family gathered around him. The rectangle of light in the doorway can be seen as the mirror at the back of Velázquez's studio, in which Picasso casts his own reflection as a symbol of possession. The painting also evokes Matisse's last large easel painting, the *Large Red Interior* of 1948 (fig. 6–36). In this final large work, one of the most radical in the series in its deconstruction of the apparatus of illusionism, Picasso places himself in a continuum that links the rich heritage of his Spanish past with the modern French tradition through a theme shared by Velázquez, Courbet, Matisse, and himself: the artist's studio.

The series comes to a close in December with small, delicately painted canvases depicting the *meninas*, individually or with a dwarf, in a technique that recalls the energetic brushwork of Goya. As Picasso's interest in Velázquez's painting fades, the world outside his studio once

Fig. 6–37 *Pablo Picasso.* Portrait of Jacqueline *57. December 3, 1957. Oil on canvas, 45⅜ × 35" (115 × 89 cm). Museu Picasso, Barcelona*

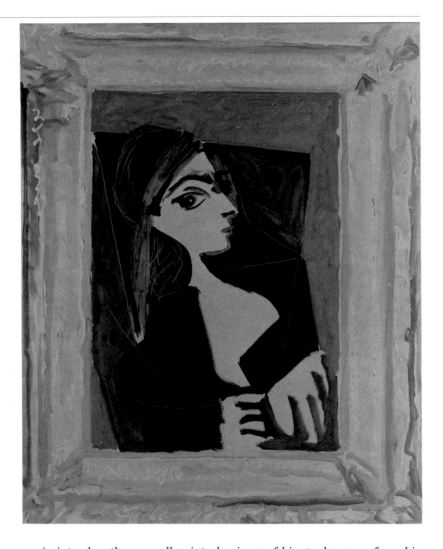

again intrudes: three small painterly views of his garden seen from his window were rapidly executed on December 3 (#54–56), and they were followed by a large portrait of Jacqueline in a painted frame (#57, fig. 6–37), Picasso's actual companion in the studio and witness to the unfolding project. In the final canvas (#58, fig. 6–38), no larger than a postcard, painted on December 30 in delicate brushstrokes and somber tones of brown and green, the Infanta/*menina* figure returns after a three week interval to take a bow as the year ends. Through this diminutive figure, one of the most enduring characters in the history of art, Picasso reaches back through Goya to Velázquez, inscribing himself in the chain of great Spanish masters.

Picasso's journey in *Las Meninas* is rooted in an essential quality of Velázquez's work, its instability. The painting's open-ended scenario, shifting perspectives, and ambiguity provide fertile ground for Picasso's transformation of the theme along new structural and narrative lines. The *modus operandi* that Picasso uses in his attack is to surround his model on all sides, submitting it to a multivalent Cubist analysis. Multiplicity replaces unity, and Picasso takes his predecessor's critique

Fig. 6–38 *Pablo Picasso.* Las Meninas, after Velázquez *58 (Isabel de Velasco). December 30, 1957. Oil on canvas, 13 × 9⅜″ (33 × 24 cm). Museu Picasso, Barcelona*

of the classical system of representation and his plurality of meaning one step further. Throughout the series, he exploits the "chemical reaction" between his own art and tradition to explore his own unconscious and the mystery of the creative process.

Velázquez's naturalism encompasses a range of styles, from the finely rendered face of the Infanta to the veiled features of Maribárbola, to the almost abstract image of the king and queen in the mirror, and the ghostly presence of the paintings on the back wall; these different representational approaches are reconciled, however, in a unified whole through his loose brushstroke and the atmospheric space that envelops them. While Velázquez's varied modes challenge stylistic unity, Picasso embraces discontinuity. The series consists of abrupt transitions of style from one set of works to another, moving from painterly Analytic Cubism to Expressionism, Surrealism, decorative Synthetic Cubism, and a mode of child-like simplicity, all united by a common origin in Picasso, and constituting an anthology of his idioms. Each of these modes carries Picasso further in his journey, though not necessarily in a progressive fashion.

Velázquez takes liberties with the unity of time and space by bending

the rules of linear perspective. What Velázquez condensed into an instantaneous scene, however, Picasso opens up into a series of separate moments or impulses. In Velázquez, pictorial and physical space are brought into sharp juxtaposition through the relationship of the painted figures and the implied ones in front of the painting. Picasso's series extends into real space and time, creating an environment that seems to surround the viewer physically.

Velázquez defies the principle of narrative unity by leaving gaps that invite multiple interpretations in the logic of his story. Picasso disrupts narrative itself. Within the series there are peaks and lulls, but the paintings do not build to a climax or a definitive statement. They are, rather, a record of the path of his explorations as he shifts his attention from the whole to the parts and back to the whole again. The paintings simply peter out as he exhausts his interest.

Picasso also exploits the tension between fact and allegory in his theme. In *Las Meninas* Velázquez literally depicts his workroom and the figures themselves. The painter, however, subverts the convention of group portraiture through carefully calculated relationships among the depicted figures on the canvas, the implied royal figures, and the viewer, to express private meaning—perhaps, as has been proposed, to comment on his personal status at court and the nobility of his art, though many other interpretations have been offered.[52] After all, the painting is, among other things, a self-portrait of Velázquez in his world. Picasso, likewise, bends the subject to express meaning of his own; the variations are also a portrait of himself as an artist in the very act of creation. The essential link between the two works is the studio. In *Las Meninas*, the studio is not simply a neutral backdrop to the action, but the ground on which Velázquez demonstrates art's triumph over reality, and his own privileged relation to his monarch. A studio is also a container not only of each artist's individual output but of the flow of the history of art. Velázquez himself alludes to this through the inclusion of dimly-lit paintings by other artists on the back wall. Palomino identified these paintings as a series of copies by Juan del Mazo after some of Rubens's pictures for the Torre de la Parada, which represent subjects from Ovid's *Metamorphoses*,[53] a theme that underscores the notion of continuous transformation at play within *Las Meninas* itself. Earlier in his career, Picasso had illustrated scenes from the *Metamorphoses* in a suite of etchings in 1930.[54] The *Meninas* series, however, is itself a form of metamorphosis through which a set of signs undergo transformation to become, in Picasso's words, "something else entirely."[55] The notion of continuous change throughout the creative process, linking the activity of the artist with that of the viewer, and the past with the present, was at the very heart of Picasso's aesthetics, as he made clear in a conversation with Zervos in 1935: "A picture is not settled beforehand. While it is being done it changes as one's thoughts change. And when it is finished, it goes on changing according to the state of mind of whoever is looking at it. A picture lives a life like a living creature, undergoing the changes imposed on us by our life from day to day. This is natural enough, as the picture lives only through the man who is looking at it."[56]

Through his suites of variations, Picasso meditates on the inescapable fact that in art the only "truth" is the spectator's fluid subjective response, and invites—or directs—his own viewers to participate with him in this double-leveled process in his variations. Picasso draws on

the theatricality of Velázquez's painting as well. The frozen poses of the figures, their outward orientation to an "audience," the deep receding, stage-like space that faces the viewer frontally, the make-shift "props," and dramatic spotlighting, all contribute to a strong sense that we are witnessing a moment from a play. Picasso inserts himself into the gap between arrested and potential motion and sets the "play" in motion again in suites of improvisations. Some of the *Meninas* variations suggest painted decor or costume studies and recall his involvement with the theater in the late teens and 1920s, an experience to which he alludes in a number of references. For Picasso the studio is a metaphorical stage on which he enacts the drama of his creative response to the masterpiece, with the variations themselves forming both the substance of the interchange and the backdrop to his ongoing performance. In his extended series of variations of his late years, Picasso's involvement with the theater is revived in new form. Here, as in his work for the stage, he continues to expand boundaries of art beyond the limits of the individual canvas, while observer becomes creator, process becomes product, past becomes present, and the self an other.

Las Meninas expressed Velázquez's confidence in his conquest of reality, and his ability to surpass it. The variations, however, are rooted in loss. An essential aspect of the meaning of the series lies in the form itself: through variation Picasso frankly acknowledges the modern artist's loss of belief in the power of painting to represent the world fully and to speak in an individual voice, and mourns his own period of producing masterpieces. The serial form of the *Meninas* variations, in which each work supersedes the next, posits an absence of certainties. Picasso's repetitions of other artists' paintings are the painted analogue to his remarks to a friend on the nature of truth in art: "What truth? Truth cannot exist. If I pursue a truth on my canvas, I can paint a hundred canvases with this same truth. Which one, then, is the truth? And what is the truth—the thing that acts as my model, or what I am painting? No, it's like everything else. Truth does not exist."[57]

It is in keeping with the nature of Picasso's artistic enterprise, however, that he made use of this "second-hand" art form to revitalize his art and himself. The detachment of variation offered a wider perspective through which he could renew his longstanding themes through an historical lens and inscribe himself in tradition. Variation also afforded Picasso the opportunity to reassert his commitment to subject matter at a time when abstraction ruled, while remaining true to his Cubist frames of reference. Furthermore, the exploration of great monuments known over a lifetime allowed Picasso to revisit significant figures and experiences and, in the most important of his themes, *Las Meninas*, to reimmerse himself in his Spanish past, both immediate and historical. In the *Meninas* suite, his own "*meninos*" Paloma and Claude, his dead sister and father, and perhaps Olga, and several of his own culminating works—the *Demoiselles d'Avignon, Three Musicians,* and *Guernica* (all of which suggest some connection with *Las Meninas* and thus its power over him as the very "model" of the masterpiece)—surface as allusions. He also carries on his competition with the most important of his contemporary rivals: the recently deceased Matisse, whose work he "continues," and perhaps also the still living Braque, who himself produced a series of significant late works on the theme of the studio between the years of 1948–56, undoubtedly a goad to Picasso's compet-

itive spirit.[58] Members of his immediate household, Jacqueline and her adolescent daughter Cathy, as well as his dog, Lump, are reflected as well. Picasso is there himself presiding over it all, the blank figure at the threshold, suspended in the door/mirror, as guardian of the gate between two spatial realms and historical periods—and perhaps between life and death—who goes on painting.

As he entered old age, variation became Picasso's primary weapon in confronting and resisting the encroachment of the past. On the one hand, he was trying to place himself in the historical continuum in which he wished his life's work to be viewed by successive generations; at the same time, paradoxically, he rejected a progressive view of history. Yet, in submitting himself at last to the *ne plus ultra* of painting, Picasso could not escape the fact that Velázquez had already anticipated his own penchant for destabilizing the old certainties. Not only had many of the ideas that Picasso explored over the course of his career already been taken up by his predecessor, but his very presence in front of Velázquez's masterpiece and his participation in its enigmatic scenario had been written into the script some three hundred years before. Velázquez, like Picasso himself, knew only too well that the artist does not, in Ortega y Gasset's words, "find himself alone in the world," and he deliberately left his studio door ajar, inviting future generations to challenge his authorial role, and thus keep his art alive. Picasso could only take up his assigned place and hold up his multi-faceted mirror to Velázquez's world. Yet even in that act of mirroring, he was anticipated.

The *Déjeuner* Series, 1959–1962

<div style="text-align: right; font-size: 2em;">7</div>

*Painting is a thing of intelligence. One sees
it in Manet. One can see the intelligence in each of
Manet's brushstrokes. . . .*
—Picasso, 1956[1]

Picasso's diverse body of works inspired by Manet's *Luncheon on the Grass (Le Déjeuner sur l'herbe)* of 1863 (fig. 7–1) consists of twenty-seven paintings in oil on canvas, some one hundred and fifty drawings, three linoleum cuts, eighteen cardboard maquettes for sculpture, five concrete sculptures, and several ceramic plaques.[2] This series of variations is by far the largest in number, and it occupied Picasso over the longest period of time. Beginning in August 1959, Picasso continued to work on the theme at intervals in three different studios until the middle of 1962.

Fig. 7–1 *Edouard Manet.* Luncheon on the Grass (Le Déjeuner sur l'herbe). *1863. Oil on canvas, 81⅞ × 104" (208 × 264 cm). Musée d'Orsay, Paris*

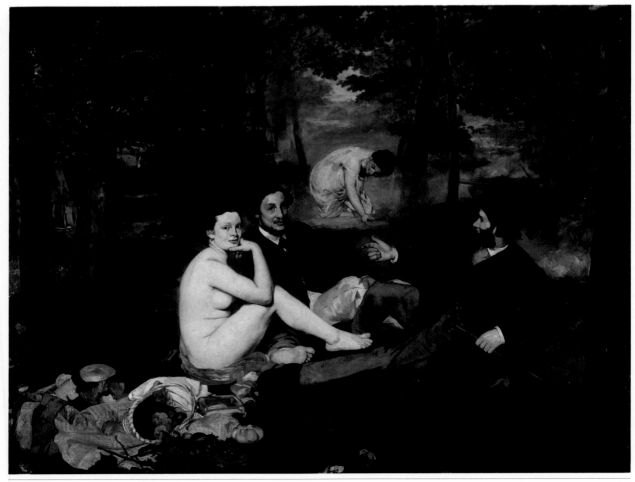

Over the course of his dialogue with Manet, Picasso takes the formal operation of variation to a new level. Variation and independent creation weave freely in and out of each other, just as one medium flows into another. Figures are added and deleted, and take on new roles: picnickers develop into bathers, and into artists and models, while references to works by other artists impose themselves on Manet's theme. Like the *Meninas* variations, this prolific series leads to no one definitive work, but rather is driven by a process of continuous transformation, as is much of his late work. The general tenor is one of *joie de vivre*, yet the outpouring of creativity that the *Déjeuner* awakened in Picasso, bordering at times on obsessiveness and laced with occasional sinister notes, strong parodic elements, bawdy humor, and eruptions of violence, bears witness to the intensity of the encounter.

Manet's infamous canvas—which was created to provoke reaction—has continued to elicit responses by artists and critics ever since it first appeared at the Salon des Refusés of 1863.[3] The painting depicts four figures in a secluded clearing in a forest along a bank of the Seine: two men in the fashionable student attire of the day and two women. The men, seated on the ground, engage in conversation: the bearded man sporting a jaunty cap at the right, depicted in profile facing left, looks directly at his friend, arm extended and index finger pointing toward him as if to underline a point. The focused expression of the speaker is countered by the abstracted air of the listener, who looks out toward the viewer. Seated alongside him, and opposite the speaker, is a young, naked woman. Her discarded clothes are heaped in a pile beside her, and on top of them is an overturned basket with the remains of a picnic spilling out. Neither of the men pays any attention to her; she looks out directly at something beyond the confines of the picture. Her alert glance momentarily intersects with the absorbed stare of the viewer, for whom she is a compelling focal point. The other woman, clad in only a shift, wades in a stream behind the trio, and not far from her a rowboat is tied up.

The outrage that this painting provoked when first exhibited centered as much on its indecipherable subject as on the obvious impropriety of a naked woman mingling with fully-clothed men in broad daylight. Even more than its subject, Manet's simplified and direct means of representation, as seen in the summary treatment of the background, the minimal amount of modeling of the nude, and the lack of integration of the figures and the setting, offended contemporary viewers.

What was Manet doing in his provocative work? Responding to the poet Charles Baudelaire's call for modernity in subject matter, and the provocative example of Courbet's realist figures, Manet aspired, as a recent essay convincingly demonstrates, to update the nude and endow it with a new directness and immediacy, underlining the contemporaneity of his work through overt comparison with examples from the museums.[4] Manet took the conception of combining a nude woman with clothed men in a landscape setting from Titian's *Concert in the Country (Concert Champêtre)* (then attributed to Giorgione) in the Louvre (fig. 7–2), while turning to a detail from Marcantonio Raimondi's popular engraving after Raphael's *The Judgment of Paris* for the composition of the triad of figures in the foreground of his painting. Here, the quotation serves not to uphold tradition, but to create simultaneously both continuity and an ironic disruption.

Fig. 7–2 *Titian.* Concert in the Country (Concert Champêtre). *1538. Oil on canvas, 41⅜ × 52½″ (105 × 136 cm). Musée du Louvre, Paris*

The *Déjeuner* claims connection with the French tradition as well, drawing on the eighteenth-century *fête champêtre*, while it openly paraphrases Courbet's *Demoiselles des bords de la Seine* (Ch. 4, fig. 4–30), a painting that only six years earlier in the Salon of 1857 had provoked a scandal similar to that of Manet's picture.[5]

Beyond his overt and ahistorical use of sources, Manet's innovation lay in his bold attack on the conventions of classical representation. His naked woman resists the usual process a studio model passes through to become a "nude," that of idealization and the assumption of a familiar mythological guise. Instead, she remains overtly a model, and is even recognizable as a particular woman—Manet's favorite model of the time, Victorine Meurent.[6] Furthermore, the painting as a whole, while depicting an outdoor scene set in contemporary life, frankly reveals its studio origin. Not only is the setting treated like a backdrop, but the figures are lit from one specific source suggestive of studio lighting.[7] As one scholar has commented, the *Déjeuner sur l'herbe* is more about the studio and what happens in it than the scene it purports to represent in the real world.[8]

Manet's masterpiece recapitulates many of the elements that, either singularly or in combination, drew Picasso to most of his sources in his interpretive works: ambiguous subject matter, sexual tension, a dynamic interaction between the depicted figures and the viewer, an interrupted narrative leading to a variety of possible solutions, a vagueness of spatial relationships, a layering of references to past works, and an implicit connection to the theme of the artist and model. As the most significant modern example of art after art, the *Déjeuner sur l'herbe* was the ultimate challenge for Picasso to surmount in his variations.

Over many decades, paintings by Manet had served as themes for Picasso's variations. His parodic sketch after *Olympia* launched his adventure in variation, while *Nana* was the underlying source for his *Lovers* of 1919 (see Ch. 2). In 1955 he based two drawings on *Lola of Valence*,[9] and he drew from Manet's oeuvre more indirectly as well. (A

Fig. 7–3 *Pablo Picasso.* The Soler Family. *Barcelona, 1903. Oil on canvas, 59 × 78¾″ (150 × 200 cm). Collection du Musée d'Art Moderne et Contemporain, Liège*

notable example of the latter was his *Massacre at Korea* (1950), which derives from Manet's *Execution of Maximilien* of 1868.[10] That he would at some point during his life confront the *Déjeuner sur l'herbe* seemed almost inevitable.

Picasso's engagement with the *Déjeuner* was lifelong. His earliest encounters with the work are connected with significant moments in his artistic development. Although he undoubtedly knew the painting in reproduction before leaving Spain, Picasso first saw the *Déjeuner* in 1900 on his first trip to Paris to visit the Universal Exposition, where it was on display.[11] Picasso had just turned nineteen and was an exhibitor himself in the Spanish pavilion.[12] The impact of the *Déjeuner* on Picasso in the early stages of his career is apparent in *The Soler Family* (fig. 7–3), a group portrait executed in Barcelona in 1903, based loosely on the composition of Manet's painting. Although not a major work, the unfinished portrait attests to Picasso's almost immediate need to ingest Manet's challenge and draw it into his own repertoire. Picasso had the opportunity to see the *Déjeuner* again in 1907, when it was exhibited at the Musée des Arts Décoratifs as part of the Moreau-Nélaton collection.[13] At that time he was in the midst of creating his own *succès de scandale*, the *Demoiselles d'Avignon*, and of claiming a place for himself in the vanguard of Parisian art. As a model of iconoclasm, the *Déjeuner* would have presented a formidable challenge; its power over him is revealed in the fact that he was still responding to it in old age.

As with his other major series of variations of the fifties, the actual commencement of work was prefaced by periods of interest, avoidance, and aborted efforts. When Picasso saw the work in 1929, he scribbled on the back of an envelope of the Galerie Simon, "When I see the *Déjeuner sur l'herbe*, I tell myself, trouble for later on."[14] It was not until June 1954, twenty-four years later, when Picasso was seventy-three, that he made his first direct approach to the painting. Between June 26 and 29, he executed four studies of the *Déjeuner*, including a sketch of the scene as a whole and realistic studies of the heads of the four protagonists.[15] But after these initial studies, as we have seen in Chapter 5, Picasso

abandoned the project and turned to Delacroix. What, then, made the summer of 1959 the right time for the painting to serve as his model? Picasso's renewed interest in landscape painting following his acquisition in September 1958 of the remote fourteenth-century Château de Vauvenargues near Aix-en-Provence, at the foot of Cézanne's famous Mont Sainte-Victoire, may well have been a factor. But more broadly, Manet's masterpiece—with its powerful visual impact, painterly qualities, and bold rejection of convention—fits in with the general direction of Picasso's art in his final decade, aptly described by one critic as "a crossing of barriers, a liberation of knowledge and technique, a return to nature, spontaneity, the "childhood" of art, and a savage, primal immediacy in painting."[16]

The Series

The series as a whole might best be characterized as a succession of waves of work of greater or lesser intensity. In its rhythmic, open-ended form, it comes closest in his art after art to approximating musical variation; here Picasso is not so much interpreting, as taking off from his source in free improvisations. In the *Déjeuner* series, Picasso gives greater play to the thematic development of his material. As the critic Douglas Cooper was the first to note, the series falls into four subject groupings, which he described as the country outing, the *baignade* (bathing scene), the nocturnal excursion, and a classical idyll.[17] Picasso launched the series at the Château de Vauvenargues, continuing to work on it in Cannes at the villa La Californie, and after June 1961, at his residence and studio at the *mas* (or farm) Notre-Dame-de-Vie in Mougins.

August 10, 1959[18]

Picasso's first essays, four outline drawings in pencil, are prophetic in certain respects. Drawing (in various materials and techniques) will continue to serve as a wellspring of ideas and the connecting link between paintings. Picasso's focus on the figures is also telling; they will remain his major interest. Of the four, the "nudes" are submitted to the greatest degree of transformation. From the outset he imposes on them his own vocabulary of multi-aspect form. He also experiments almost immediately with the composition. By the fourth drawing, he has replaced the foursome with a party of three in which the bather is framed between the phallic-headed speaker and the nude. This triadic format will serve as the alternate configuration throughout the series.

August 11, 1959, I–V[19]

The first composition, in conté crayon on paper, focuses on the bather in radiant pink and yellow tones, outlined in green. The other three figures are blended into the darkened landscape. Switching to pen and ink, Picasso now extracts the bather from the whole in three drawings of her alone. Manet's figure, clad in a shift (resembling classical garb), has metamorphosed into a primitive, hulking, nude creature with a small head on a long neck. Folded over onto herself, her breasts, belly, buttocks, genitals, and face all exposed at once, she stands in water and is surrounded by trees and foliage, her arms encircling a large black void at the very center of her body.[20] She signifies the theme that underlies

Manet's picnickers. When the *Déjeuner* was first exhibited at the Salon des Refusés, it was entitled *Le Bain* (The Bath), a motif to which Picasso will return throughout the series, and which conjures up the long line in Picasso's art of women bent over at the waist, either standing or sitting, bathing, tying a sandal, or helping a child.[21]

February 29, 1960, oil on canvas

Nine oil paintings, executed in Picasso's newly acquired Château de Vauvenargues, appear from the end of February to May, marking the culmination of the first stage of Picasso's engagement with the *Déjeuner*.

The canvas of February 29 (fig. 7–4) and the next (executed within three days of each other) have the same dimensions and format and are the largest paintings in the series as a whole. Here the setting of Manet's painting has been transformed from a secluded clearing in a wood to a wide expanse of green interrupted by a few stylized trees and a puddle of blue water in (and over) which the bather stands or squats. The figures, too, begin to lose the specificity of their Manet counterparts. Picasso parodies their cut-out character, and the theatricality of their poses, while exaggerating the thinly-painted, although sensuous, character of the surface. The complex interaction between individuals in Manet's painting is rerouted into a direct confrontation between the speaker and the listening nude, while the act of speaking has been converted into an allegory of looking and being looked at. The second male, excluded from their reciprocal gaze, and therefore irrelevant, has been largely absorbed into the landscape. Here, as in previous variations, Picasso enters into his predecessor's work and converts it to material of his own through the looking relationship.

March 3, 1960, oil on canvas

From the flattened idiom of the previous canvases, Picasso switches to a lush, ornate, and corporeal style in his painting of March 3 (fig. 7–5). Figures and landscape, trees and water, are integrated in a painterly decorative mode. The ironic mood of the source is replaced by a celebratory spirit, just as the bohemian picnicking scene gives way to the more timeless subject of artist and muse linked together through their mutual gaze, with Jacqueline taking the place of Manet's Victorine. In this canvas, one finds echoes of the *Women of Algiers* in the decorative character of the painting and in the monumental nude who occupies the same position in the Delacroix canvas.[22] But there are also recollections of another work, more closely related to the Manet painting: Courbet's *Young Ladies on the Banks of the Seine* (Ch. 4, fig. 4–30) The vivid blue-green water that cuts through the landscape like a river, the tapestry-like canopy of overhanging branches, the tree trunks silhouetted against water, and the blue and green palette recall the earlier masterpiece, yet the setting as a whole is transposed to a more Arcadian one. Picasso reconciles aspects of both the Manet and Courbet paintings, infusing some of the sensuality of the earlier image into the later, more austere one. Through several, and by now familiar, methods of variation Picasso takes possession of Manet's painting: he merges the generating image with one of its sources, thus placing his own creation in a continuum of works; he converts the style into his own idiom; he transforms the sub-

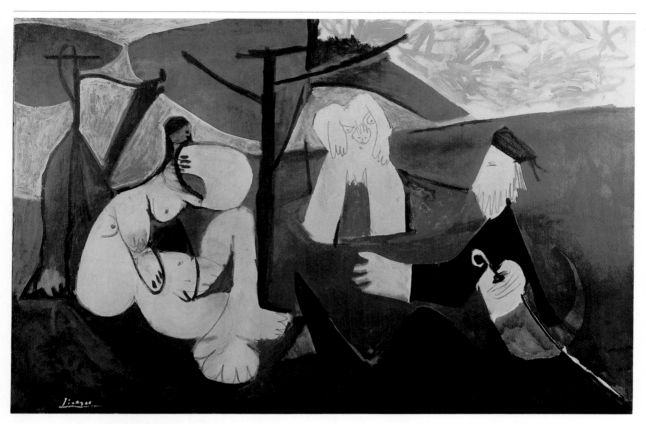

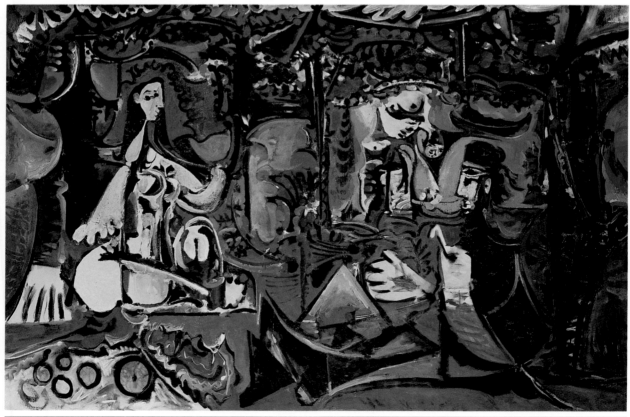

ject by altering the looking relationship, and transposes the theme of the original into that of the artist and muse, inserting a figure from his personal life in the role of the latter. The picture was taken up again and "finished" on August 20.

March 4, 1960, oil on canvas

Seizing on the element of impudence in Manet's painting, Picasso here develops it in a new direction. In this painting (fig. 7–6) the fashionable

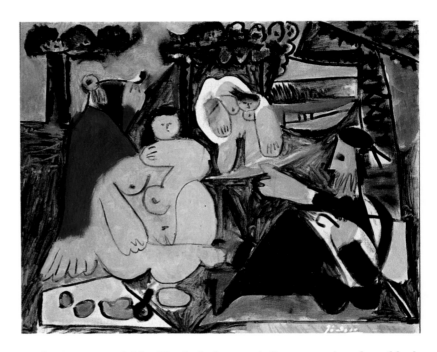

Fig. 7–6 *Pablo Picasso*. Le Déjeuner sur l'herbe, after Manet. *Vauvenargues, March 4 and July 30, 1960. Oil on canvas, 23⅝ × 28¾" (60 × 73 cm). Private collection. Courtesy Galerie Beyeler, Basel*

students are overlaid with clerical connotations: one, in a long black robe, suggests a rabbi or judge while the other wears a purple robe. Between the men sits a corpulent nude, while the other female, brought up closer to the group, hoists up her shift in a familiar motif of exposure that runs throughout the series, and Picasso's art as a whole. Even the still life elements, as in previous examples, seem to respond to the wave of eroticism, with the phallic-shaped flask strategically placed under the nude. Indirect allusions to Biblical stories, such as Susanna and the Elders (a subject Manet had treated shortly before the *Déjeuner*), or David and Bathsheba seem to hover under the surface.

Picasso also increases the contrast between the men and women in Manet's work. In the original, the men are more closely connected with the setting through a similarity of tone, while the women stand out from it, although all four may be seen as superimposed on a backdrop. In Picasso's painting, the nudes are essentially drawings inserted in the sketchily painted work, alluding again, no doubt, to the cut-out character of their Manet counterparts. Here, however, they appear as "empty signs," bare areas reserved from the canvas. The landscape, which opens onto depth, is transformed into something closer to Picasso's own environment in Southern France, perhaps hinting at the Mediterranean heritage of the *Déjeuner*.

July 20, 1960, oil on canvas

As we have seen in previous serial variations, Picasso reenters the dialogue with his source after an absence through a process of retracing his steps. On this date, he took up the canvas of March 3, the major statement of the series so far, and retouched it.

During the interval, however, Manet had remained a presence for Picasso. On May 2, at his villa La Californie in Cannes, he executed three very free interpretations of Manet's *Old Musician*[23] in a manner reminiscent of van Gogh. Like the *Déjeuner*, the *Old Musician* is connected with Picasso's beginning: it served as an underlying image in his *Family of Saltimbanques* of 1905.

July 30, 1960[24]

The process of retracing continues in seven pencil drawings of the bather. She is no longer standing, but now seated; she bends over to examine her foot, an image that refers loosely to the classical type of the sandal-tying figure. As if to signal his complete ownership of the "signs" he appropriated from Manet, Picasso now indulges in a game of visual punning. The same configuration can be read as the head of a man, in which the woman's breasts serve as his eyes, and her long neck—transposed into male genitals—serve as his facial features.

The same day, Picasso returned to his painting of March 4, and completed it. At this point, he set aside the series for nine months, turning his attention to cut-out sheet metal sculpture, among other projects.

April 19, 1961

Two loosely painted canvases,[25] which derive from his last painting (begun on March 3 and completed on July 30, 1960), set the painted variations in motion again. The figures are dematerialized and seem to float unanchored in a non-gravitational space.

June 3–June 8, 1961, The Bathers

Over three days, Picasso executes a suite of twenty-two drawings of two nudes.[26] One reclines on a bed or low couch, while the other stands or sits beside her, tying her sandal. In many of the drawings, the women are accompanied by a small child playing on the floor with a toy or pet. Initially the women appear to be at the shore, but soon they are brought back into an interior furnished with a low divan and occasionally a stool; in one of these, a pair of prying male eyes is seen looking in at the window. In others, no setting at all is indicated. Through this suite of graceful, and sometimes comical Picassoesque nudes, the artist returns to his engagement with the *Déjeuner*.

June 17, 1961, oil on canvas

On June 14, Picasso and Jacqueline Roque, whom he had married in March, moved from La Californie in Cannes to the *mas* Notre-Dame-de-Vie in Mougins, which would be their final residence. All of the earlier versions of the *Déjeuner* were transferred there.[27] A new wave of ener-

Fig. 7–7 *Pablo Picasso.* Le Déjeuner sur l'herbe, after Manet. *Mougins, June 17, 1961. Oil on canvas, 23⅝ × 28¾″ (60 × 73 cm). Museum Ludwig, Cologne*

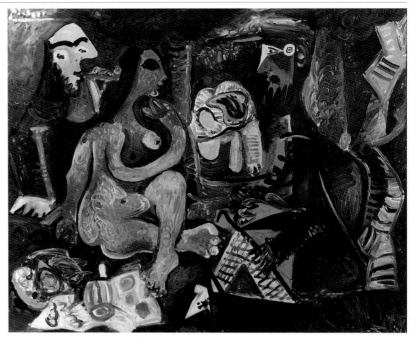

Opposite, above:

Fig. 7–8 *Pablo Picasso.* Le Déjeuner sur l'herbe, after Manet. *Mougins, July 10, 1961. Oil on canvas, 45 × 57½″ (114.2 × 146 cm). Staatsgalerie, Stuttgart*

Opposite, below:

Fig. 7–9 *Pablo Picasso.* Le Déjeuner sur l'herbe, after Manet. *Mougins, July 12, 1961. Oil on canvas, 31⅞ × 39⅜″ (81 × 100 cm). Musée Picasso, Paris*

gy sweeps over the *Déjeuner* in a canvas of June 17 (fig. 7–7), leaving its traces in the animated brushstrokes that overlay the surface in a variety of patterns of straight, curved, or scribbled lines. The speaker and the nude are here pulled upright from their original poses, their heads nearly brushing the top of the canvas, and are locked together through their reciprocated gaze. Even the dreaming smoker sits up and takes note, although he has been pushed back behind the nude. Figure and ground are more closely interrelated. The source of the magnetic force that unites the figures is revealed in the triangle of light that covers the speaker/artist's profiled eye. Picasso's nude turns toward the artist, in opposition to Manet's, while her frontal eye, superimposed on a profile view of her face, remains blank, a pool of darkness and mystery, in contrast to the alert glance of her Manet self. Here the cane that the speaker holds combines implications of a phallus and an artist's implement, which nearly bridges the gap between himself and the nude. Picasso alludes to his familiar equation of painting with lovemaking.[28]

The bather, painted in warmer tones and framed in a space of her own, is both removed and present in the scene, as she is in the original work. Yet here she may also be seen as a representation within the representation. The blue tonality of this work suggests the underlying presence of another modern master, Cézanne. In the two months between the present canvas and the last one of August 19, Picasso executed fifteen more paintings, bringing his dialogue with Manet to a culmination.

Between this canvas and the next, executed on July 10, Picasso returned to drawing, executing works too numerous to trace here in a variety of media on separate sheets and in a sketchbook. In these, he returned to many of the motifs he had explored so far and developed them in new directions. Among them are some of the finest examples of his supple drawing techniques; in others the repetitiveness stands out over the invention.[29] In them Picasso depicts the composition as a whole,[30] the two nudes,[31] nudes embellished in colored crayon in an inte-

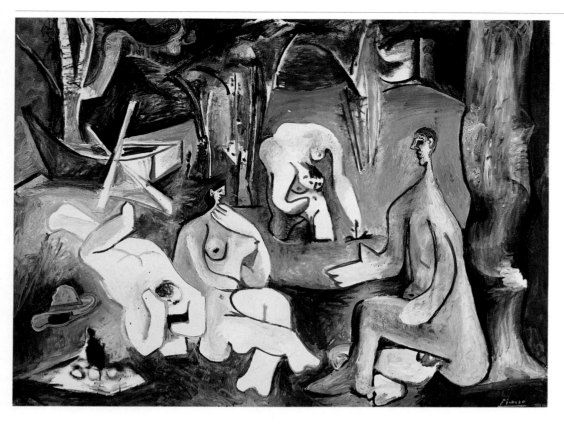

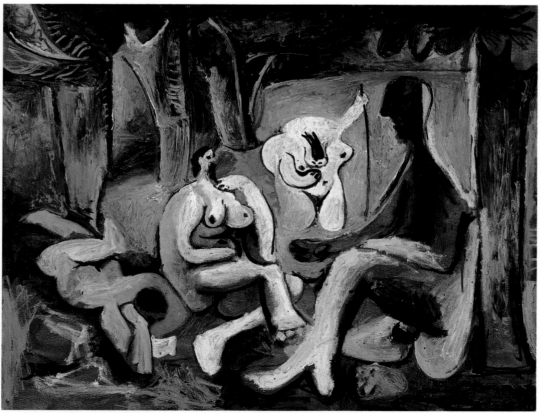

rior and on the seashore (where the reclining one becomes a mer-maid),[32] the bather alone in a quasi-classical style (reminiscent of Rembrandt's wading woman, the massive bathers of Courbet and Renoir, and those of Picasso's neoclassical period of the early twenties),[33] and the entire composition again.[34]

July 10, 12, 13, 1961

With his painting of July 10 (fig. 7–8) Picasso initiates a new series of canvases in which the picnickers are transformed into bathers. The dialogue with Manet expands at this point to a three-way conversation that includes Cézanne.[35]

In this canvas, the *dramatis personae* are set in a deep grotto-like setting. All of Manet's anecdotal references to the modern world, and his sense of the momentary, are removed, just as the figures themselves are stripped nude. Daylight is replaced with the more indeterminate Cézannesque lighting, and the flattened figures of the original with more volumetric ones. The ambiguity of the Manet painting gives way to a dream-like atmosphere and aloofness, characteristic of the great bathers of Cézanne's later years.[36] The figures are now more generalized and monumental.

Picasso imposes his stamp on his conflation of sources through his handling of the body. The voluptuous nude seen from various viewpoints, the comic "monster" bather, and the tiny-headed speaker are characteristically Picassoesque, signifying his "embodiment" or bridging of artists. That Picasso would reach out to Cézanne through Manet is understandable. Not only did Cézanne admire Manet profoundly, executing variations of several of his works, including *Olympia* and the *Déjeuner*, but Cézanne's preoccupations during his late period were similar to his own. As one scholar has written, "The extraordinary achievements of Cézanne's last decades were the result of long observation and meditation on nature, on the old masters, and above all, on the workings of his own mind."[37] Cézanne's final period would have provided a formidable challenge for Picasso to live up to in old age, just as his awkward figures had exerted a strong influence on Picasso and on Matisse in the early years of the century.

This canvas and the following one of July 12 (fig. 7–9)[38] are the most balanced in a three-way relationship among himself, Manet, and Cézanne. By the 13th, (fig. 7–10), Picasso begins to leave his partners behind. Tensions disrupt the Cézannesque passivity of the figures. Over the course of the next paintings, the figures undergo dramatic changes in form and scale. The "artist" and "model" each loom up in turn, dominating and being dominated by the other. It is not only the bodies themselves, but body parts, that grow and shrink in unpredictable ways, revealing Picasso's kinesthetic identification with his subject.

July 16, 1961, oil on canvas

Picasso returns to a three-figure arrangement and takes off on Manet's sensuous painterly idiom, adapting it to a condensed language of light and dark (fig. 7–11). He now develops the dream-like quality of Cézanne's bathers into the realm of fantasy through variables in form and scale. Cut loose from the Manet source, they are also free of gravi-

tational space. He submits Manet's figures to aggressive distortions in an expandable and contracting abstract space. The palette is restricted to green, blue, black, and white. This and the following variations bring to mind Matisse's observations on the nineteenth-century master's art in a conversation with Picasso in the post–World War II years: ". . . he disengaged pure painting from subject matter. His themes have an abstract presence, a dreamlike quality. Their sensuousness is post-Baudelairean, not directly evocative . . ."[39] Yet Picasso's distortions carry with them disturbing undertones that convert the unreality of Manet's work into something more threatening. Here the model's body shoots up, filling the canvas on the left-hand side, her head pushed back down by the upper edge of the canvas, overpowering the artist.

July 30, 1961

In this painting (fig. 7–12) and in the next five, executed over the course of two days, Picasso turns his canvases to the vertical direction, and as Cooper notes, reverses many aspects of his theme. Picasso continues to play out the drama of artist and model in three-figure compositions through aggressive distortions in scale in atmospheric space. Here, the bather, who has remained separate from the others throughout much of the series, swells, while the nude shrinks. Yet, despite the bather's imposing size, she remains, as in the Manet painting, a figure separate from the central group. The composition revolves around the large black "magical" hand of the artist that occupies the center of the composition, set off against white. The posture of the artist, seated and in profile with hand upraised, recalls Picasso's early self-portrait in his parody of *Olympia* of 1903 (Ch. 2, fig. 2–2). Here too, the gesture seems to suggest the warding off of danger.

In the last canvases Picasso takes the painter through a series of multiple personae: he is old and bearded, bald, an archaic Sumerian type—any artist and all artists. The exaggerated distortions, dark atmosphere, and sardonic humor exhibited in some of these dream-like recollections of the theme in the final paintings betray a sense of entrapment and angst.

August 22, 1961, 7 drawings

August 25, 1961, 7 drawings

The suite of drawings that appear on these two days are among the masterpieces of the series.[40] With a deep familiarity with his sources Picasso conjures up the full cast of characters again in eloquent line renderings in a classicizing mode, converting Manet's *vie de bohème* into an idyll.[41] In I (fig. 7–13), the most serene of the group, a turbaned reclining woman adopts the pose of Ingres's *Grande Odalisque* and coolly regards the laurel-wreathed classical youth who extends his arm to her. A bearded faun-like figure looks on while the wading bather picks a flower on the river bank. A few landscape elements and the still life complete the scene. The spirit of Matisse's *Joie de Vivre* reverberates through the drawing. In the variety of his markings, from the sinuous contours of the figures, to the energetic scribbles and zig-zags denoting trees and foliage, Picasso displays his range of drawing techniques. In the follow-

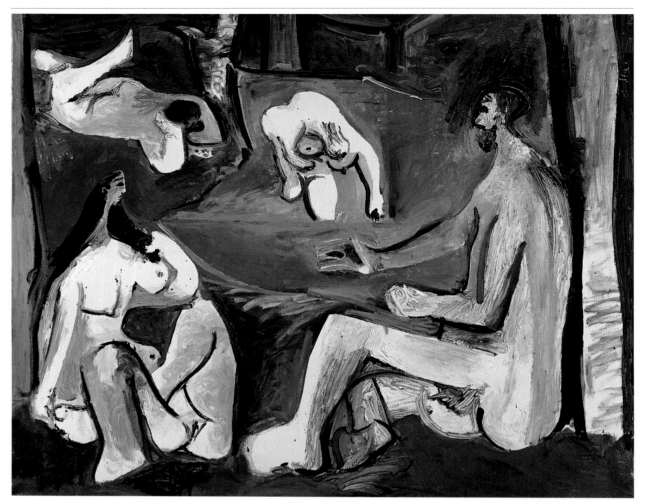

Fig. 7–10 *Pablo Picasso.* Le Déjeuner sur l'herbe, after Manet. *Mougins, July 13, 1961. Oil on canvas, 23⅝ × 28¾" (60 × 73 cm). Musée Picasso, Paris*

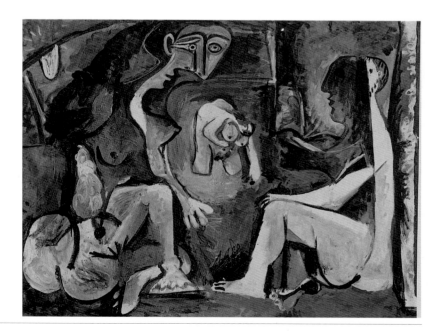

Fig. 7–11 *Pablo Picasso.* Le Déjeuner sur l'herbe, after Manet. *Mougins, July 16, 1961. Oil on canvas, 35 × 45⅝" (89 × 116 cm). Picasso Collection of the city of Lucerne. Rosengart Donation*

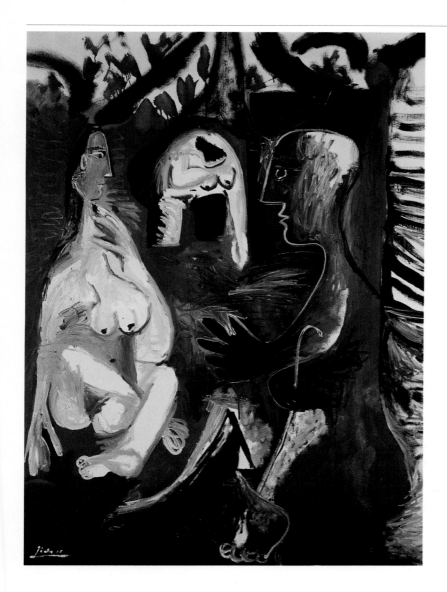

Fig. 7–12 *Pablo Picasso*. Le Déjeuner sur l'herbe, after Manet. *Mougins, July 30, 1961. Oil on canvas, 51¼ × 38¼" (130 × 97 cm). Louisiana Museum of Modern Art, Humblebaek, Denmark*

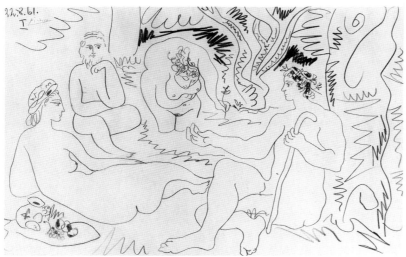

Fig. 7–13 *Pablo Picasso*. Le Déjeuner sur l'herbe, after Manet. *August 22, 1961. Pencil on paper, 10⅝ × 14½" (27 × 37 cm). Private collection, New York*

ing sheets, the equilibrium is dispelled and he returns to his central theme—the interaction of the artist and model. The artist continues to pass through various incarnations, from beautiful classical youth to Near Eastern potentate to a simian old man.

In the last group of drawings, executed on August 25,[42] the artist remains fixed: he is an older, bearded man with a fillet in his hair, and his lips are parted. His obsessive speech—a metaphor for the painter's relentless gaze—has driven the model into a deep sleep. She stretches out into a voluptuous pose, her finger in her mouth, and one of Picasso's most constant themes, the watched sleeper, emerges. By the fifth drawing, the motif takes on a more lascivious tone, as the speaker finally pauses to look upon the nude displayed before him, whom he suddenly sees for what she is—a naked woman.

These drawings do not lead to any further paintings. One more set of drawings appears on December 29,[43] a farewell to the artist and model, who are sometimes accompanied by the bather in the background.

The project rested for six months. Twenty-four more pencil drawings based on the *Déjeuner* fill a sketchbook dated from June 14 to July 7, 1962.[44] Another sketchbook, dated June 17 on the front cover, contains yet more works related to it, interspersed with other subjects. On pages 36 and 37 of this sketchbook, the series comes to a conclusion in an orgiastic scene: the two men, now transformed into a comic pair of bald, bearded men, with large, erect penises pounce upon the two naked women in a mock rape (fig. 7–14). In John Richardson's view, Picasso finally finds an ending for the series in the rape scene and goes right on to his next engagement in his art after art, drawing from both Poussin's and David's *Rape of the Sabine Women*, where the mood turns more violent.[45]

And yet there was an alternative ending as well. In what is generally regarded as a coda to the long series of paintings and drawings, between August 26 and 31, Picasso executed eighteen cardboard maquettes based on figures from the *Déjeuner*, which he folded and drew on (fig. 7–15).[46] Two years later, Picasso selected four of the models for monumental enlargements in concrete for installation in the sculpture garden of the Moderna Museet in Stockholm. The figures, which correspond to the original cast of the Manet painting, are all nude; they were installed on a grassy slope under trees in the museum's garden in 1965 (fig. 7–16).[47] As one critic notes: "They have weathered into their surroundings; trees and vegetation have made the environment look totally rural and truly Arcadian; and the sculpted complex, Picasso's original painted "*Déjeuners*," is untouched by the note of anguish which underlies so many of the final canvases."[48] The blow-up drawings, lifted from Manet's painting, are transposed into sculpture and placed in the natural world, where they remain suspended within the ultimate dialectic, that of art and nature.

At the time of Manet's *succès de scandale*, Théophile Gauthier wrote: "The nude is to painting what counterpoint is to music, the foundation of a true science; the study of human form, unrestricted and free of all apparel and all transitory fashion, is alone capable of producing complete artists. It is truth, beauty, eternity; the imagination in quest of an ideal would go no further . . ."[49] These words would have had meaning

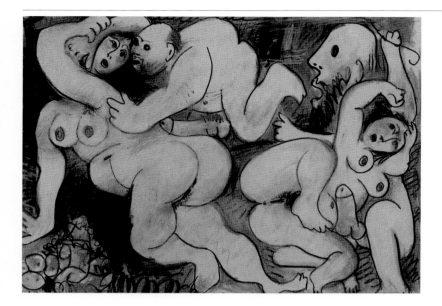

Fig. 7–14 *Pablo Picasso*. Rape Scene. *Sketchbook No. 165. August 2, 1962. Pencil drawing colored with crayon, 9 × 12½" (23 × 32 cm). Heirs of the artist*

one hundred years later for Picasso, a figurative painter in an era of abstraction. If the nude was "the last bastion of style for those interested in tradition" in Manet's era, for Picasso the nude stood for the Western classical tradition itself, for which he saw himself as the last representative and guardian.

In the *Déjeuner*, Manet's nude served as both embodier of tradition, and source of liberation and renewal. His auburn-haired model who turns her shrewd gaze to the viewer, as we have seen, plays a dichotomous role. She is on one level a recognizable studio model who could be named, depicted on a country outing with some bohemian friends. Divested of the conventional metaphors that would justify her nudity in the context of painting (bather, Venus, or odalisque), she ruptures the fiction on which painting depends, and thus conveys a strong element of shock. Yet she does not merely represent herself, for she adopts, as we have seen, the pose of figures from the history of art. She refers us back to the archive of art where there is no one original source.

For Picasso, as for Manet, the *Déjeuner* offered the opportunity to reassess the central theme of the nude and invest it with new life. Over the course of his transformations, he strips away Manet's overlay of realism, and takes the female figure back to something more timeless, enduring, and primordial. The female nude was for Picasso, as it was in Manet's time, "the very essence of art . . . its principle and its force, the mysterious armature that prevents its decomposition and dissolution."[50] She is equated with the originating impulse of art, eros, inspiration, and generativity, and is the link between generations.

The nude remained a vital source of inspiration throughout Picasso's final decade. But the *Déjeuner* also represented a powerful synthesis (and a celebration of the art of painting) in which various national schools, eras, and genres are reconciled.[51] In 1947, a critic summed up the importance of the *Déjeuner* for the current generation of artists: "His [Manet's] very theme, for a while so notorious, now so ignored, indicates how much he comes from the past, how much he looks toward the future. In a *tour de force*, he combined a classical *invenzione* (not his

Fig. 7–15 *Pablo Picasso.* Le Déjeuner sur l'herbe: Femme assise. *August 26, 1962. Pencil on cardboard, 13½ × 9⅞" (34.3 × 25 cm). Musée Picasso, Paris*

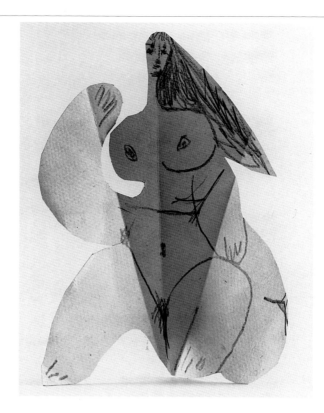

own to be sure), a genre theme, a nude studied out of doors, and a landscape. No other painter of the century managed to get so much into a canvas. If Manet achieves their union, it was paradoxically none of these that really interested him; standing apart from them he could fuse them through his only real passion—pure painting."[52]

Picasso's dialogue with Manet reveals a similar ambition to encompass within a continually transforming suite of works all of the possibilities of pictorial representation, while reaching beyond painting to drawing, graphic work, and sculpture to a synthesis of all the arts. If Manet aimed to reveal truth by stripping away academic convention, Picasso posits a rejection of any one truth. Manet's ambiguity of meaning is replaced with Picasso's ever-changing subjective responses, in which the work is filtered through his imagination, open to continual revision. He returns through the picnic to his own constant themes, and reiterates them through the basic dyad of artist and model.

Manet's painting, executed at the outset of his career, reflects the artist's wish to free painting from outworn conventions through overt comparison with recognizable models of the past. The *Déjeuner* variations come at the end of Picasso's career, and are characterized by a breaking down of barriers and a free circulation among the codes, which he juxtaposes, inverts, and rewrites in his own multivalent and disjunctive creations. Yet, in their often repetitive and obsessive character, and Picasso's ambivalent attitude, they also reveal a despair in the constricted nature of this self-enclosed world of art, the domain of the modern artist.

The *Déjeuner* series both carries on and takes Picasso beyond issues that preoccupied him in his dialogue with *Las Meninas*. Both the

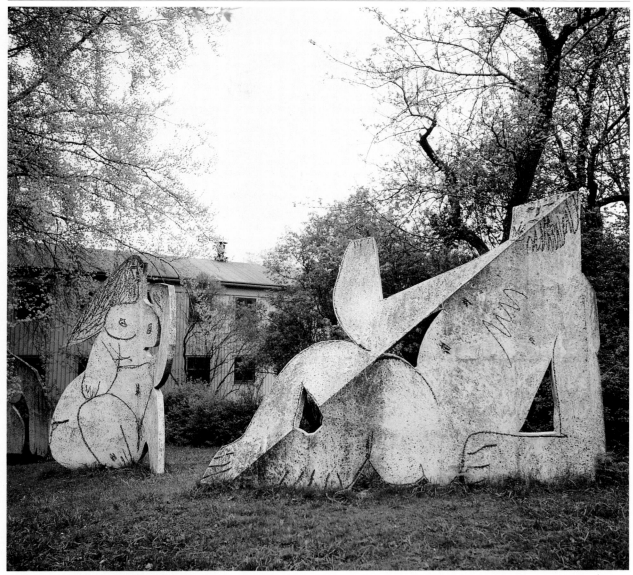

Fig. 7–16 *Pablo Picasso.* Le Déjeuner sur l'herbe, after Manet. *1965–66. Concrete, height: 10' to 13' (3 to 5 m). Moderna Museet, Stockholm*

Spanish and French paintings are, in a sense, manifestoes on art, and are thus central to Picasso's lifelong investigation of the nature of representation, the primary focus of all of his variations and of his art as a whole. But these last dialogues are rooted as well in deep personal meaning. Both series issue from a particularly strong attachment to the earlier master. With Velázquez Picasso shared the bond of nationality, and with Manet a locale, while their respective careers marked the beginning and end of an artistic era. (The "father of modernism" was in fact a man of Picasso's father's generation.) It is fitting that Picasso would turn to the *Déjeuner* at the end of his life, and at a moment that he perceived to be, as he so often called it to friends, the end of modern art.[53] In returning to his own beginnings in his later years, and to the origins of modern art—the course of which was so strongly shaped by his life's work—the *Déjeuners*, based on the original "museum masterpiece," carried Picasso beyond *Las Meninas* and closed the circle of his art after art.

Notes

Chapter 1

1 André Warnod, "En peinture tout n'est que signe, nous dit Picasso," *Arts* (1945), excerpted in Dore Ashton, *Picasso on Art, A Selection of Views*, The Documents of 20th Century Art (New York: Viking, 1972), 51.

2 See, for example, Klaus Gallwitz, *Picasso at 90: The Late Work* (New York: Putnam and Sons, 1971); Jean Sutherland Boggs, "Picasso, The Last Thirty Years," in *Picasso in Retrospect*, ed. Sir Roland Penrose and John Golding (reprint, New York: Harper and Row, Icon Editions, 1980), 127–161; Gert Schiff, "Introduction," *Picasso in Perspective* (Englewood Cliffs: Prentice Hall, 1976), 1–15; Christian Geelhaar, *Pablo Picasso: Das Spätwerk, Themen 1964–1972* (Basel: Kunstmuseum, 1981); Marie-Laure Bernadac, "Picasso et des Peintres du Passé," in Georges Boudaille, *Picasso* (Paris: Nouvelles Editions Françaises, 1985), 121–46; Bernadac, Isabelle Monod-Fontaine, and David Sylvester, *Late Picasso: Paintings, Sculpture, Drawings, Prints, 1953–1972* (London: The Tate Gallery, 1988).

Pioneering studies on important series of variations include: Jaime Sabartès, *Picasso: Variations on Velázquez' Painting "The Maids of Honor" and Other Recent Works* (Paris: Editions Cercle d'Art, New York: Harry N. Abrams, 1959); Douglas Cooper, *Pablo Picasso: Les Déjeuners* (Paris: Editions Cercle d'Art, 1962, New York: Harry N. Abrams, 1963); and Leo Steinberg, "'The Algerian Women' and Picasso at Large," in *Other Criteria: Confrontations with Twentieth Century Art* (New York: Oxford University Press, 1972), 125–235.

Hélène Parmelin, a novelist and critic, contributed numerous first-hand accounts of the variations, many of which she saw in the making. See her *Picasso sur la place* (Paris: Édition René Julliard, 1959); *Picasso: Les dames de Mougins* (Paris: Éditions Cercle d'Art, 1964); *Le Peintre et son modèle* (Paris: Éditions Cercle d'Art, 1965); *Picasso: Notre-Dame-de-Vie* (Paris: Éditions Cercle d'Art, 1966); *Picasso dit . . .* (Paris: Éditions Gonthier, 1966); and *Voyage en Picasso* (Paris, Robert Laffont, 1980). Among early commentators on the variations are Christian Zervos, "Confrontation de Picasso avec des oeuvres d'art d'autre fois," in *Cahiers d'Art* 33–35 années (1960): 9–119, and John Lucas, "Picasso as a Copyist," *Art News* 54, no. 4 (1955): 36–39, 53–54, 56.

3 A sampling of writings on Picasso's variations from a variety of critical viewpoints includes: Rosalind Krauss, "Representing Picasso," *Art in America* (December 1980): 90–96;

Diane Daval, *L'Art d'après l'art: le cas de Picasso*, thesis, University of Paris I, 1985; Timothy Anglin-Burgard, "Picasso and Appropriation," *The Art Bulletin* 72, no. 3 (1991): 479–94; Karen Kleinfelder, "Picasso's Meninas: Changing the Order of Things," in *The Artist, His Model, Her Image, His Gaze: Picasso's Pursuit of the Model* (Chicago and London: University of Chicago Press, 1993), 57–67; Richard Wollheim, "Painting, Textuality, and Borrowing: Poussin, Manet, and Picasso," 187–247; and "Painting, Omnipotence, and the Gaze: Ingres, The Wolf Man, Picasso," 248–304 in *Painting as an Art* (London: Thames and Hudson, 1987); and Nelson Goodman and Catherine Z. Elgin, "Variations on Variation—Or Picasso back to Bach," in *Reconceptions in Philosophy and Other Arts and Sciences* (Indianapolis and Cambridge: Hackett Publishing Company, 1988), 66–81.

Many of the issues connected with variation, such as representation, appropriation, repetition, influence, and notions of authorship and of the original, have become a major focus for critics in the last two decades. The literature is too vast to summarize here. A few examples include: Rosalind Krauss, "Originality as Repetition: Introduction," *October* 37 (Summer 1986): 35–40. (Included in this issue are other articles from the 1985 College Art Symposium chaired by Krauss, "Multiples without Originals: The Challenge to Art History of the 'Copy'."); Jean Baudrillard, *Simulacres et Simulations*, (Paris: Galilée, 1981); Michel Foucault, "Fantasia of the Library," in *Language, Counter-Memory, and Practice*, ed. Donald F. Bouchard (Ithaca: Cornell University Press, 1977); Michel Foucault, "What is an Author?" in *The Foucault Reader*, ed. Paul Rabinow (New York: Pantheon, 1984), 101–20; Richard Schiff, "Representation, Copying and the Technique of Originality," *New Literary History* 15, no. 2 (1984): 333–63.

4 In discussing his variations of 1932 after Matthias Grünewald's *Crucifixion* (see Chapter 3), Picasso said to the photographer Brassaï: "I love that painting and I tried to interpret it, but as soon as I began to draw, it became something else entirely. . . ." Brassaï, *Picasso and Company*, trans. Francis Price (Garden City, NY: Doubleday, 1966), 24.

5 On the history and theory of interpretive copying, see K. E. Maison, *Themes and Variations, Five Centuries of Master Copies and Interpretations* (London and New York: Harry N. Abrams, 1960); Egbert Haverkamp-Begemann and Carolyn Logan, *Creative Copies: Interpretative Drawings from Michelangelo to Picasso* (New York: The Drawing Center, 1988); and Roger Benjamin, "Recovering Authors: The Modern

Copy, Copy Exhibitions and Matisse," *Art History* 12, no. 2 (1989): 176–201, in which the commodification of the copy as replica and the function of the author are discussed.

6 Arthur Danto, "Artworks and Real Things," in *Art and Philosophy*, ed. W. E. Kennick, 2nd ed. (New York: St. Martin's Press, 1979), 102–03.

7 Picasso wrote to Joachim Bas: "What painters, dear Bas, it's Velázquez for painting and Michelangelo for sculpture," cited in Josep Palau y Fabre, *Picasso, The Early Years*, trans. Kenneth Lyons (New York: Rizzoli, 1981), 134–35.

8 Ibid., 138.

9 John Richardson, "Picasso's Apocalyptic Whorehouse," *The New York Review of Books* 37, no. 7 (1987): 42. The drawings have now disappeared. *The Burial of Count Orgaz*, 1585, is in the church of Santo Tomé, Toledo, Spain.

10 Christian Zervos, "Conversation avec Picasso," *Cahiers d'Art* 10, no. 10 (1935): 173–78, excerpted in Ashton, 73.

11 Robert Rosenblum, "Picasso and History," in *Picasso, A Loan Exhibition for the Benefit of Cancer Care, Inc.* (New York: Acquavella Gallery, 1975), unpaginated. See also Rosenblum, "'The Demoiselles d'Avignon' Revisited," *Art News* 72, no. 4 (April 1973): 45–48.

12 In describing variation in art, I have drawn from a description of musical variation as "the reciprocal action of unchanging and changing musical materials." *The New Grove Dictionary of Music and Musicians*, ed. Stanley Sadie, 19 (London: Macmillan Publishers, 1980), 536.

13 Walter Benjamin, "Allegory and Trauerspiel," in *The Origins of German Tragic Drama*, John Osborne, trans. (London and New York: Verve, 1977), 184. I thank Robert Lubar for bringing this essay to my attention.

14 R. Benjamin, 180. See also his note 4, 195, for an excellent summary of contemporary literature on this subject.

15 Ibid., 183–4. Zola insisted that art is a "personal mark," which is infinitely variable: "There are as many works as there are different spirits. If temperament did not exist at all, paintings would simply be photographs," "Art at the Moment" in *L'Evénement*, 4 May 1866, excerpted in *Nineteenth-Century Theories of Art*, ed. Joshua Taylor (Berkeley, Los Angeles, London: University of California Press, 1987), 428.

16 See Theodore Reff, "Pictorial Sources and Structure," chap. 2 in *Manet: Olympia* (New York: Viking, 1976), esp. 59 ff.; and Ann Coffin Hanson, *Manet and the Modern Tradition* (New Haven: Yale University Press, 1977). In the extensive body of literature on this subject the following articles by Michael Fried are especially pertinent: "Manet's Sources: Aspects of his Art, 1859–1865," *Artforum* 7 (March 1967): 28–82; "Painting Memories: On the Containment of the Past in Baudelaire and Manet," *Critical Inquiry* 10, no. 3 (1984): 510–42.

17 Foucault, "Fantasia of the Library," 72.

18 R. Benjamin, 181–82, notes that the critical acclaim given to van Gogh's *Raising of Lazarus* (after an etching by Rembrandt) when it was shown in the Salon des Indépendants in 1891, brought legitimacy of this formal exercise as a creative act. Furthermore, the appearance of several of van Gogh's interpretive copies in an exhibition at Bernheim Jeune in 1901 attended by Vlaminck, Matisse and Derain influenced the younger generation in their way of copying.

19 Lt697, Vincent to his brother Theo, 19 September, 1889 in *The Complete Letters of Vincent Van Gogh*, vol. 3 (Boston, Toronto, London: A Bullfinch Press Book, Little Brown and Company, 1991), 215–16.

20 Ronald Pickvance, *Van Gogh in St. Rémy and Auvers* (New York: The Metropolitan Museum of Art, 1986), 173.

21 Lt613, Vincent to his brother Theo, (1889) *Complete Letters*, 227. Van Gogh's painting was based on a lithograph by Celestin Nanteuil after Delacroix's painting. See Pickvance, 44, illus. R. Benjamin notes that in the nineteenth century, "only copies which did the work of translating the image from one medium to another were considered worthy of exhibition" (181).

22 Pickvance, 155.

23 Lt623, *Complete Letters*, 173.

24 Lt643, *Complete Letters*, 177.

25 A connection between Picasso's and van Gogh's use of variation was made by G. Schiff, 19.

26 Picasso to André Vernet, preface to the exhibition catalogue, *Picasso*, Musée de l'Athenée, 1963, excerpted in Ashton, 95.

27 Leo Steinberg, "The Philosophical Brothel," reprinted and revised in *October* 44 (Spring 1988), 64.

28 Ibid.

29 Yve-Alain Bois, "The Semiology of Cubism," in *Picasso and Braque: A Symposium*, ed. William Rubin and Lynn Zelevansky (New York: The Museum of Modern Art, 1992), 175.

30 See especially, Bois, 169–209, and Rosalind Krauss, "The Motivation of the Sign," in *Picasso and Braque: A Symposium*, 261–87. The following section draws on these articles.

31 See also Robert Rosenblum, *Cubism and Twentieth Century Art* (New York: Abrams, 1966), the classic study on this period, to which I am indebted.

32 François Gilot and Carlton Lake, *Life with Picasso* (New York, Toronto, London: McGraw-Hill Book Company, 1964), 75.

33 Krauss, 275.

34 Rosenblum, *Cubism and Twentieth Century Art*, 93.

35 Picasso to Warnod, 1945, excerpted in Ashton, 66.

36 See the classic essay on this subject: Walter Benjamin, "The Work of Art in the Age of Mechanical Reproduction," in *Illuminations*, ed. Hannah Arendt, trans. Harry Zohn (Frankfurt: Surkamp Verlag, 1955; reprint New York: Shocken Paperback Edition, 1976), 217–51.

37 See, for example, Harold Bloom, *The Anxiety of Influence, A Theory of Modern Poetry* (New York: Oxford University Press, 1973). In his Freudian theory of modern poetics, Bloom explores the psychological dimension of the writer's bondage to the past, and his struggle with his precursors. For Bloom, artistic growth is rooted in "misprision" or deliberate creative misinterpretation of one's predecessor to clear a place for oneself (30). For a discussion of this issue in relation to the visual arts, see Norman Bryson, *Tradition and Desire, from David to Delacroix* (Cambridge and New York: Cambridge University Press, 1987), 18–24. Like Bloom, Bryson rejects the notion of a peaceful transmission of tradition, arguing that the painter's relationship to the past is not merely one of "deliberate misreading" but of antagonism, transgression or effacement. Given the inextricability of the present from the past, the artist invents "tropes" that interrupt the force of tradition by turning it against itself (129–30).

38 Roland Penrose, *Picasso, His Life and Art* (New York: Harper and Row, 1958), 350.

39 André Malraux, *Picasso's Mask*, trans. June Guicharnaud with Jacques Guicharnaud (New York: Holt, Rinehart and Winston, 1974), 137.

40 The most recent study on this issue is Robert Lubar, "Picasso, El Greco, and the Construction of National History," in Jonathan Brown, ed., *Picasso and the Spanish Tradition* (New Haven, London: Yale University Press, forthcoming 1996). On Picasso's early interest in Nietzsche see also Marilyn McCully, *El Quatre Gats: Art in Barcelona around 1900* (Princeton: Princeton University Press, 1978); Ron Johnson, "The *Demoiselles d'Avignon* and Dionysian Destruction," *Arts Magazine* 55 (October, 1980): 94–101; Mark Rosenthal, "The Nietzchean Character of Picasso's Early Development," *Arts Magazine* 55 (October, 1908): 87–91; and Patricia Leighton, "Picasso's Collages and the Threat of War," *The Art Bulletin* 67, no. 4 (1985): 653–672.

41 Frederick Nietzsche, "The Use and Abuse of History," in *The Philosophy of Nietzsche*, ed. Geoffrey Clive, trans. Oscar Levy (New York: New American Library, Meridian Classic, 1984), 232.

42 Nietzsche, 232.

43 Picasso to Guttuso, excerpted in Ashton, 55.

44 Alexander Liberman, "Picasso," *Vogue* (November 1956): 132–34, excerpted in Ashton, 61.

45 Marius de Zayas, "Picasso Speaks," *The Arts* 3 (May 1923): 315–26, cited in Ashton, 4.

46 Linda Hutcheon, *A Theory of Parody, The Teachings of 20th Century Art Forms* (London and New York: Methuen, 1985), 75.

47 Marius de Zayas (1923), excerpted in Ashton, 4.

48 Ibid., 5.

49 Ibid.

50 The term is from James Longenbach, *Modernist Poetics of History: Pound, Eliot, and the Sense of the Past* (Princeton: Princeton University Press, 1987), 14.

51 Zervos, "Conversation avec Picasso," *Cahiers d'Art* 10 (1935), excerpted in Ashton, 27.

52 On the beholder's share in Picasso's Cubist work, see Christine Poggi, "Frames of Reference: Table and Tableau in Picasso's Collages and Constructions," *Art Journal* 47, no. 4 (1988): 311–323; and Baxandall, 57. See also Richardson on his discussion of the Spanish concept *mirada fuerte* (strong gazing) and its relation to Picasso's late work, "L'Époque Jacqueline," in *The Late Picasso*, 30–31.

53 Vladimir E. Alexandrov, *Nabokov's Otherworld* (Princeton: Princeton University Press, 1991), 9. Picasso's emphasis on the beholder's share throughout his art, and most overtly in his variations, anticipates Reception theory or Reader-Response criticism which arose in the 1970's in the work of Hans Robert Jauss and Wolfgang Iser.

54 Zervos (1935), excerpted in Ashton, 9.

55 Daniel-Henry Kahnweiler, "Gespräche mit Picasso," *Jahresring* 59–60 (Stuttgart: Deutsche Verlags Ausstalt, 1959): 85–98, excerpted in Ashton, 29. Picasso expressed similar sentiments to other friends.

56 Hélène Parmelin, *Picasso: Women, Cannes and Mougins, 1954–1963* (New York: Time-Life, 1964), 142.

57 Mary Mathews Gedo, *Picasso: Art as Autobiography* (Chicago and London: University of Chicago Press, 1980), 226–239.

58 Ibid., 235.

59 Richardson, "L'Époque Jacqueline," 31–2. The term comes from Freud.

60 Wollheim, 243.

61 Howard S. Baker and Margaret N. Baker, "Heinz Kohut's Self-Psychology: An Overview," *The American Journal of Psychiatry* 144, no. 1 (1987): 6. My thanks to Sue Hallowell for sending me this article.

62 Gedo points to the dynamic tension between Velázquez and Picasso's father in the *Meninas* series, as a form of psychic economy, 233. This is not an isolated instance, however; the principal of identification with multiple and shifting figures is a central characteristic of all of Picasso's variations.

63 Ashton, xvii.

64 Parmelin, *The Artist and Model and Other Recent Works* (New York: Harry N. Abrams, 1965), excerpted in Ashton, 53.

65 Warnod (1945), excerpted in Ashton, 51.

66 R. Schiff, in "Representation, Copying, and the Technique of Originality," (358), discusses the different value accorded to the terms "originality" and "creativity" in modernist discourse, noting that "originality dominates because of creativity's factor of conscious making. In other words, ultimate artistic expression is conceived as original self-discovery, as something found, rather than made."

67 Kahnweiler (1959), excerpted in Ashton, 29.

68 Spoken to Jaime Sabartès (1946), Ashton, 21.

69 Zervos (1935), excerpted in Ashton, 51.

70 Ibid., 56.

71 Dor de la Souchère, *Picasso in Antibes*, trans. W. J. Strachan (New York: Pantheon, 1960), excerpted in Ashton, 53.

72 Bloom, 80.

73 Ibid.

74 For the most recent and complete study of the later variations in Picasso's graphic art see Janie Cohen, "Memory, Transformation, and Encounter in Picasso's Late Prints," in *Picasso: Inside the Image: Prints from the Ludwig Museum, Cologne*, ed. Janie Cohen (London: Thames and Hudson, 1995), 88–128. For earlier studies on Picasso's painted and graphic variations of his last decade, see Gert Schiff, "The Sabine Sketchbook, No. 163, 1962," in *Je Suis le cahier: The Sketchbooks of Picasso*, ed. Arnold Glimscher and Marc Glimscher (Boston, New York: Atlantic Monthly Press, 1986), 179–212; *Picasso: the Last Years, 1963–1973* (New York: George Braziller, Inc., 1983); and Brigitte Baer, *Picasso the Printmaker, Graphics from the Marina Picasso Collection* (Dallas: The Dallas Museum of Art, 1983).

75 Daniel-Henry Kahnweiler, "Entretiens avec Picasso au sujet des "Femmes d'Alger," in *Aujourd'hui* (September 1955), excerpted in Ashton, 36.

76 Wollheim, 102. For an extensive discussion of this concept, see his chap. 3, "The Spectator in the Picture," 101–186.

77 Michel Leiris, "The Artist and his Model," in Penrose and Golding, 170. Leiris notes that the theme runs through the three major series of the fifties and sixties.

78 See Kleinfelder, *Artist and Model*, 1954, ink on paper, repr. p. 126.

79 As Kleinfelder notes in her discussion of the variations after Velázquez's *Las Meninas* (57).

80 An observation that Wollheim makes on Manet's relation to his sources (235–36), which is relevant to Picasso as well.

81 Rudolf Arnheim, "The Late Style," in *New Essays on the Psychology of Art* (Berkeley, Los Angeles, London: University of California Press, 1986), 287. The essay describes the stages of the life of the creative individual.

82 Malraux, *Picasso's Mask*, 135. Picasso refers here to Malraux's Museum Without Walls.

1 Jean Ravenel [pseud. for Alfred Sensier], *L'Epoque* (7 June 1865), in T. J. Clark, "Olympia's Choice," in *The Painting of Modern Life, Paris in the Art of Manet and His Followers* (New York: Alfred A. Knopf, 1984), 139–40.

2 The term "female gorilla" was used in a review by Amédée Cantaloube in *Le Grand Journal* (1865), in Clark, 94. For a summary of the critical reactions to *Olympia*'s initial viewing at the Salon of 1865, see 89–103. For the most complete study of the painting see Theodore Reff, *Manet: Olympia* (New York: Viking, Art in Context Series, 1976); for critical reactions to *Olympia*, see 14–43.

3 Reff, 82.

4 Bernard Dorival, *Cézanne*, trans. H. H. A. Thackthwaite (Boston: Boston Book and Art Shop, 1948), 112. Robert Goldwater, *Gauguin* (New York: Harry N. Abrams, 1928), 28.

5 Goldwater, 28.

6 Otto Friedrich, *Olympia: Paris in the Age of Manet* (New York, London, and Toronto: Simon and Schuster, A Touchstone Book, 1993), 305. The painting was hung in the Musée du Luxembourg in Paris where the work of more contemporary artists was exhibited.

7 On Manet's sources see Reff, 43–88. See also Kathleen Adler, *Manet* (London: Salem House/Phaidon Press, 1986), 57–63, and Clark, 79–147.

8 Clark, 94.

9 Eunice Lipton, "Manet: A Radicalized Female Imagery," *Artforum* 13 (1975): 49.

10 I draw here on the comparison of the two paintings by Heather McPherson, "Manet's Reclining Women of Virtue and Vice," *Gazette des Beaux Arts*, VI période CXV (January 1990): 38. The suggestion of masturbation in *Olympia* was made by C. van Emde Boss, "La Geste de Olympia," in *Livre jubilaire offert au Dr. Jean Dalsace* (Paris: Masson et Cie., 1966), 190.

11 Adler, 62.

12 Sebastià Junyer-Vidal (1879–1966), an unsuccessful painter, and his brother, Carles, a writer, critic and supporter of Picasso's work, were close friends of the artist in Barcelona. On Picasso's friendship with Sebastià Junyer-Vidal, see Marilyn McCully, *Els Quatre Gats* (Princeton: Princeton University Press, 1978), 108; and John Richardson with Marilyn McCully, *A Life of Picasso*, vol. 1, (New York: Random House, 1991), 282. Junyer-Vidal appears in some twenty caricatural sketches at around this time, as well as in an oil painting. See *Sebastià Junyer-Vidal and a Woman in a Cafe* (June 1903), oil on canvas, Los Angeles County Museum of Art (Zervos 1: 174).

Given the autobiographical nature of Picasso's art, it is possible that his black Olympia is also based on a figure from life, blended with aspects of Manet's African servant. She resembles a figure portrayed bust-length in the nude, *Genoveva* (Zervos 6: 462) who appears in a pastel drawing on paper. In a conversation with Richardson many years later, Picasso identified the woman as the poet Max Jacob's "one and only mistress" and dated the drawing "vers 1903." During the end of his impoverished stay in Paris in the last months of 1902, Picasso moved in with Jacob, sharing his bed with him (though sleeping in it at different times of day), and perhaps Genoveva as well (Richardson, 260–61).

13 Richardson, 283. For the traditional dating of the work to 1901, see Zervos 6: 343; Pierre Daix, Georges Boudaille, Joan Rosselet, *Picasso, The Blue and Rose Periods*, trans.

Phoebe Pool (Greenwich, Conn.: New York Graphic Society, 1967), no. D.IV.7, p. 148; Alexandro Circi Pellicer, *Picasso antes de Picasso*, Barcelona: Iberia-Joachim Gil, Editores, S.A., 1946)), no. 105; Reff, 37 (places it in first trip to Paris). For a 1902 dating see Jaime Sabartès, *Documents Iconographiques*, Collection Visages d'Hommes Célèbres, 8 (Genève: Pierre Cailler, 1954), 69; Pierre Daix, *La Vie de peintre de Pablo Picasso* (Paris: Le Seuil, 1977), 58 n. 11 (revision of his earlier dating).

14 Museu Picasso, Barcelona (Zervos 6: 485–89). I thank Robert Lubar, Professor of the Institute of Fine Arts, N.Y.U., for suggesting the connection between the cartoon strip of the two men and the *Parody of Manet's Olympia*, and for his comments on this section.

15 Sigmund Freud, "Wit and its Relation to the Unconscious" (1916), in *The Basic Writings of Sigmund Freud*, ed. and trans. A. A. Brill (New York: The Modern Library, 1938), 711.

16 Clark, 92. Clark argues that the picture's power had to do largely with the instability of meaning given to such concepts as "the Nude," "the Courtesan," and "Femininity," 131 ff.

17 Meyer Schapiro, "Picasso's *Woman with a Fan*: On Transformation and Self-Transformation," in *Modern Art, 19th and 20th Centuries, Selected Papers* (New York: Braziller, 1978), 112–13, 119 n. 6. Schapiro's lengthy note is, to my knowledge, the first discussion of the parody in the Picasso literature.

18 National Gallery of Art, Washington D.C., Zervos 1: 308.

19 Schapiro, 119, n. 6.

20 I draw here from Bryson's analysis of Ingres's relation to his sources in *Tradition and Desire*, 124–25.

21 Reff observes that while the connection between Manet's *Olympia* and Titian's *Venus of Urbino* was first noted in the late 1890s, it was not widely discussed until a decade later, 38. Another, closer source for the posture of Junyer-Vidal, as noted by William Rubin, "From Narrative to 'Iconic,'" in Picasso: The Buried Allegory in *Bread and Fruitdish on a Table* and the Role of the *Demoiselles d'Avignon*," *The Art Bulletin* 64, no. 4 (1983): 638, is the servant in Cézanne's *L'Après-midi à Naples* who also holds aloft a bowl of fruit. The painting by Cézanne was executed in response to Manet's *Olympia*.

22 See note 1.

23 José Ortega y Gasset, "The Dehumanization of Art," in *Criticism, The Major Texts*, ed. Walter Jackson Bate (New York: Harcourt, Brace, Jovanovich, 1970), 663.

24 *Nevermore*, oil on canvas, The Courtauld Institute, London. *Anna the Javanese*, oil on canvas, private collection, Winterthur. Both were painted in 1893.

25 On Picasso's early interest in Gauguin see Rubin, "Narrative to 'Iconic'"; see also Rubin, "Picasso," 242–45, 633–34 and Kirk Varnedoe, "Gauguin," 179–212, in *"Primitivism" and Twentieth Century Art*, vol. 1 (New York: The Museum of Modern Art, 1984).

26 Jaime Sabartès, *Picasso: An Intimate Portrait*, trans. Angel Flores (New York: Prentice Hall, 1948), 80.

27 Richardson, 264–65, illus.

28 Rubin, in *"Primitivism,"* discusses the significance of the Gauguin painting for Picasso in connection with his *Demoiselles d'Avignon* of 1907 (264). The lithograph dates from 1894. On his return to Paris from Barcelona in December 1902, Picasso was given a copy of Gauguin's long poem *Noa-Noa*, which he covered with sketches.

29 Goldwater, 114.

30 Of Picasso's *Olympia* parody, Reff writes: "By increasing the number of figures . . . and reversing their social status and racial roles, he underlined the latent primitivism of Manet's concept" (38).

31 Goldwater, 28.

32 On the perception of blacks in the French avant-garde, and racist attitudes, see Patricia Leighton, "The White Peril and L'Art Nègre: Picasso, Primitivism, and Anticolonialism," *The Art Bulletin* 72, no. 4 (1990): 609–630.

33 Richardson, 274.

34 Reff, 38.

35 Leo Steinberg, "The Philosophical Brothel," *October* 44 (Spring 1988): 43. This essay was first published in *Art News* 71 (September/October 1972).

36 Rubin, "Narrative to 'Iconic'," 630. See also Rubin's most recent study of the genesis of the painting, in Rubin, Hélène Seckel and Judith Cousins, *Les Demoiselles d'Avignon* (New York: The Museum of Modern Art [Studies in Modern Art, 3] 1994), 73–144.

37 Ibid., 630. Otto Friedrich, 282–83, discusses at length the widespread fear of syphilis in the early years of the twentieth century, when it was still fatal. He also states, 279, that the tertiary phase of syphilis was most likely the cause for Manet's painful and early death from locomotor ataxia, after years of suffering. If Picasso was aware of this, it may have figured into the multi-leveled meaning of his parody.

38 On the sources of the *Demoiselles*, including *Olympia*, see Robert Rosenblum, "*Les Demoiselles d'Avignon* Revisited," *Artnews* 72, no. 4 (1973): 45–48.

39 Ravenel in Clark, 139–40.

40 The unsigned and undated variation on Ingres's *Grande Odalisque* has traditionally been assigned to the summer or fall of 1907 in the months following *Les Demoiselles d'Avignon* and before *Nude with Drapery*, executed late in 1907 (Zervos 2: 47). Gary Tinterow, in *Master Drawings by Picasso* (Cambridge: Fogg Art Museum, 1981), 90, however, dates the work to the winter of 1907–08, because of the connection of the palette of strong blue and orange with the nudes of that period, such as *Standing Nude* (Museum of Fine Arts, Boston; Zervos 2: 103).

41 For the first article on Picasso and Ingres during the Cubist period, see Michael Marrinan, "Picasso as an 'Ingres' Young Cubist," *Burlington Magazine* 119, no. 876 (1977): 756–763. The most complete study to date is Robert Rosenblum's unpublished lecture presented at the Fogg Art Museum, Harvard University, in February 1981, in conjunction with the exhibition, *Master Drawings by Picasso*.

42 Alfred H. Barr, Jr., *Matisse, His Art and His Public* (New York: The Museum of Modern Art, 1951), 91. See also Marrinan, 756, and n. 5.

43 On *Olympia*'s entry into the Louvre, see Friedrich, 304–06.

44 Marrinan, 756, and n. 5.

45 Rosenblum, "Demoiselles Revisited," 46–7.

46 This variation forms part of a group of studies of individual reclining or standing female figures that Picasso executed in the summer or fall of 1907 for his large canvas, *Nude with Drapery* (fall 1907 or winter 1908), The Hermitage Museum, St. Petersburg, his major post-*Demoiselles* painting. The variation shares with the preparatory studies for *Nude with Drapery* (see Zervos 2: 45; Zervos 26: 264) a similar style of hatched planes and a representation of the body from multiple perspectives. But the greater spontaneity of

execution, and the intense blue and ocher palette, as Tinterow has observed on page 90, may indicate that it was executed some months after the oil painting.

47 Robert Rosenblum, *Jean-Auguste-Dominique Ingres* (New York, London: Harry N. Abrams, 1968), 107.

48 On the Cubist character of Ingres's *Grande Odalisque* see Rosenblum, *Ingres*, 48, and Bryson, 136–37.

49 The issue of the body seen from multiple perspectives is discussed at length in Steinberg, "'The Algerian Women' and Picasso at Large," 125–235.

50 Jean Puy, "Souvenirs," *Le Point* (Colmar, July 1939), 36, in John Elderfield, *The "Wild Beasts," Fauvism and Its Affinities* (New York: The Museum of Modern Art, 1976), 97.

51 Rosenblum, *Ingres*, 168.

52 On the intense rivalry in 1907 of the two leaders of the avant-garde and their followers, see Elderfield, 131–36.

53 Barr, 86.

54 A connection between Matisse's *Blue Nude* and Picasso's *Nude with Drapery* has been made by Pierre Daix, *Le Cubisme de Picasso, 1907–1916* (Neuchâtel: Editions Ides et Calendre, 1979), 38.

55 Elderfield, 98.

56 See Jacques Thuillier, *Les Frères Le Nain* (Paris: Éditions de la Réunion des Musées Nationaux, 1978), 176–79.

57 For the most recent book on *Parade*, see Deborah Menaker Rothschild, *Picasso's "Parade": From Street to Stage* (New York: The Drawing Center, Sotheby's Publications, 1991).

58 Thuillier, 176.

59 Ibid.

60 Letter dated 20 March, 1918, from Apollinaire to Picasso in his studio in Montrouge, a suburb of Paris. The poet expresses his pleasure in seeing Picasso's dazzling copy of the seventeenth-century painting. *Picasso/Apollinaire Correspondance*, ed. Pierre Caizergues and Hélène Seckel (Paris: Gallimard/Réunion des musées nationaux, 1992), Lt. 132, 163–56. In the catalogue of the Musée Picasso, the painting is dated 1917. As it remained unfinished, Picasso may well have been working on it in the early months of 1918 as well.

61 See Pierre Rosenberg, *Donation Picasso: la collection personelle de Picasso* (Paris: Éditions des musées nationaux, 1978), nos. 44, 46. The latter painting had formerly been owned by the family of André Malraux. Neither work is today considered a genuine work of Le Nain.

62 See Kenneth E. Silver, *Esprit de Corps, the Art of the Parisian Avant-Garde and the First World War, 1914–1925* (Princeton: Princeton University Press, 1989).

63 See Christopher Green, *Cubism and Its Enemies, Modern Movements and Reactions in French Art, 1916–1928* (New Haven and London: Yale University Press, 1987), 187–202.

64 Stanley Meltzoff, "The Revival of the Le Nains," *The Art Bulletin* 24, no. 3 (September 1942): 277.

65 Christopher Green, *Léger and the Avant-Garde* (New Haven: Yale University Press, 1976), 236.

66 *The Peasant Family*, like *The Happy Family*, had gone unrecorded in the Le Nain literature. It appeared at a sale just before the war from a private collection. Thuillier, 185.

67 Maurice Raynal, *L'Intransigeant*; cited in Green, *Léger*, 235. Some critics of the period went even further, dismissing the subject matter altogether. See comments by Tristan Klingsor, in "Les Le Nains," *L'Amour de l'Art* (April 1922): 100;

cited in Green, 237.

68 Paul Jamot, *Les Le Nains* (Paris: Henri Laurens, 1929), 39.

69 Thuillier (176) rejected Jamot's original title for the painting, "Le retour du baptême," claiming that the child is too old for baptism, and renamed it *The Happy Family*.

70 On the Germanic invasion of French art, see Silver, 1–14.

71 See *L'Italienne*, Zervos 3: 362. See also Zervos 3: 431. On Picasso's drawings after *cartolini* see Giovanni Caraandente, "Picasso's Italienishe Reise," in *Pablo Picasso, Werke aus der Sammlung Maria Picasso*, ed. Werner Spies (München: Prestel Verlag, 1981), 71–83. On the significant role of popular imagery in Picasso's ballet work, see Rothschild, *Picasso's "Parade"*; and Jeffrey Weiss, *The Popular Culture of Modern Art: Picasso, Duchamp, and Avant-Gardism* (New Haven and London: Yale University Press, 1994).

72 Kahnweiler (1935), excerpted in Ashton, 166.

73 Meltzoff, 277.

74 André Salmon, "Georges Seurat," *Burlington Magazine* 37, no. 210 (September 1920): 116.

75 George Heard Hamilton, *Painting and Sculpture in Europe, 1880–1940*, rev. ed. (Harmondsworth, Middlesex: Penguin Books, 1972), 51. See also Michel-Eugène Chevreul, "The Principles of Harmony and Contrast of Color, and Their Applications in the Arts," in *Nineteenth Century Theories of Art*, ed. Joshua Taylor (Berkeley and Los Angeles: University of California Press, 1987), 448–467.

76 Picasso had been embellishing his Cubist works with pointillist dots since 1913, but it was only in 1917 that he experimented briefly with larger strokes in figurative painting, as seen, for example, in the unfinished *La Salchichona*, painted in Barcelona in 1917 (Zervos 3: 45).

77 Krauss, "Re-presenting Picasso," 92.

78 See Krauss's discussion of Picasso's collapse of the polarities of the linear and painterly traditions in this variation (94).

79 See Chapter 1.

80 See E. A. Carmean, *Picasso, The Saltimbanques* (Washington, D.C.: The National Gallery of Art, 1980), 23.

81 On the connection of *Parade* to a source in nineteenth-century Neapolitan art see Silver, 119–20.

82 See Thuillier, 241–46, *La Tabagie* or *Groupe d'hommes autour d'un table, le corps de garde*. Until 1969, when it entered the Louvre, the work had remained since the mid-nineteenth century in the family of the Comte de Pourtalès-Gorgier. Picasso may have known it in reproduction.

83 Picasso might have known Le Nain's work through a copy (Thuillier, 297–8), which had been exhibited and reproduced frequently in the late nineteenth century and first decade of the twentieth. The painting is now in the Galleria Nazionale d'Arte Antica, Rome.

84 Gedo, 114.

85 In his program notes for *Parade*, first presented at the Théâtre du Chatelet in Paris in May 1917, provoking a great scandal, Apollinaire declared that the ballet was "the point of departure for a new series of manifestations . . . which cannot fail to seduce the elite, and which promises to completely modify the arts and manners in universal lightness," LeRoy Bruening, ed., *Apollinaire on Art, Essays and Reviews, 1902–1918* (New York: Viking Press, 1972), 452–53.

86 Ibid., 458.

87 Letter from Apollinaire to Picasso, September 4, 1918. *A Picasso Anthology: Documents, Criticism, Reminiscences*, ed. Marilyn McCully (Princeton: Princeton University Press, 1987), 130–32.

88 Letter from Apollinaire to Picasso in Biarritz, September 11, 1918, *Picasso/Apollinaire Correspondance*, Lt.151, p. 181.

89 *The Lovers* was exhibited only once in 1966 in the major retrospective, *Homage à Picasso*, Paris, Grand Palais, Nov. 1966–Feb. 1967, no. 11, illus. It has been discussed only briefly in the Picasso literature. See André Malraux, *Picasso's Mask*, 60–61, illus., no. 17. Malraux, however, erroneously identified the work as after Manet's *Déjeuner sur l'herbe*.

90 *L'Instransigeant* was a Parisian daily newspaper for which several of Picasso's friends wrote. Fragments of its masthead appear in several Synthetic Cubist works by Picasso, and in works by other artists, such as Gris. The letters that Picasso abstracted from the whole "Sigean" in this painting also spell the name of a Catalan village near the Spanish/French border.

91 *Littérature*, nouvelle série (10 May 1923), hors texte illustration opposite contents; André Breton, *Le Surréalisme et la peinture* (Paris: Librairie Gallimard, 1928), illus. no. 10.

92 Robert Rosenblum, *Picasso from the Musée Picasso, Paris* (Minneapolis: Walker Art Gallery, 1980), 57.

93 Robert Rosenblum, "Picasso and the Typology of Cubism," in *Picasso in Retrospect, 1881–1973*, 33–49.

94 An observation first made by Deborah Rothschild, Exhibitions Curator at the Williams College Art Museum, in a conversation with me about this painting. For a contextual study of *Nana* see Werner Hofmann, *Nana, Mythos und Wirklichkeit* (Cologne: Verlag M. Du Mont Schauberg, 1974).

95 Reff, 85. *L'Assommoir* was one of a series of 20 books by Zola, known collectively under title of *The Rougon-Macquart*. The character Nana subsequently became the heroine of another book in the series named after her, which appeared in 1879.

96 Friedrich, 154.

97 Reff notes on page 85 that the crane (*grue*) in popular speech signified a "more than fast girl, kept woman, or demi-rep." See also 124 n. 114.

98 Picasso would have had the chance to see *Nana*, however, in 1910 when the painting, then owned by Auguste Pellerin, was exhibited with his collection at the Bernheim Jeune Gallery. For a complete listing of the various books, catalogues, and articles in which *Nana* was reproduced by 1919, see Paul Jamot and Georges Wildenstein, *Manet, Catalogue Critique*, vol. 1 (Paris: Les Beaux-Arts, Éditions d'Études et des Documents, 1932), 154.

99 George Heard Hamilton, *Manet and His Critics* (New Haven: Yale University Press, 1954), 201.

100 Douglas Cooper, *Picasso Theater* (New York: Harry N. Abrams, 1964), 43–48. The subject of the ballet was taken from part of a play of 1700 entitled *The Four Identical Pulcinellas*. The ballet was first performed by the Paris Opera on May 14, 1920.

101 Pierre Daix, *La Vie de peintre de Pablo Picasso* (Paris: Éditions de Seuil, 1977), 174.

102 Cooper, 46.

103 *Sketch for the Decor of Pulcinella*, 1920, Zervos 30: 50. For other *Pulcinella* sketches, see Zervos 4: 15–28 and Zervos 31: 7–59, 63–64.

104 Cooper, 46.

105 Pierre Cabanne, *Picasso, His Life and Work*, trans. Harold J. Salemson (New York: William Morrow, 1977), 213.

106 On the dating of the sketches, see Cooper, 46.

107 The figures in this sketch are based on Renoir's *The Opera Box* of 1874. See F. Daulte, *Auguste Renoir, Catalogue raisonné de l'oeuvre peinte*, vol. 1 (Lausanne: Editions Durand-Ruel, 1971), no. 115.

108 See Cooper, 49–51. The first performance of the *Cuadro Flamenco* was held at the Théâtre de la Gaité Lyrique in Paris on May 22, 1921. Picasso stepped in at the last minute to take over the decor from Juan Gris, and reworked his first plans for *Pulcinella*.

109 *Design for the Decor of "Cuadro Flamenco*, gouache, Paris, 1921; *Cuadro Flamenco, The Box* (fragment from the lower left of the decor after Renoir *La Loge*) Zervos 4: 248, Cooper, 294. For other drawings of the *Cuadro Flamenco*, see Zervos 30: 156–176, and Cooper, 291–302.

110 The fact that *The Lovers* is also related to other independent works drawn from the *commedia dell'arte* both preceding and following *Pulcinella* strengthens its connection with the ballet. One such work is *Harlequin and Woman* (Zervos 2: 559), a small watercolor of 1915 connected with his oil painting *Harlequin* (Zervos 2: 555) of the same year. Though the styles of *Harlequin and Woman* and *The Lovers* differ, both depict reveling couples who face the viewer directly, one of whom holds aloft a bottle or glass in a toast. In both the woman has a guitar (or violin)-shaped body and clearly delineated breasts, and in both works there is a convulsive strain. *Harlequin and Woman* is the closest precedent for *The Lovers* and points to a connection between the latter and *Harlequin* of 1915. *Harlequin* and *The Lovers* also share a slightly sinister quality; the famous toothed smile of the former has been handed down to the female character in the latter.

111 I thank the late Gert Schiff for his suggestion of this connection.

112 Bob Haak, *Rembrandt, His Life, His Work and His Time*, trans. Elisabeth Williams-Treeman (New York: Harry N. Abrams, 1969), 238.

Chapter 3

1 Joris-Karl Huysmans, *Trois Primitifs* (1904), trans. Robert Baldick, in E. Ruhmer, *Grünewald, the Paintings, Complete Edition* (New York: Phaidon Publishers, 1958), 10. The French critic and novelist was one of the first to rediscover Grünewald at the end of the nineteenth century.

2 For basic catalogue information on the altarpiece see Ruhmer, 118–20. The vast literature on this monument includes numerous monographs in German, French and English. For the most recent and authoritative study see Andrée Hayum, *The Isenheim Altarpiece, God's Medicine and the Painter's Vision* (Princeton: Princeton University Press, 1989). The following description of the monument is drawn primarily from these two sources. I am grateful to Dr. Hayum for her comments on this chapter.

3 Ruhmer, 118. With the wings fully open, three carved figures were revealed: at the center a seated St. Anthony, patron of the order, flanked by the standing figures of Sts. Augustine and Jerome (executed by the Strasbourg sculptor, Nikolaus Hagenauer.) To either side of the sculptures were Grünewald's panels depicting scenes from the life of Saint Anthony—*The Meeting of Saints Anthony and Paul* and *The Temptation by the Devil*. With these wings folded back, the middle state, devoted to the Virgin, was exposed, portraying at the center *The Angelic Concert* and the *Madonna and Child* in glowing color, with the *Annunciation* and the *Resurrection* on either side. In the closed state, *The Crucifixion* was revealed. Two standing saints, Sebastian and Anthony, to the left and right of Calvary, and a *Lamentation* depicted on the predella below, complete the imagery of the altarpiece in this position.

4 Ruhmer, 118.

5 Gertrude Schiller, *Iconography of Christian Art*, trans. Janet Seligman, vol. 2 (Greenwich, Conn.: The New York Graphic Society, 1972), 158.

6 *Minotaure* 1 (June 1933): 29–31. *Minotaure*, which encompassed all the arts and included articles on anthropology, was directed by Albert Skira and E. Teriade, and was published from 1933–39.

7 Picasso to Renato Guttuso, quoted in Mario de Micheli, *Scritti di Picasso* (Milan, 1964), excerpted in Ashton, 35.

8 Raymond Ritter, *L'Espagne corps et âme* (Pau: Marrimpouey Jeune, 1972), 226, in Lydia Gasman, "Crucifixions: 1926–1936," in *Mystery, Magic and Love in Picasso, 1925–1938: Picasso and the Surrealist Poets*, vol. 3, ch. 14, Columbia University Ph.D., 1981 (Ann Arbor: University Microfilms International, 1981), 991.

9 For the most recent literature of the Crucifixion in Picasso's art see Christian Heck, "Entre le mythe et le modèle formel: *Les Crucifixions* de Grünewald et L'art de XXe siècle," in *Corps Crucifiés* (Paris: Réunion des musées nationaux, 1993), 84–108. See also William Rubin, *Dada and Surrealist Art* (New York: Harry N. Abrams, 1968), 290–295; Ruth Kaufmann, "Picasso's Crucifixion of 1930," *Burlington Magazine* 111, no. 798 (1969): 553–60; John Golding, "Picasso and Surrealism," in Golding and Penrose, 49–79; and Gasman, "Crucifixions: 1926–1936," in *Mystery, Magic*, 978–1078. The latter is the most comprehensive study of the theme. On the impact of Grünewald on contemporary art, see Sylvie Lecoq-Ramond et al., *Variations autour de la Crucifixion, Regards Contemporains sur Grünewald* (Colmar: Musée d'Unterlinden, 1993).

10 Frank D. Russell, *Picasso's Guernica, The Labyrinth of Narrative Vision* (Montclair, N.J.: Allanheld and Schram, 1980), 24–5.

11 Richardson, *A Life of Picasso*, vol. 1, 71–2.

12 Russell notes that it was the only Biblical moment to crop up during the six decades (1902–59) that the Crucifixion image appeared (10). There are, however, examples of the Crucifixion in Picasso's work of the 1890s as well.

13 Kaufmann, 553.

14 Kaufmann establishes a connection between Surrealism and Grünewald, noting that in Breton's essay "Autodidacts, dits Naïfs" in his *Le Surréalisme et la peinture* (Paris: Librairie Gallimard, 1945), he links Grünewald with the Douanier Rousseau, as a forebear of the modern rebirth of primitivism, and thus "an appropriate subject for study in the investigation of the irrational through primitive art forms" (558 n. 16).

15 André Breton, "What is Surrealism?" in *Theories of Modern Art, A Source Book by Artists and Critics*, ed. Herschel B. Chipp (Berkeley, Los Angeles, London: University of California Press, 1971), 414.

16 Kaufmann, 561.

17 Gasman notes, "Seen in the light of his magic code, the *Crucifixions* whose primitivistic dimension is generally accepted reveal a now familiar function of transferring the sacred to Picasso. Invested with a divinity of the crucified Christ, Picasso could now vie with the "All" by controlling its effigies painted during the same period. . . ." 978. On the anti-

religious attitudes of the Surrealist writers, see Gasman, 986–990.

18 See Gasman, "Picasso's Conception of Art as a Form of Magic: Sources and Psychological Motivations," chap. 6 in *Mystery, Magic*, 449–538, for an extensive discussion on his magical primitivism, esp. pp. 537–38.

19 Gasman, 465. On pp. 449–471 she summarizes the notion of magic in Picasso's art as the artist himself related it to members of his immediate circle.

20 André Malraux, *Picasso's Mask*, 10–11. See also a discussion of these words in William Rubin, "Picasso," in *"Primitivism" in Twentieth Century Art*, vol. 1, 254–56.

21 Gasman, 1059.

22 Schiller, 158.

23 Hayum, 13–52. See also Hayum, "The Meaning and Function of the Isenheim Altarpiece: The Hospital Context Revisited," *The Art Bulletin* 59, no. 4 (1977): 501–17.

24 Hayum, *Isenheim Altarpiece*, 20–21.

25 Ibid., 20. See also her notes 24 and 28.

26 Huysmans, *Trois Primitifs*, in Ruhmer, 20–21.

27 Louis Réau, *Matthias Grünewald et le retable de Colmar* (Nancy: Berger-Levrault, 1920).

28 Malraux, 11.

29 Gedo, 149.

30 For a discussion of the fate of the altarpiece from 1917, when it was transferred for safekeeping to the Alte Pinakothek in Munich, to its return to France and its return to Colmar in 1919, when Alsace reverted to French control, see Hayum, 139–41.

31 See Ruhmer, 118, and Hayum, 3–12.

32 Ruhmer, 118.

33 Jacob Burckhardt, *Grünewald* (1844), 151, in Ruhmer, 118.

34 Peter Selz, *German Expressionist Painting* (Berkeley and Los Angeles: University of California Press, 1957), 16–19 on the importance of Grünewald to the German Expressionist group.

35 On the critical fortunes of the altarpiece see Hayum, 118–149, and Heck, 84–108. My thanks to Professor Marsha Morton, Pratt Institute, for sharing her unpublished paper on this topic with me.

36 On Huysmans's key role in the recovery of Grünewald, see Hayum, 129–39.

37 See Hayum, 118–49; Heck, 84–108; and Lecoq-Ramond, 12–34. In the later part of the twentieth century, artists as diverse as Francis Bacon, Graham Sutherland, Matisse, and Renato Guttoso have drawn inspiration from the altarpiece.

38 On the Picasso/Zervos/Eluard connection in relation to the Isenheim altar in the later thirties, see Hayum, 142–43.

39 Two obituary articles on Picasso in Alsatian newspapers report that Picasso stopped in Colmar for a few hours in August 1932 to see the altarpiece in the Unterlinden museum, while en route to Switzerland: Michel Thévénin, "Quand le retable d'Issenheim (sic) inspirait Pablo Picasso," *L'Alsace*, 10 April 1973; and "Il y a quarante-et-un ans, Picasso visitait le musée d'Unterlinden," *Dernier Nouvelles d'Alsace*, 12 April 1932. This purported stop-over, however, is not recorded anywhere in the Picasso literature. Heck dismisses the articles as a local Colmar myth, 104 n. 104. In a letter to me dated 23 September 1994, Mme. Sylvie Lecoq-Ramond, Director of the Musée d'Unterlinden in Colmar, reported that Pierre Daix had confirmed in a conversation with her that Picasso had never gone to Unterlinden and that he had worked from reproductions. I am very grateful to Mme. Lecoq-

Ramond for this information and for articles in museum's files she sent me.

40 Brassaï, *Picasso and Company*, trans. Francis Price (Garden City, N.Y.: Doubleday, 1966), 24. The photographer Brassaï, who was associated with the Surrealist circle, photographed the drawings shortly after Picasso executed them for publication in *Minotaure*.

41 Linda Nochlin, *Mathis at Colmar, A Visual Confrontation* (New York: Red Dust, 1963), 13.

42 J. E. Cirlot, *A Dictionary of Symbols*, trans. Jack Sage (New York: Philosophical Library, second edition, 1971), 73.

43 Rosalind E. Krauss, *The Optical Unconscious* (Cambridge, Mass., and London: MIT Press, An October Book, 1993). I draw here on her notion of the "mark-as-graffito," discussed in the context of Cy Twombly's drawing (266).

44 Alexander Liberman, "Picasso," *Vogue*, New York (Nov. 1, 1956): 132–34, excerpted in Ashton, 24.

45 Cirlot, 78.

46 Gasman, 1054–55. The author notes that both types of heads appear in Picasso's *Crucifixion* of 1930 and in works before then, always as symbols of evil.

47 Werner Spies, *Picasso Sculpture*, trans. J. Maxwell Brownjohn (London: Thames and Hudson, 1972), 79.

48 I draw here from Walter Benjamin's discussion of the ruin in "Allegory and Trauerspiel," 177–182.

49 See Gasman, 707–08, for connections between the figure of Harlequin and occultism, and its association with evil.

50 Brassaï, 25.

51 Gasman, 1069.

52 Brassaï, 74.

53 Malraux, 137.

54 See Spies, *Picasso Sculpture*, nos. 108, 110–11, pp. 110–13.

55 Zervos 7: 370, dated 29 Jan. 1932, as noted by Laszlo Glozer in *Picasso und der Surrealismus* (München: Dumont Kunsttashenbucher, 1974), 52–53. Numerous other drawings by Giacommetti for his "inner models," as the sculptor referred to his work of this period, were published in the *Le Surréalisme au service de la Révolution* (December 1953) and may have also been sources of inspiration.

56 Ronald Ally, "The Three Dancers," in the *Catalogue of The Tate Gallery Collection of Modern Art (Other than British)* (London: The Tate Gallery, Sotheby Parke Bernet, 1981), 604. See also Lawrence Gowing, "Two Notable Acquisitions," *The Tate Gallery Annual Report, 1964–1965* (London: The Tate Gallery, 1966), 7–11, 49–50, for the first interpretation of this work.

57 James Hall, *Dictionary of Subjects and Symbols in Art* (New York: Harper and Row, 1974), 94.

58 Golding notes " . . . it is possible that Grünewald's great masterpiece was already in the back of his mind in the finishing stages of *The Three Dancers*, in "Picasso and Surrealism," in Penrose and Golding, 54. A careful analysis of the two works (for which there is no room here) reveals the extent to which the 1925 painting draws from the *Crucifixion*.

59 Gilot, *Life with Picasso*, 266. The term "image magic" is used by Gasman, 1071.

60 Zervos (1935), excerpted in Ashton, 43.

61 See *Drawing*, 1930–31, pencil on paper, Zervos 7: 315, for an example of this type of Crucifixion in Picasso's art.

62 Rudolf Arnheim, *Guernica: The Genesis of a Painting* (Berkeley and Los Angeles: University of California Press, 1962), 36, referring to one of the preparatory drawings for

Guernica.

63 *Surrealist Figures*, pencil and ink on a page from a sketchbook, Dinard, 1928; Zervos 7: 190. The quote is taken from John Richardson, "Picasso and Marie-Thérèse Walter," introduction to *Through the Eye of Picasso, 1928–1934* (New York: William Beadleston, Inc., 1985), unpaginated, and it refers to a drawing in the Dinard notebook of August 1, 1928, 9, repr.

64 Brassaï, 25. The flapping cloth also seems to anticipate Picasso's drawings of March 2 and 3, 1959, in which he conflates the Crucifixion with the bullfight, Zervos 18: 333, 334, 336–359. In these drawings Christ, pinned to the cross, waves his loincloth at the charging bull.

65 Gasman, 1072–73.

66 Meier and Pevsner, 16.

67 Gasman, 1059.

68 Hayum compares the unfolding panels to the medium of film (6).

69 Hall, 81.

70 Hayum, 53–89.

71 Ibid., 61.

72 Ibid., 69.

73 Tinterow, *Master Drawings by Picasso*, 14. See also a recent study of Picasso's draftsmaship: Bernice Rose, *Picasso and Drawing* (New York: Pace/Wildenstein, 1995).

74 Rose, 19.

75 Geneviève Laporte, *Si tard le soir, le soleil brille* (Paris: Plon, 1973), 143–44, in Gasman, 464.

76 Rubin, *Dada and Surrealist Art*, 294–95, connects the head of the braying horse with Grünewald's crucified Christ in the Isenheim Altarpiece.

Chapter 4

1 For the most recent study on this topic, see Gertja Utley, "Paragon or Nemesis of the Civilizing Mission of Post-War France," in *Picasso and the Spanish Tradition*, ed. Jonathan Brown (New Haven and London: Yale University Press, forthcoming.) My thanks to Gertja Utley for her comments on this chapter.

2 Ibid.

3 Ibid.

4 Ibid.

5 *The Milliner's Workshop*, Zervos 6: 2; and *Pitcher, Candle, and Casserole*, Zervos 14: 71. Both works today are in the Musée National d'Art Moderne, Centre National d'Art et de Culture Georges Pompidou, Paris.

6 Gilot, *Life with Picasso*, 202–03. See also Cabanne, 409.

7 Penrose, *Picasso, His Life and Work*, 350.

8 Cabanne, 409.

9 John Pudney, "Picasso—A Glimpse in Sunlight," *The New Statesman and Nation*, London (16 September 1944): 182. For examples of Picasso's work of this time, see *Tomato Plant on a Window Sill* (August 9, 1944), Zervos 14: 25; and *Portrait of a Young Boy* (August 13, 1944), Zervos 14: 289.

10 This point has been made by Werner Spies, *Picasso: Die Zeit nach "Guernica," 1937–1973* (Stuttgart: Verlag Gerd Hatje, 1993), 48–50.

11 Warnod (1945), excerpted in Ashton, 66.

12 Picasso to de Zayas (1923), excerpted in Ashton, 64.

13 Picasso to Gilot, in Daix, 270–71.

14 See Christopher Wright, *Poussin's Paintings, A Catalogue Raisonné* (London: Harlequin Books, 1985), no. 82. See also Anthony Blunt, *The Paintings of Nicolas Poussin: A*

Critical Catalogue (London: Phaidon, 1966), nos. 136, 97. The painting entered the Louvre in 1939 with the bequest of Paul Jamot. The work had formerly been in the collection of Emile Bernard and was bought by Jamot in 1921. Le Nain's *The Happy Family*, after which Picasso executed a variation in 1917, was also in the Jamot collection. The Louvre version (now in the Musée des Beaux-Arts, Rheims) is now considered a copy of the original painting, which was acquired by the National Gallery, London, in 1982.

15 William L. Langer, ed., *An Encyclopedia of World History*, 5th ed. (Boston: Houghton Mifflin, 1972), 1150.

16 Gilot, *Life with Picasso*, 60–61.

17 Hugh Brigstocke, *Poussin: Sacraments and Bacchanals, Paintings and Drawings of Sacred and Profane Themes by Nicolas Poussin, 1594–1665* (Edinburgh: National Gallery of Scotland, 1981), 37. Along with the *Triumph of Pan*, there was also a *Triumph of Bacchus*, and a *Triumph of Silenus*.

18 Malraux, 53–4. The painting disappeared from Picasso's studio and has never been recovered.

19 On Picasso and Poussin in the early twenties, see Christopher Green, *Léger and the Avant-Garde* (New Haven: Yale University Press, 1976), 219–20. In 1931, Picasso illustrated Balzac's story, "The Unknown Masterpiece" (1837), in which Poussin plays a role. On this latter topic, see Dore Ashton, *A Fable of Modern Art* (London and New York: Thames and Hudson, 1980). On Poussin's impact on modern art see André Chastel, "Poussin et la postérité" in *Nicolas Poussin* (Paris: Éditions du Centre National de la Recherche Scientifique, 1960), 305–310.

20 Blunt, 135. See also Wright, 178.

21 Blunt, 97. Both are represented as red-faced and are so closely associated that often their functions and attributes overlapped. On the iconography of the painting, see also Walter Friedlander, *Nicolas Poussin, A New Approach* (New York: Harry N. Abrams, n.d.), 132–133.

22 Ibid., 38.

23 Anthony Blunt, *Nicolas Poussin*, A.W. Mellon Lectures in the Fine Arts, Bollinger Series XXXV. 7 (New York: Pantheon Books, 1967), 146.

24 Gilot, *Life with Picasso*, 124.

25 Picasso to Kahnweiler (1936), excerpted in Ashton, 167.

26 Brigstocke, 37.

27 Gilot, *Life with Picasso*, 270.

28 This figure recalls the early states of Picasso's monumental etching and aquatint of 1938, *Woman with Tambourine*, in which he may have already have been thinking of Poussin. See Brigitte Baer, *Picasso, Peintre-Graveur*, vol. 3, *Catalogue raisonné de l'oeuvre gravé et des monotypes, 1935–1945* (Berlin: Éditions Kornfeld, 1986], no. 646, states I, II, III, 156–160. See also Baer, *Picasso the Printmaker, Graphics from the Marina Picasso Collection* (Dallas: Dallas Museum of Art, 1983), 106.

29 Cooper, *Les Déjeuners*, 28.

30 As noted by Daix, 272. See other similar representations of her, as, for example, Zervos 13: 107.

31 Wilhelm Boeck and Jaime Sabartès, *Picasso* (New York: Harry N. Abrams, 1955), 269. See also John Richardson, *Pablo Picasso: Watercolors and Gouaches* (London: Barrie and Rockcliff, 1964), 72. The latter connects Picasso's *Bacchanale* with his Antipolis pictures and the Vallauris panel, *Peace*, of 1952, noting that the choice of this work by Poussin heralds a new direction in his subject matter.

32 Brigstocke, 44. Friedlander informs us that, "the motif of the bacchante kneeling on a goat is taken from an ancient terra-cotta Campana relief which had also been used in an engraving by the Master of the Die after Guilio Romano's *Feast of Priapus*, 132."

33 Gilot, *Matisse and Picasso*, 11–12.

34 Howard Hibbard, *The Holy Family on the Steps* (London: Allen Lane, 1974), 27.

35 Ibid.

36 Picasso's drawings in pen and ink, after Albrecht Altdorfer's *The Burial of Saint Sebastian*, one of the wings of the St. Florian Altarpiece (1518), were carried out on November 103 and 18, 1953. (Not in Zervos). See Rosamond Bernier, "Altdorfer as Seen by Picasso" *L'Oeil* (May 1955): 35–39. Because these drawings are closer to copies—although very free ones—I have not included them in this study. See also *The Carrying of the Cross, after Master Francke* (from the St. Thomas Altarpiece), pen and ink, March 9, 1951, Musée Picasso, Paris, Marina Picasso Bequest, 1982 (Not in Zervos).

37 For biographical information see Gert von der Osten and Horst Vey, *Painting and Sculpture in Germany and the Netherlands, 1500–1600* (Harmondsworth, Middlesex: Penguin Books, 1969), 132.

38 Max J. Friedlander and Jacob Rosenberg, *The Paintings of Lucas Cranach* (Ithaca, New York: Cornell University Press, 1978), 25.

39 Ibid., 31.

40 Klaus Gallwitz, *Picasso at 90: The Late Work*, trans. from the German (New York: Putnam, 1971), 123. Picasso lived in the villa La Galloise in Vallauris from 1948 to 1954. Cranach, *Portrait of an Unknown Woman*, oil on panel, 1534, Lyon Museum (Friedlander and Rosenberg, no. 282).

41 For a critical history of Cranach in twentieth-century art see Dieter Koepplin, "Zum Cranach–Verständnis bei Künstkritikern und Kunstlern des 20. Jahrhunderts," in Dieter Koepplin and Tilman Falk, *Lukas Cranach, Gemälde, Zeichnungen, Druckgraphik*, Band 2 (Basel und Stuttgart: Birkhauser Verlag, 1976), 735–744.

42 On the interest in Cranch by German Expressionists see Selz, *German Expressionist Painting*, 6.

43 Raynal, "Réalité et mythologie des Cranach," in *Minotaure* no. 9, 2ème série (1936), cited in Koepplin, 735.

44 Koepplin, 735–7.

45 Christian Zervos, *Nus de Lucas Cranach* (Paris: Éditions "Cahiers d'Art," 1950), in Koepplin, 736.

46 See Lynn H. Nicolas, *The Rape of Europa* (New York: Random House, 1994), 36. My thanks to Michael Fitzgerald for pointing out the Nazi connection to me, and to Cynthia Saltzman for directing me to this source.

47 Pierre Assouline, *L'Homme de l'art, D.-H. Kahnweiler* (Paris: Editions Balland, 1988), 428–434.

48 *Venus and Cupid as a Honey Thief*, pen and ink on paper; Zervos 12: 86. The subject, from Theocritus, warns that pleasure is often mixed with pain. Exactly which work by Cranach the drawing is based on remains unclear. Koepplin had made the plausible suggestion that the drawing combines more than one work by Cranach (786 n. 1).

49 *Venus and Cupid as a Honey Thief, after Cranach*, June 12, 13, 1957, ink and gouache on paper, formerly Collection Jacqueline Picasso; Zervos 17: 339. This painting is based on Cranach the Elder's *Venus and Cupid as a Honey Thief*, 1530, oil on wood, Lehman Collection, The Metropolitan Museum of Art; see Koepplin, 787 n. 1. See also a late pastiche of *Venus and Cupid*, oil on canvas, 1968, Zervos 27: 385.

50 For Picasso's linocuts after Cranach the Younger see Brigitte Baer, *Picasso Peintre-Graveur: Catalogue raisonée de l'oeuvre gravé et des Monotypes*, IV (Berne: Editions Kornfeld, 1988) nos. 1052, 1053, pp. 390–96. See also *Portrait of a Woman after Lucas Cranach*, five wood blocks (1958), in William S. Lieberman, *Picasso's Linoleum Cuts, The Mr. and Mrs. Charles Kramer Collection in the Metropolitan Museum of Art* (New York: The Metropolitan Museum of Art, Random House, 1985), no. 1. This is one of Picasso's most complex and successful colored linocuts. The original work by Cranach the Younger, *Portrait of a Woman* (1564), is in the Kunsthistorisches Museum, Vienna.

51 For Cranach the Elder's works, see Friedlander and Rosenberg, *Venus and Cupid* (1530), Gemäldegalerie, Berlin-Dahlem, no. 241; *Princess Sibylle von Cleve as a Bride* (1526) Schloss Museum, Weimar, no. 305; and *David and Bathsheba* (1526) Gemäldegalerie, Berlin-Dahlem, no. 210.

For the Picasso variations see Fernand Mourlot, *Picasso Lithographs*, trans. Jean Didry (Boston: Boston Book and Art Publisher, 1970): *Venus and Cupid*, 1st variation, 25 May 1949, Mourlot 182; 2nd variation, 1st state, 25 May 1949, 2nd state, 30 May 1949, Mourlot 183; 3rd variation, 25 May 1949, Mourlot 184. For the sugar acquaint based on *Venus and Cupid*, see Baer, IV, no. 876, states I–VI, 131–37. The *Venus and Cupid* prints were executed after a post card sent to Picasso by Kahnweiler.

For *Young Woman Inspired by Cranach*, 26–27 March 1949, Mourlot 176; and *David and Bathsheba*, states 1–10, Mourlot 109. Mourlot 163 a, *Fond Rose*, 28 March 1949.

For an excellent survey of the full range of Picasso's dialogue with Cranach through his variations, indirect quotations, and allusions from 1942–1958, see Heribert Hutter, *Cranach und Picasso*, Introduction by Daniel-Henry Kahnweiler (Nürnberg: Albrecht Dürer Gesellschaft, Kunsthalle, 1968).

On Picasso's *David and Bathsheba* variations there is an extensive literature: see especially Kurt Martin, *Picasso und Cranach: Das Kunstwerk*, 3, Heft 3, 1949, 10–11; and Werner Timm "Picasso und Cranach," in *Museum und Kunst, Beiträge für Alfred Hentzen* (Hamburg, 1970), 277–89; and Dieter Koepplin, "Eine Lithographie Picassos nach Cranach aus der Schenkung Georges Bloch," in *Zeitschrift für Schweizerische Archäeologie und Kunst-Geschichte*, Band 47, (1990), 90–97. I thank Dr. Koepplin for sending me his insightful article.

52 See Baer, *Picasso the Printmaker*, 122–3, for a discussion of Picasso's involvement with lithography and partnership with Mourlot, which began in November 1945.

53 See Riva Castleman, "David and Bathsheba," in William Rubin, ed., *Picasso in the Collection of the Museum of Modern Art* (New York: Museum of Modern Art, 1972), 170.

54 Introduction to auction catalogue, *Picasso Lithographs from the Mourlot Collection* (New York: Sotheby's, Monday, November 14, 1994), unpaginated.

55 Kahnweiler, Introduction to *Cranach und Picasso*, unpaginated. The studies after *David and Bathsheba*, Kahnweiler notes, were executed after a little reproduction of that work in the catalogue of the exhibition in April–May 1937, *Lucas Cranach d.Ä. und Lucas Cranach d.J.* Deutsches Museum, Berlin-Dahlem, April–June, 1937, nos. 55, 52.

56 The variations measure 25½ x 19½". Picasso's variation of 1950 after El Greco's *Portrait of a Painter* is also larger than the original.

57 *The Annotated Bible with Apocrypha*, Herbert G. May and Bruce R. Metzger, eds. (New York: Oxford University Press, 1965), 388–391.

58 On the subject of looking and longing in Picasso's art, see Leo Steinberg, "Picasso's Sleepwatchers" in *Other Criteria*, 93–113. On the subject of voyeurism in Picasso's later work, see Gert Schiff, *Picasso: The Last Years, 1963–1973* (New York: George Braziller, in association with the Grey Art Gallery and Study Center, New York University, 1983), 54–62.

59 Castlemen notes that Picasso was never interested in adapting his drawing to the medium, so that the dates frequently come out in reverse in his prints, 170.

60 Koepplin ("Eine Lithographie Picassos," 93) develops this point in a discussion of the sense of "imprisonment" of the figure of Bathsheba.

61 Rudolf Arnheim, *The Power of the Center: A Study of Composition in the Visual Arts* (Berkeley, Los Angeles, London: University of California Press, 1982), 108.

62 Mourlot 109, state 4. The composition is entirely recovered with ink and redrawn with the scraper.

63 Werner Schade, *A Family of Master Painters*, trans. Helen Sebba (New York: Putnam and Sons, 1980), 82.

64 The connection of the Cranach variations to the *Femme-fleur* was noted by André Fermigier, *Picasso* (Paris: Livre de Poche, Librairie Generale Française, 1969), 329.

65 Gilot, *Matisse and Picasso*, 27.

66 *Seated Sculptor and two Sculpted Heads*, March 26, 1933; in Bloch, no. 157.

67 Mourlot, 109, 5th state. Some figures are disengaged with the scraper.

68 Hutter, *Cranach und Picasso*, unpaginated.

69 Rembrandt, *Bathsheba with King David's Letter*, 1654, Musée du Louvre, Paris. Picasso to Kahnweiler, in "Entretiens avec Picasso au sujet des *Femmes d'Alger*," *Aujourd'hui* 4 (September 1955): 12–13, excerpted in Ashton, 169. The servant in the Rembrandt, however, is an old woman. Picasso executed a variation after this painting: *After Rembrandt's Bathsheba*, colored wax crayons on a page from a sketchbook, (II) May 3, September 14, 19, 20, 1963; Zervos 23: 249. See earlier versions, such as an oil painting of Jan. 30, 1960, Zervos 19: 157.

70 There may be a parallel in real life: Gilot describes their young, beautiful Spanish servant, Inès, who had given birth to a child not long before Claude was born, as competitive with her for Picasso's affection (163–65).

71 Mourlot, 109, 6th state.

72 Mourlot, 49.

73 Mourlot, 109, state 7; the eight figures are redrawn in ink.

74 Mourlot 109, 9th state, 83.

75 Mourlot, 83.

76 *Two Nudes and Portrait of Rembrandt*. Etching, combined technique, January 31, 1934; Bloch, 1907–1967, no. 214. See also no. 215. Rembrandt executed various works on the theme of Bathsheba. See for example, *Bathsheba Being Groomed for King David*, c. 1633, National Gallery, Ottawa; *Bathsheba Bathing*, 1643, Metropolitan Museum, New York; and *Bathsheba with King David's Letter*, 1654, Musée du Louvre, Paris.

77 See especially Picasso's series of 180 drawings executed between November 28, 1953 and February 3, 1954, known as *La Comédie Humaine*, executed at Vallauris after Gilot left him.

78 Daix, 289

79 See, for example, *Portrait of Dora Maar*, pencil on paper, January 27, 1937, Zervos 11: 193.

80 Mourlot, 109, 10th state: Takes up wash and scraper again.

81 Mourlot, 109 bis. 1st state, 9 mai (sic 29 mai) 1949. Transfer of the composition on zinc of the 30th of October, 1948, 6th state. Drawing with pen, numerous scrapings.

82 Raynal, 12.

83 Pierre Daix, *Picasso: Life and Art*, trans. Olivia Emmet (New York: Harper and Collins, Icon Editions, 1993), 366.

84 For a summary of the history of lithography, see Frances Carey and Anthony Griffiths, *Géricault to Toulouse-Lautrec, French Lithographs 1860–1900* (London: Department of Prints and Drawings, the British Museum, 1978), 11. Lithography was an invention of the Munich printmaker, Alois Senefelder in 1798, but did not get underway for another twenty years. In France, lithography became fashionable around 1820, after Godefroy Engelmann moved his press from Mulhouse to Paris in 1816. Géricault and Delacroix were among the early French lithographers.

85 Cabanne, 419, reports that Picasso told him that his variation after El Greco's *Portrait of a Painter*, dated February 22, was executed a few weeks before the Courbet variation. However, according to Daix, *Picasso* (1964), 204, the Courbet variation was done a few days before the El Greco.

86 Cited in Edward Fry, *Cubism* (New York and Toronto: McGraw-Hill Book Co., 1978), 37. On Courbet's influence on Cubism, see V. Combalia-Dexeus, "Introduction," *Estudios sobre Picasso*, ed. V. Combalia-Dexeus (Barcelona: Editorial Gustavo Gili, S.A., 1981), 7–43.

87 Fry, 37. Courbet's "Realist Manifesto" (1855) was written in connection with his one-man show outside the grounds of the Universal Exposition, from which several of his major works were excluded. See Courbet, "Realist Manifesto," in Linda Nochlin, ed., *Realism and Tradition in Art, 1848–1900*, Sources and Documents (Englewood Cliffs, N. J.: Prentice-Hall, 1966), 33–4.

88 Courbet, "An Open Letter to his Students" December 25, 1861, in Nochlin, 36.

89 Gilot, 203. Picasso owned some small paintings by Courbet. See *Donation Picasso*, #12, 18. See also Brassaï, 7 n. 1, in which he notes that he had seen several small canvases by Courbet in Picasso's rue de la Boétie apartment, which may have been obtained through exchanges with Vollard for his own paintings.

90 Combalia-Dexeus, 23.

91 Daix, 297.

92 Combalia-Dexeus, 23

93 Daix, *Life and Work*, 298. Another instance of Picasso's involvement with Courbet at this time is noted in Louis Aragon, *L'Exemple de Courbet* (Paris: Éditions Cercle d'Art, 1952), 90–91: Picasso based his drawing, *Visage de la Paix* (plate XL) on Courbet's plaster plaque, *La Dame à La Mouette* (plate XXXIX), executed at the end of his life while in exile in Vevey, Switzerland, transforming it into a symbol of peace. One of a series of twenty-nine drawings executed on December 5, 1950, it was published in the *Cercle d'Art*.

94 Baer, *Picasso the Printmaker*, 57. The theme had a long history in Picasso's graphic art as well.

95 Drawing and watercolor, Paris, 1904, Zervos 22: 63.

96 India ink on a page from a sketchbook, Boisgeloup, July 30, 1933, Zervos 12: 354.

97 Zervos 12: 69, Musée National d'Art Moderne, Centre National d'Art et de Culture Georges Pompidou.

98 Eugène Pelletan, *Feuilleton du Courrier de Paris* (7, août, 1857), cited in Robert Fernier, *La vie et l'oeuvre de Gustave Courbet: catalogue raisonné*, 3 vols. (Lausanne and Paris: Foundation Wildenstein, La Bibliothèque des Arts, 1977), 124.

99 Ibid.

100 Cooper, *Les Déjeuners*, 29. *The Kitchen*, Nov. 9, 1949, Zervos 15: 106.

101 Gilot, *Matisse and Picasso*, 93.

102 Pelletan in Fernier, 124

103 Picasso used this style frequently at this time. See *Claude and Paloma at Play*, oil and enamel on plywood, Zervos 15: 163, and *Goat, Skull, Bottle and Candle*, oil on canvas, 1952, Zervos 15: 198.

104 Jean Rousseau, "Salon de 1857," *Le Figaro* in Fernier, 124.

105 Elderfield, 88. See also Rubin, *Picasso in the Collection of The Museum of Modern Art*, for his discussion of the juxtapositions of states of mind in the *Girl before the Mirror*, 138–141.

106 This painting, however, is drawn more directly from Millet's *Le méridienne*, pastel, 1866.

107 Goya's strong influence in this decade is particularly evident in Picasso's bullfighting scenes, which draw from the *Tauromachia* prints of his predecessor. See, for example, Picasso's bullfight sketchbook, Carnet I (June 6, 1957–July 15, 1959) and Carnet III (April 3, 1959–October 4, 1958) in Luis Miguel Dominguín, *Picasso Toros y Toreros* (Paris; Éditions Cercle d'Art, n.d.).

108 As will be discussed in Chapter VI.

109 See *El Bobo, after Murillo*, oil and enamel on canvas 36¼ x 28¾ inches, April 14–15, 1959 (private collection); Zervos 18: 484 which draws in a general way from Murillo's well-known paintings of 1650–60 of picaresque street urchins of Seville, such as *Boys Eating Pastries*, in the Alte Pinakothek, Munich. Other sources from the Spanish masters appear to have entered into this pastiche, among them Ribera's *Club-Footed Boy* (1642) in the Louvre (which shares with *El Bobo* its setting of an open plain with a single tree to the left, and the boy's open-mouthed, simple-minded grin) and Velázquez' famous *Old Woman Cooking*, 1618, Edinburgh, National Gallery and his *Three Men at a Table*, 1620–21. My thanks to the late Gert Schiff for sharing his observations on *El Bobo* with me.

110 For El Greco's critical fortunes, see Jonathan Brown, "El Greco, the Man and the Myth," in *El Greco of Toledo* (Boston: Little, Brown and Co., 1982), 15–33.

111 On Picasso's relation to El Greco see John Richardson, "Picasso's Apocalyptic Whorehouse," *The New York Review of Books* 34, no. 7 (23 April 1987): 40–47; Juan Antonio Gaya Nuño, "Picasso y el Greco," *Revista de Ideas Estéticas* in *Picasso, Exposició Antologica* (Barcelona, 1981); Beryl Barr-Scharrar, "Some Aspects of Early Autobiographical Imagery in Picasso's *Suite 347*," *The Art Bulletin* 54 (December 1972): 516–533; and Anthony Blunt and Phoebe Pool, *Picasso, the Formative Years, A Study of His Sources* (Greenwich Conn., New York Graphic Society, 1962). The most recent contribution to the topic is Robert Lubar, "Picasso, El Greco, and the Construction of National History," in *Picasso and the Spanish Tradition*, ed. Jonathan Brown.

112 Letter from Picasso to the painter Joachim Bas, in Josep Palau y Fabre, *Picasso: The Early Years* (New York:

Rizzoli, 1981), 134–35.

113 Blunt and Pool, 6. The quote attributed to Don José is recorded by a friend and the Argentinean painter Francisco Bernareggi, who studied with Picasso at the Academy of San Fernando in 1897.

114 See Beryrl Barr-Scharrar, "Some Aspects of Early Autobiographical Imagery," *The Art Bulletin* 54 (December 1972): 530–31, nos. 40, 41, 110, 130, 194.

115 Richardson, "Picasso's Apocalyptic Whorehouse," 42.

116 Richardson argues convincingly that although Picasso acknowledged Cézanne as his "one and only master," throughout the formation of his Cubist idiom, El Greco's influence was equally strong or dominant up to 1909, 40. Richardson calls attention to the significant role of El Greco's *Apocalyptic Vision* (formerly called *The Opening of the Fifth Seal*, oil on canvas, Metropolitan Museum of Art, New York) in the gestation of the *Demoiselles*.

117 Daniel-Henry Kahnweiler, "Entretiens avec Picasso au sujet des *Femmes d'Alger*," *Aujourd'hui* 4 (September 1955); excerpted in Ashton, 169. On Picasso's change of feeling in later life about El Greco see his remarks to Brassaï in *Picasso and Company*, 226.

118 Brassaï, 143.

119 Ibid.

120 Utley, 22.

121 Brown, 23–24. This view, Brown notes, was colored by ongoing discussions concerning national identity that were of critical importance to Cossío as well as the young writers and philosophers known as the Generation of 1898 seeking to define and revitalize the authentic Spanish tradition following the country's disastrous loss of her colonies in the Spanish-American War. On the issue of national identity and its impact on the Generation of 1898, see also Donald L. Shaw, *The Generation of 1898 in Spain* (London and Tonbridge: Ernest Benn Limited, New York: Barnes and Noble Books, 1975); and Lubar, cited above.

122 Brown, 22.

123 The plywood board measures 39⅝ x 31⅞ inches compared with El Greco's canvas of 12⅝ x 8⅝ inches.

124 Cabanne refers to this variation as "nocturnal" (417).

125 See Paul La Porte, "Picasso's *Portrait of the Artist*," *The Centennial Review* 5, no. 3 (Summer 1961): 302. La Porte notes: "The parodistic quotation is put on like a mask."

126 Penrose, 343. There is no way of knowing if this observation comes directly from Picasso. I have found no other comments on this variation that either support or contradict this.

127 *Notice des tableaux de la Galerie Espagnole exposés dans les salles du Musée Royal du Louvre* (Paris: l'Imprimerie de Crapelet, 1838), #260 "Le Portrait du Greco"; Sir William Stirling-Maxwell, Bart. *Annals of the Artists of Spain* (London: S. Ollivier, 1848; new edition, London: John Nimmo, 1891), vol. 1, #338 "Portrait of a Painter thought to be a Self-Portrait."

128 For biographical information see Elizabeth du Gué Trapier, "The son of El Greco," *Notes Hispanics* III (1943): 1–47; and Wethey, vol. 1, 119. Wethey notes that Jorge Manuel's style was "completely dependent upon the late style of El Greco, the figures weak, formless and devoid of emotional depth"(115).

129 José Guidol, *Domenikos Theotokopoulos, El Greco, 1541–1614*, trans. Kenneth Lyons (New York: A Studio Book, Viking, 1973), 214. See also Wethey, vol. 2, no. 158, 97. Jorge Manuel also appears in *The Madonna of Charity* in Illescas.

The page appears in a etching by Picasso as part of his Suite 347. See Barr-Scharrar, 522 and figs. 30, 31.

130 José Camon Aznar, *Domenico Greco*, vol. 2 (Madrid: Espasa-Calpe S.A., 1950), fig. 883, 1133.

131 Christian Zervos, *Les oeuvres du Greco en Espagne* (Paris: Éditions "Cahiers d'Art," 1939), reproduced in detail, 214. Zervos goes into a fairly lengthy explanation as to why the work is considered the son of El Greco, 133. The painting also appears in a book of a few years later by Picasso's friend, Jean Cocteau: *Le Greco* (Paris: Au Divan, 1942), no. 48 (full-page black and white illustration).

132 Richardson cites this variation as one more example of Picasso's identification with El Greco, noting: "Given that Picasso was the genius son of an ungifted painter, and El Greco the genius father of an ungifted painter, this choice of portrait was eerily appropriate"(46).

133 Paulo, Picasso's son from his marriage to Olga Koklova, was born in 1921. At the time of undertaking the variation, he was serving as his father's chauffeur.

134 Camon Aznar, 1132.

135 Jaime Sabartès, *An Intimate Portrait*, trans. Angel Flores (New York: Prentice Hall, 1948), 32–33, also notes that Picasso had a lifelong obsession with brushes and that during the Second World War, in Royan, afraid he would not be able to obtain them, made his own. The tools of the trade also played a large role in the Picasso "mythology" concerning the painter's relationship to his father. According to Picasso, his father handed over his brushes and palette to him at age fourteen, and never painted again, a story which has since been discounted as apocryphal. See Gedo, 17, and Richardson, *A Life of Picasso*, 51.

136 Noted by El Senor Marqués de Casa Torres in an article published in *ABC* (Marzo 1944), cited in José Camon Aznar, *Domenico Greco*, vol. 2 (Madrid: Espasa-Calpe S.A., 1950), 1132. The obvious difference between the two works, of course, is the fact that the artist in the Velázquez *is* a self-portrait, while in the El Greco it is another artist.

137 Robert Enggass and Jonathan Brown, eds., "Palomino's Life of Velázquez" in *Sources and Documents, Italy and Spain 1600–750* (Englewood Cliffs, N. J.: Prentice-Hall, 1970), 183.

Chapter 5

1 Maxime du Camp, *Souvenirs Littéraires*, in René Huyghe, *Delacroix*, trans. Jonathan Griffin (New York: Harry N. Abrams, 1963), 7.

2 D. H. Kahnweiler, "Entretiens avec Picasso au subjet des *Femmes d'Alger, Aujourd'hui*," 4 (Sept. 1955): 12–13, excerpted in McCully, 251.

3 Michel Ragon, cited in Daix, *Picasso, Life and Art*, 305.

4 Carsten-Peter Warncke, *Pablo Picasso, 1881–1973*, ed. Ingo F. Walther, vol. 2 (Köln: Benedikt Tashen Verlag, 1991), 532.

5 Daix, 309–10.

6 Penrose, 344.

7 For an excellent study of the theme of the artist and model in Picasso's art, see Karen Kleinfelder, *The Artist, His Model, Her Image, His Gaze* (Chicago: University of Chicago Press, 1993), 124–186.

8 On this series see Michel Leiris, "Picasso and the *Human Comedy* or the Avatars of Fat-Foot," in Schiff, *Picasso in Perspective*, 140–151. See also Bernadac, "Picasso 1953–1972: Painting as Model," in *Late Picasso* (London: Tate Gallery,

1988), 49–94. Bernadac notes that these drawings "serve an overture to the opera that is to come"(51).

9 Michel Leiris, "The Artist and Model," in Golding and Penrose, eds., 170.

10 Gilot, *Matisse and Picasso*, 95.

11 Ibid., 90.

12 Ibid.

13 Daix, 365.

14 For the paintings see Zervos 16: 342–43, 345–49, 352–53, 357, 359–60. The series was exhibited in *Picasso*, Paris, Musée des Arts Decoratifs, 1955, nos. A–N. Seventy (almost all) of the preparatory drawings for the suite are in the Musée Picasso. See Michèle Richet, *Catalogue sommaire des collections: Dessins, Aquarelles, Gouaches, Pastels*, vol. 2 (Paris: Editions de la Réunion des musées nationaux, 1987, nos. 1321–1391. For the lithographs see Fernand Mourlot, *Lithographs*, trans. Jean Didry (Paris: Boston Art and Book Publisher, 1970) nos. 265, 266. For the etchings and aquatints, see Baer, *Picasso, Peinture-Graveur*, IV, nos. 908, 909, 911–13, 915–18, pp. 213–229.

15 Lee Johnson, *The Paintings of Eugène Delacroix: A Critical Catalogue, 1832–1863*, vol. 3 (Oxford: Clarendon Press, 1986), no. 376, 166.

16 For a full account of the genesis of Delacroix's *Women of Algiers* (1834), see Johnson, 165–69. See also Elie Lambert, *Delacroix et Les Femmes d'Alger* (Paris: Librairie Renouard, H. Laurens, Editeur), 1937. Picasso may well have known the latter.

17 Johnson, 161.

18 Johnson, 167.

19 Johnson, *Delacroix* (London: Weidenfeld and Nicholson, 1963), 62.

20 Johnson (1986), vol. 3, no. 382, 191–93.

21 Huyghe, 286.

22 See Lambert, 35–49.

23 Steinberg, "The Women of Algiers and Picasso at Large," in *Other Criteria*, 125–234.

24 Ibid., 128.

25 Ibid., 130.

26 Ibid., 223.

27 Ibid., 234.

28 Picasso to Kahnweiler (1935), excerpted in Ashton, 166.

29 Lambert, 9–12.

30 Pierre Daix, *La Vie de peintre de Pablo Picasso* (Paris: Le Seuil, 1977), 363 n. 11. (translation by the author)

31 Ibid.

32 See Norman Bryson, *Tradition and Desire: From David to Delacroix* (Cambridge: Cambridge University Press, paperback edition, 1987), 176–212, for a discussion of the issue of artistic belatedness in Delacroix's cycle of paintings representing Science, Philosophy, Law, Theology, and Poetry on the ceiling of the Library of the Chamber of Deputies in the Palais Bourbon in Paris.

33 Lambert, 11.

34 Johnson (1963), 61.

35 Bryson,

36 Daix, *La Vie de peintre de Picasso*, 359.

37 Dumur (1988) 114, cited in Jack Cowart et al., *Matisse in Morocco: The Paintings and Drawings, 1912–1913* (Washington: National Gallery of Art, 1990), 23.

38 For Renoir's versions, see Barbara Ehrlich White, *Renoir, His Life, Art and Letters* (New York: Harry N. Abrams, 1984): *The Women of Algiers*, 1870, Washington, National Gallery, p. 36; *The Harem*, 1872, National Museum of Western Art,

Tokyo, 44.

39 The notion of Picasso's return to the origins of modern art was proposed by John Golding in his discussion of the *Déjeuner* series in John Golding and Elizabeth Cowling, *Picasso: Sculptor/Painter* (London: Tate Gallery, 1994), 37.

40 Catherine Bock, *Henri Matisse and Neo-Impressionism, 1898–1908* (Ann Arbor: U.M.I Research Press, 1981), 1. See also Roger Benjamin, *Matisse's "Notes of a Painter": Criticism, Theory, and Context, 1891–1908* (Ann Arbor: U.M.I. Research Press, 1987), and Floyd Ratliff, *Paul Signac and Color in Neo-Impressionism* (New York: Rockefeller University Press, 1992.) The latter contains the first English translation of Signac's treatise.

41 Signac in Ratliff, 206.

42 Johnson (1963), 63–72.

43 Signac in Ratliff, 285.

44 See Jack Flam, *Matisse, The Man and His Art, 1869– 1918* (Ithaca and London: Cornell University Press, 1986), 109–14.

45 Flam, 170.

46 Johnson (1963), 62.

47 Flam, 174.

48 Flam, 195.

49 On the connection of the *Demoiselles d'Avignon* with the *Women of Algiers*, see Robert Rosenblum, "Les Demoiselles Revisited," *ArtNews* 72, no. 4 (April 1973): 47. On the *Blue Nude*, see Flam, 191–200, esp. 196.

50 Zervos 10: 204–08.

51 Malraux, 54.

52 Gilot, *Life with Picasso*, 203.

53 Zervos 16: 316–319.

54 Charles Baudelaire, *Eugène Delacroix: His Life and Art* (New York: Lear Publishers, 1947), 62.

55 Zervos 21: 192.

56 See Kleinfelder for a discussion of Romanticism in Picasso's late work (42–47). Aragon, in *L'Exemple de Courbet*, refers to Picasso as "that Delacroix of the xxth century"(92).

57 Kahnweiler, "Entretiens avec Picasso au sujet des Femmes d'Alger" (1955), excerpted in McCully, 252.

58 Penrose, 351–52.

59 Penrose, 350.

60 Kahnweiler, "Entretiens," in McCully, 251.

61 Location unknown, see Zervos 16: 342.

62 In *"Demoiselles* Revisited" (p. 47), Rosenblum notes that in the *Women of Algiers* series Picasso included at least as many references to the *Turkish Bath* as to the harem, if not more, and on pages 45–46 discusses the role of both nineteenth-century works in the genesis of the *Demoiselles*.

63 C. Zervos 16: 345. D. Zervos 16: 346.

64 See Musée Picasso, *Catalogue des collections*, vol. 2, nos. 1335–1350, dated December 25–28.

65 Marguerite Duthuit-Matisse and Claude Duthuit, *Henri Matisse: Catalogue raisonné de l'oeuvre gravé* (Paris: 1983), plate 500, p. 97. See also plates 501–07.

66 Steinberg notes a connection with Matisse, 133–36.

67 Ibid., 136.

68 Rosenblum, *Ingres*, 145.

69 See Gilot, *Matisse and Picasso*, 90.

70 Steinberg, 136.

71 Zervos 16: 348.

72 Steinberg, 140.

73 For Matisse's interest in Michelangelo, see Pierre Schneider, *Matisse*, trans. by Michael Taylor and Bridget Strevens Romer (London: Thames and Hudson, 1984), 523–40.

74 Steinberg, 142.

75 Zervos 16: 353, 355.

76 Gilot in *Matisse and Picasso* sees the series as a whole as a nihilistic gesture, 317.

77 Penrose, 352.

78 Johnson (1986), 192.

79 Jean Sutherland Boggs, in Joseph Ketner and Jane E. Neidhardt, *A Gallery of Modern Art at Washington University in Saint Louis* (St. Louis: Washington University, 1994), 78.

80 Ibid.

81 John Richardson in conversation with the author, June 1995.

82 Steinberg, 223.

83 Walter Benjamin, "The Task of the Translator, An Introduction to the Translation of Baudelaire's *Tableaux parisiens*," in *Illuminations*, ed. Hannah Arendt. trans. Harry Zohn (Frankfurt: Surkamp Verlag, 1955, reprint, New York: Schocken Paperback Edition, 1976), 72.

Chapter 6

1 José Ortega y Gasset, *The Dehumanization of Art* (1948), in Walter Jackson Bate, ed., *Criticism, The Major Texts* (New York: Harcourt, Brace and Jovanovich, 1970), 663.

2 To carry out his dialogue, Picasso set up a separate studio on the unused third floor of his villa, admitting no one except Jacqueline until early October. As Richardson remarked ("L'Epoque Jacqueline" *The Late Picasso*, 20): "So absorbed and temperamental did the artist become that Jacqueline and the Pignons dubbed him the 'abominable snowman.'" The entire suite was donated by Picasso in 1970 to the Museu Picasso in Barcelona in honor of his friend, Jaime Sabartès. The standard work on this series is Sabartès, *Picasso's Variations on Velázquez' Painting "The Maids of Honor" and Other Recent Works* (New York: Harry N. Abrams, Inc., 1959). All paintings are reproduced in color. The numbering of the variations in this chapter follow that of the plates in the Sabartès book. For the first critical study, see José Palau y Fabre, *El Secret de les Menines de Picasso* (Barcelona: Edicions Polígrafa, S.A., 1981).

3 Noted in Leo Steinberg, "Velázquez' *Las Meninas*," *October* 19 (Winter 1981): 45.

4 Antonio Palomino de Castro, "Life of Velázquez," in *El museo pictórico y escala óptica*, Part 3: *El paranaso español pintoresco laureado* (Madrid, 1724), translated from the edition published by M. Aguilar (Madrid, 1947), in Robert Enggass and Jonathan Brown, *Sources and Documents, Italy and Spain, 1600–1750* (Englewood Cliffs, N.J.: Prentice-Hall, 1970), 193–94.

5 Ibid., 194.

6 Jonathan Brown, "Picasso and the Spanish Tradition of Painting" in *Picasso and the Spanish Tradition*, ed. Jonathan Brown (New Haven and London: Yale University Press, 1996).

7 Ibid.

8 Carl Justi, *Velázquez and His Times*, trans. A. H. Keane (London: H. Grevel and Co., 1889), 418.

9 For a summary of some of these interpretations and his own notable contribution to the subject, see Jonathan Brown, "The Meaning of *Las Meninas*," in *Images and Ideas in Seventeenth-Century Spanish Painting* (Princeton: Princeton University Press, 1978), 87–110.

10 Michel Foucault, "Las Meninas," in *The Order of Things, An Archaeology of the Human Sciences.* Translation

of *Les Mots et Les Choses* (1966), (New York: Random House, Vintage Books Edition, 1973), 4–5.

11 On this point, see John Searle, "*Las Meninas* and the Paradox of Pictorial Representation," *Critical Inquiry*, 6 (Spring 1987), 477–488; Joel Synder and Ted Cohen, "Critical Response on *Las Meninas*, Paradox Lost," *Critical Inquiry* 7 (Winter 1980), 429–447. See also Steinberg, "Las Meninas." A year after the Searle and the Synder and Cohen articles, Steinberg came to a similar conclusion to the latter, asserting that the mirror's image comes from two sources—from both the actual king and queen in front of the painting and their painted likeness on the front of the canvas in the picture. The conflation, he argues pays tribute to the mimetic power of painting "as if to grant that the masterpiece on the canvas mirrors the truth beyond any mirror's capacity to surpass it." See also Jonathan Brown, *Velázquez, Painter and Courtier* (New Haven and London: Yale University Press, 1986), 259.

12 Martin Kemp, *The Science of Art, Optical Themes in Western Art from Brunelleschi to Seurat* (New Haven and London: Yale University Press, 1990), 108–09.

13 Ibid., 109.

14 Karl M. Birkmayer, "Realism and Realities in the Paintings of Velázquez," *Gazette des Beaux Arts* 52 (1958), 70.

15 See Roland Penrose, *Picasso, His Life and Work* (New York: Harper, 1959), 371–72. In a conversation about *Las Meninas* with the author shortly after he executed the variations, Picasso commented: "Look at it, and try to find where each of these is actually situated. Velázquez can be seen in the picture, whereas in reality, he must be standing outside it, he is shown turning his back to the Infanta who at first glance we would expect to be his model. He faces a large canvas on which he seems to be at work but it has its back to us and we have no idea what he is painting. The only solution is that he is painting the king and queen, who are only to be seen by their reflection in the mirror at the far end of the room. This implies, incidently, that if we can see them in the mirror, they are not looking at Velázquez, but at us. Velázquez therefore is not painting las Meninas. The girls have gathered around him not to pose but to see his picture of the king and queen with us standing beside them."

16 For a discussion of this point in *Las Meninas*, see Ann Hurley, "The Elided Self: Witty Dis-Locations in Velázquez and Donne," *The Journal of Aesthetics and Art Criticism* vol. 44 (Summer 1986), 357–369.

17 For a detailed account of this period of Picasso's life, see Richardson, *A Life of Picasso*, I, 57–89.

18 Ibid., 47–51.

19 Leo Steinberg, "The Philosophical Brothel," I, *Art News* 71 (September 1972), 22. Steinberg's observation is corroborated by the appearance of a reference to Velázquez's dog in one of the studies for the *Demoiselles*. See Werner Spies, *Pablo Picasso: Eine Ausstellung zum hundersten Geburtstag. Werke aus der Sammlung Marina Picasso* (München: Prestel Verlag, 1981), 25, fig. 16.

20 Spies, Ibid., fig. 17. Zervos 26: 5. *Self-Portrait with a Palette*, Zervos 1: 375.

21 See, for example, Picasso's *Painter and Model* of 1927–28 in The Museum of Modern Art, New York (Zervos VII, 142). William Rubin, in *Picasso in the Collection of The Museum of Modern Art* (New York, 1971), p. 123, notes a connection between this painting and *Las Meninas*.

22 See S. G. Galassi in "The Arnheim Connection: *Las Meninas* and *Guernica*," *The Journal of Aesthetic Education* 27, no. 4 (Winter 1993).

23 Justi, 10. For a summary of Velázquez's critical fortunes see 10–15. See also Jose Oretga y Gasset, "Velázquez and His Fame," *Velázquez* (New York: Random House, 1953). In 1983, I participated in Jonathan Brown's seminar at the Institute of Fine Arts, N.Y.U. on Velázquez's fame; I am grateful to him and fellow students for the background material for this section.

24 Angel Gavinet, "La pintura espanola juz en el extranjero," 1895, collected in *Varía Velázqueña. Homenaje a Velázquez en el III centenario de su muerte, 1660–1960*, 2 vols. (Madrid: Minesterio de educacíon national, 1960), 200–02. Gavinet was a member of the so-called "Generation of 1898."

25 The first Spanish monograph was by Gregorío Cruzada Villamil's *Anales de la vida y los obras de Diego de Silva Velázquez, con ayuda de nuevos documentos* (Madrid, 1888).

26 Aureliano de Beruete, *Velázquez*, (London: Methuen and Co., 1906), xxx.

27 Palau y Fabre, *Picasso, the Early Years, 1881–1907*, 124. For a recent extensive study of this subject, see Lubar, "Picasso, El Greco and the Construction of a National History."

28 Statement to Marius de Zayas (1923), cited in Ashton, 165.

29 Kurt Badt, *Das Spätswerk Cézannes* (1971), cited in Rudolf Arnheim, "On the Late Style," *New Essays on the Psychology of Art* (Berkeley, Los Angeles, London: University of California Press, 1986), 291.

30 Sabartès, *Picasso's Variations on Velazquez's Painting*, Introduction, unpaginated.

31 Schiff, "Introduction," *Picasso in Retrospect*, 25.

32 See Steinberg, "The Algerian Women"(136) for a reference to *Las Meninas* in the previous series of variations through the figure at the door.

33 Zervos 16: 100, Musée Picasso, Paris. Picasso commented to a friend that the shadow was his own, thrown across the bedroom he had until recently shared with Françoise Gilot. See David Douglas Duncan, *Picasso's Picassos* (New York: Harper and Row, 1953), 183.

34 On the subject of the magical significance of windows and doors in Picasso's art, see Gasman, 661–756.

35 Steinberg, "*Velázquez' Las Meninas*," 51–2, discusses the "scatter effect" brought about by the picture's multiple centers. A third center, Steinberg notes, is the centerline of the painting, marked by the looking glass. These three centers, he notes, are subordinated to yet another centrality outside of the picture, the royal couple.

36 See John Anderson, "Faustus/Velázquez/Picasso," in Schiff, ed., *Picasso in Perspective*, 158–162, for an excellent discussion of the subversive aspects of *Las Meninas*.

37 Foucault, 4.

38 Hurley, 357.

39 Sabartès, Introduction, unpaginated.

40 Brown, "The Meaning of *Las Meninas*," 91.

41 My perception of the artistic process in Picasso's art in this series has been strongly shaped by the analysis of another body of his work: Rudolf Arnheim, *The Genesis of a Painting, Picasso's Guernica* (Berkeley and Los Angeles; University of California Press, 1962). I would like to acknowledge here my debt to my former teacher, and continuing appreciation of his work.

42 Brown, *Velázquez*, p. 261.

43 Zervos II, 19, Kunstmuseum, Basel.

44 Gedo, *Picasso: Art as Autobiography*, 235–36.

45 Ibid., 235

46 *The Open Window*, oil on canvas, 1905

47 Gasman, 1130.

48 Baudelaire, *Oeuvres*, II (Paris, 1939), 171, in Penrose, 374.

49 Steinberg, "The Algerian Women and Picasso at Large," 230. The term "simultaneous space" comes from Steinberg's discussion of Canvas O.

50 See Theodore Reff, "Picasso's *Three Musicians*: Maskers, Artists and Friends," *Art in America*, Special Issue: Picasso (December 1980), 125–42. Reff links this work to the death of Apollinaire and sees it as connected with Picasso's mourning for his youth as he enters his forties.

51 Penrose, 374.

52 Brown, "The Meaning of Las Meninas."

53 Palomino de Castro, cited in Enggass and Brown, p. 194.

54 Picasso executed thirty etchings for Ovid's *Metamorphoses*, published by Albert Skira in Lausanne in 1930.

55 Picasso in a conversation Brassaï about the Isenheim altarpiece, Brassaï, 24.

56 Picasso to Zervos (1935), excerpted in Ashton, 27.

57 Picasso to Hélène Parmelin, excerpted in Ashton, 22.

58 I thank Robert Rosenblum for suggesting this observation. For the Atelier paintings see Nicole S. Mangin, ed., *Catalogue de l'oeuvre de Georges Braque, Peintures*, 1948–1957, (Paris: Maeght Editeur, 1959), I–IV (1949) 7–10; V, 11; VI (1950–51), 29; VII (1954–55), 93.

Chapter 7

1 Picasso to Alexander Liberman (1956), excerpted in Ashton, 16.

2 Some of the paintings and drawings in the Déjeuner series are reproduced in Zervos 19: 35–43, 200–05, 289–92, 465–66, and Zervos 20: 35–134, 172–78, 259–302, 343–350. The main source for the variations executed between August 10, 1959 and December 1961, is Douglas Cooper, Pablo Picasso: *Les Déjeuners* (Paris: Cercle d'Art, 1962, New York: Harry N. Abrams, 1963). The suite continued sporadically after the completion of Cooper's book; as the works are now widely dispersed, this monograph remains an indispensable resource for examining this suite as the works. For the cardboard maquettes, see *Musée Picasso: Catalogue des collections* (1985), nos. 414–431. For the concrete sculpture, see Sally Fairweather, *Picasso Concrete Sculpture* (New York: Hudson Hill Press, 1982), 89–92. For the linoleum cuts, see William S. Lieberman, *Picasso: Linoleum Cuts, The Collection of Mr. and Mrs. Charles Kramer in the Metropolitan Museum of Art* (New York: The Metropolitan Museum of Art and Random House, 1985), nos. 84–89.

For critical literature on this series see: Marie-Laure Bernadac, "De Manet à Picasso, l'éternel retour," *Bonjour Monsieur Manet* (Paris: Musée national d'art moderne, Centre Georges Pompidou, 1983), 33–46; Rosalind Krauss, "The Impulse to See," in *Vision and Visuality*, ed. Hal Foster, Dia Art Foundation Discussions in Contemporary Culture, No. 2 (Seattle: Bay Press, 1988), 51–78; and Wollheim, *Painting as an Art*, 187–249.

3 For a recent summary of the literature on this work see Françoise Cachin et al., *Manet, 1832–1883*, (New York: The Metropolitan Museum of Art and Harry N. Abrams, Inc., Publishers, 1983), no. 62, 165–173.

4 Henri Loyrette, "The Nude," in Gary Tinterow and Henri Loyrette, *Origins of Impressionism* (New York: The Metropolitan Museum of Art, Harry N. Abrams, Inc., 1995), 95–124. See also Beatrice Farwell, *Manet and the Nude: A Study in Iconography in the Second Empire* (New York: Garland, 1981).

5 Michael Fried, "Manet's Sources, Aspects of His Art," *Artforum* 7 (March 1969), 46.

6 Anne Coffin Hanson, *Manet and the Modern Tradition* (New Haven and London: Yale University Press, 1977), 95. On the issue of the model, see also Juliet Wilson-Bareau, *Manet by Himself: Correspondence and Conversation* (Boston, Toronto, London: Bullfinch Press, 1991), 14–15, and Cachin, 170.

7 Kathleen Adler, *Manet* (Oxford: Oxford University Press, 1986), 52.

8 Carol Armstrong, "To Paint, To Point, To Pose," (paper presented at the College Art Annual Meeting, New York, 1994).

9 Zervos 16: 478–79.

10 Musée Picasso, Paris (Zervos 15: 173). The work by Manet in the Städtische Kunsthalle, Mannheim.

11 The painting remained in the artist's possession until 1878, when he sold it to the singer Faure. Durand-Ruel bought the work in 1898 and sold it soon after to Étienne Moreau-Nélalton. The *Déjeuner* entered the Louvre in 1934 through his bequest, and was installed in the Jeu de Paume in 1947 with the Impressionist collection (Cachin, 172–73).

12 Picasso's exhibit, *The Last Moments* (1899) has now disappeared under his Blue Period masterpiece, *La Vie*, Barcelona, 1903, now in The Cleveland Museum of Art, Zervos I: 179.

13 Cachin, *Manet*, 173. The *Déjeuner* was part of his gift of 1906 of thirty-four works to the State.

14 Marie-Laure Bernadac, "Picasso, 1953–1973: The Painting as Model, p. 70 and n. 44 The sentence reads: "Quand je vois Le Déjeuner sur l'herbe de Manet, je me dis, des douleurs pour plus tard." Bernadac cites as her source an envelope of the Galerie Simon now in the archives of the Musée Picasso in Paris, and comments in note 44 that the date might well be 1939, the year of the Manet retrospective at the Musée de l'Orangerie.

15 Zervos 16: 316–19.

16 Bernadac, 50.

17 Cooper, 34.

18 Zervos 19: 40–43.

19 Zervos 19: 35–39.

20 Zervos 19: 35–37.

21 As noted by Cooper, 12.

22 Cooper, 35

23 Zervos 20: 289–92.

24 Zervos 19: 376–382.

25 Zervos 19: 465–66.

26 Zervos 20: 9–31.

27 Cooper, 17.

28 John Golding and Elizabeth Cowling, *Picasso: Sculptor/Painter* (London: The Tate Gallery, 1994), 39.

29 On these drawings see Krauss, "The Impulse to See."

30 June 20–July 7, 1961 (First carnet) 26 drawings (Cooper no. 53–54, 56–70, Zervos 20: 33, 36–61). On June 20 all four protagonists appear.

31 June 23, 1961—8 drawings (Cooper, nos. 63–70, Zervos 20: 44–51). In seven of these drawings he returns to two nudes.

32 July 1, 1961—I–IV, 3 drawings in colored chalk or crayon, one in black and white (Cooper, nos. 71–74, Zervos 20:

52–55). The pencil studies are followed by 4 developed drawings of the two nudes, the first three of which are in brilliant color.

33 July 4 and 7, 1961 (return to the first carnet) (Cooper, nos. 75–81, Zervos 20: 56–61). The bather becomes the focus of the next six drawings, which Picasso executed in the first of the *Déjeuner* notebooks, begun on June 20. In drawings III–VI, he turns the notebook to the vertical direction focuses on the bather alone, monumentalizing her in the process. The notebook concludes with the drawing of the frontal mask-like head of a bearded man.

34 Second Carnet, Notre Dame de Vie, 25 drawings, July 8 and 9, 1961 (Cooper, nos. 84–108, Zervos 20: 62–86). In most of the first 10 drawings in simple outline form, the nudes are portrayed with the speaker, and scene shifts between the river bank of Manet's painting to the seashore; in others the speaker and bather are shown alone. These are directly related to the painting of July 10.

35 As first noted by Cooper, 19. They recall no one particular bather painting by Cézanne, but the four and five-figure bather compositions by the mid-eighties. Picasso owned one of Cézanne's bathers. See *Donation Picasso: la collection personelle de Picasso* (Paris: Éditions de la Réunion des musées nationaux, 1978), no. 4, *Cinq Baigneuses* (1879–82).

36 See Theodore Reff, "Painting and Theory in the Final Decade," in *Cézanne: The Late Work* (New York: The Museum of Modern Art, 1977), 39.

37 Reff, 44.

38 Musée Picasso, MP 216.

39 Gilot, *Matisse and Picasso*, 94.

40 Zervos 20: 120–26, 127–133.

41 Cooper, 44.

42 Zervos 20: 127–133.

43 Zervos 20: 172–178.

44 Zervos 19: 259–302.

45 Richardson, "Picasso's Sketchbook: Genius at Work," *Vanity Fair* (May, 1986). These works, however, are not variations in the same sense, as they draw from multiple sources, and so are not included in this study. For an extensive analysis, see Gert Schiff, "The Sabines, Sketchbook No. 163, 1962," in *Je suis le cahier, The Sketchbooks of Picasso* (Boston and New York: Pace Gallery, Altantic Monthly Press, 1986). For the two rape scenes see No. 165 (36), p. 289, and No. 165 (37), p. 287.

46 For an excellent discussion of these works and their relation to Picasso's paintings and drawings for the Déjeuner series, see Golding and Cowling, *Picasso: Sculptor/Painter*, 286.

47 For a full account of this project see Fairweather, *Picasso Concrete Sculpture*, 89–92. The concrete sculptures were executed by Carl Nesjar with whom Picasso collaborated on numerous works in concrete. Pontus Hulten, then director of the Moderna Museet in Stockholm, initiated the project and saw the installation through. The sculptures range in height from 10 to 13 feet. See also Golding and Cowling, 286.

48 Golding and Cowling, 38.

49 Salon du mai, *Le moniteur universel*, Mai 21, 1864, 1, in Tinterow and Loyette, 101 n. 17.

50 Paul de Saint Vence, Salon of 1864, *La Presse*, May 7, 1864, in Tinterow and Loyette, 101.

51 Michael Fried, "Painting Memories: On the Containment of the Past in Baudelaire and Manet," *Critical Inquiry* 10 (March 1984): 521. Comparing painting with sculpture, Fried notes that in painting "the entirety of its past being in some sense [is] held in reserve." See also Golding, 37, on the *Déjeuner* as a celebration of the art of painting.

52 Robert Goldwater, "A French Nineteenth-Century Painting: Manet's Picnic," *Art in America* 34, no. 4 (October, 1947): 328.

53 Parmelin, *Intimate Secrets of the Studio*, 65.

Picasso: Standard Catalogues

Baer, Brigitte. *Picasso, Peintre-Graveur, Catalogue raisonné de l'oeuvre gravé et des monotypes, 1935–1968*. 4 vols. Berne, Editions Kornfeld, 1986–89.

Bloch, Georges. *Pablo Picasso, Catalogue de l'oeuvre gravé et lithographié*, 4 vols. Berne: Kornfeld and Klipstein, 1968–79.

Daix, Pierre, Boudaille, Georges, and Rosselet, Joan. *Picasso, The Blue and Rose Periods. A Catalogue of the Paintings, 1900–06*. Greenwich, Conn.: New York Graphic Society, 1967. Originally published as *Picasso, 1900–06*. Neuchâtel: Ides et Calendes, 1966.

Daix, Pierre and Rosselet, Joan. *Picasso, The Cubist Years, 1907–1916. A Catalogue Raisonné of the Paintings and Related Works*. Originally published as *Le Cubisme de Picasso*. Neuchâtel: Ides et Calendes; Boston: New York Graphic Society, 1979.

Geiser, Bernhard. *Picasso, peintre-graveur*. 2 vols. Berne: Geiser, 1955; Kornfeld and Klipstein, 1968.

Mourlot, Fernand. *Picasso Lithographe*. 3 vols. Monte Carlo: André Sauret, Editions du Livre, 1949–56. English translation: Mourlot, Fernand. *Picasso Lithographs*. Boston: Boston Book and Art Publishers, 1970.

Palau y Fabre, Josep. *Picasso, The Early Years, 1881–1907*. Translated by Kenneth Lyons. New York: Rizzoli, 1981. Originally published as *Picasso Vivent, 1881–1907*. Barcelona: Edicions Polígrafa, S.A., 1980.

Spies, Werner. *Sculpture by Picasso with a Catalogue of the Works*. New York: Harry N. Abrams, 1971. Originally published as *Picasso: Das plastische Werk*. Stuttgart: Gerd Hatje, 1983.

Zervos, Christian. *Pablo Picasso*. 33 vols. Paris: Cahiers d'Art, 1932–78.

Zervos, Christian. *Dessins de Picasso, 1892–1948*. Paris: Editions "Cahiers d'Art," 1949.

Picasso: Monographs, Anthologies, Exhibition and Collection Catalogues

Arnheim, Rudolf. *The Genesis of a Painting, Picasso's Guernica*. Berkeley, Los Angeles, London: University of California Press, 1962; paperback edition, 1973.

Ashton, Dore, editor. *Picasso on Art: A Selection of Views*. Documents of 20th Century Art. New York: Viking, 1972.

Baer, Brigitte. *Picasso the Printmaker, Graphics from the Marina Picasso Collection*. Dallas: The Dallas Museum of Art, 1983.

Barr, Alfred H. Jr. *Picasso, Fifty Years of his Art*. New York: The Museum of Modern Art, 1946; paperback edition, 1974.

Berger, John. *The Success and Failure of Picasso*. Harmondsworth, Middlesex, Baltimore: Penguin Books, 1965; reprint edition, New York: Pantheon, 1980.

Bernadac, Marie-Laure, Monod-Fontaine, Isabelle, and Sylvester, David. *Late Picasso, Paintings, Sculpture, Drawings and Prints, 1953–72*. London: The Tate Gallery, 1988.

Blunt, Anthony and Phoebe Pool. *Picasso, The Formative Years, A Study of his Sources*. London: Studio Books, 1962.

Boggs, Jean Sutherland. *Picasso and Man*. Toronto: Toronto Art Gallery, 1964.

Bozo, Dominique. *Picasso, oeuvres reçues en paiement des droits de succession*. Paris: Editions de la Réunion des musées nationaux, 1979–80.

Bozo, Dominique. (Introduction) *Musée Picasso. Catalogue des collections*. Paris: Editions de la Réunion des musées nationaux, 1985.

Bozo, Dominique; Friedman, Martin; Rosenblum, Robert; Penrose, Roland. *Picasso from the Musée Picasso, Paris*. Minneapolis: Walker Art Center, 1980.

Brassaï, G. H. *Picasso and Company*. Translated from the French by Francis Price. Garden City, New York: Doubleday and Co., 1966.

Cabanne, Pierre. *Picasso, His Life and Work*. Translated from the French by Harold J. Salemson. New York: William Morrow and Co., 1977.

Carmean, E. A. *Picasso, the Saltimbanques*. Washington, D.C.: National Gallery of Art, 1980.

Circi-Pellicer, Alejandro. *Picasso avant Picasso*. Translated from the Spanish by Marguerite de Flores and Ventura Gasol. Revised edition. Paris: Pierre Cailler, 1950.

Cirlot, Juan Eduardo. *Picasso, Birth of a Genius*. Translated from the Spanish. Forward by Juan Ainaud de LaSarte. New York: Praeger, 1972.

Cohen, Janie, et al. *Picasso, Inside the Image: Prints from the Ludwig Museum, Cologne*, Janie Cohen, editor. London: Thames and Hudson, 1995.

Combalia Dexeus, Victoria, editor. *Estudios sobre Picasso*. Barcelona: Gustave Gili, S.A., 1981.

Cooper, Douglas. *Pablo Picasso: Les Déjeuners*. Paris: Editions Cercle d'Art, 1962.

Cooper, Douglas. *Picasso Theater*. New York: Harry N. Abrams, Inc., 1967.

Daix, Pierre. *La vie de peintre de Pablo Picasso*. Paris: Editions du Seuil, 1977.

Daix, Pierre. *Picasso*. Translated from the French. Praeger World of Art Profiles. New York: Praeger, 1964.

Dennery, Etienne. *Pablo Picasso, Gravures*. With a foreword by Jean Adhémar. Paris: Bibliothèque Nationale, 1966.

Fairweather, Sally. *Picasso's Concrete Sculpture*. New York: Hudson Hill Press, 1982.

Fermigier, André. *Picasso*. Paris: Livres de Poche, Librairie Générale Française, 1969.

Fitzgerald, Michael C. *Making Modernism: Picasso and the Creation of the Market for Twentieth Century Art*. New York: Farrar, Straus and Giroux, 1995.

Galerie Louise Leiris. *Picasso; Le Déjeuner sur l'herbe 1960–1961*. Séries A, no. 16, Paris, 1962.

Galerie Louise Leiris. *Picasso; Les Ménines*, 1957. Séries A, no. 10, Paris, 1959.

Galerie Louise Leiris. *Picasso: Peintures 1962–1963*. Introduction by Michel Leiris. Séries A, no. 18, Paris, 1964.

Gallwitz, Klaus. *Picasso at 90, The Late Work*. Translated from the German, *Picasso Laureatus, Sein Mälerisches Werk Seit 1945* New York: Putnam, 1971.

Gasman, Lydia. *Mystery, Magic and Love in Picasso, 1925–1938: Picasso and the Surrealist Poets*. (Ph.D. dissertation, Columbia University, 1981.) 4 vols. Ann Arbor, Michigan: University Microfilms International, 1986.

Gedo, Mary Mathews. *Picasso, Art as Autobiography*. Chicago: University of Chicago Press, 1980.

Gilot, Françoise and Carlton Lake. *Life with Picasso*. New York, Toronto, London: McGraw-Hill Book Company, 1964.

Gilot, Françoise. *Matisse and Picasso: A Friendship in Art*. London: Bloomsbury, 1990.

Glózer, Lázló. *Picasso und der Surrealismus*. Köln: M. Dumont Schauberg, 1974.

Geelhaar, Christian. *Picasso: Das Spätwerk, Themen, 1964–1972*. Basel: Kunstmuseum, 1981.

Glimcher, Arnold and Marc Glimcher, editors. *Je suis le cahier: the Sketchbooks of Picasso*. Boston and New York: The Atlantic Monthly Press, 1986.

Golding John, and Cowling, Elizabeth. *Picasso, Painter/Sculptor*. London: The Tate Gallery, 1994.

Kahnweiler, Daniel Henry. *Cranach und Picasso*. Katalog 9. Nuremberg: Albrecht Dürer Gesellschaft, 1968.

Kleinfelder, Karen. *The Artist, His Model, Her Image, His Gaze: Picasso's Pursuit of the Model*. Chicago and London: University of Chicago Press, 1993.

Leymarie, Jean. *Picasso, Artist of the Century*. Translated from the French, *Picasso, Metamorphoses et unité*, by James Emmons. New York: Viking, 1962.

Lieberman, William S. *Picasso's Linoleum Cuts, The Mr. and Mrs. Charles Kramer Collection in the Metropolitan Museum of Art*. New York: The Metropolitan Museum of Art and Random House, 1985.

Malraux, André. *Picasso's Mask*. Translated from the French by June Guicharnaud with Jacques Guicharnaud. New York: Holt, Rinehart and Winston, 1976.

McCully, Marilyn. *Els Quatre Gats*. Princeton: Princeton University Press, 1978.

McCully, Marilyn, editor. *A Picasso Anthology: Documents, Criticism, Reminiscences*. London: Arts Council of Great Britain in association with Thames and Hudson, 1981.

O'Brian, Patrick. *Pablo Ruiz Picasso*. New York: G. P. Putnam's Sons, 1976.

Olivier, Fernande. *Picasso et ses amis*. Paris: Stock, 1933.

Otero, Roberto. *Forever Picasso: An Intimate Look at his Last Years*. New York: Harry N. Abrams, 1974.

Palau y Fabre, Josep. *El secret de les menines de Picasso*. Barcelona: Edicions Polígrafa, S.A., 1981.

Parmelin, Hélène. *Picasso Says . . .* Translated from the French, *Picasso Dit* by Christine Trollope. 1st American edition. South Brunswick, New Jersey: A. S. Barnes, 1969.

Parmelin, Hélène. *Picasso: The Artist and his Model and Other Recent Works*. Translated from the French. New York: Harry N. Abrams, Inc., 1965.

Parmelin, Hélène. *Voyage en Picasso*. Paris: Laffont, 1980.

Parmelin, Hélène. *Picasso Plain: An Intimate Portrait*. Translated from the French by Humphrey Hare. New York: St. Martin's Press, 1963.

Parmelin, Hélène. *Picasso: Women, Cannes and Mougins, 1954–1963*. Preface by Douglas Cooper. Paris: Editions Cercle d'Art, 1967.

Penrose, Sir Roland. *Picasso: His Life and Work*. New York: Harper and Row, Icon Editions, 1973.

Penrose, Sir Roland; Golding, John; Bozo, Dominique. *Picasso's Picassos*. London: Arts Council of Great Britain, 1981.

Penrose, Sir Roland and Golding, John. *Picasso in Retrospect*. London: Paul Elek, 1973; reprint edition New York: Harper and Row, Icon Editions, 1980.

Richardson, John (with the collaboration of Marilyn McCully). *A Life of Picasso*, Vol. I, 1881–1906. New York: Random House, 1991.

Richardson, John. *Pablo Picasso, Watercolors and Gouaches*. London: Barrie and Rockliff, 1964.

Richardson, John. *Through the Eye of Picasso, 1928–1934. The Dinard Sketchbook and Related Paintings and Sculpture*. New York: William Beadleston, Inc., 1985.

Richet, Michèle. *Musée Picasso: Catalogue sommaire des collections, II, Dessins, Aquarelles, Gouaches, Pastels*. Paris: Editions de la réunion des musées nationaux, 1987.

Rose, Bernice. *Picasso and Drawing*. New York: Pace/Wildenstein, 1995.

Rosenberg, Pierre. *Donation Picasso. La collection personnelle de Picasso*. Sylvie Beguin, Commissariat. Paris: Editions de la Réunion des musées nationaux, 1978.

Rothschild, Deborah Menaker. *Picasso's "Parade": From Street to Stage*. New York: The Drawing Center, Sotheby's Publications, 1991.

Rubin, William; Seckel, Hélène; and Cousins, Judith. *Les Demoiselles d'Avignon*. New York: The Museum of Modern Art, Studies in Modern Art, 3, 1994: 73–144.

Rubin, William S. *Pablo Picasso: A Retrospective*. Chronology by Jane Flugel. New York: The Museum of Modern Art and Boston: New York Graphic Society, 1980.

Rubin, William S. *Picasso and Braque, Pioneering Cubism*. New York: The Museum of Modern Art, 1989.

Rubin, William S. *Picasso in the Collection of the Museum of Modern Art*. New York: The Museum of Modern Art, 1972.

Russell, Frank D. *Picasso's Guernica, The Labyrinth of Narrative Vision*. Montclair: Allenheld and Schram, 1980.

Sabartès, Jaime. *Picasso, An Intimate Portrait*. 1st American edition. Translated from the Spanish by Angel Flores. New York: Prentice-Hall, 1948.

Sabartès, Jaime. *Picasso, Documents iconographiques*. Collection Visages d'Hommes Celebres, 8. Genève: Pierre Cailler, 1954.

Sabartès, Jaime. *Picasso's Variations on Velázquez' Painting, "The Maids of Honor" and Other Recent Work*. (Translation of *Les Menines et la vie*). New York: Harry N. Abrams, 1959.

Schiff, Gert. *Picasso at Work at Home, Selections from the Marina Picasso Collection*. Miami: Center for the Fine Arts, 1986.

Schiff, Gert. *Picasso, The Last Years, 1963–1973*. New York:

George Braziller, Inc., in association with the Grey Art Gallery and Study Center, New York University, 1983.

Schiff, Gert, editor. *Picasso in Perspective*. The Artist in Perspective Séries, H.W. Janson, general editor. Englewood Cliffs: New Jersey: Prentice-Hall, 1976.

Spies, Werner. *Pablo Picasso, Werke aus der Sammlung Marina Picasso, Eine Ausstellung zum hundertsten Geburtstag*. München: Prestel Verlag, 1981.

Stein, Gertrude, *Picasso*. London: C. Scribner's Sons, 1939.

Subirana, Rosa M. *Picasso Erótic*. Barcelona: Museu Picasso, 1979.

Tinterow, Gary. *Master Drawings by Picasso*. Cambridge, Mass.: Fogg Art Museum, 1981.

Udhe, Wilhelm. *Picasso and the French Tradition*. Translated by F. M. Loving. Paris: Editions des Quatre Chemins, New York: Weyhe, 1929.

Warncke, Carsten-Peter. *Pablo Picasso, 1881–1973*. Ed. Ingo F. Walther. 2 vols. Köln: Benedikt Tashen Verlag, 1991.

Picasso: Essays, Articles and Sections of Books

Alley, Ronald. "The Three Dancers." *Catalogue of the Tate Gallery, Collection of Modern Art (other than British)*. London: The Tate Gallery, Sotheby Parke Bernet, 1981. Originally published Newcastle-upon-Tyne, 1967.

Anderson, John. "Faustus/Velázquez/Picasso." *Arts Canada* no. 106 (March 1976), reprinted in *Picasso in Retrospect*. Edited by Gert Schiff. Englewood Cliffs, New Jersey: Prentice-Hall, 1976 158–162.

Anglin-Burgard, Timothy. "Picasso and Appropriation," *The Art Bulletin*, vol. 72, no. 3 (1991): 479–94.

Baer, Brigitte. "Seven Years of Printmaking, The Theater and its Limits." *Late Picasso*. London: The Tate Gallery, 1988: 95–135.

Barr-Sharrar, Beryl. "Some Aspects of Early Autobiographical Imagery in Picasso's Suite 347." *Art Bulletin* 54 (December 1972): 516–533.

Berger, John. "Only Connect-I." *New Statesman* 59 (February 20, 1960): 247. "Only Connect-II." *New Statesman* 59 (February 27, 1960): 286, 288.

Bernadac, Marie-Laure. "Picasso: 1953–1972: Painting as Model." *Late Picasso*. London: The Tate Gallery, 1988: 49–94.

Bernier, Rosamund. "Altdorfer as Seen by Picasso." *L'Oeil*, mai, 1955: 37–39.

Blunt, Anthony. "Picasso's Classical Period (1917–1925)." *Burlington Magazine* 110 (April 1968): 187–191.

Boggs, Jean Sutherland. "Picasso, the Last Thirty Years." *Picasso in Retrospect*. Edited by Sir Roland Penrose and John Golding, reprint edition, New York: Harper and Row, Icon Editions, 1980.

Bois, Yve-Alain. "The Semiology of Cubism," in *Picasso and Braque, A Symposium*, edited by Lynn Zelevansky. New York: The Museum of Modern Art, 1992, 169–208.

Camon Aznar, José. " 'Las Meninas' de Velázquez, segun Picasso." *Goya* 86 (September–October 1986): 88–93.

Cirlot, Juan Eduardo. "El Informalismo de Las Meninas de Picasso." *Revista*, Barcelona (13 Junio, 1959): 16–23.

Cohen, Janie L. "Picasso's Exploration of Rembrandt's Art, 1967–1972." *Arts Magazine* 58 (October 1983): 119–127.

Galassi, Susan Grace. "Picasso's 'The Lovers' of 1919. *Arts Magazine* 56, no. 6 (February 1982): 76–83.

Galassi, Susan Grace. "Picasso's Odalisque." *Source: Notes in the History of Art*, 9 (Spring/Summer 1992): 32–38.

Gallego, José. "Picasso y Las Meninas." *Goya* 31 (July–August 1959): 38–44.

Gaya Nuño, Juan Antonio. "Velázquez, 'Las Meninas' y Picasso." *Mundo Hispanico* no. 155 (February 1961): 54–56.

Golding, John. "Picasso and Surrealism." *Picasso in Retrospect*. Edited by Sir Roland Penrose and John Golding, reprint edition, New York: Harper and Row, Icon Editions, 1980: 49–79.

Goodman, Nelson, and Elgin, Catherine Z. "Variations on Variation—or Picasso back to Bach," in *Reconceptions in Philosophy and Other Arts and Sciences*. Indianapolis and Cambridge: Hackett Publishing Co., 1988: 66–82.

Gowing, Lawrence. "Two Notable Acquisitions." *The Tate Gallery Annual Report 1964–65*." London: The Tate Gallery, 1966.

Heck, Christian. "Entre le mythe et le modèle formel: les Crucifixions de Grünewald et l'art de XXe siècle," in *Corps Crucifiés*. Paris: Réunion des musées nationaux, 1993: 84–108.

Johnson, Ronald. "The Demoiselles d'Avignon and Dionysian Destruction." *Arts Magazine* 55 (October, 1980): 94–101.

Kahnweiler, Daniel Henry. "Entretiens avec Picasso au sujet des *Femmes d'Algers*." *Aujord'hui* no. 4 (September 1955): 12–13.

Kaufmann, Ruth. "Picasso's Crucifixion of 1930." *Burlington Magazine* 111 (September 1969): 553–561.

Koepplin, Dieter. "Eine Lithographie Picassos nach Cranach aus der Schenkung Georges Bloch," in *Zeitschrift für Schweizerische Archäeologie und Kunst-Geschichte*, Band 47, 1990.

Krauss, Rosalind. "In the Name of Picasso." *October* no. 16 (Spring 1981): 2–22.

Krauss, Rosalind. "The Impulse to See," *Vision and Visuality*, Dia Art Foundation, Discussions in Contemporary Culture, #2, edited by Hal Foster. Seattle: Bay Press, 1988: 51–78.

Krauss, Rosalind. "The Motivation of the Sign," in *Picasso and Braque: A Symposium*, edited by Lynn Zelevansky. New York: Museum of Modern Art, 1992: 261–286.

Krauss, Rosalind. "Re-presenting Picasso." *Art in America* LXVII, no. 10, Special Issue: *Picasso* (December 1980): 90–96.

Leighton, Patricia. "Picasso's Collages and the Threat of War." *The Art Bulletin* 67, no. 4 (December 1985): 653–72.

Leighton, Patricia. "The White Peril and l'Art Negre: Picasso, Primitivism, and Anticolonialism." *The Art Bulletin* 72, no. 4 (1990): 609–630.

Lucas, John. "Picasso as a Copyist." *Art News* 54 (November 1955): 36–39, 53–54, 56.

Martin, Kurt. "Picasso und Cranach. Bemerkingen zu Drei im Jahre 1947 Entstanden Lithographien von Picasso." *Das Kunstwerk* 3 (1949): 10–15.

Marrinan, Michael. "Picasso as an 'Ingres' Young Cubist." *Burlington Magazine* vol. CXIX, no. 896 (November 1977): 756–763.

Parmelin, Hélène. "Picasso and Las Meninas." *Yale Review* 47 (June 1958): 578–588.

Parmelin, Hélène. "Picasso ou le collectionneur qui n'en est pas un." *L'Oeil* 230 (September 1974): 6–9.

Poggi, Christine. "Frames of Reference, "Table and Tableau" in Picasso's Collages and Constructions." *Art Journal* vol. 47, no. 4 (Winter 1988): 311–323.

Pool, Phoebe. "Picasso's Neo-classicism: First Period, 1905–1906." *Apollo* 81 (February 1965): 122–127.

Pool, Phoebe. "Picasso's Neo-classicism: Second Period, 1917–1925." *Apollo* 85 (March 1967): 198–207.

Pudney, John. "Picasso—A Glimpse in the Sunlight." *The New Statesman and Nation* (London, September 16, 1944): 182–83.

Reff, Theodore. "Harlequins, Saltimbanques, Clowns and Fools." *Artforum* 10 (October 1971): 30–43.

Reff, Theodore. "Themes of Love and Death in Picasso's Early Work." *Picasso in Retrospect.* Edited by Sir Roland Penrose and John Golding. London: Paul Elek Ltd.; reprint edition, New York: Harper and Row, Icon Editions, 1980: 5–33.

Richardson, John. "The Catch in the Late Picasso." *The New York Review of Books* XXXI, 12 (July 19, 1984).

Richardson, John. "L'Epoque Jacqueline." *Late Picasso, Paintings, Drawings Sculpture and Prints, 1953–1972.* London: The Tate Gallery, 1988.

Richardson, John. "Picasso's Apocalyptic Whorehouse." *The New York Review of Books.* XXXIV, no.7 (April 23, 1987).

Rosenblum, Robert. " 'Demoiselles d'Avignon' Revisited." *Art News* 72 (April 1973): 45–48.

Rosenblum, Robert. "Picasso and History." Catalogue essay in *Picasso, A Loan Exhibition for the Benefit of Cancer Care, Inc.* New York: Acquavella Galleries, 1975: unpaginated.

Rosenblum, Robert. "Picasso and Ingres." A lecture presented at the Fogg Art Museum, Cambridge, Mass., in conjunction with the exhibition, *Master Drawings by Picasso*, February, 1981.

Rosenblum, Robert. "Picasso and the Typology of Cubism." *Picasso in Retrospect.* Edited by Sir Roland Penrose and John Golding, reprint edition, New York: Harper and Row, Icon Editions, 1980: 33–48.

Rosenthal, Mark. "The Nietzschean Character of Picasso's Early Development." *Arts Magazine* 55 (October 1980): 87–91.

Rubin, William. "From Narrative to Iconic in Picasso: The Buried Allegory in 'Bread and Fruitdish on a Table' and the Role of 'Les Demoiselles d'Avignon.'" *Art Bulletin* 65, no. 4 (December 1983): 615–649.

Rubin, William. "Modernist Primitivism, An Introduction," in *"Primitivism" in Twentieth Century Art*, vol. I. New York: The Museum of Modern Art, 1980: 615–49.

Rubin, William. "Picasso." In *"Primitivism" in Twentieth Century Art*, vol. I. New York: The Museum of Modern Art, 1984: 1–84.

Schapiro, Meyer. "Picasso's 'Woman with a Fan'; On Transformation and Self-Transformation." (1976) *Modern Art, 19th and 20th Centuries, Selected Papers.* New York: George Braziller, 1978: 111–120.

Schiff, Gert. Introduction. *Picasso in Perspective.* Edited by Gert Schiff. The Artists in Perspective Series, H. W. Janson, general editor. Englewood Cliffs, Prentice-Hall, 1976: 1–26.

Schiff, Gert. " 'The Sabines,' Sketchbook No. 163, 1962." *Je suis le cahier. The Sketchbooks of Picasso.* Edited by Arnold Glimcher and Marc Glimcher. Boston and New York: The Atlantic Monthly Press, 1986: 179–209.

Steinberg, Leo. "The Algerian Women and Picasso at Large." *Other Criteria: Confrontations with Twentieth Century Art.* New York: Oxford University Press, 1972: 125–234.

Steinberg, Leo. "The Philosophical Brothel, Part 1." *Art News* 71 (September 1972): 20–29. "The Philosophical Brothel, Part 2." *Art News* 71 (October 1972): 38–47. Revised and reprinted in *October* 44 (Spring 1988): 17–74.

Steinberg, Leo. "Resisting Cézanne: Picasso's 'Three Women.'" *Art in America* LXVI, no. 6 (November–December 1978): 114–133.

Zervos, Christian. "Confrontations de Picasso avec des oeuvres d'art d'autrefois." *Cahiers d'Art* 33–35 (1960): 9–119.

General Background

Adler, Kathleen. *Manet.* London: Salem House/Phaidon Press, 1986.

Alpers, Svetlana. "Interpretations without Representations or the Viewing of Las Meninas." *Representations* 1, no.1 (February 1983): 31–43.

Apollinaire, Guillaume. *The Cubist Painters, Aesthetic Meditations.* Translated by Lionel Abel from the French, *Les Peintres Cubistes* (Paris: Eugène Figuiere et Cie., 1913). New York: Wittenborn and Co., 1944.

Arnheim, Rudolf. "On the Late Style." *New Essays on the Psychology of Art.* Berkeley, Los Angeles and London: University of California Press, 1986: 285–296.

Arnheim, Rudolf. *The Power of the Center, A Study of Composition in the Visual Arts.* Berkeley, Los Angeles, London: University of California Press, 1982.

Barthes, Roland, "The Death of the Author," *Image, Music, Text*, translated by Stephen Heath. New York: Hill and Wang, 1977.

Baudrillard, Jean. *Simulacres et Simulations.* Paris: Galilée, 1981.

Baxandall, Michael. *Patterns of Intention: On the Historical Explanation of Pictures.* New Haven and London: Yale University Press, 1985.

Benjamin, Roger. *Matisse's "Notes of a Painter": Criticism, Theory, and Context, 1891–1908.* Ann Arbor: UMI Research Press, 1987.

Benjamin, Roger. "Recovering Authors: The Modern Copy, Copy Exhibitions and Matisse." *Art History*, vol. 12, no. 2 (June 1989): 176–201.

Benjamin, Walter. "The Task of the Translator: An Introduction to the Translations of Baudelaire's *Tableaux parisiens*." *Illuminations.* Edited by Hannah Arendt. Frankfurt: Suhrkamp Verlag, 1955; New York: Schocken, paperback edition, 1976: 69–82.

Benjamin, Walter. "The Work of Art in the Age of Mechanical Reproduction." *Illuminations.* Edited by Hannah Arendt. Frankfurt: Suhrkamp Verlag, 1955; New York: Schocken, paperback edition, 1976: 217–252.

Benjamin, Walter. "Allegory and Trauerspiel." In *The Origins of German Tragic Drama.* Translated by John Osborne. London and New York: Verso, 1985: 159–235. Originally published as *Ursprung des deutschen Trauerspiel*, Frankfurt-am-Main: Suhrkamp Verlag, 1963.

Bernadac, Marie-Laure. *Bonjour Monsieur Manet.* Paris: Centre Georges Pompidou, 1985.

Birkmayer, Karl M. "Realism and Realities in the Paintings of Velázquez," *Gazette des Beaux Arts.* 613ème séries, 52, 1958: 63–80.

Bloom, Harold. *The Anxiety of Influence, A Theory of Poetry.* New York: Oxford University Press, 1973.

Blunt, Anthony. *The Paintings of Nicolas Poussin, A Critical Catalogue.* London: Phaidon, 1966.

Brendel, Otto. "The Classic Style in Modern Art." *From Sophocles to Picasso: The Present Day Vitality of the Classical Tradition.* Edited by Whitney J. Oates. Bloomington, Indiana: Indiana University Press, 1962.

Breton, André. *Le Surréalisme et la peinture.* Paris: Librairie

Gallimard, 1928.

Brigstocke, Hugh. *Sacraments and Bacchanals, Paintings and Drawings on Sacred and Profane Themes by Nicolas Poussin*. Edinburgh: The National Gallery of Scotland, 1981.

Brown, Jonathan. "El Greco, The Man and the Myth," in *El Greco of Toledo*. Boston: Little, Brown & Co. A New York Graphic Society Book, 1982.

Brown, Jonathan. *Images and Ideas in 17th Century Spanish Painting*. Princeton: Princeton University Press, 1978.

Brown, Jonathan, editor. *Picasso and the Spanish Tradition* (with contributions by Jonathan Brown, Susan Grace Galassi, Robert Lubar, Robert Rosenblum, and Gertja Utley). New Haven and London: Yale University Press, forthcoming.

Brown, Jonathan. *Velázquez, Painter and Courtier*. New Haven and London: Yale University Press, 1989.

Bryson, Norman. *Tradition and Desire, From David to Delacroix*. Cambridge, London, New York: Cambridge University Press, 1984, paperback edition, 1987.

Bryson, Norman. *Vision and Painting, The Logic of the Gaze*. New Haven and London: Yale University Press, 1983.

Camon Aznar, José. *Domenico Greco*. 2 vols. Madrid: Espasa-Calpe S. A., 1950.

Centre nationale de la recherche scientifique. *Nicolas Poussin*. Paris: Editions du centre nationale de la recherche scientifique, 1960.

Clark, T. J. *Image of the People, Gustave Courbet and the 1848 Revolution*. London: Thames and Hudson, 1973; Princeton: Princeton University Press, 1988.

Clark, T. J. *The Painting of Modern Life in the Art of Manet and his Followers*. New York, Alfred A. Knopf, 1985.

Cocteau, Jean. *Le Greco*. Paris: Au Divan, 1942.

Cocteau, Jean. *A Call to Order*. Translated from the French by Rollo H. Myers. (Paris, 1926) New York: Henry Holt and Company, 1927.

Crimp, Douglas. "On the Museum's Ruins." *October* 13 (Summer 1980): 41–57.

Danto, Arthur, C. "Works of Art and Mere Real Things." *The Transfiguration of the Commonplace, A Philosophy of Art*. Cambridge, Mass. and London: Cambridge University Press, paperback edition, 1981: 1–32.

Elderfield, John. *"The Wild Beasts," Fauvism and its Affinities*. New York: The Museum of Modern Art, 1976.

Eliot, T. S. "Tradition and the Individual Talent" (1919), in *Selected Essays*. London: Faber and Faber, Ltd., 1932, reprint edition, 1972: 13–22.

Emmens, J. A. "Les Menines de Velázquez: Miroir des Princes pour Philippe IV." *Nederlands Kunsthistorisch Jaarboek* 12, 1961: 51–79.

Fernier, Robert. *La vie de l'oeuvre de Gustave Courbet, catalogue raisonné*. 3 vols, Lausanne and Paris: Foundation Wildenstein, La Bibliothèque des Arts, 1977.

Flam, Jack. *Matisse, The Man and his Art, 1869–1918*. Ithaca and London: Cornell University Press, 1986.

Foucault, Michel. "Las Meninas." *The Order of Things, an Archeology of the Human Sciences*. Translation of *Les mots et les choses* Paris, Gallimard, 1966; New York: Viking, 1973: 3–16.

Foucault, Michel. "Fantasia of the Library." *Language, Counter-Memory and Practice*. Edited by Donald F. Bouchard. Ithaca, New York: Cornell University Press, 1977.

Foucault, Michel. "What is an Author?" (1969) *The Foucault Reader*, edited by Paul Rabinow, New York: Pantheon, 1984: 101–120.

Fried, Michael. "Manet's Sources." *Artforum* VII, 7 (March 1969): 28–82.

Fried, Michael. "Painting Memories: On the Containment of the Past in Baudelaire and Manet." *Critical Inquiry* 10 (March 3, 1984): 510–42.

Friedrich, Otto. *Olympia: Paris in the Age of Manet*. New York, London, and Toronto: Simon and Schuster, A Touchstone Book, 1993.

Freud, Sigmund. "Wit and its Relation to the Unconscious." Book IV, *The Basic Writings of Sigmund Freud*. Translated and edited by Dr. A. A. Brill. New York: Modern Library, 1938: 633–762.

Gleizes, Albert and Metzinger, Jean. *Cubism*. Translated from the French, *Du cubisme* (Paris: 1912). London: T. Fisher Unwin, 1913.

Green, Christopher. *Léger and the Avant-Garde*. New Haven: Yale University Press, 1976.

Green, Christopher. *Cubism and its Enemies: Modern Movements and Reactions in French Art, 1916–1928*. New Haven and London: Yale University Press, 1987.

Guidol, José. *Domeikos Theotokopoulos, El Greco, 1541–1614*. Translated from the Spanish by Kenneth Lyons. New York: A Studio Book, Viking, 1973.

Haverkamp-Begemann and Logan Carolyn. *Creative Copies: Interpretative Drawings from Michelangelo to Picasso*. New York: The Drawing Center, 1988.

Hayum, Andrée. *The Isenheim Altarpiece: God's Medicine and the Painter's Vision*. Princeton University Press, 1989.

Hofmann, Werner. *Nana, Mythos und Wirklichkeit*. Cologne: Verlag M. DuMont Schauberg, 1973.

Hutcheon, Linda. *A Theory of Parody, The Teachings of Twentieth Century Art Forms*. London and New York: Metheun, 1985.

Huyghe, René. *Delacroix*. Translated by Jonathan Griffin, London: Thames and Hudson, 1963.

Huysmans, J.-K. "Trois Primitifs." (1904). Translated by Robert Balrick. *Grünewald, The Paintings*. Complete Edition. Edited by E. Ruhmer. New York: Phaidon: 1958.

Jamot, Paul. *Les Le Nain*. Paris: Henri Laurens, ed., 1929.

Johnson, Lee. *The Paintings of Eugène Delacroix: A Critical Catalogue, 1832–63*. 6 vols. Oxford: Clarendon Press; New York: Oxford University Press, 1986.

Johnson, Lee. *Delacroix*. London: Widenfeld and Nicolson, 1963.

Justi, Carl. *Diego Velázquez and his Times*. Translated from the German by A. H. Keane. London: H. Grevel and Co., 1889.

Kahnweiler, Daniel Henry with Crémieux, Francis. *My Galleries and Painters*. Translated by Helen Weaver. The Documents of Twentieth Century Art. New York: The Viking Press, 1971.

Kierkegaard, Søren. "Constantine Constantius Revisits Berlin" (from *Repetition* (1835) in *A Kierkegaard Anthology*, edited by Robert Bretall, New York: The Modern Library, 1946.

Koepplin, Dieter and Tilman Falk. *Lukas Cranach, Gemälde, Zeichnungen, Druckgraphik*. Band 2. Basel und Stuttgart: Birkhauser Verlag, 1976.

Krauss, Rosalind. *The Originality of the Avant-Garde and other Modernist Myths*. Cambridge, Mass. and London: The M.I.T. Press, 1985, paperback edition, 1988.

Lambert, Elie. *Delacroix and Les Femmes d'Alger*. Paris: Librairie Renouard, H. Laurens, Editeur, 1937.

Lecoq-Ramond, Sylvie, et al. *Variations autour de la*

Crucifixion, Regards contemporains sur Grünewald. Colmar: Musée d'Unterlinden, 1993: 12–34.

Loyrette, Henri, "The Nude," in *Origins of Impressionism,* edited by Gary Tinterow and Henri Loyrette. New York: The Metropolitan Museum of Art and Harry N. Abrams, Inc., 1995, 95–124.

Maison, K. E. *Themes and Variations. Five Centuries of Master Copies and Interpretations.* New York: Harry N. Abrams, Inc., 1960.

de Man, Paul. "Literary History and Literary Modernity." *Blindness and Insight, Essays in the Rhetoric of Contemporary Criticism,* 2nd ed. Minneapolis: University of Minnesota Press, 1983.

Meier, Michael and Pevsner, Nikolaus. *Grünewald,* New York: Harry N. Abrams, 1958.

Meltzoff, Stanley. "The Revival of the Le Nains." *The Art Bulletin* 3 (September 1942): 260–286.

Nietzsche, Frederick, "The Use and Abuse of History," in *The Philosophy of Nietzsche.* Edited by Geoffrey Clive. Translated by Oscar Levy. New York: New American Library, A Meridian Classic, 1984: 218–238.

Nichols, Lynn. *The Rape of Europa.* New York: Random House, 1994.

Nochlin, Linda. *Mathis at Colmar, A Visual Confrontation.* New York: Red Dust, 1963.

Ortega y Gasset, José. *The Dehumanization of Art* (1925) in *Criticism, The Major Texts,* edited by Walter Jackson Bate. New York: Harcourt, Brace, Jovanovich, 1970.

Ortega y Gasset, José. *Velázquez.* New York: Random House, 1953.

Pickvance, Ronald. *Van Gogh at St. Rémy and Auvers.* New York: The Metropolitan Museum of Art, 1986.

Posse, Hans. *Lucas Cranach d.ä.* Wien: Verlag Anton Schroll and Co., 1942.

Randel, Dan, editor. *The New Harvard Dictionary of Music.* Cambridge and London: The Belknap Press of Harvard University, 1986.

Raynal, Maurice. "Réalité et Mythologie des Cranach." *Minotaure* #9 2ème série, 1936.

Reff, Theodore. *Manet: Olympia.* New York: Viking (Art in Context), 1976.

Rosen, Charles and Zerner, Henri. *Romanticism and Realism, The Mythology of 19th Century Art.* New York and London: Norton, 1984.

Rosenblum, Robert. *Cubism and Twentieth Century Art.* (1959), revised edition. New York: Harry N. Abrams, 1976.

Rosenblum, Robert. *Jean-Auguste Dominique Ingres.* New York: Harry N. Abrams, 1967.

Rubin, William S. *Dada and Surrealist Art.* New York: Harry N. Abrams, 1969.

Ruhmer, E. *Grünewald, The Paintings.* Complete edition. New York: Phaidon Publishers, 1958.

Salmon, André. "Georges Seurat." *Burlington Magazine* (September 1920): 115–22.

Schade, Werner. *Cranach, A Family of Master Painters.* Translated by Helen Sebba. New York: G. P. Putnam Sons, 1980.

Schiff, Richard. "Representation, Copying, and the Technique of Originality," *New Literary History.* vol. 15, no. 2 (Winter 1984): 331–63.

Schiller, Gertrude. *Iconography of Christian Art.* 2 vols. (1968), Greenwich: The New York Graphic Society, 1972.

Schneider, Pierre. *Matisse.* Translated by Michael Taylor and Briget Strevens Romer. New York, Rizzoli, 1984.

Searle, John. "Las Meninas and the Paradox of Pictorial Representation." *Critical Inquiry* 6 (Spring 1980): 429–47.

Silver, Kenneth E. "Esprit de Corps." *The Art of the Parisian Avant-Garde and the First World War, 1914–1925.* Princeton: Princeton University Press, 1989.

Steinberg, Leo. "Introduction—The Glorious Company." *Art about Art.* Jean Lipman and Richard Marshall. New York: E.P. Dutton in association with the Whitney Museum of American Art, 1978: 8–31.

Steinberg, Leo. "Velázquez' Las Meninas." *October* 19 (Winter 1981).

Synder, Joel and Cohen, Ted. "Critical Response on Las Meninas, Paradox Lost." *Critical Inquiry,* 7 (Winter 1980): 477–88.

Thuillier, Jacques. *Les Frères Le Nain.* Paris: Editions de la Réunion des musées nationaux, 1978.

Toussaint, Hélène. *Gustave Courbet, 1819–1877.* Exhibition catalogue, Paris, Grand Palais, 1977–78.

Trapier, Elizabeth du Gué. "The Son of El Greco." *Notes Hispanics III,* New York: The Hispanic Society of America, 1943. Paris: Editions de la Réunion des musées nationaux, 1978.

Varnedoe, Kirk. "Gauguin." *"Primitivism" in 20th Century Art.* Edited by William Rubin. New York: The Museum of Modern Art, 1980: 179–210.

Varia Velázqueña, Homenaje en el III centenario de su muerte. 2 vols. Madrid: Ministerio de educación naciónal; Dirección general de Bellas Artes, 1960.

Warren, Rosanna, editor. *The Art of Translation, Voices from the Field.* Boston: Northeastern University Press, 1989.

Wethey, Harold E. *El Greco and his School.* Catalogue Raisonné. 2 vols. Princeton: Princeton University Press, 1962.

Wollheim, Richard. *Painting as an Art.* London: Thames and Hudson, 1987.

Zervos, Christian. *Nus de Lucas Cranach.* Paris: Editions "Cahiers d'Art," 1950.

Zervos, Christian. *Les Oeuvres du Greco en Espagne.* Paris: Editions "Cahiers d'Art," 1939.

C

Cabanne, Pierre, 57
Calder, Alexander, 72
Casagemas, Carles, 34; represented in *La Vie* (Fig. 2-13), 34; *35*
Cézanne, Paul, 12, 18, 26, 39, 92, 129, 133, 135, 189, 194, 196; *An Afternoon in Naples*, 29; *A Modern Olympia* (Fig. 2-4), 29; *29*
Champfleury (Jules Husson), 44
Chants des Morts (poems; Reverdy), 116
Château de Richelieu, 92
Château de Vauvenargues, 189, 190
Chevreul, Michel-Eugène, 46, 133
Clark, T. J., 29
classicism, 37, 42–44, 46, 49
Claude Drawing, Paloma and Françoise (Fig. 4-28), 114; *115*
Cocteau, Jean, 42
coloristic tradition, 132, 133
color theory, 133
Comédie Humaine, La, series, 23, 128
commedia dell'arte, 48, 54, 56
Communists, *see* French Communist Party
Concert in the Country (*Concert Champêtre*) (Titian) (Fig. 7-2), 186; *187*
Concert of Angels, Isenheim Altarpiece (Grünewald) (Fig. 3-2), *61*
Cooper, Douglas, 54–56, 95, 189, 197
copying, 9; by Gauguin, 33; van Gogh's view, 13–14; by Manet, 27–28; new era, 12–13; Picasso's views, 8, 20, 21; variation compared to, 11
Cossío, Manuel, 121
Courbet, Gustave, 17, 18, 90, 114, 116, 179, 186, 196; *Burial at Ornans*, 89, 114; *Portrait of Pierre-Joseph Proud'hon and His Children* (Fig. 4-29), 114; *115*; realist nudes, 27; *Studio*, 89, 114; *Young Ladies on the Banks of the Seine* (*Les Demoiselles des bords de la Seine*) (Fig. 4-30), 22, 114–16, 118, 133, 187; *117*; elements of in Picasso's works, 118, 190; Picasso's painting after (Fig. 4-31), 113–18; *117*
Cranach, Lucas the Elder, 90, 98–100, 104–5, 112; *David and Bathsheba* (Fig. 4-13), 22, 101–2, 103, 104; *102*; Picasso's lithographs after (Figs. 4-14 to 4-17, 4-19, 4-21 to 4-24, 4-26, 4-27), 100–113, 124; *103, 104, 105, 106, 108, 109, 110, 111, 112, 113*; *Princess Sibylle of Cleves as a Bride*, Picasso's lithograph after, 100; *Venus and Cupid* (Fig. 4-12), *101*; Picasso's lithographs after (Fig. 4-11), 100; *101*; *Venus and Cupid as a Honey Thief*, Picasso's works after, 100
Cranach, Lucas the Younger, 98, 100; *Portrait of a Noblewoman* (Fig. 4-10), *99*; Picasso's lino-cut after (Fig. 4-9), 100; *99*
Crucifixion (February 7, 1930) (Fig. 3-5), 64, 74, 76, 87; *63*
Crucifixion, The, Isenheim Altarpiece (Grünewald) (Figs. 3-1, 3-4), 22, 60, 64–65, 66, 67, 70, 74, 76, 79, 81, 82, 83, 84, 86, 87, 98; *61, 62*; Picasso's variations after (Figs. 3-6 to 3-9, 3-11, 3-12, 3-17, 3-18, 3-20 to 3-24), 60–87, 98, 102; *67, 69, 71, 73, 78, 81, 82, 83, 84*
Crucifixion, Karlsruhe (Grünewald), 66
Crucifixion, after Grünewald (1; September 17, 1932) (Fig. 3-6), 66–68, 70, 79, 82, 102; *67*
Crucifixion, after Grünewald (2; September 17, 1932) (Fig. 3-7), 68, 70, 81, 82; *69*
Crucifixion, after Grünewald (3; September 17, 1932) (Fig. 3-8), 68–70, 82; *69*

Crucifixion, after Grünewald (4; September 19, 1932) (Fig. 3-9), 70–72, 81, 82; *71*
Crucifixion, after Grünewald (5; September 19, 1932) (Fig. 3-11), 70, 72–76, 81, 82; *73*
Crucifixion, after Grünewald (6; September 19, 1932) (Fig. 3-12), 70, 72–76, 81, 82; *73*
Crucifixion, after Grünewald (7; October 4, 1932) (Fig. 3-17), 76–79, 82; *78*
Crucifixion, after Grünewald (8; October 4, 1932) (Fig. 3-18), 76–79, 82; *78*
Crucifixion, after Grünewald, studies for, see entries at *Study for the Crucifixion, after Grünewald*
Crucifixion, cycle of 1926–36, 64
Crucifixion theme, 21, 62–64, 76
Cuadro Flamenco (dance-scene), 58; fragment of the set design of, *The Box* (Fig. 2-34), 58; *57*; sketch of a set design reworked for (Fig. 2-32), *56*
Cubism, 15–16, 18, 48, 146; development of, 15, 37, 39, 41, 120, 151; and Fauvism, 40; *femme fatale* figure, 51; French view of, 45; El Greco's influence, 120; Matisse's variation after de Heem, 14; phases: Analytic (1909–12), 15–16, 52, 143; Synthetic (1912–21), 16, 48, 51, 143; Picasso's use of idioms in later works, 52, 94–95, 124, 126, 136, 142–43, 146, 152, 155, 156, 159, 160, 171, 172–73, 176, 180, 181, 183; realist stance, 114

D

Dadaism, 51
Daix, Pierre, 132
Dalí, Salvador, 74
Danto, Arthur, 9
Daumier, Honoré, 14
David, Jacques-Louis, 44; *Rape of the Sabine Women*, 200
David and Bathsheba (Cranach the Elder) (Fig. 4-13), 22, 101–2, 103, 104; *102*; Picasso's lithographs after (Figs. 4-14 to 4-17, 4-19, 4-21 to 4-24, 4-26, 4-27), 100–113, 124; *103, 104, 105, 106, 108, 109, 110, 111, 112, 113*
David and Bathsheba, theme of, 192
David and Bathsheba, after Cranach (March 30, 1947; State 1) (Fig. 4-14), 102–3, 111; *103*
David and Bathsheba, after Cranach (March 30, 1947; State 2) (Fig. 4-15), 103, 111; *104*
David and Bathsheba, after Cranach (March 30, 1947; State 3) (Fig. 4-16), 104; *105*
David and Bathsheba, after Cranach (March 30, 1947; State 4) (Fig. 4-17), 105–6, 111; *106*
David and Bathsheba, after Cranach (March 30, 1947; State 5) (Fig. 4-19), 106–8, 111; *108*
David and Bathsheba, after Cranach (March 30, 1948; State 6) (Fig. 4-21), 108, 111; *109*
David and Bathsheba, after Cranach (March 6, 1949; State 7) (Fig. 4-22), 109; *110*
David and Bathsheba, after Cranach (April 10, 1949; State 8) (Fig. 4-23), 109; *110*
David and Bathsheba, after Cranach (April 12, 1949; State 9) (Fig. 4-24), 110; *110*
David and Bathsheba, after Cranach (April 17, 1949; State 10) (Fig. 4-26), 111; *112*
David and Bathsheba, after Cranach (May 29, 1949; [2d] State 1) (Fig. 4-27), 111–12; *113*
Death of Sardanapaulus, The (Delacroix), 89
decorative tradition, 135

List of Credits

The author and publisher wish to thank the museums, libraries, galleries, and private collectors named in the picture captions for permitting the reproduction of works of art in their collections and for supplying the necessary photographs. Other photograph credits are listed below by page number.

Artists' Copyrights

WITHDRAWN